The
Complete Photographer

by Andreas Feininger

Prentice-Hall, Inc., Englewood Cliffs, New Jersey

Books by ANDREAS FEININGER

Library of Congress Catalog Card Number: 65-12017

Printed in the United States of America

T 16221

Prentice-Hall International, Inc., *London*
Prentice-Hall of Australia, Pty., Ltd., *Sydney*
Prentice-Hall of Canada, Ltd., *Toronto*
Prentice-Hall of India Private Ltd., *New Delhi*
Prentice-Hall of Japan, Inc., *Tokyo*

20 19 18 17 16 15 14 13 12 11

Contents

Introduction

WHY I WROTE THIS BOOK

I wrote this book because rapid progress in photo-technology has brought about some entirely new trends in photography. These trends are:

1. The increasing emphasis on color

The greatest barrier to widespread use of color in photography, the slow speed of color films, has been removed. The dream of color-in-a-minute pictures is no longer a dream—Polaroid color film has made it a reality. As a result, there has been an enormous increase in the number of photographs taken in color.

2. The emergence of photographic services

The time when the amateur had to do his own darkroom work or take his film to a drugstore is gone. Today, the services of highly competent, professional photo-finishers and custom laboratories are available where one lives or through mail order for those who do not wish to do their own darkroom work. In consequence, lack of darkroom facilities or lack of interest in negative or print processing is no longer a block to serious creative photographic work.

3. The automation of equipment and technique

The instruments and processes by which photographs are made are constantly being refined and automated. This makes it possible for photographers to get technically excellent photographs with less and less experience and skill. As a result, today's photographers are almost completely free from the need to spend a large part of their attention on technicalities and can concentrate instead almost entirely upon the more important aspects of content and meaning in their pictures.

These advances make necessary a re-evaluation of where emphasis in instruction should be placed in a new photographic textbook. The following seemed of particular importance to me:

1. Emphasis must now be placed on color instead of black and white.

2. Emphasis must now be placed on those problems which the photographer alone can solve. Those procedures that can be done by a custom lab can be treated more summarily. This means the assignment of more space to discussions of problems involved in selecting the right kind of equipment and in taking a photograph, and less space to the developing, printing, and enlarging of it.

3. Emphasis must now be placed on the creative aspects of photography—impact, content, and meaning of the picture—instead of on the technical problems which in the past have been the main subject of textbooks on photography.

This leads to another point: in this book, no information for the use of specific brands of photographic equipment and material will be given. Adequate instructions are provided by most manufacturers to accompany their products. Inclusion here of such information is therefore not necessary. And since progress in the photo-technological field is so rapid, its inclusion would doubtlessly be of little relevance by the time this book is published. Instead, I will explain the basic principles which underlie the entire field of photography and, when necessary, refer the reader to the respective manufacturer's instruction sheets for specific data.

IDEA AND PLAN

This book is a synthesis of all my photo-technical texts,* but the material has been completely reorganized and includes the latest developments in photography. As a result, this is a bulky volume—a fact which must not discourage the reader who is inexperienced in photographic matters. For besides providing information on just about every conceivable photo-technical problem that a practicing professional or amateur photographer might have to face, this book also contains advice as basic as telling the beginner how to choose his first camera or expose his first roll of film. And drawing on my twenty years of experience as a staff photographer for *Life,* I have also included observations and thoughts not found anywhere else regarding the making of pictures.

To keep the price of the book within reason, the illustrations had to be restricted to thirty-two pages, sixteen of which are in color. As a result, how-to-do-it photographs and comparison picture series which can be found in any photo-magazine are not shown. Instead, I selected pictures made by some of the foremost photogra-

* In particular: *Successful Photography,* Prentice-Hall, 1954
 Successful Color Photography, Prentice-Hall, 1954
 The Creative Photographer, Prentice-Hall, 1955

phers. Each picture was chosen to illustrate a specific aspect of modern photography. Although these photographs represent some of the best work done today, they are related to the techniques discussed in this text. These techniques can be mastered by any reader who completes the course in photography given in this book.

The book is organized as follows:

PART 1 is devoted to a discussion of the purpose of photography as I see it.

PART 2 is given to an examination of the nature of the photographic medium. This is perhaps the most important chapter in the book because it is his attitude toward photography which decides the direction in which the student will develop and determines the goal he ultimately may reach.

PART 3 deals with photographic seeing. Though all photographers use basically the same kind of equipment, material, and techniques, differences in the emotional impact, artistic quality, and meaning of their pictures range from the hackneyed to the profound. The most consequential reason for this is the ability or inability to "see in terms of photography."

PART 4 introduces the student to the tools and materials of his craft. Based on more than thirty years of professional experience, this chapter tells him precisely and completely what equipment is necessary for different kinds of photographic work and how to assemble the outfit that will best suit his personality and needs.

PART 5 teaches the reader how to take a photograph. Besides receiving instructions for taking black-and-white and color photographs in both natural and artificial light, this chapter will give him insight into the interrelationship of all the technical factors that are involved in making a photograph. He'll understand why a change in one can set off a chain reaction that affects many others.

PART 6 deals with the darkroom. The student is shown how to set up his own improvised or permanent darkroom. He'll learn how to develop films, both black-and-white and color. In addition, he'll be told how to print negatives and use techniques which will make it possible for him to have a very high degree of control over the final appearance of his pictures.

PART 7 examines the concept of symbolism, a fascinating aspect of creative photography. It tells how any subject can be rendered in an infinite number of different forms through imaginative use of photographic controls and how a photographer

can, therefore, not only express in his pictures *precisely* what he wishes to say, but can also give impact to his work. This is particularly important to the gifted student who wishes to reach the top.

PART 8 investigates the scope and the limitations of photography. The reader will learn how he can, with very modest additional expenditure for equipment, extend the range of his work into fields he might have thought reserved for specialists. In addition to a brief introduction dealing with the rewards and pitfalls of nonroutine photography, nine specific fields are discussed in which pictures can be made that extend the scope of our visual experience.

PART 9 probes the question why certain photographs appeal to us while others leave us cold. I discuss the qualities which, in my opinion, a photograph must possess to be called good, and I tell how these qualities can be achieved.

WHAT THIS BOOK CAN DO FOR YOU

The purpose of this book is to help you to become a good photographer. It is a training manual and a reference work. A maximum of information is packed within a minimum of space. However, the value of information depends upon its accessibility. To make information quickly available I have provided a very detailed table of contents at the beginning of the book, a very detailed index in the back, and complete cross-references throughout the entire text. Each picture has a specific purpose and illustrates a specific point. And cross-references link pictures and text, relating detail to the whole.

In fairness to you, the student of photography, I must add the following:

Photography at its best is a form of art. And like any other form of art, it involves two different levels:

> The level of creation
> The level of execution

Creation of any work of art begins with a flash of inspiration or a train of thought, with an idea and a plan. The forces which motivate it are inventiveness and imagination. These qualities are inherent in the artist. They are elusive—hard to define; and one either does or does not possess them. They cannot be taught.

In contrast, the execution of any work of art is based upon concrete techniques

4

involving means and devices. Anyone who is willing to make the effort can learn to master them.

A comparison with music might be useful. A good composer is an artist who, from the individuality of his imagination, creates new forms in sound. However, to communicate what he has composed, someone must play it. Instruments—mechanical devices—must be used by technically trained performers. A composer must not necessarily be a good technician, nor does he have to play his music himself. Conversely, a musical performer must not necessarily have a creative mind; he does not have to write his own music. But only if creative and technical abilities are brought together can a work of art take concrete form and its meaning be communicated to others.

A duality of creativity and technical ability is also found in photography. I know personally several unusually creative photographers who have only the most rudimentary understanding of photographic techniques and who would not think of developing films or making prints. And I have met quite a few extraordinarily skilled photo-technicians who lacked a creative mind.

What I wish to arrive at is this: if you study the following pages you can with work become an expert photo-technician but not necessarily an artist. Whether or not you can do original work depends entirely upon your inherent qualifications. However, talent is often dormant until stirred by some outside influence. This book might conceivably provide that influence. With this in mind I have included many thoughts and observations on the purpose, nature, and uses of photography which, I hope, will stimulate you to strike out on your own. Once started in the right direction, the satisfaction you experience from doing original work will carry you on to the limit of your ability.

The Purpose of Photography

Photography is picture language, the newest version of the oldest form of graphic communication. Unlike the spoken or written word, it is a form of communication that can be internationally understood. This, it seems to me, gives a photograph added meaning—and a photographer added responsibility. Since photographs can be so widely understood we should be concerned with whether what we have to say is worth saying, and whether we can say it well.

The essential purpose of photography is communication. Few people take pictures solely to please themselves. Most of us take them because we want them seen by others. We wish—or are compelled—to inform, educate, entertain, reform, or share some experience with others. Pictures are a photographer's means of expression as a writer's means are words. And as a writer must choose a major field of work —journalism, creative writing, biography, advertising, etc.—so a photographer must choose a specific field, each field having a specific purpose. Some of these purposes are:

Information. Documentary photographs as well as the majority of photographs found in picture magazines, newspapers, manuals, scientific publications, and pictures used for visual education belong to this category. Their purpose is either to educate people or to enable them to make correct decisions.

Slanted information. This is the province of commercial and advertising photography and political propaganda. The purpose of such pictures is to make the subject glamorous and more desirable. The goal is the selling of a product, a service, or an idea.

Discovery. Because the camera is in many respects superior to the eye, it can be used to make discoveries in the realm of vision. This is the field of research and scientific photography, close-up and telephotography, ultra-wide-angle and high-speed photography, abstract photographs and photograms. The purpose of such pictures is to open new fields for exploration, to widen man's visual and intellectual horizons, and to enrich his life.

Recording. Photography provides the simplest and cheapest means for preserving facts in picture form. Catalogue pictures, reproductions of works of art, microfilming of documents and books, identification pictures, and certain kinds of documentary photographs, fall into this category. Used for recording purposes, photography preserves knowledge and facts in easily accessible form suitable for widest dissemination and utilization.

Entertainment. Photography provides an endless source of entertainment and pleasure: motion pictures, amateur photographs, travel pictures, fine picture books and photographic annuals, pin-up photographs, photographic feature stories in picture magazines, etc.

Self-expression. An increasing number of talented, creative people find in photography a relatively inexpensive means for self-expression. Almost any subject can be photographed in an almost unlimited number of different ways, and more and more photographers seek new and more expressive forms of photographic rendition through which to share with others their own visions of the world, their feelings, ideas, and thoughts.

These six categories form the main body of modern photography. Although, of course, overlappings and duplications exist, for practical purposes they can be combined in the three following groups.

REPRODUCTIVE-UTILITARIAN PHOTOGRAPHY

This type of photography is used in connection with a specific profession, business, industry, or science. Its purpose is to record facts and events and preserve them for immediate or future use. The closer this sort of picture is to actuality, the greater its usefulness, the ideal being the perfect reproduction. In this field a considerable degree of technical ingenuity is often needed to solve problems involved in making this kind of photograph and to fully exploit the potential of the highly complex instruments at times required for this purpose.

Often this type of picture is not made by professional photographers but by laboratory technicians, scientists, researchers, engineers, airforce personnel, physicians, dentists, etc., who use photography as an important part of their regular work. Their interest in it is strictly practical; as far as they are concerned, a photograph is a record whose value is directly proportional to its accuracy, clarity, and objectivity.

Typical examples of this kind of photography are photo-micrographs, aerial pho-

tographs taken for mapping purposes, medical and industrial X-ray photographs, microfilming of documents and books, copy-work and photo-engraving, catalogue photographs and photographs used for the illustration of training manuals and instruction booklets, and, of course, the entire enormously diversified complex of scientific photography from actinology to zymology.

DOCUMENTARY-ILLUSTRATIVE PHOTOGRAPHY

Its primary function is to inform and educate. Its nature is admirably defined in Webster's definition of the word "documentary": "Recording or depicting in artistic form a factual and authoritative presentation as of an event or a social or cultural phenomenon." Two words—"artistic" and "factual"—stand out in this definition; together, they contain the essence of a good documentary photograph: subject and content of the picture are factual, but the form in which they are presented is artistic.

In contrast to reproductive-utilitarian photographs which are primarily addressed to a professional audience, documentary photographs are intended for the general public. The professional audience is exclusively interested in the factual content of a photograph and cares little about the form of presentation as long as it is accurate and clear. On the other hand, the public, caught in a flood of pictures in magazines, newspapers, Sunday supplements, movies, and on television screens, will give attention to a photograph only if it is outstanding in content or presentation. Unfortunately, since the subjects of most photographs are familiar, and since photographs lack two of a subject's most important qualities—three-dimensionality and motion—and a black-and-white photograph lacks another subject quality—color—it becomes clear that in documentary-illustrative photography
p. 12 the objective subject approach, so indispensable in reproductive-utilitarian photography, makes dull and uninteresting pictures. This dullness that is inherent in most subjects and in the usual form of photographic rendition must be replaced by an
pp. 9, 13 unusual creative approach to the subject and a graphically interesting form of presentation.

Typical examples of documentary-illustrative photography are found in the picture stories of such magazines as *Life, Look,* and *Paris Match;* the type of photography that began with the Farm Security Administration and which was subsequently used by the publicity departments of the Standard Oil Company, Cities Service Company, and U.S. Steel; political and news photographs; and the majority of amateur snapshots and travel pictures.

8

CREATIVE-INTERPRETATIVE PHOTOGRAPHY

Its prime function is to stimulate and enrich the mind. If one were to draw a parallel between photography and writing, documentary photographers might be compared to journalists and biographers, creative photographers to writers of fiction and poetry.

Whereas documentary photography is primarily concerned with specific subjects, facts, and events, creative photography is concerned with the essence of things and its interpretation. In this type of photography the subject becomes a vehicle for an idea, a symbol that represents something other than itself. Here feelings are more important than facts, and the subject of the picture is a mood. pp. 40, 262

WHY DO YOU WISH TO PHOTOGRAPH?

Anyone who expects to derive satisfaction from photography must decide precisely what he wishes to do. His career as a photographer, whether amateur or professional, and the degree of fulfillment he will experience from his work will depend upon the answers to three important questions: Why does he wish to photograph? What does he wish to photograph? How does he wish to photograph?

Is it because you need photographs as records in your work . . . wish to inform and educate others . . . make pictures for your own enjoyment and pleasure . . . feel compelled to express your feelings or ideas? Do you wish to take up photography as a hobby? As a career? As a supplement to other work? As a means of self-expression?

Answering these questions truthfully is, believe me, vitally important to your future as a photographer.

Photography as a hobby

If photography is your hobby you are an amateur. An amateur is defined as a person who does something because he loves to do it—he does it for the pleasure of it. If you are to be successful as an amateur you must have pride in your work and derive a feeling of self-respect and satisfaction through doing it. The only way to reach this desirable state is to do original work. p. 330

As an amateur, you have an advantage over other photographers—you can do as you wish. You have no boss. No one to tell you what is wanted; nor to suggest how it might be done. This should make amateurs the happiest of photographers.

Unfortunately, this is rarely true. Very few amateurs realize their unique position

and take advantage of it. Most of them are indecisive, lacking in both purpose and goal. To compensate for a lack of direction they look desperately for guidance. This inevitably leads them into imitation of the work of others in the thought that what worked well for someone else will work as well or better for them. Once a photographer competes on this level, he will quite likely end by being part of that society for mutual admiration, the photo-club. If this happens, he gives up the chance of becoming a photographer with something of value to say.

To avoid the trap of imitation, don't concentrate your attention on what some other photographer does, whether he is your friend or a stranger whose work you respect. People are different, and another's approach or interest may be totally wrong for you. You are *you*—so be yourself, and be proud of it. Listen to criticism, but analyze it carefully and accept only that advice which you are convinced applies to *you*—*your* kind of work, *your* temperament and personality, *your* goals.

Photography as a career

pp. 25, 326

If you intend to make a career of photography and wish to be content in your profession, try to find a field that goes with your interests. For example, if you like to travel, to see new people and things, you might consider working toward a career as a photo-journalist on a big picture magazine. If your interests are predominantly technical, you might consider industrial photography or becoming a plant photographer. If you have a feeling for people, consider news reporting or portraiture. And so on.

The great satisfaction of working in a field in which one is genuinely interested seems more important to me than the amount of money to be earned. The happiest professional photographers are those for whom photography is a way of life and who appreciate how lucky they are to be paid for doing something they would do anyway. Without exception, all our best photographers belong to this group. A complete absorption in their work that stems from interest in the subjects they photograph lies at the root of their success.

Photography as supplement to other work

Today photography is used in almost every field in one capacity or another. A few examples of its use in conjunction with other work are the microfilming of checks, documents, and all kinds of printed matter; use of photo-mechanical reproduction in publishing; photography in identification and law enforcement; X-ray photography in medicine and dentistry.

In all these examples the purpose of photography is to produce records whose

10

value is their authenticity. To produce such records, an objective approach, photo-technical knowledge, experience, and capability are needed.

However, these qualifications are insufficient when applied to another kind of record. If, for example, photographic reproductions of sculpture are to be used to p. 238 illustrate a book, although the purpose of such photographs will be to provide records of statues, "technically perfect" pictures are not sufficient. This is shown by many such reproductions of sculpture in art books. They are inadequate because, although they record the shape of the work, they do not record the feeling. Though such photographs are clear and sharp and detailed, they are not well "seen"—the angle of view may be unfortunate, overlapping of individual forms may create an awkward impression, or perspective distortion may destroy the proportions of the work. In addition, they may not be well lighted—highlights and shadows, wrongly placed, may destroy that feeling of three-dimensionality without which sculpture appears flat in pictures. This is the reason why a record photograph of high technical quality alone will not be satisfactory if more than photo-technical quality is needed to produce a valid image of the subject as in the example of sculpture.

Similar considerations apply in other fields. Again and again I have been disappointed by illustrations in scientific and technical magazines, books, or articles on archeology, architecture, and other subjects that interest me. Although these photographs were faultless photo-technically, they were so dull, so badly seen and conceived that they aroused little interest as supplements to the text. I cannot help thinking of the many people who have marvelous opportunities to photograph strange and fascinating things who record them in ways that suggest none of their inherent qualities. Such pictures fail because those who made them did not know how to "see in terms of photography." This waste of opportunity is deplorable. pp. 47-66 That it is also totally unnecessary is proved by photographs of similar subjects that were excellently "seen," published in *Life* and a few other magazines. These stir the mind and the imagination because they were made by photographers who know how to "see."

Photography as a means of self-expression

Creative photographers are found among amateurs as well as professionals. Many of the most gifted professional photographers began as amateurs, changing because full-time photographic work was practicable only if someone else paid for it. As professionals they could also gain access to means and opportunities which would enable them to broaden the scope of their work.

p. 328 Creative photographers are artists in the true meaning of the word. Their imaginative faculties are far greater than those of most photographers. They make up the *avant-garde* of photography. They are usually stubborn, persistent, and opinionated. Their work is always stimulating, often controversial, and occasionally shocking to those who are conservative in approach. They follow no "rules" and respect p. 27 no "taboos." Driven by the compulsion common to all creative people, they must find expression for their feelings and views. It is they who first explored the potentialities of such "revolutionary" methods and techniques as the bird's-eye and worm's-eye views, candid photographs taken by "available light," blur as an p. 320 indicator of motion, multiple exposures and photograms, and the graphic control processes of solarization, reticulation, bas-relief. These techniques, once derided as "faults" and "fads," are today part of the vocabulary of any visually articulate photographer.

WHAT DO YOU WISH TO PHOTOGRAPH?

To say something valid, something worth saying, something that will be of interest to others, one must know what one wishes to speak about. So you must ask yourself the question: What subjects interest me most? In answering this question you will also find the answer to your second problem: what subjects you should photograph.

In this, amateurs are more fortunate than many professional photographers, for pp. 25, 326 they can combine their hobby and their interest. If you hike, climb mountains, or ski, you can take your camera with you and photograph scenes that are important to you, or other things that make the world beautiful—trees, flowers, rock formations, wind-rippled sands, the crystal or shell you may find, or the sky. Perhaps your interest is in people, fishing or boats, the beach, guns, cars, insects or other forms of nature, painting, sculpture, the theatre, children, community activities, folk art, jazz . . . the choice of subjects is endless. The important thing is that you choose what YOU want to do, that you do not copy through competition or admiration the work of others.

HOW DO YOU WISH TO PHOTOGRAPH?

Any photographer, amateur or professional, has the choice of two basically different approaches to his subject:

The objective approach is that in which the photographer makes a conscious effort to report according to fact, without expressing bias or personal opinion. The

12

subject is more important than the form in which it is presented. Clarity of rendition is all-important. Imagination may be a hindrance rather than an aid; objectivity, however, does not imply dullness. The approach is, in essence, that of the scientist or documentarian who wishes to present the facts as precisely as he can, allowing those who see the picture to draw their own conclusions and form their own opinions of the things shown.

The subjective approach is that in which the photographer makes a deliberate effort to express what he feels about what he sees. Instead of recording facts in his pictures he works to express his opinion or personal reaction to the subject. Here, imagination, a genuine feeling for and knowledge of the subject, are vitally p. 328 important. The form in which the subject of the picture is presented is often more important than the subject itself. In essence, this is the approach of the artist, the creative photographer who must share his experience with others and wishes to make them share his point of view. While a subjective photograph may reveal more about the photographer than the subject, subjective photographs, as a rule, show the subject in an unusual form which makes them in comparison to objective photographs more interesting and stimulating because they present a subject in a way not seen before and so give one a new insight, awareness, or experience.

Although these two approaches are diametrically opposed, neither is better than the other. They are merely different. In each, outstanding photographs can be made. It is, of course, possible to combine elements of both approaches. Which kind of approach a photographer should choose depends upon his nature, the nature of the subject, and the purpose of the picture. As a rule, the objective approach is selected by photo-journalists, documentary photographers, scientists and scientifically oriented photographers whose object is to show specific subjects for purposes of information, education, study, or record. On the other hand, the subjective approach is most suitable to the artist in search of material for creative work.

The Nature of Photography

Photography is a unique form of visual expression. It has nothing to do with drawing and painting and any attempt to relate it to any other visual art is, in my opinion, pointless. Photography is governed by its own characteristics of which the three most important ones are briefly discussed below. They define the medium's scope and limitations, what it can and cannot do.

Authenticity

Perhaps the main characteristic of any photograph is authenticity. Drawings or paintings made from reality or memory are often inaccurate or incomplete; those created entirely from imagination may be totally untrue. But every photograph is an "eyewitness report." It is this quality that makes a photograph "more convincing than a thousand words" and gives it a power of conviction that is not found in any other form of communication. No matter how subjectively the subject may have been seen or how imaginatively treated, the observer is aware that he is looking at an aspect of reality. No matter how strange a rendition may appear, he is aware that the lens cannot "invent" something that wasn't there. Even the most heightened form of perspective distortion, such as produced by extreme closeness or inclusion of an enormous angle of view, is a rendition of reality. That many people object to what they call "unnatural" forms of photographic rendition merely shows that they are not able to "read" such photographs. This difficulty is overcome as one learns more about photography.

p. 13

pp. 291, 315

Speed of recording

As a rule, only fractions of a second are needed to make the exposure which freezes a subject or records an event in a photographic image on film. This high speed of recording is a tremendous advantage which photography has over all other media of communication. It means that the camera can produce records when other kinds of recording cannot because time is too short or events happen too fast to be clearly seen by the eye. In the time a draftsman needs to make a

sketch, a photographer can take dozens of different pictures from which he can later select the most significant shot. It means that he can show the entire course of an event in a sequence of photographs. It means that he can be insured against photo-technical failure by taking several shots of the subject in rapid succession p. 172 with different diaphragm stops or shutter speeds and later pick the one which is best.

On the other hand, he must be aware that speed of recording alone has its drawbacks. It can produce hasty, thoughtless picture-taking based on the idea that out of a large number of pictures, according to the laws of chance, a certain number will be good. Needless to say, this is a fallacy. What actually happens is that the photographer grinds out yards and yards of film with pictures so dull they are not worth printing.

Precision of drawing and definition

Because it is produced by precise mechanical means, every sharp photograph is p. 160 an accurate reflection of reality, correct in every detail. In my opinion, the availability of such precise rendition is one of the most valuable characteristics of photography because, through it, a photograph can show us many things far more clearly than we could possibly see them directly with our eyes.

Unfortunately, this clarity is rejected by some photographers as seeming "unnatural." Others deliberately soften their photographs by means of special devices in a p. 112 misguided effort to make them appear "artistic." Conversely, photographers who are aware of the possibilities that precision of rendition offers for making effective photographs exploit it to its limit and produce pictures that have an almost tangible textural quality.

FIVE FACTORS DECIDE YOUR PHOTOGRAPH

Contrary to general belief, the production of good photographs is a rather complex process involving a combination of five major factors:

> The nature of the subject
> The personality of the photographer
> The photographer's concept of his subject
> The technical execution of the photograph
> The audience for which the picture is intended.

It is impossible to say which of these five factors is the most important since all are

necessary and interrelated. A good photographer regards them as a unit and is able to balance the individual components so that the picture is harmoniously governed by the different demands.

THE NATURE OF THE SUBJECT

Anyone knows that different problems are involved in taking a picture of a girl or a galaxy, of something inanimate or something alive, or when it is necessary to express an intangible concept or depict a concrete thing.

A good way to find out what kind of treatment a subject needs is to classify photographic subjects according to their nature. Most photographic subjects can be assigned to one of the two following groups:

> Static subjects (primarily inanimate)
> Dynamic subjects (primarily animate)

Static subjects

The quality common to static subjects is immobility; they remain still unless moved by external forces. Typical subjects of this kind are:

> Landscapes, seascapes, flowers, and trees
> Inanimate objects of nature
> Most man-made objects—architecture, machinery,
> works of art, objects of daily life
> Posed portraits, fashion shots, and nudes
> Still lifes and reproductions

Static subjects allow the photographer all the time he needs to make the best possible picture. This, of course, influences both his approach to the subject and his choice of technique. He can take more time to study his subject from different angles and under different conditions, and give more attention to photo-technical problems of rendition than if he were photographing a dynamic subject. In addition, he can work with larger cameras which are too cumbersome and slow in operation to be used for dynamic subjects but which, in comparison to smaller cameras, have the advantage of producing pictures of superior photo-technical quality.

The key to successful photographing of static subjects is *contemplation*. Don't rush,

p. 73

16

take full advantage of the fact that your subject won't change or run away. Study it carefully from different angles and points of view—literally as well as figuratively—before you finally capture it on film. Pay particular attention to such often neglected factors as texture rendition, tonal separation, background, and composition. pp. 261, 19 And if you or your audience appreciate technical quality, photograph your subject on the largest film size that can be used to do a perfect job under the prevailing conditions.

Dynamic subjects

The quality common to all dynamic subjects is mobility—constant change and motion. Typical subjects are:

> People and children
> Animals
> Sports events and war
> Objects in motion

Dynamic subjects with their change and motion are never exactly alike, and once the significant moment is past, it is lost forever. When a photographer must try to capture in a single photograph the essence of a situation, he must take picture after picture because he cannot know in advance what will take place in the course of the whole event, always aware that, if he were to conserve film, he might miss taking his best picture. This is the reason that good photo-journalists often use so much film, something which the amateur with his tighter budget can never quite seem to understand. The professional photographer cannot afford to fail, and film is the cheapest of his commodities. It is *not* wasteful to expose large amounts of film to make one important picture. The waste would be in giving time and effort and fail.

The key to successful photographing of dynamic subjects is *preparedness*. As far as the photographer is concerned, this means that he must not only be observant and alert, but able to anticipate the significant moment so that he will be ready when it arrives. This presupposes at least some degree of knowledge of the subject or event to know what to look for and more or less when to expect it. Quick reactions and reflexes are necessary. In terms of equipment, preparedness means primarily that the camera must be small, light, inconspicuous, fast in operation, and p. 72 equipped with a capacious film magazine.

17

Another way of classifying subjects for study and analysis is to assign them to one of the two following groups:

Tangible subjects
Intangible subjects

Everything that has substance and could be touched is a tangible subject. Concepts, emotions, feelings, and moods are intangible subjects.

p. 263

It may seem that only tangible subjects can be photographed, for how can one get a picture of a feeling? Yet photographs in which joy is reflected in a child's face, tenderness expressed in a smile, hate in a snarl, or sex appeal in a beautiful girl, are pictures of intangibles. As a matter of fact, a photograph that expresses no feeling, emotion, or mood at all cannot evoke any emotional response in one who sees it. It is an empty reflection of the subject with no value other than that of a document to illustrate a catalogue, a shop manual, or a scientific report.

Although it is quite easy to photograph a tangible subject (a person, a house) without giving expression to intangible qualities, it is, of course, impossible to photograph an intangible subject (the concept of beauty, the feeling of happiness, the emotion of hate) without a tangible subject through which an intangible quality can be expressed in visible form. Typical examples of photographs devoid of intangible qualities are the majority of calendar pictures, catalogue illustrations, identification portraits, picture postcards, and scientific illustrations—the type of photograph associated with what I have referred to as reproductive-utilitarian photography. Examples of photographs which are rich in intangible qualities are found in the work of all creative photographers.

p. 233

p. 7

Although talk of intangible qualities may at first seem theoretical, proof that inclusion of these qualities has value becomes apparent in every photograph. Why, for instance, are picture postcards dull? Because in lacking any intangible quality they also lack emotional appeal. Why are some studies of nudes boring, others interesting? Because some lack, and others possess, that intangible quality, sex appeal. Why do we find one picture beautiful, another not? Because one contains that intangible quality of beauty and the other lacks it.

Photographers engaged in work for advertising are particularly conscious of the importance of intangible qualities. As a matter of fact, their livelihood depends on their ability to make pictures that express such qualities. Intangible qualities—concepts such as beauty, strength, reliability, efficiency, safety, wholesomeness, etc.—must be expressed in advertising photographs to make products or services sell.

18

Snob appeal is another intangible quality frequently used in promotion photographs. After all, would anyone really look at a picture of a cigarette, a washing machine, or an automobile unless his emotions were somehow involved? To be made to feel that what is shown represents something better than another product of its kind—something better tasting, more efficient, more beautiful, etc.—such intangibles must be given graphic expression. Whether a photograph expresses intangible qualities depends almost exclusively upon whether the photographer is sensitive enough to perceive such qualities in his subject, and is skilled enough to express them in his pictures with photo-technical means.

THE SECONDARY SUBJECTS

In my opinion, many photographs are ineffective because not enough attention is given to what might be called the secondary subjects, those picture elements which, although less important than the subject itself, nevertheless exert a strong pictorial influence upon the impression of the picture. In particular, the following secondary subjects demand attention:

> The background
> The foreground
> The sky
> The horizon

The background

Pictorially speaking, most photographs have two main elements: the subject proper of the picture, and its surrounding areas. To take a simple example, an outdoor portrait: the head is the subject proper; all else that appears in the picture is "background." And yet, if the picture is to be pictorially satisfying, the background demands as much attention as the subject itself.

Why? Because, normally, it is of utmost importance that subject and background do not become graphically entangled. The classic example of this is the tree that seems to sprout from the beautiful model's head. Other common examples of confusion between subject and background are: a background which in tone, color, or pattern is so similar to that of the subject proper that the two merge, making it difficult or impossible to see where one ends and the other begins; a background that is so aggressive either in color or design that it detracts attention from the subject; and finally, a background that is more interesting than the subject itself.

In practice, separation of subject and background can be achieved by using one of the following methods and means:

Selection and discrimination. The simplest way to avoid an inappropriate background is to see it in time, to reject it, and to find one that is suitable. To do

p. 47
this a photographer must know how to "see in terms of photography" (which I'll discuss in Part 3) because the eye and the camera see things differently and what looks good may not necessarily make a good picture. In particular, whereas the eye sees separation between subject and background in terms of color, the black-and-white process transforms colors into shades of gray, and separation exists through contrast between light and dark. Two colors may be totally different in hue (for example, red and green), yet they may appear as more or less identical tones in a black-and-white photograph. If such is the case, the separation which was so apparent to the eye will be lost in the picture and subject and background will merge.

Color filters. In black-and-white photography the gray shade in which a specific

p. 135
p. 141
color will normally appear can be changed by the use of color filters; how this can be done will be discussed later. Consequently, in a black-and-white photograph if the colors of subject and background are such that normally they would appear as similar or identical shades of gray (for example, red and light green), they can be graphically separated, either made to appear lighter or darker than the other.

pp. 55, 175,
251-267
Illumination. Any brightly illuminated object appears lighter than it would if it were dimly lighted or in shade. Consequently, light can be used to emphasize either the subject or the background, making one appear lighter in the photograph than the other, and thus create graphic separation. Outdoors, I have often waited for the shadow of a cloud to darken the background and give the desired separation.

Selective focus. A very effective means for separating subject and background

p. 297
is contrast between sharp and unsharp. This technique, which will be discussed later, is called "selective focus." It has the further advantage that, in addition to graphically separating the subject and the background, it also produces a strong impression of depth in the picture.

Panning. A particularly effective method of separating subject and background

p. 302
through contrast between sharpness and blur, called panning, can be used only when the subject is in rapid and fairly uniform motion. It will be discussed later.

20

Uniform and neutral backgrounds. For greatest clarity of rendition, or to achieve special graphic effects, a subject may need to be shown against a perfectly neutral background. There are several ways to do this. Outdoors, an evenly overcast, hazy, or cloudless blue sky offers such a background. In black-and-white photography, uniformity and tone of such skies can be controlled with filters. To p. 135 eliminate cloud structure from an overcast or hazy sky, use a light blue filter and the sky will photograph as an even white; to render a blue sky white (and simultaneously eliminate any existing white clouds), use a dark blue filter; to render a blue sky a medium gray, use a medium or dark yellow filter (existing clouds, however, will show rather prominently in the picture); and to render a blue sky dark gray, use a red filter (existing clouds will appear white in the picture).

Indoors, in the studio or at home, the simplest way to provide a uniform background is to use photographic background paper (Noseam Paper) which comes in rolls nine feet wide (some colors ten feet wide) and in dozens of different colors as well as white and black. This paper should be tacked high on the wall, rolled down and out onto the floor in an uninterrupted arc to cover the necessary space, no sharp line or crease allowed to occur at the junction of wall and floor.

A special version of this technique is the light-tent which gives a completely shadowless illumination that makes the subject seem to float in space: white background paper is used to completely surround the subject, enclosing it within a kind of large, cubical "tent" that has no opening other than an aperture large enough for the lens. A number of photoflood lamps are placed *outside* the "tent"—more or p. 146 less evenly distributed around it, light from these lamps shielded so that direct light cannot accidentally strike the lens—and *directed toward the center of the tent* so that the light penetrates the white paper walls and, thoroughly diffused, completely envelops the subject inside the tent.

Shadowless backgrounds. For photographing small subjects against a perfectly neutral, shadow-free background, place the subject on a sheet of groundglass that is supported a foot or two above a large sheet of white paper. Brightly illuminate the paper with a photoflood lamp. This kind of background will completely absorb any shadows cast by the lamps used to illuminate the subject. By varying the distance between the photoflood and the paper, in the photograph the tone of the background can be made to appear either as white or any desired shade of gray. In color photography, if a colored instead of a white paper is used (or a colored gelatine filter placed in front of the lamp), the background can, of course, be made to appear in any desired color.

21

If the subject is photographed against a vertical background and a shadowless rendition is desired, distance between subject and background must be great enough to prevent shadows cast by lamps that illuminate the subject from touching the background. In addition, for complete control and highest uniformity of tone and color, a separate set of lamps must be used to illuminate the background.

Faulty backgrounds. Perhaps the mistake most commonly made, particularly in color photography, is to light the background insufficiently. When this happens the background will appear too dark in the photograph and distorted in color. To avoid this, use a gray-card and an exposure meter to determine whether the brightness of the background corresponds to the general level of illumination used in calculating the exposure; if necessary, give the background additional light.

Another mistake frequently made is to let the shadow of the subject fall on the background. This fault is particularly unsightly if several lamps are used and criss-cross shadows result. An attempt to correct this fault by using additional lamps to "burn out the shadows" merely makes matters worse. The only way to avoid such shadows is to place the subject at a sufficiently great distance from the background.

A third common fault is the choice of a background that is too vivid or distracting in color or design. In particular, photographers seem to place subjects that have subtle color against the most brilliant red they can find, apparently to compensate for the subject's lack of color by setting the background on fire. Needless to say, this kills the effect of the subject. Normally, such subjects should be photographed against the most delicate pastel shades or pure white.

The foreground

In a photograph the foreground symbolizes nearness, intimacy, and earthy qualities; conversely, the background, and more intensely the sky, symbolizes distance, remoteness, space, and spiritual qualities. By deliberately accentuating one or the other in the picture, a photographer can emphasize those qualities which are most typical to the subject. This can be done as follows:

Tilting the camera downward or upward, or lowering or raising the lens (if converging verticals must be avoided), respectively, leads to inclusion of a larger or smaller portion of foreground in the picture.

Use of a wide-angle or telephoto (long-focus) lens, respectively, emphasizes or minimizes the foreground in a photograph, wide-angle lenses tending to increase and long-focus lenses to decrease the feeling of depth in the picture.

22

Contrast between near and far, between foreground and background, creates
the impression of depth. The most effective way to utilize foreground matter for p. 284
this purpose is through "framing," i.e., showing a distant subject partly or entirely
surrounded by a "frame" provided by something in the foreground. This is illus-
trated by photographs taken through arches, doorways, windows, two columns,
the branches of a tree, etc., in which the foreground objects appear as frames for
the subject of the picture. Although photographs of this kind are often stereotyped,
the principle of creating an illusion of depth through juxtaposition of near and
distant objects is effective and can take many different forms. The effect will be
particularly strong if contrast of near and far is further emphasized by contrast
of dark and light, the foreground dark and the background light. p. 298

A common fault of many photographs is that they include too much foreground.
There are three reasons for this:

1. The focal length of the average lens is relatively short, and therefore it covers
a fairly wide angle of view which includes a large area of foreground.

2. Photographers owning cameras with interchangeable lenses often use a moder-
ate wide-angle lens instead of a standard lens; such a lens includes an additional
area of foreground matter.

3. There was too much distance between the photographer and the subject which
makes the subject appear diminished by the foreground.

Excessive foreground can be eliminated and the effect of many photographs
considerably improved, by decreasing the distance between subject and camera
until the subject proper fills the entire frame of the viewfinder, working with lenses
of longer than standard focal lengths, or enlarging the most important section p. 213
of the negative.

The sky

Most outdoor photographs include both earth and sky. Photographers usually give
time and thought to the rendition of people, objects, and things—subjects belonging
to the earth—but they usually give little attention to the sky. They take the sky as
it happens to be, apparently not knowing that it is of great importance to a picture
and also that its character can be changed as well as chosen.

The sky strongly influences the effect of the picture. When photographed in bright
sunshine, a subject gives a totally different impression than when photographed
under an overcast sky. The same subject photographed at noon in color appears

very different than it does when photographed at sunset in reddish light against a flaming sky.

So many outdoor photographs, particularly those taken in color, are taken in bright sunshine under a sky that has white clouds that pictures with blue skies and white clouds have become a cliché—the calendar kind of photograph. If one is striving for interesting effects, for pictures that draw attention, such skies should not be used—or used only with great skill.

The appearance of the sky depends upon atmospheric conditions and the position of the sun, and with the changes in these an unlimited number of variations occur. There is a wide range of skies from which to choose: the quiet of a hazy or evenly overcast sky under which objects acquire pastel color shades, the excitement of stormy skies and thunderclouds, the delicate colors of an early morning sky, the brilliance of the sky at sunset . . . its softness in fog and mist . . . its changes in rain and snow—skies with color that cover the entire range of the spectrum and white, gray, and gold.

The appearance of the sky can be controlled in two ways. The photographer can wait until the sky is "right," which often takes a long time. Or he can control the appearance of the sky to a large degree by using a polarizer or one of the many color filters as explained elsewhere in this book.

p. 143
p. 21

The horizon

The horizon is important pictorially because it divides the picture into two major parts: earth and sky; and its form, whether straight or jagged, influences the picture's effect.

As far as the balance of a picture is concerned, the placement of the dividing line of the horizon has a major influence upon the impression the picture creates. The lower the horizon, the greater the area of sky, and the lighter and airier the general impression of the picture; the "big view" is emphasized. Conversely, the higher the horizon, the less sky, and the heavier and earthier the effect of the picture; intimate detail is emphasized.

The more predominant one or the other—the earth or the sky—the tenser the composition, and the more equal the areas of earth and sky, the lesser the tension. If the horizon divides the picture equally, all tension is lost and the composition is static. Although this is composition normally frowned upon, an equal division of earth and sky is artistically meaningful when used to symbolize such subject qualities as tranquility or monotony.

It makes a great difference in the effect of a photograph whether the line of the horizon is straight, undulating, or jagged and whether it is level or tilted. A straight, level horizon—the sea, the plains—evokes feelings of equilibrium, serenity, stability, and permanence. If the horizon is straight but tilted, a feeling of instability results and the picture has a dynamic quality. When speed and motion cannot be symbolized in other forms, these qualities can often be symbolized by tilting a straight horizon. An undulating or jagged horizon suggests fluidity, change, drama, and violence, the effect becoming more intense, the greater the contrast of height and depth of the line. This can be seen in photographs of high mountains and the skyline of New York.

THE PERSONALITY OF THE PHOTOGRAPHER

If one were to give a number of good photographers the same kind of camera, the same type of film, and the same subject to photograph, each would photograph it differently. And the differences in the pictures would reflect the differences in their personalities. This can be seen in the work of good photographers if one compares their pictures of similar subjects.

If you ask a photographer to take some pictures to show what he can do, giving him complete freedom to choose any subject, the odds are that he will photograph a subject that appeals to him. Some photographers find interest only in photographing architecture; others in photographing fashion, beautiful girls, industrial subjects, or insects. Ansel Adams is the acknowledged master of the landscape; Roman Vishniac has no peer in photographing micro-organisms; Karsh specializes in portraits of the great. Anyone who wishes to become a good photographer should know that in photography, as in anything else, interest is the force that p. 326 drives one toward fulfillment and success in his work.

Personality and interest are, of course, related. An adventurous person is not apt to photograph perfume bottles, nor is a timid person inclined to photograph news events or sports. Good assignment editors and good art directors do not ask a photographer to photograph a subject that does not interest him. And an amateur, being free to choose his subjects, should choose only those that interest him, not those that seem fashionable or those that have won praise at the local photo-club.

Some people are technically inclined, others are not. Whether intense interest in the technical side of photography is an asset to a photographer is debatable. Many say it is, for photography seems to them primarily a mechanical form of

reproduction. On the other hand, some of the world's greatest photographers know very little about photo-technique, not being concerned with the type of camera to use or how to develop or print films, and not caring about such things. And then there are the many untalented amateurs who know almost everything about photo-technology; but obsessed with their beautiful cameras and gem-like lenses and overly proud of their encyclopedic knowledge, they spend so much time pursuing their technological interests that they find no time to make pictures.

What a person is and what he does reflects his personality. And whether he is active or passive, sensitive and artistic or tough and practical, manually clever or clumsy, nervous or calm, whether he likes to go out into the world or stay close to home, whether his interests are in people, plants, or postage stamps will influence his photographic work. No one can expect to be happy working in photography or finding fulfillment through it unless he works in a way that suits his personality. I know this from my own experience. On occasion, I have tried to break through the barrier of my own limitations and work in ways alien to me, and each time I failed. In a workmanlike manner I did what I had set out to do, but the pictures had no spark, lacked feeling, were uninteresting to others, and disappointing to me. These failings quickly sent me back to my own ways of working.

The qualities that I consider most important for success in almost any photographic field are:

An ability to see in terms of photography
A compelling drive to create
A capacity for hard work
The faculty to handle photographic equipment
The desire to experiment
The knack to get along with people
Editorial judgment and integrity

The ability to see in terms of photography

In photography, the ability to *consciously* see, to actually *notice* not only what takes place, but also the appearance of things which others overlook through inattention such as the quality and distribution of light and shadow, the shapes of objects seen as contributing to a composition, precise color shades perceived as clashing color or color harmonies—in short, awareness of everything that determines the graphic appearance of a picture is, in my opinion, a photographer's most valuable asset. I consider this ability to "see in terms of photography" of such

p. 47

importance that I have given the whole of Part 3 to its discussion. Why? Because although basically the same kind of equipment and material and the same techniques are used by all photographers, their pictures are widely different—some are dull, some good, some outstanding, and some are unforgettable. What accounts for these differences is primarily a photographer's ability or inability to "see in terms of photography."

The drive to create

One of the most insistent forces in man is his compulsion to create, the drive that compels an artist to give form to something which seems always just beyond his grasp, and to persist in this no matter how painful the struggle, how terrible the frustration of finding the hand unable to transmit what is formed in his mind. It was this force that drove Gauguin from his family and Van Gogh into insanity. It is this force that has created the great masterpieces of art.

The drive to create is the basis for all great photographs; the will to try again and again for perfection, each time in the hope of coming closer to what the mind has envisioned. It is this that makes some photographers print a negative twenty times in succession to bring out a particular quality or effect. It is this that drives other photographers into jungles or the loneliness of arctic wastes, into hardship, danger, and war, and sometimes death, as it did Robert Capa and Werner Bishop, to accomplish something of essential worth to them. Their way of work determines their way of life. The lure is not money, for much more could be earned in advertising. Nor fame, for general interest in a magazine picture story lasts only a brief time. The lure is their need to create through a conviction that part of their work will survive them, giving them a kind of immortality. Compelled to look toward the future, the creative artist consciously or unconsciously believes that his work will add to the betterment of man. And, it seems to me, anyone with a creative drive, no matter how great the difficulty of doing so, is duty bound to obey it through his work, adding his contribution, be it ever so small, to the cultural heritage of man.

A capacity for hard work

To be exceptional in photography, a photographer must be part artist, part artisan. Hard work can in time make a photographer an accomplished artisan, a master of the various technical aspects of his craft. But no matter how hard he may work, he can never truthfully say: as an artist, I know everything there is to be known. Because there is neither end nor perfection in art.

A true artist rarely rests. Even if he is not working at something, his mind is wrestling with unsolved problems, evaluating impressions and observations, searching for new forms of expression, planning future work. A creative photographer alike in this respect does not work only when he photographs; he relates everything he sees and what happens around him to his work, seeing it in terms of pictures, contrast and black-and-white, color and form, analyzing and evaluating it for the possibility of future use.

Unfortunately, many photographers never go much beyond this stage of preparation, becoming too taken up with the work they feel they'll some day do, something always interfering with their intention—the pressure of business, family obligations, the chores of daily life. "You'll be surprised, wait and see, next week I'll get around to it," seems to be their motto. But the days go by, next week is never free, and routine, inertia, and frustration claim them. The special pictures are never taken, the contribution is never made.

Others get bogged down in a morass of "technical" concerns, and in "trading" and "testing" of equipment. Since they feel that only the latest type of equipment is good enough for them, they must buy it. Then comes the "testing" of their brand-new acquisition. They are the proud owners of the sharpest lenses (each carefully picked), and their greatest pleasure comes from being able to make huge enlargements of small negative sections that are "almost grainless." But they never make a worthwhile photograph.

This is not what I call working hard. Of course, a photographer must be familiar with his equipment and know what it can and cannot do; and he must also know how to produce a fine-grain negative. But once such tests have been made and techniques mastered, they should be taken for granted and not spoken of with pride. The work that advances a photographer is the actual making of pictures. Pictures, pictures, and more pictures. Practical experience is what counts. The knowing how to deal with a specific subject or event is based on having photographed similar subjects or events enough times to have learned how to photograph them successfully.

But this is still not enough to really succeed. Any competent photographer can do a routine job well, and there are any number of hard-working nine-to-fivers who can handle any kind of routine photographic assignment. Editors have no trouble in finding them. But they are always looking for *the photographer willing to give more than is demanded from him*—one who may work through a night yet not

think of it as overtime, and not mind the effort involved in making a picture better. Such a photographer will succeed if he is given a chance. And he will succeed because he is willing to give *more* than is expected of him, work longer and harder than he was asked to, and give generously of himself—his ideas, his interest, experience, and time.

The faculty to handle photographic equipment

It would seem that any photographer should know how to handle his equipment properly. However, this supposition is not correct. Two mistakes in the use of equipment which block the making of good pictures are handling that is too rough and handling that is too delicate.

A camera, an exposure meter, or any other piece of photographic equipment is a tool. Each is designed to fulfill a certain purpose and withstand only a certain amount of abuse. If equipment is treated carelessly, it often will not perform as it should. For instance, when something in a camera jams and force is used in the hope of unclogging the mechanism, the result is that a camera part may be bent or broken and the damage increased. When a lens is carelessly put on a table it may roll and fall to the floor. The surface of a lens or filter may be scratched by "spit and polish." Film kept in the glove compartment of a car will become ruined through overheating in summer. Care is not taken when a photographer has no understanding of materials or mechanical things.

The opposite kind of handling is the treating of a camera or other piece of photographic equipment as if it were priceless, overprotecting it from dirt and wear, not taking a picture in the rain for fear that equipment might get wet, and all but using white cotton gloves in touching a camera because, as anyone knows, hands are often sweaty and sweat is bad for leather, metal, and glass. This is common to the photographer who is a gadgeteer, his interest being more in shiny photographic hardware, leather, and chrome than in pictures. He collects cameras and lenses as others collect postage stamps. He often owns more, and more expensive, equipment than many successful professional photographers. But he never uses it for taking photographs apart from making "tests."

The right way to handle photographic equipment is between these extremes. All of it should be used with workmanlike respect, neither abused nor protected unduly. Its purpose is to make photographs, not to become a collector's item or provide a status symbol.

The desire to experiment

Each camera, exposure meter, roll of film, etc., that one buys is accompanied by explicit directions for its use. By following these directions one can get acceptable results. Why, then, is some experimenting necessary?

For two reasons: 1. Because a photographer can learn only through *practice* how to use his equipment and materials correctly. For, as every beginner soon finds out, the reading of instructions and theoretically knowing how a thing should be done is quite different from actually doing it, and far different from doing it *well*. 2. Because a photographer may wish to widen the scope of his work through finding new forms of expression.

To continue to captivate attention, photography, like any other form of visual expression, must develop and grow. Though rules are vitally important to guide the beginner, if rules were not broken, photography would remain at a standstill; in concept and style at least, all pictures would appear the same. New ways of seeing and depicting subjects lie beyond the barrier of "rules."

Experimentation must be supported by knowledge and sustained by curiosity and a plan if it is not to degenerate into an amateurish pastime. For example, if a

p. 305 photographer were intrigued by the graphic effect of harsh, grainy photographs, he might want to know how to produce such effects and how to deliberately increase both contrast and grain. He would probably know enough to try different types of high-speed films, reduced exposure, and prolonged development in high-contrast developers, and to print his negatives on paper of hard gradation. But he could only find out how much he could reduce exposure times, how far development could be prolonged, and what kind of developer to use through experiment. For only he can know *exactly* what it is he is after.

Or a photographer, fascinated by the effect of monumentality in pictures taken with extreme telephoto lenses, might want to try this kind of photography. After getting the necessary equipment, he might be unable to get sharp pictures because he couldn't keep the camera from vibrating. What should he do to avoid this? The textbooks say to support the camera at the center of gravity, but this, he found, didn't prevent vibration. Not finding an answer, he is forced to experiment with different kinds of support and vibration-dampening devices of his own invention

p. 313 (solutions to this particular problem will be given later). Another photographer might wish to express intangible qualities through softness, diffusion, and light. He, of course, would have to experiment with different types of simple, uncorrected

meniscus lenses, such as positive spectacle lenses, magnifiers, and condensers, and also with the effects of sieve-like diaphragms like those used in the Rodenstock p. 112 Imagon lenses; and so on.

Experimenting is vital to the development of a photographer. It is a necessary phase through which one has to go to find his own expression through command of his medium.

The knack to get along with people

A photographer usually works with other people or for other people. And the better he is able to get along with these people, the better his work will be. In particular, he should think of the following things:

He should be considerate. A photographer on assignment finds himself constantly in need of asking others to do something for him. Sometimes he must ask that they interrupt their work, sometimes he invades their privacy, and often he takes up their time. The more gracious and considerate he is, the more cooperative will people be. The worst thing he can do is to be "authoritative," push people around, act like a "big shot" under the guise of efficiency. Such behavior is not only rude, but unwise because it antagonizes everyone and makes the taking of pictures very difficult.

He should be reliable. If a photographer should be at a certain place at a certain time, he must be there at that time. Those he will work with are doing *him* a favor, and they should not be kept waiting. Furthermore, he shouldn't make promises he cannot or will not keep. Unfortunately, many photographers say how much good someone will derive from pictures being published (when they know perfectly well that, perhaps, their pictures may never appear), or they promise to send someone courtesy prints as a token of appreciation (which is an excellent way to repay favors) and they do not.

He should be clean in his work. It is often necessary to somewhat rearrange a place where one photographs. But there is no excuse for not putting it in perfect order on finishing work. In particular, furniture should be put back in place, film wrappers and flashbulbs picked up and disposed of properly, and objects replaced exactly where they were before work began. Few things are more annoying to people than giving their place, time, and cooperation to a careless photographer who leaves things in a shambles and goes away in such a hurry that he forgets to say thank you and goodbye.

31

Editorial judgment and integrity

Every photographer who makes pictures for others fills a double role: that of *collector* and *disseminator* of visual information. To do both successfully, he must possess editorial qualities.

Although some assignments are set up in a way that allows only one solution, it is much more common that a photographer has considerable leeway in his work. If he can approach his assignments in many different ways, he has the task of choosing only one approach. If he has a choice of a large number of subjects from which he must choose one and has many different ways in which he can render his subject, he must decide that which will be best. To make the right decision in each case demands editorial judgment.

For example, a photographer is given an assignment to make a picture report on a foreign country, and the choice of what to photograph and how to photograph it is left to him. By *not* showing certain aspects of the country and stressing others, he will give his story a specific slant; he may do this unwittingly (if he lacks editorial judgment) or deliberately (if he lacks editorial integrity). If he disagrees with the country's political system, his conscience alone can keep him from falsifying the truth—from omitting to show the good aspects of the system while emphasizing the bad. If he does slant his picture story and it is published in a magazine seen by millions of people, he may make public opinion turn in a direction which will be harmful to everyone.

Good editorial judgment is based upon knowledge of the subject from which a valid opinion of it can be formed. If a person is highly opinionated, influenced by prejudice, and carried away by emotion, he will not, of course, make a good photo-reporter. For a good photo-journalist must be able to change his opinion in the light of new knowledge and additional facts.

No photographer is so lacking in emotion that he can always be completely objective in his reporting. Whether objectivity is desirable depends upon the purpose of the picture—whether it is supposed to be an objective-documentary report or a creative-subjective interpretation. We demand that a documentary report be factual because it often provides us with the only basis on which to form our opinion. Subjective photographs express a personal opinion, and as long as they are not presented as factual, they can often be stimulating precisely *because* they are *not* factual and show subjects in new forms; misrepresented as factual, they become propaganda.

p. 12
p. 13

How to become a professional photographer

There are two requirements: the first is the experience necessary for doing work of professional quality; the second is breaking into the field and getting assignments.

Experience can be acquired in three ways:

1. A beginner can go it alone, learn by consciously following the instructions that accompany each piece of photographic equipment and material, studying photographic textbooks and analyzing the work of accomplished photographers. This is the road I took, and I recommend it to anyone who likes to or is forced to work by himself.

2. He can become apprenticed to a professional photographer, assist him in the studio and work with him on location, develop his films and print his negatives. This is probably the most practical way to learn the craft, but chances for this are few and competition is great.

3. He can enroll in a photo-school or take a correspondence course in photography. This is recommended particularly to those primarily interested in the technical aspects of photography.

Breaking into the photographic field and getting assignments is a more difficult matter. To be successful in this, it is absolutely necessary to have a representative portfolio of one's photographic work. This can be either a scrapbook of clippings of published photographs or a collection of original color transparencies and prints. No effort should be spared in compiling such a collection. If necessary, specific assignments should be set and executed to the best of one's ability. I can think of no better investment for one's future as a photographer. To be effective, such a portfolio must fulfill three requirements:

1. It must be representative of the kind of work the photographer intends to do. If he wishes to specialize in fashion photography, his portfolio must have a set of fashion photographs; if he wishes to become a photo-journalist engaged in general magazine work, it must have a number of coherent picture stories and not be made up of a stack of unrelated photographs. As a rule, editors of picture magazines are not interested in single photographs. Besides, any picture editor knows that it is comparatively easy to capture the climax of an event in an impressive photograph, but quite a special talent is required to depict the whole event in the form of a coherent, well-organized, interesting picture story. Advertising agencies, on the other hand, are interested only in individual pictures.

2. A portfolio must be presented in a professional form. Sloppiness as well as ostentation immediately court rejection. Sepia toned prints, prints on mat or textured papers, and buckled, bubbly, or dog-eared photographs mark the amateur. To make a good impression, it is vitally important that all prints be clean in appearance, flattened, carefully spotted, evenly trimmed, and presented *without* a white border. They must *never* be mounted on boards, "matted," or signed (but should be stamped on the back with the photographer's name). No photograph should be smaller than 5 x 7 nor larger than 11 x 14 inches, and all photographs must be uniformly printed on white, glossy, double-weight paper.

p. 212

pp. 194,
211

3. A portfolio must not contain too many photographs. An editor doesn't need to see large numbers of prints to form an opinion of one's work, and he resents the waste of time involved in looking at too many. Twelve to twenty photographs, or three or four picture stories, carefully selected from one's best work, make a much better impression than a box full of pictures.

When his portfolio is complete, a photographer can try to find work through an agent or a photo-agency. Or he can take his portfolio to the magazine's picture editor or the advertising agency's art director. Each course has advantages as well as drawbacks.

An agent or an agency save the photographer a great deal of time which he can use profitably shooting pictures, but either will cost him a good deal of money because an agent or an agency takes a commission of 30% or more on all sales. In return, they do all the legwork and show the photographer's pictures at the right time to the right people—a service which can only be appreciated after experiencing the difficulty of trying to get interviews with editors. In addition, a good agent will advise the inexperienced photographer on all professional matters —technical, financial, and ethical; he will get him assignments and introduce him to people who can help him, keep him informed about what is going on in his field, talk to him about whether contemplated picture stories are salable and thus save the photographer from wasting time and effort by preventing him from shooting something which has recently been done by another.

There are two tempting advantages in getting in touch with editors and art directors oneself: it gives the photographer a personal contact with those he works for and it saves the commission which agents charge. However, this probably will require hours of frustrating waiting, or the distress of finding out that many editors will not see beginners.

THE PHOTOGRAPHER'S CONCEPT OF HIS SUBJECT

Every successful photograph, except for lucky shots, begins with an idea and a plan. The more precisely a photographer knows what it is that he wishes to do, the better the chances are that he will do it. *Before* he begins to take a picture, he should visualize it because otherwise he will be unable to insure its success through appropriate planning. In particular, he must consider the following aspects:

> Color or black and white?
> Illustration or interpretation?
> The concept of mood
> Editorial concepts and considerations
> The technical execution of a photograph
> The audience for which the picture is intended.

COLOR OR BLACK AND WHITE?

The first thing to decide is whether the picture should be taken in color or black and white, each medium having distinctive characteristics and neither as such superior to the other. The choice between color and black and white must be made solely on the basis of *suitability*, each considered in relation to the nature of the subject and the purpose of the photograph. This involves consideration of two different aspects, one pictorial, one practical.

Pictorial considerations

Naturalistic or semi-abstract rendition? If we compare two photographs of the same subject made under identical conditions, one taken in color, the other in black and white, the greatest difference between the two is that the color shot gives a more naturalistic impression than the black-and-white shot. This is usually true even when the color rendition is poor, since any rendition in color seems closer to colorful reality than a rendition in black and white. Consequently, if naturalism and the closest possible similarity between subject and rendition are important considerations, a rendition in color is better than one in black and white. This applies particularly often (for example, in scientific photography) in cases in which a documentary-illustrative approach is necessary.

p. 8

When a creative-interpretative subject approach is to be used, the choice of color or black and white is not governed by the subject, but by the one which will best express the photographer's concept. Naturalism is not necessarily a desirable picture quality; it often makes a photograph trite. Many landscapes that were pleas-

p. 9

ing to the eye appear incredibly boring when photographed in color. But the same landscapes, imaginatively translated into semi-abstract black and white, can often be remarkably effective precisely because they lack color. Conditioned by seeing many black-and-white photographs, we do not feel that the absence of color in a photograph, except in rare instances, makes a subject less recognizable. As a matter of fact, the opposite is sometimes true. In portraiture, for example, a good rendition in black and white generally makes a more pleasant impression than a color rendition in which skin tones are tinged with purple, green, or blue.

pp. 240-241 **Is color a subject's most important quality?** If the answer is yes, color should be used (unless cancelled by another, more important consideration such as cost). Typical subjects whose most important quality is color are colorful flowers, birds, insects, and fruit; women's fashions; food arrangements; vivid sunsets; modern interiors; paintings and other colorful works of art; and landscapes and outdoor scenes that have an unusual quality, an unusual light. Photographing such subjects, the use of color is mandatory for best results.

If color is not of great importance, rendition in black and white is often preferable because it allows the photographer a higher degree of control over his picture. The semi-abstract quality of black and white, well used, creates stark graphic effects. When form, space, and light are of primary importance, black and white is usually preferable, since color in a photograph tends to suppress such qualities because color is a picture's most important and graphically strongest characteristic.

Will color be good or poor? The possibility of photographing a subject in color does not guarantee that color rendition will be either accurate or pleasing. If p. 273 accurate color is necessary and the colors are not accurate, or if a pleasing color effect (which is *not* necessarily the same as accurate color rendition) is wanted but the colors in the photograph are not pleasant, a rendition in color is valueless.

p. 120 As will be discussed later, no color film can produce an accurate or even an inaccurate but pleasing rendition of subject color under all conditions. Inaccurate or unpleasant color rendition is most likely to occur under the following conditions:

p. 252 If the spectral composition ("color") of the prevailing light differs from that for which the color film is balanced.

p. 278 If the subject contrast, exclusive of pure black and white, is abnormally high.

If the subject's colors are pastel shades (desaturated color).

Under such conditions it is always advisable, as a precaution, to take a color shot

and a shot in black and white, in case the color photograph should be unsatisfactory. This is particularly recommended if the subject's colors are likely to be commonly known, for slight deviations from familiar colors will be noticed and may cause the photograph to be rejected. Subjects of this kind are plants, trees, and flowers; sky and clouds; sea and sand; common animals, etc. Faithful color rendition is particularly critical in color photographs of food and people, and especially portraits in color, in which the slightest deviation from normal skin tones appears objectionable unless it is obvious that such color deviation was intended.

Practical considerations

Whether to shoot a subject in color or black and white involves the question of cost and what the photograph will be used for. Amateurs taking pictures exclusively for their own pleasure have little to be concerned about except, perhaps, the higher cost of color film. But professional photographers, and even those who hope to sell photographs occasionally, must decide the use to which their pictures will be put before they can properly decide whether to use color or black and white. In making the decision, the following should be considered:

Color photographs bring considerably higher prices than black-and-white pictures because they are more difficult and costly to produce. Sometimes, a few days of color work are as remunerative as a month of work devoted to black-and-white photography. The market for color photographs is, however, very much smaller than the market for black-and-white pictures because color is more or less limited to high-class advertising and promotion, covers of, and feature articles in, the better, nationally distributed picture magazines, record album covers, pictorial calendars, book jackets, and 35-mm slides used in education, lectures, and training programs.

Color photographs are sold either in the form of positive transparencies or color paper prints. The larger the transparency or print, the easier it is to sell—size, unfortunately, rather than artistic quality often making a greater impression upon the buyer. Many commercial users of color photographs won't look at 35-mm slides (although this prejudice is slowly being changed); minimum standard size that is usually required is 2¼ x 2¼ and often 4 x 5 inches. Most magazine editors have finally realized that the 35-mm camera is unsurpassed for making pictures of people and subjects in action and accept 35-mm transparencies. For projection (lectures, training, education), both 35-mm and 3¼ x 4¼ inch slides are commonly used. If color photographs are to be sold in the form of transparencies, the use

of the pictures should be considered *before* the photographer buys his camera, for film size often has a decisive influence upon the success of his venture.

Another point that should be considered in planning a picture in color is whether positive (reversal) or negative color film should be used. Each has specific advantages and disadvantages. The advantages of positive color film are: relatively low cost because the developed film is the finished, salable product; in comparison to negative color film, rendition is sharper, colors are more brilliant, and the time needed between shooting a picture and seeing the final result is much less (this is often a decisive factor in commercial and magazine photography); and time and cost are also saved in using reversal color film because the transparencies can be edited immediately, avoiding the delay needed for making contact prints from color negatives. The disadvantages of its use are that since it is virtually impossible to make corrections after the photograph has been taken, unless lighting and exposure are perfect the picture will not be successful; and that each shot is an original and thus unique, and if it is damaged or lost, it is not replaceable. Although it is possible to duplicate a positive color transparency, this is a process that often involves expensive masking if the duplicate is to match the original, a masked, *good* duplicate costing about twenty-five dollars.

p. 120

The advantages of negative color film are that it allows a photographer as much control over a picture as a black-and-white film does: unsatisfactory color and faulty exposure of the color negative can largely be corrected in making the print, a fact which eliminates the necessity for bracketing and filtering and thus saves expensive color film; negatives can be kept by the photographer and as many prints made from them as are needed; prints can be sent simultaneously to different places; and small-format cameras can be used to make large-size color photographs. The disadvantages of working with negative color film are that it is impossible to edit from color negatives and it is necessary to wait for proof prints to be made which, when time is short, prohibits the use of negative color film; cost of good prints is high.

p. 120

p. 172

Black-and-white photographs are much simpler and cheaper to produce than color photographs. Since their basis is a negative, the photographer has the original from which any number of prints can be made for very little cost which becomes an important consideration if original prints are to be widely distributed. Faults of the negative can often be corrected during printing. Prints of almost any size can be made regardless of the size of the negative. A disadvantage of black-and-white photographs is that they command lower prices than color photographs.

pp. 203, 213

On the other hand, since there is a much larger market for black-and-white than for color photographs, competition is not quite so fierce. A color photographer must be pretty good or well known if he expects to sell; in black-and-white photography a beginner can make a sale. Markets for black-and-white photography include: amateur photo magazines, general picture magazines, trade magazines and house organs, newspapers, Sunday supplements and rotogravure sections, advertising and promotion, books and booklets, photo-murals, office and home decorations.

ILLUSTRATION OR INTERPRETATION?

Any subject can be photographed in a limitless number of ways. Which should be chosen depends, of course, on a large number of considerations. A very important one is whether an illustrative or an interpretative subject rendition is more likely to produce the result desired.

The difference between these two forms of rendition is essentially the difference between fact and feeling. An illustrative photograph should be factual—true to the subject. If a photographer's approach to his subject is factual, his range of expression is, of course, restricted. This approach is the documentarian's or the scientist's p. 8 approach which requires self-effacement in the process of showing a subject as objectively as possible so that the photograph will convey the subject as it is known to be.

On the other hand, an interpretative approach (whose more extreme forms are p. 9 popularly called "experimental") is personal and subjective, reflecting a photographer's response to his subject or his symbolic use of it. Such photographs are carefully considered statements involving much time and thought, interest, knowledge, observation, and first-hand experience in their making. They embody the feelings and thoughts that a photographer has about a subject rather than the surface aspects of it. To try to convey thoughts and feelings pictorially is difficult, for the photographer must be able to capture these concepts, and he must be an artist to do this. If he succeeds, the subject will be shown in a new way, and those who see his pictures will be given a new insight and an unexpected visual experience.

Since they serve different purposes, neither approach is better than the other. Which should be chosen depends upon what use the picture was made for and the "audience" for which it was made. A reference to painting might clarify what p. 45

I mean: Norman Rockwell's well-known magazine illustrations and covers represent the "illustrative" approach in painting; the work of Picasso represents the "interpretative" approach. As one needing a cover for a magazine with a great many subscribers would commission Rockwell rather than Picasso, so one wanting to stress the horrors of war would choose Picasso's *Guernica* rather than an illustration of war done by Norman Rockwell.

It would be as foolish to ask Picasso to make drawings for a catalogue of women's fashions or to illustrate a cigarette ad as it would be for a photographer given such assignments to use an interpretative approach. If a photographer were asked to convey "happiness" in a picture or to do a picture story on haunted houses, however, an illustrative approach would be inadequate. Each approach has its own uses, and the editorial judgment of the photographer will decide which should be chosen.

Each approach, of course, can borrow elements of the other. A strictly factual photo-report can be made pictorially attractive through the incorporation of certain imaginative touches without loss of accuracy. And an interpretative subject approach need not be so experimental that the subject becomes unrecognizable; it can include factual aspects without losing its subjective character.

THE CONCEPT OF MOOD

There obviously will be a great difference in the impression that a specific subject creates if the subject is photographed in sunshine or rain, at noon or at night, whether the print is flat or contrasty, light or dark, etc. Such differences in conditions and treatment account for the mood induced in the observer.

pp. 262, 305

Specific moods may be induced by various means. To give two examples: a photographer can photograph a subject under an evenly overcast sky to induce a peaceful placid mood. Or, to induce a somber mood, he could do this by prolonging the exposure of his black-and-white print beyond normal and thus darken it to a degree which would evoke a feeling of gloom.

One of the most common mistakes made by many photographers, amateurs and professionals alike, is that on finding a suitable subject for a picture they photograph it hastily without thinking that possibly a more interesting photograph could be made if the mood-inducing factors were different.

For example, if a visitor sees Times Square, New York, by daylight, its huge signs and bustling crowds are impressive. But it is far more impressive when darkness

closes in and walls and windows glitter and glow in bursts of light. Night is obviously the time to photograph it, for night gives it its most typical mood.

Or, in another example, a slum picture must be made—its atmosphere of dilapidation and decay must be captured. If photographed in sunshine, and particularly in backlight, even the worst slum can be made to appear "quaint," full of "picturesque" places. To capture the essence of a slum, its mood of depression and gloom, a photographer must photograph it on a gray, wet, windy day when mood-inducing conditions and the characteristics of the subject combine to make the photograph evoke the required mood.

A photographer's selecting the right mood-inducing factors *before* he takes a photograph might be compared to a theatre producer's selecting the characters, lighting, and stage designs that will evoke specific reactions and moods in the audience. And to evoke a certain response, an art director in advertising chooses the type of model he thinks will suggest sophistication, innocence, youthfulness, virility, strength, or whatever quality it is that he wishes to stress.

Mood is an intangible quality which can be shown in photographs only in symbolic form. There are many symbols which can be used. Different moods are evoked by light of different qualities: light that is bright or gloomy, harsh or softly diffused, p. 251 "plastic" or "flat," neutral during the middle of the day, yellowish and "warm" early or late, reddish and "hot" at sunset, or blue and "cold" at dusk. In addition, there are the different moods evoked by different atmospheric conditions: sunshine, the different kinds of overcast skies, haze, mist, rain, fog, and snow, heat and cold, pp. 244-245 calm, breeze, high wind, and storm. And there are in addition various devices and techniques that a photographer can use to evoke specific kinds of mood: high-key or low-key printing, changes in contrast, color filters, perspective distortion, and pp. 277, 135, 284, 291 so on. These will be discussed later.

The experience of mood is intimately connected with sensitivity. The more sensitive a person is, the more strongly will he be affected by a mood. A photographer must be able to feel a mood and capture it in his photographs, and what the observer will feel in response to these photographs will depend upon the sensitivity of both. A photograph capable of inducing a mood guides the mind in a particular direction, *but it does not reveal everything.* Clear and uniform illumination combined with evenly sharp rendition leaves nothing to the imagination. Darkness and blinding light, unsharpness and blur are the strongest means that can be used to induce mood because they obscure detail and with it reality, leaving one to complete what the photographer has suggested in his picture through the symbols he has used.

EDITORIAL CONCEPTS AND CONSIDERATIONS

Every successful photographer is part editor. One of the reasons that he is successful is probably that his interest in his pictures goes *beyond* that of the artist who thinks of each of his pictures as a self-contained unit rather than as part of a larger whole: a picture story, a magazine, a book, or an advertising campaign. The editorially minded photographer gives a lot of thought, not only to what his photographs should mean to others, but also to the way in which they could or should be used—the context in which they might be published in a magazine or book. Although this is not the place for an essay on photo-journalism, I believe that any photographer can profit from giving some attention to the following:

Horizontal or vertical. Whether to render a subject in the form of a horizontal or vertical picture is sometimes difficult to decide. Often, of course, the subject or the purpose of the picture is such that only one or the other can be used. More often, however, a photographer has a choice between the two. Whenever there is a choice, it is always advisable to compose and shoot the subject both as a vertical and as a horizontal picture. If this is done, the layout man can use the photograph that will best fit into the allotted space of the magazine or book, whether as a single picture or as part of a picture story. If it is impossible to photograph a subject in both forms, sufficient space should be left on the film around the subject proper so that the layout man has leeway to crop the picture horizontally or vertically.

Cover possibilities. To many photographers, the ultimate in recognition is having one of their pictures accepted for use as a magazine cover. Unfortunately, many otherwise excellent photographs which might have made the cover could not be used because they did not fulfill one or several of the following editorial requirements:

A cover photograph must usually be a vertical or square shot (on rare occasions, a magazine may require narrow horizontal photographs for its fold-out covers).

It must have a poster effect, which means that it must be bold and simple in design so that it will attract attention from a distance.

It must be composed so that suitable space free of important subject matter is left for the name of the magazine.

Full-page pictures and double-spreads. The more beautiful a photograph is and the more unusual or important its subject, the larger the size an editor will

give it in print. He can, however, give a photograph such prominence only if it is technically adequate and able to stand the necessary high degree of magnification without becoming too unsharp and grainy. To avoid the rejection that comes from technical shortcomings, an editorially minded photographer makes important photographs on the largest film size that can be used, even if this makes extra work for him.

Single picture or picture story? Reality is in a constant flux of motion and change. In more complex situations these changes are limitless and, therefore, to show a subject or event in a single picture may, or may not, be adequate. Unless already instructed by an editor, a photographer must decide whether it is more desirable to condense the subject or event in a single photograph or to report it more fully in a picture story. The principles and problems involved have been discussed in my book *The Creative Photographer*.

The over-all shot. A picture of this type shows the subject in its entirety, relates detail to the whole, and the whole to the subject's background and surroundings. A photograph of this kind is usually made with a lens of standard focal length and a relatively great distance between subject and camera or, when enough distance is not available, with a wide-angle lens. It is frequently advantageous to take such photographs from an elevation—a ladder, a scaffold, a roof, or from the air.

p. 110
p. 111

The medium-long shot. This is the most common type of view. It more or less corresponds to the view as seen by the eye. A picture of this kind is normally made with a lens of standard focal length or a moderate telephoto lens and it is taken from a medium subject-to-camera distance.

p. 112

The close-up. The most outstanding quality of a close-up is that it shows the subject in larger size, with more detail, and in greater clarity, than it is normally seen by the eye. Close-ups are made from relatively short subject-to-camera distances and any kind of lens from wide-angle to telephoto can be used.

pp. 234, 309

THE TECHNICAL EXECUTION OF A PHOTOGRAPH

A photograph can be made with many technical means and devices. Each will have a different influence upon the impression the photograph will give. Unfortunately, too many photographers don't take full advantage of the means that are available and make pictures without first giving thought to the demands of the subject and the purpose of the photograph.

What is needed is an understanding of the interrelationship of all the factors which influence the making of a photograph and which must be considered *before* the photographer takes a picture if he wishes to produce the best possible results. A few examples chosen at random will, I hope, illustrate the kind of reasoning which must guide such considerations.

p. 15
p. 116
If precise definition and rendition of fine detail are important for the characterization of the subject or necessary to the purpose of the picture, a large camera should be used because a large negative is superior to a small one in producing these qualities.

If getting a picture depends upon speed of action, a small camera is superior to a large one because it is faster to operate, weighs less, is less conspicuous, and has a larger film magazine.

p. 82
If perspective distortion must be kept at a minimum, a lens with a relatively long focal length will produce more satisfactory results than a lens with a relatively short focal length.

p. 129
p. 305
Pictures made with high-speed films are generally more grainy and less smooth in tonal gradation than pictures made with low-speed films. A fast film is not automatically preferable to a slow film, nor is a fine-grain film necessarily superior to a film of coarser grain, because if grain is used with discrimination and understanding, it can symbolize certain subject qualities and suggest specific moods.

pp. 146-151
Daylight, photoflood, spotlight, flash, and speedlight may provide identical levels of illumination and make identical exposure times possible, but because their characteristics are very different, they are not normally interchangeable. Only after considering what purpose a photograph will be used for and how the subject should be photographed can a photographer decide which type of light will give the best result.

p. 46
If a photograph is addressed to a sophisticated audience it is usually not only possible, but actually desirable to use more creative forms of rendition than if it is intended for an audience that has simpler tastes. Imaginative use of multiple exposure or printing, grain, blur, flare, or halation in a picture would, for example, probably be appreciated in a photograph intended for use in *Vogue* but would be totally wrong in a picture for *Woman's Day*.

As these examples show, selection of devices and techniques should always be made in relation to the nature of the subject, the purpose of the picture, and the type of the photographer's "audience." Misled, perhaps, by the advertisements of

44

some manufacturers who proclaim that their camera can do everything, many photographers may not realize that certain types of cameras are *more* *suitable* to certain purposes than others. Or they may not think about light beyond using their exposure meters to find out if there is enough of it, not knowing that pictorially there is a great difference in effect between, for instance, the light of a hazy sky and a flash, although both may make it possible for the photographer to shoot a picture at 1/100 sec. at f/16, or that in taking a color photograph there is a great difference between the reddish light at sunset and white light at noon. It seems that many photographers do not know about, or do not care about, the subtle differences which make one photographic device or technique better for a particular subject or occasion than another device or technique which produces slightly different qualities. These differences will be pointed out and discussed in later chapters.

THE AUDIENCE FOR WHICH THE PICTURE IS INTENDED

Since a photograph is a means of communication, to be successful it must be appreciated and understood by the audience for which it was intended. Consequently, when planning his pictures, a photographer must always keep his audience in mind.

If an amateur makes pictures for himself, his family, or his colleagues at the photoclub, he has little concern beyond pleasing himself. However, when he decides to make photographs for sale, he must consider other points of view. He must realize that the same subject might have to be approached in different ways, the choice depending upon the nature of the audience to which the pictures will be addressed. In this respect, there are four different kinds of audiences:

> The general public
> The sophisticated audience
> The professional audience
> Advertising and promotion

The general public includes readers of picture magazines, buyers of picture books and photo calendars, and generally anyone who looks at photographs for pleasure or information without having any special interest in photographs as such. Pictures made for the general public should have a documentary-illustrative approach, and imaginative treatment must not be carried to a point where the picture cannot be understood by the average person. Good examples of photographs addressed to

p. 8

the general public can be found in picture magazines, such as *Life, Look, Holiday, Paris-Match,* etc., and in some of the better picture books on different cities and countries.

The sophisticated audience is made up of people who, because of their background, education, or interests, are capable of seeing and appreciating photographs as works of art. Their demands in regard to a picture's meaning, originality, and creativity are far more exacting than those of the general public, and to interest them a photograph must be quite outstanding in both concept and execu-

p. 9 tion. This is the audience for which the subjective-interpretative approach can be used and a creative photographer can express his talent fully and freely in his work. Photographs of this kind are found in magazines like *Vogue, Harper's Bazaar,* and *Show,* and in certain photo books, particularly those devoted to "experimental" photography, most of which are published in Europe.

The professional audience is made up of people to whom a photograph is merely a visual record. Consequently, the main quality photographs intended for this kind of audience must have is clarity. Precision must begin with the concept of the subject and the approach to it, and it must also determine the technical execution of

p. 7 the picture. For purposes of record, the reproductive-utilitarian approach will usually produce the best results. Photographs of this kind are used mainly as illustrations in technical, commercial, and scientific publications, in catalogues, for instruction manuals, and for educational purposes and lecturing.

Advertising and promotion. This is a highly specialized field, greatly diversified, and almost defying classification. However, in this field, the essence of the

p. 18 subject is usually an intangible quality which must be expressed in a single photograph, and in most cases this photograph must conform to very definite ideas expressed either by the client, his representative, or the art director of the agency, and therefore, the photographer's freedom of expression is often limited. Within this narrow concept, however, the utmost ingenuity and creativity is usually needed to complete the assignment successfully. It seems to me that in advertising everyone shuns the unusual, likes to stick to what has been successful before, and yet demands something that is "refreshingly new." How this is to be achieved is usually left to the resourcefulness of the photographer who, if he wants to succeed, must solve this paradox. That it can be solved has been shown by the work of photographers like Bert Stern, John Rawlings, Ben Rose, and others whose highly sophisticated, imaginative, and successful ads can be found in many of our nationally distributed magazines.

46

Seeing in Terms of Photography

Seeing in terms of photography means realizing potentialities: not seeing things as they are, but visualizing them as they could be made to appear in picture form. This kind of seeing depends as much on the eye of the mind as the eyes. It is based upon imagination—imagining what could be made out of a subject or event, how p. 328 it can be isolated from its surroundings, characterized, condensed, and finally presented in the most graphically effective form. Seeing in terms of photography is potentially the most powerful control a photographer has to improve the impression of his pictures.

WHY IT IS IMPORTANT TO SEE REALITY IN PHOTOGRAPHIC TERMS

Perhaps the greatest misconception about photography is expressed in the saying "the camera does not lie." If anything, the opposite is true. The great majority of photographs are "lies" in the sense that they don't fully conform to fact: they are two-dimensional representations of three-dimensional subjects; black-and-white pictures of colorful reality; "frozen" stills of subjects that moved. Every photograph that "didn't come off," every picture that was a disappointment to the photographer because it did not express what he wanted to say, is an example. Yet every photograph is at the same time a truthful and authentic rendition of a subject or event at the moment the picture was made.

An explanation of this seeming paradox is that a photograph is an authentic rendition of *everything* visible within the field of view of the lens, whether interesting or dull, graphically effective or weak, and that it does *not* automatically contain perhaps important intangible qualities of the subject. It is primarily the abundance of p. 18 dull subject matter, the absence of graphically effective qualities, and the lack of emotionally important intangibles which makes so many photographs appear to "lie."

47

POSITIVE CAMERA LIES

Once a photographer is convinced that the camera can lie and that, strictly speaking, the vast majority of photographs are "camera lies," inasmuch as they tell only part of a story or tell it in distorted form, half the battle is won. He then can concede that photography is *not* a "naturalistic" medium of rendition and know, therefore, that to strive for "naturalism" in a photograph is futile, and he can turn his attention to using a camera to make more effective pictures. For "photographic lying" is not necessarily a negative quality. It implies only that a difference exists between a photograph and the subject it depicts. If left to luck and chance, such differences between subject and picture tend to make a photograph inferior to the experience that triggered it. On the other hand, because the vision of the camera pp. 50-53 is more penetrating than that of the human eye, virtually independent of subject distance, highly variable in regard to angle of view, and capable of "stopping" any kind of motion, the camera permits us to produce pictures which show *more* than what we could have seen in reality at the moment of exposure. Therefore, the camera's ability to "lie" can also be used to produce positive results, the photograph being *more* effective than the actual experience. Here are a few examples of such use:

Any telephotograph that clearly shows us something too far away to be distinctly seen by the eye, any close-up that shows us interesting detail which the eye had failed to notice in reality, any picture in which insipid natural color has been transformed into powerful, graphic black and white, any high-speed photograph in which a rapidly moving subject has been "frozen" into tack-sharp rendition, any photograph in which unsharpness, blur, film grain, or halation have been creatively used to symbolize some intangible qualities of a subject or the photographer's response to it and to convey them effectively to others.

In such photographs the subject is shown in a form *different* from that in which it would have appeared to the eye—in a form *superior* to that in which it would have appeared to the eye because it is *more informative*. As a result of this difference, such photographs must be called "unnatural." And yet—probably no one would deny that such photographs are more interesting and hence *better* than many photographs which, strictly speaking, are more "natural" because they conform more closely to the images perceived by the eye.

Arnold Newman once said that "a camera is a mirror with a memory, but it cannot think." This expresses a basic truth about photography. It implies that every photo-

graph is a "true" image, but not necessarily one that is effective or "good." In many cases a photograph will *appear* "true" only if it actually *"lies,"* as in the following examples:

A black-and-white fashion photograph of a green dress trimmed with red is to be made. A "true" rendition would translate these two colors, which are approximately equal in brightness, into more or less identical shades of gray. The effect of the dress—the contrast between the fabric and the trim—would be destroyed through the technical correctness of such a black-and-white translation true to the characteristics of the medium. To *appear* true, the photograph must *"lie"*: to show the contrast between the dress and its trim in a black-and-white rendition, the photographer must translate one of the colors into a lighter shade of gray than the other. p. 141 He can do this by using either a red filter to make the red trim appear light and the green fabric dark, or a green filter to make the red trim appear dark and the green fabric light. In either case the contrast upon which the effect of the dress depended would have been preserved in the black-and-white rendition and the photograph made effective despite its being, or rather because it was, a "camera lie."

Another example: a tall building has to be photographed. To get its entire height on the film, the camera must be tilted upward, and in this position the vertical lines of the building converge toward the top of the picture. Such convergence of vertical lines is a natural manifestation of perspective which we find perfectly natural when it occurs in the horizontal plane (such as the apparent convergence of railroad tracks toward depth) but which most people object to as "unnatural" when manifested in the vertical plane. To make a photograph of a tall building p. 285 which *appears* natural, we must make the camera "lie" by rendering vertical lines p. 286 as parallels, even though this is contrary to the laws of perspective.

A third example: a racing car has to be photographed during a race. Most pictures of cars racing are sharp. They show every detail of the car and the course. This kind of photograph may show the form in which the eye perceived the event, but it does *not* convey the feeling of a race—speed. From looking at such a uniformly sharp picture, one cannot tell whether the car was photographed while racing or while standing still. To express the feeling of speed, a photographer must indicate motion in his picture. Motion, however, is an intangible that in a photo- p. 299 graph can be expressed only in symbolic form, perhaps through blur, although the eye saw the car sharp. But in picture form matters are different, and to produce an impression that conveys the feeling of racing, the camera must be made to "lie."

49

WHAT ARE THE DIFFERENCES IN SEEING
BETWEEN EYE AND CAMERA?

The habit of comparing the eye and the camera with one another and stressing only the *similarities* in their construction has made trouble in understanding photography as a medium of expression and communication because it disregards the enormous *differences* in their function. These differences make the eye superior to the camera in some respects and the camera superior to the eye in others. The following is a summary of these differences in seeing.

1. Human vision is binocular and stereoscopic, that of the camera is monocular. This explains why so many photographs lack "depth"—the photographer, through his stereoscopic vision, saw his subject as three-dimensional and forgot that, with only one "eye," his camera "saw" his subject without depth. Unless depth is expressed in a photograph in symbolic form, the picture must appear "flat."

p. 283

2. The eye, guided by the brain, is selective. It sees subjectively, generally noticing only what the mind is interested in, wishes to see, or has been forced to see. In contrast, the camera "sees" objectively, recording *everything* within its field of view. This is why so many photographs are cluttered with pointless subject matter. Photographers who know how to see in photographic terms *edit* their pictures *before* they take them by eliminating superfluous subject matter through an appropriate angle of view, subject-to-camera distance, choice of lens, or other means.

p. 47

3. The eye is sensitive to color; black-and-white photography "sees" color as shades of gray. However, these gray shades can be changed to a great degree through the use of color filters. To produce pictures that are effective, a photographer who works in black and white must not only know the corresponding shades of gray for different colors, but he must also know how to change these normal shades into lighter or darker tones.

p. 135

4. The eye does not normally notice minor changes in the color of light. Color film is very sensitive to small changes in the color of light. Since we generally do not notice small changes in the color of the light which, however, cause corresponding changes in the color of objects, we are astonished when we see such changes recorded on color film. It is the failure to notice such changes in the color of the incident light which accounts for the majority of color transparencies in which color appears "unnatural." However, if we could compare such transparencies with the subject seen under the same conditions under which the picture was made, we would most likely find that the color film was right and our judgment wrong. Later

I'll have more to say about this phenomenon *color adaptation* which is the most p. 269 common cause of apparently "unnatural" color transparencies.

5. The eye cannot store and add up light impressions—the dimmer the light, the less we see, no matter how long and hard we stare. Photographic emulsions, however, can do this and, within certain limits, produce images whose strength and clarity increase with increases in the duration of the exposure. This capacity to accumulate light impressions makes it possible to take detailed photographs under p. 252 light conditions of a level so low that little or nothing can be seen by the eye.

6. The eye is sensitive only to that part of the electromagnetic spectrum which we know as light. Photographic emulsions, sensitive also to other types of radiation, such as infrared, ultraviolet, and X-rays, make it possible to produce pictures which p. 119 show familiar objects in new and more informative forms as well as to show many things otherwise invisible.

7. The focal length of the lens of the eye is fixed, but a camera can be equipped p. 82 with lenses of almost any focal length. As a result, the scale of the photographic image is virtually unlimited.

8. The angle of view of the eye is fixed, but lenses range in angle of view from very narrow to 180 degrees. Unlike our own vision, a photographic angle of view p. 111 can be chosen to give a desired effect.

9. Our vision functions so that we see three-dimensional things in the form of rectilinear perspective. Although most photographic lenses are designed to pro- p. 285 duce this type of perspective, other lenses produce perspective that is cyclindrical p. 294 or spherical. The remarkable properties of these types of perspective make it possible to create impressions and show relationships between a subject and its surroundings which are beyond the scope of other graphic means.

10. The focusing range of the eye is severely restricted in regard to near distances; anything closer than approximately 10 inches can be seen only indistinctly, increasingly so, the shorter the distance between the subject and the eye. And small objects can be perceived less and less clearly the smaller they are, until a limit is reached beyond which they become invisible to the unaided eye. The camera, however, equipped with a lens of suitable focal length or in conjunction with a microscope, has none of these restrictions.

11. To the normal eye, all things appear sharp at the same time (this is actually an illusion caused by the ability of the eye to constantly adjust focus as it scans a scene in depth). The camera produces not only pictures in any desired degree of

51

unsharpness, but can also make pictures in which a predetermined zone in depth is rendered sharp while everything else is unsharp.

12. The eye adjusts almost instantly to changes in brightness, its pupil contracting and expanding as it scans the light and dark parts of a scene. The "pupil" of the camera, the diaphragm, can be adjusted only for over-all brightness. The contrast range of our vision is thus much wider than that of a photograph [exception: photographs taken on XR Film which has a contrast range of 100,000,000:1]; we can see detail in the brightest and darkest parts of a scene whereas in a corresponding photograph, if contrast was high enough, such areas would be shown as over-exposed, detailless white, and underexposed, detailless black. To compensate for the limited contrast range, a photographer must check the brightness range of his p.132 subject with an exposure meter (since his eye is untrustworthy in this respect) and, p. 277 if contrast is excessive, he must take appropriate counteraction.

13. The eye cannot function virtually instantaneously, cannot retain an image, and cannot combine a number of successive images in one impression. The camera can p. 304 do all three. As a result, a photographer cannot only superimpose different images in one picture, but also express movement graphically, either by instantaneously pp. 301, 303 "freezing" the image of the moving subject or by symbolizing motion through blur p. 304 and multiple images and thus expressing movement in heretofore unknown beauty and fluidity of form.

14. The eye notices and accepts as normal the apparent converging of receding parallel lines in the horizontal plane. However, as a rule, it does not notice in reality, and generally rejects as "unnatural" in picture form, the apparent convergence of receding parallel lines in the vertical plane. The camera does not make a distinction between horizontal and vertical parallels but treats them alike. The result is well known in photographs of buildings and is generally considered p. 286 a fault. How this fault can be avoided is explained later.

15. The eye sees everything it focuses on in the context of its surroundings, relating part to the whole. We do not see sharp boundaries between the things we see sharply and the things we see vaguely or not at all because they are near the periphery or outside of our field of vision. As a result we are generally not conscious of any particular over-all design because we focus successively upon different parts of a much larger whole which we never take in all at once. In contrast, p. 59 a photograph shows the subject out of context, cut off from related subject matter so that attention is centered upon it alone and the picture must stand on its own merit. Because it is a small, limited view it can be seen at a glance. Each com-

ponent of the picture is seen in relation to the others in the form of a design, and if the design is weak, the picture "falls apart." As a result, a subject that was appealing in reality because it was contributed to by surrounding subject matter that had a special atmosphere or mood is dull in picture form when divorced from those elements. Photographers who know how to see in terms of photography are aware of this and, if possible, choose subjects that are inherently photogenic. p. 61

HOW TO SEE IN TERMS OF PHOTOGRAPHY

To be able to successfully bridge the gap between ordinary and photographic seeing, a photographer must train himself to see as the camera sees. He must remember that human vision is augmented by other sense impressions: sound, smell, taste, and tactile sensations combine to inform him about the various aspects of his surroundings. If he stands by the ocean, he *sees* water, sand, and sky; he *hears* wind and waves; he *smells* the kelp, *tastes* the salty spray, and *feels* the pounding of the surf. But if he takes a photograph trying to record these impressions, he probably will be dismayed that it lacks the feeling of that experience.

To see as the camera sees, a photographer must mute all his senses except sight. To the camera, a person is a shape consisting of various lighter and darker areas, each characterized by its own texture; a dinner plate is an oval form of a specific color and brightness, or a circle if the lens looks straight down at it; a house is a pattern consisting of rectangular or trapezoid forms which differ in brightness and texture; and so on. There is no feeling, meaning, implication, or value involved except the graphic values of form and texture, color, light and dark. No depth and perspective, only monocular projection of reality onto the surface of film and paper where two-dimensional shapes lie side by side. No motion or life, only sharpness, unsharpness, or blur. No radiant light, only the white of the paper.

A good way to learn to see a subject in terms of photography is to analyze it in regard to its different visual qualities and to study these qualities in terms of design, light, color, and perspective. To do this, one must be able temporarily to forget the purpose and meaning of the subject and see it as an abstract design consisting of lines and forms, color, light, and darkness. Specifically, one might go about this as follows:

Design

Begin by studying the subject's design (often called "composition"), the arrangement of its components in terms of masses, light, and color. Ask yourself where the pp. 92-93

53

focal point of your composition should be within the framework of your picture (the focal point is also known as the "center of interest"). Should it be high or low, near one side or the other, or in the middle? Each placement will produce a different impression: the more centered, the more static the composition, and the more off center, the more dynamic the design. Which placement would best express the nature of the subject?

Forget, for the moment, that your subject has "depth." Try to see it "flat," as it will appear on paper where all its components are in one plane. The simplest way to do this is to look at it with one eye. This will change your normal stereoscopic vision to monocular vision and you will see as the camera sees. Relationships between picture components that you probably had not noticed before will become apparent: a tree that seemed safely behind your model may now seem to grow out of her head. Or another part of the background, unnoticed before, will suddenly relate to the subject and would weaken—or strengthen—the impression of the picture. Lines that previously appeared parallel, such as verticals of a building when one looks up at it, will now seem to converge.

Analyze the subject's design in terms of shapes and masses. Does it consist primarily of a few large forms or a multitude of smaller shapes? Are these shapes arranged in an over-all organization, a "pattern" which can be used advantageously to lend order and graphic interest to your composition? Perhaps in the form of a repetition of similar picture elements?

What are the dominant forms? Vertical shapes? Horizontal shapes? Irregular shapes? Is there a form that can be used as the "backbone" of the over-all design around which other picture elements can be arranged to make a self-contained design? How will such considerations influence the proportions of your picture?

p. 214 Regardless of the proportions of your negative, should the photograph be oblong or square, perhaps very narrow and wide, or very narrow and high? Such decisions should *not* be made in the darkroom when enlarging the negative but *before* one makes the exposure, while choice of methods and means is still unlimited and radical changes can be made.

Analyzing a concrete subject in such abstract terms may seem difficult at first but it eventually becomes routine. Begin such exercises in photographic seeing by studying simple forms, for example, a leafless tree seen against an empty sky. Try to see *not* the tree but its linear design—the pattern that is characteristic for this tree. Not *any* tree, but one specific kind of tree: an elm, a maple, an oak—because each kind of tree has its own characteristics, the pattern typical for its particular

species, different from all others. Each kind of tree has its own particular "design."

From there, go to more complicated subjects: a face, a room, a street. See them in terms of lines, outlines, and forms, angles and curves, each related to, and part of, the whole. It is this relationship that forms the design which a photographer must discover. More often than not he will find that the design is not clear, but obscured by extraneous subject matter. He'll sense it rather than see it. This is the moment that determines whether he is a *good* photographer. It is the mark of a good photographer to be able to sense the design, to find it, and to reveal it in his picture. To do this he may have to eliminate disturbing subject matter, select a different angle of view, a different type of perspective, or go farther away from the subject and use a lens of greater focal length, rearrange the lights and change the placement of the shadows, or wait for more suitable illumination, or employ other photographic controls. I cannot emphasize strongly enough that he can do such things *only before* he makes the exposure, because only before that moment can he radically influence and change the concept, design, and effect of his picture.

Light

Most photographers see light *quantitatively*: if there is enough light to make a hand-held exposure at a shutter speed short enough to keep the camera from shaking and blurring the picture, they are satisfied. In contrast, photographers who know how to see in terms of photography perceive light *qualitatively*: to them, it makes a great difference whether the light is directional or diffused; whether it is front, side, back, or top light; whether its "color" is white or tinted; whether there is one source of light or several. They are also aware of contrast: they know that high-contrast illumination and low-contrast illumination produce entirely different impressions. As a result, unlike one who seeing a subject that appeals to him shoots it without considering that it might be more effective in a different kind of light—and with different shadows—the photographer who knows how to see in terms of photography is aware of these different aspects of light, and if the light is not to his liking, he waits for the light to change, changes the illumination if he can, or does not take the picture.

p. 251

p. 258
pp. 260, 252

To learn to see light in terms of photography, a photographer must constantly consider such questions as these: Is the intensity of the illumination high, medium, or low? Does the light strike the subject from the front, the side, the back, or from above? Is the source of illumination point-like or an area-type? Is it direct or reflected light? What is the color of the light, how will it affect my color film?

If the light is unsatisfactory, a resourceful photographer has a number of means
pp. 251-267 by which he can change the quality of the light. These will be discussed later. What
is important here is that the reader becomes aware of the fact that differences
in the quality of light are as consequential as the quantity of the available light.
The *quantity* of light influences the *exposure* of the film; the *quality* of the light
p. 262 influences a picture's mood. And if the mood of a picture is wrong for the depicted
subject, not even a perfect exposure can make such a picture "good."

Color

p. 267 Similar considerations apply, of course, to color. Color is part of the over-all
design of a photograph, and a photographer must learn to see and appreciate
color apart from its subject association. He must learn to see and think in terms
p. 135 of color harmonies and clashing color, related and complementary color, colors
p. 277 that are "warm" or "cold," aggressive or receding, saturated or soft. He must train
himself to see color, *not* with the eye of the calendar photographer, who evaluates
color only in relation to its "naturalness," but with the eye of the painter, who if
he finds it necessary, paints a face green, a horse blue, or a shadow pink. Shock-
ing? Unnatural? Modernistic nonsense? Not at all—as any color photographer can
easily prove: if he photographs a person beneath a big tree with the light filtering
p. 95 through its leaves, the face will appear green in the color photograph; if he photo-
graphs a white horse in the shade of a barn when the sky is blue, the horse will
appear blue in the color photograph; and if he photographs the shadow of a
building cast on freshly fallen snow at sunset when the sky is red, it will appear
pink in the color photograph. Unnatural? Distorted color? Inherent weakness of
the color film? Not at all. Under such conditions, things actually look like that, and
the reason that most people don't notice such "abnormal" color is that they tend
to see color as they remember seeing it in average "white" daylight and *not* as it
pp. 269-270 is. I'll have more to say about this later.

The first result of a newly acquired ability to see color as an independent quality,
disassociated from the subject, will be the realization that there is no such thing
as "true" color. Skin color is *not* necessarily pink or tan in a "white" person, nor is
freshly fallen snow necessarily white. All colors change with changes in the color
of the incident light. As a result, since the color of the light is almost constantly
changing, even though changes are small, what at one moment looked white at
another will have pink, blue, yellow, or green overtones. Color may be *unusual*
but it is rarely "unnatural." If I see a picture in which a face is blue, I say the color
is true because the photograph was made either in blue light or through a blue

filter, and under such conditions a face must appear blue. And had I seen it in blue light or through a blue filter, my eyes would have received exactly the same impression.

Another change of a photographer's attitude toward color that will result from an awareness of color as a dimension in itself, will be the realization that color does not have to be bright and loud to be effective. If anything, the opposite is true. Loud color has been used so much in our loud and ruthless society that we are quite immune to it. On the other hand, soft, muted colors are rarely used and they thus automatically attract attention. Besides, their subtlety can express feelings and moods which loud color cannot. In these delicate shades a color photographer will find a scarcely touched world of sophisticated color. Fog and mist, the subtle tints of rainy days and overcast skies, of dawn and dusk, and indoors the use of bounce-flash and shadowless light arrangements, offer limitless opportunities for discovery and invention to anyone who has learned to see color in photographic terms.

Through seeing color in photographic terms, a photographer will become aware of color to a degree he would not have thought possible. He will not only become *consciously* aware of color, but he will become aware of its subtle shades and changes. Where he had seen color quantitatively, he will now see and appreciate it qualitatively. The world will look marvelously rich and beautiful, everchanging. The photographer will feel his imagination stir in this discovery. He will now wonder whether color could be made better, more interesting and more significant by waiting for changes in the color of the light—toward sunset or dusk, very early in the morning, or under a different sky—or by using special filters: to "warm up" pp. 135-144 a scene or to "cool it off," to give it a pink glow, or to soften it and create a sense of mystery by giving it a purplish tint. Who is to say this should not be done? Who should suggest how one should create?

Perspective

Unfortunately, the habit of seeing their surroundings always in the same "perspective" makes most people believe that only one type of perspective exists and that p. 284 any perspective that does not conform to that concept is "distorted." But photography proves this a fallacy. Actually, although our eyes function like a camera's lens, our brain corrects our visual images in the light of knowledge and previous experience and as a result, we often "see" things as we think they ought to be, not as they really are. For example, looking up at a building, we still see its verticals as parallels, although according to the laws of perspective, they should appear p. 285

to converge as they recede. The camera, of course, registers this convergence. Actually, this type of perspective is entirely true to reality. To prove this, cut a rectangular hole 2 x 2½ inches in the center of a piece of cardboard. Hold this frame in front of one eye, close the other. Look through the cutout at the building. If you tilt both your head and the frame as you tilted your camera, the vertical lines will appear to converge. And if you had set up a groundglass-equipped camera and were to compare the groundglass image with the image you see through the cardboard frame, you would find that the angle of convergence in the two would be the same. Similarly, you can also prove that the apparent "compression of space" in telephotographs is real. To do this, hold the frame at arm's length and center in its opening a subject such as the far end of a street. You must look carefully because the image is so small. You will see, perhaps to your surprise, that

p. 60 the highly foreshortened buildings give exactly the same kind of compressed effect that you have seen in telephotographs in which, of course, this phenomenon was more obvious because the image was larger.

Seeing in terms of photography means training one's eye to see consciously, and training one's mind to accept as true, these and other phenomena of perspective.
p. 315
p. 109 The phenomenon known as "wide-angle distortion," for instance, is *not* true distortion (as will be explained later), but the natural effect of a relatively short distance between subject and camera in conjunction with a lens that has a wide angle of view. Whether such perspective should be considered a fault depends upon the intent of the photographer and the purpose of the picture. What matters here is that the photographer should be aware of it and learn how to recognize it in reality *before* he takes a picture so that he can either use it to good advantage or avoid it.

p. 293 Another phenomenon that belongs here is scale. Time and again people take pictures of landscapes or other very large subjects and are dismayed that in the photograph the subject looks so small. This effect results from the photographer's inability to see space in photographic terms. Such photographers forget that in reality they experience the landscape in relation to themselves—as small human beings surrounded by its immensity. As a result, their experience has scale. But in their pictures the landscape is without an indicator of scale. If a human figure were included and placed far enough from the camera so that it appears small, in contrast to the figure's smallness the landscape would appear large. Without such an indicator of scale, the landscape, or any other large subject, appears, of course, no larger than the paper it is printed on.

THE PRACTICE OF SEEING AS A CAMERA SEES

A great aid in learning to see as a camera sees is the cardboard frame previously described. A similar but even more versatile frame can be made from two L-shaped pieces of cardboard. Its advantage is that the frame can be varied both in size and in the proportions of the opening. Lacking such frames, of course, a frame can always be improvised by using the hands to form an opening through which to study the subject.

Studying a subject through a frame has several advantages. The frame isolates the subject from its surroundings. It thus makes it possible to see a subject "out of context" and to more or less tell how the finished picture will look: whether it will stand up on its own merit, whether it will be a self-contained unit in regard to editorial content and graphic design. p. 52

By gradually and progressively scanning the subject through a frame, holding the frame close to one eye while keeping the other shut, then farther away, and then at arm's length, a photographer can locate the best possible view. To dupli-cate this view on film, a lens is selected that has a focal length that will make the view that was seen through the frame exactly fill the camera's viewfinder or ground-glass. If the subject looked best when the frame was held very close to the eye, a lens of relatively short focal length—a wide-angle lens—must be used; on the other hand, the farther the frame was held from the eye to isolate the most effective view, the longer the focal length of the lens must be. p. 111

Another advantage of studying a subject through a frame is that the perspective of the future picture can be evaluated more easily. I have already mentioned that, seen through the rectangular opening of the frame with its parallel sides used as guides, "converging verticals" can be recognized with ease. Similarly, other mani-festations of what is popularly known as "perspective distortion" show more clearly when seen through a right-angle frame than when seen without it. Objects which, because of their nearness to the camera, would be rendered unproportionally large in the picture (best known examples: hands or feet extended toward the photog-rapher), will clearly reveal themselves in their exaggerated size when studied through a frame but may not when seen without it. p. 284

Two other valuable aids in learning to see as a camera sees are viewfinders and groundglass-equipped cameras (twin-lens reflex cameras, because their viewing lenses cannot be stopped down, are less suitable). The most suitable types of viewfinder are multiple-focus and zoom finders because they enable a photog- p. 69

rapher to isolate his subject from its surroundings and to study it in different degrees of image size. Incidentally, studying reality from close range through a 100-degree wide-angle viewfinder is almost a traumatic experience but very worthwhile because it can lead to a more thorough understanding of perspective and space. I recommend that a serious student of photography always carry a viewfinder and use it as often as he can.

Studying a subject on the groundglass of a camera has the advantage that it enables a photographer to observe directly the extension of sharpness in depth. This phenomenon is difficult to visualize without this direct visual aid; it cannot be

pp. 162-167 seen through a viewfinder or a frame. As will be explained later, extension of the sharply rendered zone in depth is one of the functions of the diaphragm and can be studied by gradually changing the diaphragm aperture while observing the image on the groundglass.

Another advantage that the groundglass-equipped camera provides in learning to see in photographic terms is that it permits a photographer to study and evaluate a subject in terms of masses, color, and distribution of light and dark. To see a subject in these terms, all he has to do is throw the image out of focus. In doing this he destroys sharpness of rendition and eliminates detail. What is left is a blurred picture which, removed from reality, reduces the subject to an arrangement of masses, daubs of color, and areas of light and dark. The underlying design emerges much more clearly than it does in an ordinary view in which it is always more difficult to see beyond the realistic qualities and find the underlying graphic-abstract design.

To further increase his experience and his understanding of photographic phenomena, a photographer should look at things through as many suitable devices as possible. For example: study landscapes, street scenes, buildings, ships, etc.,

p. 58 through *binoculars* and you will see things in telephoto perspective—space "compressed" and objects in more nearly true proportions to one another. In such views, perspective and distortion will be virtually eliminated and *you will be able to see things as they are,* not as you *think* they are. This is the first step in learning to see space in photographic terms.

Study your nearest surroundings through a *magnifier.* Discover the structural and textural beauty of that indescribably rich world which is not otherwise clearly seen because of small size or closeness.

Look at reflections in *shiny curved surfaces.* Observe the images of familiar objects which are, through distortion, turned into caricatures whose grotesque shapes are

often extraordinarily expressive. Study reflections in a *mirrored sphere* (a Christmas tree decoration or a garden ornament). You will see your surroundings in spherical perspective, exactly as a 180-degree fisheye lens would render them. You may have seen pictures with such perspective reproduced in magazines or books. Looking at images reflected in a mirrored sphere, you can study such perspective, learn to translate the images, and see for yourself what is represented.

pp. 316, 79, 111

Study objects through *filters* of different colors. See how a subject looks in a rose light, a cool blue light, etc. Remember that there are no "true" colors because the color of all things changes with the color of the incident light. In rosy light, a face appears rosy, in blue light, blue. Although you may not be able to change the color of the light, you can get the desired effect by using a filter of the right color.

p. 267

A creative photographer looks at things through rippled and pebbled glass, through the bottom of a beer bottle, the stem of a wine glass, or other likely material to find new effects. Instead of using a photographic lens, he puts a magnifying glass, a condensor, a positive spectacle lens, or a pinhole in front of his camera and studies the images they produce on the groundglass. He experiments with diffusion screens of various kinds to find new ways to express concepts of radiance and light. Later he uses such images to show in symbolic form subject qualities he could not render directly.

THOUGHTS ABOUT THE PHOTOGENIC

A perceptive photographer will find that certain subjects are effective in picture form, that others are not. Those subjects that make good photographs have attributes popularly known as photogenic qualities. Although technical advances in photography have made it possible to photograph *any* subject, whenever they have a choice, experienced photographers photograph only subjects that have photogenic qualities. Because, as a rule it is simpler to reject an unsuitable subject and to find a better one than it is to try to make a *good* photograph of a subject which is deficient in photogenic qualities.

Photogenic subjects and subject qualities

Subjects that are animate or unusual are more likely to make good photographs than subjects that are inanimate, common, or those that have been photographed many times before. Subjects that can be photographed in the form of a close-up or closely cropped are generally more effective in pictures than those that cannot be photographed in this way.

As far as specific photogenic subject qualities are concerned, opinions may vary, but those qualities that I consider particularly important are:

Simplicity, clarity, and order. In my opinion, these qualities must be present to make a photograph effective. Consequently, if a subject is unusually complex, it should be shown, once in an over-all view and again in a number of close-ups, each showing one specific aspect or detail of the subject in a clear and well-organized form that will supplement the over-all view. If only a single photograph can be used, it is often possible to convey the essence of the subject through a part. p. 239 For example, instead of taking an over-all shot of an automobile show, I have been able to capture its impression through a close-up of the front of one car, suggesting the rest of the show through out-of-focus shapes and blurred lights in the background.

The maximum clarity and graphic impact is found in subjects that have a "poster effect"—subjects that are so simple and at the same time so bold in design that they are effective even at a distance that obscures detail. This effect is particularly desirable in photographs intended for use as magazine covers, book jackets, travel posters, and other pictures that must be effective from afar.

Contrast between light and dark keeps a photograph from appearing "flat." p. 282 In black-and-white photography inclusion of pure black and white gives a picture strength. In color photography use of pure black and white also strengthens the effect of the picture although, in color subjects, exclusive of black and white, the over-all contrast should, as a rule, be somewhat lower than in black-and-white pp. 277-281 photography. I'll have more to say about this later.

Forms that are large, simple, and bold usually make better pictures than forms that are small, complex, or indistinct. A particularly strong form is the silhouette. p. 309 Close-ups are, as a rule, more effective than long-shots because they contain fewer and larger forms.

Outlines that are distinct complement forms that are strong. Outlines that are weak or blurred weaken a picture.

Detail that can be rendered sharp gives photographers a chance to exploit one p. 15 of the medium's best qualities: definition that is superior to that of any other graphic technique.

Texture gives character and identity to a subject through defining its material: wood, stone, sand, paper, leather, skin. . . . Without texture a surface appears

"lifeless." How to produce good texture rendition is discussed later. p. 261

Pattern, rhythm, and repetition of identical or similar forms are important to the organization of a photograph and the unity of its design. However, because patterns are highly photogenic, they have become a photographic cliché. They should never be used for their interest alone, but only as an integral part of the picture.

Motion gives a dynamical quality to a picture by suggesting action and life. How motion can be indicated through photographic means is the subject of a later pp. 299-305 chapter.

Spontaneity is a quality difficult to define but easy to recognize in a picture. Spontaneity is revealed in a natural expression or gesture, movement, arrangement of forms, and in many other ways. Overdirection of the subject weakens spontaneity; posing destroys it.

Photogenic devices and techniques

Some photographic devices and techniques are more likely to produce good photographs than others. Whenever I have a choice, I prefer to work with the following:

Telephoto and long-focus lenses are, in my opinion, preferable to standard and wide-angle lenses because they preserve to a higher degree the true proportions of the subject by forcing the photographer to keep a greater distance from it. Information on the advantages, uses, and effects of telephoto lenses will be pp. 112, 313 given later.

Close-ups, as a rule, make more interesting pictures than over-all shots because the subject is more tightly seen and shown in larger scale. Detailed instructions for close-up photography will be given later. p. 309

Backlight is, to me, the most dramatic form of illumination, superior in beauty and strength to front or side light. For specific instructions concerning its use see pp. 261-265 the chapter on light.

THOUGHTS ABOUT THE UNPHOTOGENIC

As certain qualities make a subject particularly well suited to photographic rendition, other qualities make a subject less suitable. Those qualities that are most likely to make a subject look disappointing in a photograph are listed below. However, I wish to make it quite clear that an imaginative photographer can, on occasion, turn even an unphotogenic subject into a striking photograph.

Insipidity. This quality is found in many different forms; most common: too little contrast, no distinctive form or color, and lack of subject interest. It is seen not only in an appallingly large number of photographs made by amateurs, but also in those made by professionals. It can be avoided only through better subject selection and better use of the medium.

Complexity and disorder rank high among unphotogenic subject qualities. Because the camera shows everything within its field of view, many photographs are overloaded with pointless subject matter and extraneous detail which makes them confusing and therefore ineffective. This is the reason why I consider the "editing" of a subject *before* an exposure is made the most important single control in photography.

Distinctive color. If a photographer works in black and white, distinctive subject color is usually an unphotogenic quality because its elimination is likely to result in a poor picture. If distinctively colored subjects must be rendered in black and white, color must be suggested. This can be done with color filters. The rules

pp. 135-144 for their use will be given later.

Subjects that, because of their color, are basically unphotogenic in black and white are, among others, colorful flowers and fruit, food, women's clothes, birds and butterflies, paintings, gems, postage stamps, neon-lighted night scenes, and brilliant sunset skies.

Posing. Highly photogenic subjects are made into bad photographs by photographers who confuse posing with directing. Directing is often vitally important. Posing, with its commands, destroys naturalness, as we can see in advertisements in which beautiful girls have frozen grins instead of smiles. And the results of posing are just as unfortunate in academic studies of the nude.

Faking. Faking is another approach that results in bad photographs. Faking, as I see it, is tampering with the authenticity of a subject, scene, or event. The most common example is shooting an "outdoors scene" in the studio. No matter how resourceful and skilled the photographer is and how well equipped the studio, there is always something that marks it as a fake: the background has no depth; there are shadows within shadows, and shadows too well filled in that show the use of artificial light; the hair too well groomed, the faultlessly fitted dress, the immaculate accessories and "props," the perfection of the entire setup. All these combine to destroy a feeling of reality and life which the picture is supposed to have. In a picture taken outdoors, light comes from only one direction, shadows on a sunny day are harsh, people are windblown, and perfection is absent.

Faking, as I see it, also includes the use of professional models dressed as doctors, nurses, workers, etc., who in photographs are obviously not what they are claimed as, betrayed by hands too well manicured, hairdo too stylishly perfect, and poses that would not fit the real work. Such things are quickly seen by an observant eye and the picture is rejected as false.

Unphotogenic techniques

As certain photo-techniques almost invariably produce *good* pictures, others are likely to produce bad photographs. Those that, in my opinion, tend to produce bad results are:

Flash at the camera. This illumination makes that part of the subject which is close to the comera appear overlighted and that which is far appear too dark. In addition, the feeling of depth is lacking because shadows that suggest space which only side light or backlight can produce, are missing. The prototype of this picture is the old-fashioned news photograph.

Multiple lighting. As a rule, one light source is preferable to two, and two (one main and one fill-in light) are preferable to three or more because the larger the number of light sources, the greater the danger of shadows within shadows and shadows pointing in different directions—two of the most unsightly photographic faults.

Overlighting and indiscriminate shadow fill-in. Outdoors on sunny days, contrast is often so great that shadows would appear too dark in close-up photographs if not lightened by fill-in illumination. However, unless correctly used, fill-in p. 280 illumination will create a shadow within a shadow or make shadows appear too light. Both mistakes are common, perhaps because overlighted pictures are commonly used by flashbulb and speedlight manufacturers in their promotion. "Filling-in" has also been so publicized that many photographers seem to have forgotten how to take outdoor pictures without flash. If not well used, flash destroys the mood of a subject.

Shooting from too far away and including too much subject matter are typical faults of the beginner. In this connection it is interesting that when a beginner acquires a second lens, it is usually a wide-angle lens (which includes even more subject matter than a standard lens), whereas the second lens of a more experienced photographer is usually a telephoto lens (which takes in a narrower angle of view and thus improves the picture).

p. 193 **Printing on paper that is too soft.** Many photographers still heed the obsolete academic rule that, to be acceptable, a print must have a full range of tones without areas of unrelieved black and white. Accordingly, they print their negatives on paper that is too soft and their photographs lack graphic appeal because they consist almost totally of shades of medium gray. The dull, depressing effect of such prints destroys the most photogenic subject.

THE CONCEPT OF TOTAL SEEING

One of the reasons that a good photographer is good is that he is capable of what I call "total seeing." This visualization is made up of the following stages:

1. The conceptual stage. At this stage the picture exists only in the photographer's mind—it is what he wishes to express. Although he sees his future picture clearly with "the eye of the mind," he often does not yet know exactly how he will express it in concrete form, since this will depend to a large degree on the particular subject and the conditions surrounding it.

2. Through the viewfinder. The photographer, looking at the subject, analyzes it in photographic terms. He selects the combination of specific photographic means and techniques that will produce the picture that will most closely correspond to the one he saw in his mind. And he will not make the exposure until he is satisfied with what he sees in the viewfinder or on the groundglass.

3. On the contact sheet. If possible, an experienced photographer makes a p. 203 number of different shots of the same subject. Most photographers contact-print all the frames of a roll of film on one sheet of 8 x 10-inch paper and use these proof prints as a basis for selecting specific negatives for final printing. However, smallness and technical inequalities of individual negatives often make their correct evaluation difficult because some of the little contact prints may be too light, others too dark, some may be too contrasty and others too soft, since all are printed together under identical conditions. Proper evaluation thus requires experience and imagination. What a photographer must learn to see is *not* the often badly printed picture in the contact sheet, but how it could be made to appear in the final, expertly controlled print.

pp. 213-217 **4. In the darkroom.** Differences in printing—in cropping, lightness, contrast, etc.—will result in prints that look so different that an untrained person could not believe they were made from the same negative. A good photographer "sees" his final print before it is made.

Tools and Materials

Many students of photography are convinced that the better and more expensive equipment is, the better and more expressive pictures will be. They say, "If I only had a Leica . . ."; they say, "No wonder that picture is good, it was made with a Linhof." Such attitudes are held without knowing the facts.

Although it is true that many good photographs are taken with Leicas and Linhofs, is is equally true that these pictures are good, *not* because they were made with good cameras, but *because they were made by good photographers.* In perhaps ninety-nine cases out of a hundred, these pictures could have been made with one of the many other cameras of the same type which cost, perhaps, half as much or less. The reader will probably wonder why, then, so many successful photographers use expensive cameras if cheaper cameras can produce equally good pictures. The reason is that expensive cameras are generally more reliable than cheap cameras of similar types. The difference in picture quality, if it exists at all, is negligible. But the expensive cameras, because they are better designed and engineered and built of better material, will stand up better under hard use; their alignment, focusing mechanism, shutter, etc., will stay accurate longer—they are more trustworthy and dependable. Good photographers buy the best equipment they can afford so that they can concentrate on the creative side of photography and not waste time and energy over failure of their equipment.

In itself, a camera is not creative. In inspired hands it is a means for creative expression. "Prize-winning cameras" and "cameras that can do everything" exist only in the words of advertisements. There are only prize-winning photographers. Meaningful pictures can be made with a camera of any kind or size. Great pictures have been taken with a "lowly box." Some cameras are more suitable to certain types of work or more versatile than others. But—and this is a point that cannot be emphasized enough—it is the photographer's imagination and his ability to see in terms of photography that are important, and not the equipment he uses to express his ideas.

THE EQUIPMENT OF A PHOTOGRAPHER

Photography is as simple or as complex as one wishes to make it. I know a world-famous photographer who carries only two 35-mm cameras for his work. I also know an amateur who has not made a worthwhile picture who owns about $4,000 worth of equipment.

Adequate information about photographic equipment and material is necessary to choosing the things a photographer needs for his work. The following pages give this basic information. However, space is not wasted on information that the reader can get from instructions that accompany every new camera, exposure meter, filter, or package of film which he buys. And I rarely mention specific products by name because information of this kind is short-lived and much of it would be obsolete by the time this text appears in print. This kind of information is the province of photo-magazines where it is always published in up-to-date form.

The most valuable *practical* lesson that twenty years of work as a staff photographer for *Life* has taught me, was to keep my equipment simple. The simpler the equipment, the simpler its use. The less attention technical aspects of picture-making demand, the more attention can be given to the subject. The less equipment I had to carry, the less I had to take care of and worry about; the less dependent I was on porters, taxicabs, and help in general, the more ground I could cover, and the less tired I got. All these factors reflect, of course, favorably on the quality of one's work.

THE CAMERA

Any camera, whatever its type, size, or price, is basically nothing but a light-tight box or sleeve connecting two vitally important components:

> **The lens** that produces the picture, and
> **The film** that retains it.

Its other components are merely auxiliary devices that control the three operations by which a picture is made:

> **Aiming**
> **Focusing**
> **Exposing**

Controls for aiming and focusing

Without an accurate aiming device, a photographer cannot accurately compose

his subject. A viewfinder enables him to do this. Through it he sees how the subject separated from its surrounding will appear in the picture.

Focusing a camera means adjusting the lens-to-film distance in relation to the lens-to-subject distance to a point that produces a sharp image. To focus correctly, two devices are needed:

p. 160

A mechanical device (in small cameras, a helical lens mount; in most larger cameras, a rack and pinion drive) that makes it possible to vary the distance between lens and film.

An optical focusing control (a rangefinder or a groundglass) which shows when the distance between lens and film is correctly adjusted.

The combination viewfinder-rangefinder, employed by many 35 mm and press cameras, is the fastest of all focusing systems but has the following drawbacks: its synchronization can fail and not be noticed in time, resulting in unsharp pictures; it cannot be used at ranges closer than approximately 3 feet from the subject; it does not show the extent of the sharply covered zone in depth; it cannot be used with extreme telephoto lenses; and, unless specifically designed to compensate for parallax, it does not show the exact boundaries of the picture.

The groundglass or focusing screen employed by all reflex, view, and press cameras (in the latter, in addition to a rangefinder) is, as far as focusing is concerned, not quite as fast to operate as a combination viewfinder-rangefinder but has the following advantages: image size is as large as the respective negative which facilitates evaluation of the image; direct, visual indication of the extent of the sharply covered zone in depth (exception: all twin-lens reflex cameras); freedom from parallax at all focusing distances (exception: twin-lens reflex cameras); unlimited range of operation with any type of lens at any lens-to-subject distance.

There are different kinds of groundglass viewing and focusing systems:

The groundless panel. This is the "old-fashioned" type of focusing screen attached to the back of a press or view camera. In addition to the desirable features listed above, it has the advantage (not found in any other viewing and focusing system) that a camera so equipped can be fitted with independent front and back adjustments—the tilts, slides, and swings necessary for perspective control which are essential to architectural, industrial, commercial, and interior photography and, under certain conditions, for increasing the sharply covered zone in depth without the necessity for excessively small diaphragm stops. Disadvantages: the image appears upside-down and reversed; inserting the film holder blocks out

pp. 78, 287

p. 289

the image; and unless the camera has an auxiliary viewfinder (or an additional viewfinder-rangefinder), it must be used on a tripod.

The reflex system. A mirror mounted at an angle of 45 degrees behind the lens intercepts the image, reflects it upward, and projects it on a horizontal focusing screen. This viewing and focusing system can take three forms:

1. The image, projected on a horizontal focusing screen, is viewed from above, i.e., the camera is normally held at waist-level. This is the principle employed by all large, medium, and some (now obsolete) 35-mm single-lens reflex cameras. It has these drawbacks:

The image, although right-side up, is reversed.

Immediately before the exposure, the mirror flips up so that the light can reach the film, removing the image when it is most important to see it; this shortcoming, however, is virtually eliminated if the camera has an instant-return mirror which automatically reverts to viewing position immediately after the exposure.

Unless the camera has a revolving back, vertical views must be made by turning one's self 90 degrees from the subject, turning the camera on its side, and looking into it sideways, a position which makes fast and accurate shooting impossible. Cameras which produce square negatives do not, of course, involve this problem, which is why most modern, medium-size, single-lens reflex cameras are designed to produce square pictures.

2. The image is projected as above but viewed through a pentaprism mounted on top of the focusing screen. This system is the most popular in use today. It has the following advantages:

The image appears right-side up and *not* reversed.

Vertical views can be taken by simply turning the camera into a vertical position.

The camera is held at eye-level (as a rangefinder camera is) which makes for faster operation and, in many cases, for more natural perspective.

3. The image-viewing and picture-taking systems of the camera are separated, each equipped with a lens of identical focal length. This is the principle of the twin-lens reflex camera which has the following advantages and drawbacks:

The image is right-side up but reversed.

The image is always visible, even during the exposure.

70

The image is viewed from above—the camera held normally at waist-level. However, if necessary, the camera can also be held in upside-down position above the head and the image viewed from below which makes it possible to take pictures over the heads of a crowd that otherwise would block a view.

Combinations. There is no viewing and focusing system that is satisfactory for all purposes. As a result, more and more cameras are designed for use with several viewing and focusing devices. Anyone who needs different types of viewing and focusing systems should look for a camera that offers such a choice.

Controls for exposing

Exposing is admitting the amount of light to the film that will produce a negative p. 167 of correct density or a color transparency of pleasing color. Two devices control this:

The diaphragm, a variable aperture built into the lens, controls the *amount* of *light* admitted to the film. It is operated either manually or semi- or fully automatically.

The shutter, in conjunction with a built-in timing device, regulates the *length of time* the light is admitted to the film. There are two main types of shutter:

Between-the-lens shutters are built into the lens. Advantages: they are, as a rule, more reliable in operation than focal-plane shutters, produce more uniform light distribution on the film, and they can be synchronized for speedlight illumination at any shutter speed. However, in 35-mm and rollfilm cameras that feature interchangeability of lenses, their use involves technical complications which are sometimes avoided by using a leaf-type or rotary-type "behind-the-lens shutter."

Focal-plane shutters are built into the camera. They have these advantages over between-the-lens shutters: they allow for shorter exposures and considerably simplify the construction of cameras that feature interchangeability of lenses. On the other hand, they are often unreliable, subject to "wedging" (exposing one side of the film progressively more than the other), and synchronization with speedlight is possible only at relatively slow shutter speeds.

HOW TO SELECT YOUR CAMERA

I am constantly asked which camera I consider "best." This question cannot be answered unless it is qualified: best for what purpose, and best for whom? In my opinion, the way to decide which camera and other photographic equipment is

most likely to suit one's need is on the basis of the following considerations:

> The personality of the photographer
> The purpose the camera must serve
> The quality of the workmanship of the camera
> The price the photographer wishes to pay

The personality of the photographer—it determines the film size

Today there are two trends in photography: one characterized by a demand for immediacy, spontaneity, human interest, and action; the other by a quest for the highest photo-technical quality and precision of rendition. The first has among its followers such eminent photographers as Henry Cartier-Bresson, Alfred Eisenstaedt, Leonard McCombe, and W. Eugene Smith; the second, such outstanding cameramen as Edward and Brett Weston, Ansel Adams, Eliot Porter, and Paul Strand.

With the development of these trends, two diametrically different types of camera have been developed to highest perfection: the 35-mm camera designed for maximum speed of operation and minimum size and weight, and the 4 x 5-inch camera designed primarily to produce photographs of the highest photo-technical quality.

Characteristics of 35-mm cameras

Smallness, lightness, inconspicuousness, maneuverability—prerequisites for fast and unobserved photographing of people, action, and events—make the 35-mm camera unsurpassed for the reporter and the documentarian who wants unposed pictures of people.

Super-fast lenses are generally available *only* for 35-mm cameras.

Rapid-fire operation. Lens-coupled rangefinder or instant-return mirror systems, film transport-coupled shutter-winding mechanisms, and magazines that hold film for thirty-six or more exposures that can in some cases be "fired" at a rate of up to five frames per second by a built-in or accessory motor, make 35-mm cameras unsurpassed for all sequence and motion photography.

Low cost of 35-mm film makes complete subject coverage possible.

Against these desirable features, the following disadvantages must be weighed:

The small size of the 35-mm negative or transparency makes technically satisfactory quality more difficult to get than a larger film size does. No matter how technically perfect, a 35-mm photograph will not be as sharp, detailed, or free from

72

unwanted grain as a technically perfect photograph made with a larger camera.

The technical complexity of a 35-mm camera is considerably greater than that of a 4 x 5-inch camera. It is more likely to break down, repairs can be costly, and such cameras require a very competent repair man. Because the shutter is an essential part of all 35-mm cameras, its failure puts the entire outfit out of commission whereas, because the shutter of a 4 x 5 is built into the lens, if the shutter breaks down, another lens can be used and the camera remains operational—and shutter failure is the most common cause of camera break-downs.

Specialization makes 35-mm cameras less suited, and in certain cases totally unsuited, to certain types of photography. 35-mm rangefinder cameras are difficult if not impossible to adapt to close-up photography (an expensive accessory reflexhousing is required). Lack of "swings" prohibits the use of 35-mm cameras for any photographic work in which perspective must be controlled on the film (exception: the limited perspective control provided by the 35-mm f/3.5 Nikkor Perspective Control Lens).

Characteristics of 4 x 5-inch cameras

Sharpness and definition of rendition, tonal gradation, and quality of the color transparency or negative are superb because 4 x 5-inch films must be magnified only twice linear to produce 8 x 10-inch prints, and less than three times linear to produce 11 x 14-inch prints. To produce prints of corresponding size, 35-mm negatives require magnification of approximately seven and ten times with corresponding loss in sharpness and increase in grain.

Simplicity of construction results in simplicity of operation, unequalled reliability, infrequent repairs and, for many models, a comparatively low purchase price.

Unequalled adaptability, particularly when extreme extensions between lens and film are needed, individual front and back adjustments are required (the "swings" for perspective control), and adaptability for the use of extreme wideangle lenses is important.

Ease and simplicity of processing and printing 4 x 5-inch film. Ordinary rapid developers which permit the utilization of the full inherent film speed can be used without producing objectionable grain in prints because 4 x 5-inch negatives are normally not given a high degree of enlargement. Dust, scratches, and abrasion marks do not show nearly as much in enlargements made from 4 x 5-inch negatives as in those made from 35-mm negatives because less magnification is required;

those that show are much easier to "spot." Individual shots can be processed individually and immediately after shooting without the need to finish the entire roll of film.

The impression a 4 x 5-inch color transparency makes upon the observer is far superior to that made by a 35-mm slide; 4 x 5-inch transparencies are therefore much easier to sell.

Against these desirable features the following disadvantages must be weighed:

Size, weight, and relatively slow speed of operation of 4 x 5-inch cameras prohibit their use under many conditions, particularly for photographing dynamic subjects.

Hand-held operation is impossible with all *view cameras* (but *not* press-type cameras)—a tripod must be used.

Film cost is considerably higher for each exposure than for the 35-mm camera.

Extreme high-speed lenses are not available for 4 x 5-inch cameras.

Cameras of intermediate sizes

Most cameras in this category are larger and heavier than 35-mm cameras but smaller and lighter than 4 x 5-inch cameras. The most successful of these are designed for use with size 120 rollfilm. They produce negatives or color transparencies either 2¼ x 2¼ inches (6 x 6 centimeters), 2¼ x 2¾, or 2¼ x 3¼ inches (6 x 9 centimeters). Because they have either a lens-coupled rangefinder or a reflex focusing system, a tripod is not necessary and hand-held exposures can be made as quickly as with a 35-mm camera. They produce pictures that are almost as sharp and grainless as those made with a 4 x 5-inch camera. Most of these cameras feature interchangeability of lenses. Several are equipped with independent front and back adjustments that are similar to, though generally not quite as versatile as, those of a view camera. Some well-known cameras in this category are the Bronica, Hasselblad, Kowa Six, Linhof Super Technika V 2¼ x 3¼, Mamiya Press 23, Mamiya RB67, Mamiya TLR, and Rolleiflex.

Cameras of extreme sizes

The cameras in this category are designed either to produce negatives that are *smaller* than standard 35-mm negatives, or *larger* than 4 x 5-inch negatives. Although they are particularly well suited to a few special tasks, they are not recommended for most types of serious photographic work. The ultra-miniature cameras are scarcely more than toys. Cameras larger than 4 x 5 inches—5 x 7, 8 x 10—are

obsolescent by today's standards because the slight improvement they offer in photo-technical quality over a 4 x 5 is, in most *but not all* cases, more than offset by the drawback of their weight and size.

The camera that is best for YOU

To find the camera that will best suit him, a photographer should begin by considering which film size would be most likely to fit his personality, the purpose of his work, and the kind of subject he will most frequently photograph. For example, if he is primarily interested in static subjects, if he intends to make color photo- p. 16
graphs for sale, if he is a slow and deliberate worker who would rather forego a picture than lower his standards, if he likes to compose his subjects carefully; and if he is willing to pay, in the form of greater weight and bulk of his outfit, the price for photo-technical excellency, *only a camera designed to take a large film size will satisfy his needs.*

On the other hand, if he is primarily interested in dynamic subjects, if he is nervous p. 17
and impulsive, instinctively acts on the spur of the moment and likes to shoot fast, capturing on film life as it passes by, if he is more interested in action and motion than in definition and texture, if he wants to travel with a minimum of weight and use his camera as a photographic sketch-book, and if he is willing to pay the price for this in the form of a somewhat lower standard of photo-technical quality, *only a camera designed to take a small film size will satisfy his needs.*

And if he feels that he belongs somewhere between these two extremes, if his interests are comprehensive rather than specialized and include both static and dynamic subjects, if he has a feeling for photo-technical quality but does not wish to inconvenience himself excessively to achieve it, *a camera designed to take a medium film size will be most likely to satisfy his needs.*

The purpose the camera must serve—it determines the camera's design

A camera is a tool. And like any other tool, it will produce good results only if it is used for the purpose for which it was designed. Although, of course, almost any camera will make some kind of picture of almost any subject, specific kinds of cameras are designed for specific kinds of work and consequently will do this kind of work better and with greater ease than cameras of different design intended for other kinds of work. It is a waste of time, money, and energy to search for the "ideal" camera; it does not exist.

In selecting a camera a photographer's worst mistake is perhaps choosing one used by another whose work he admires, in the belief that it would serve him equally well. Perhaps it will; more likely, it will not, because his personality, temperament, interests, and working habits are different. The name of a camera or its price are unimportant. The only thing that counts is its *suitability* for the work intended.

There are three main groups of cameras and ten basic designs from which a photographer can select his camera. If he does more than one kind of work he may need more than one camera for best results.

Group 1: Cameras suitable to general photography

> Rangefinder equipped cameras
> Reflex cameras

Group 2: Semi-specialized cameras

> View cameras
> Polaroid Land cameras
> Box-type cameras

Group 3: Highly specialized cameras

> Super wide-angle cameras
> Panoramic cameras
> Aerial cameras
> "Big Berthas"
> Subminiature cameras

CAMERAS SUITABLE TO GENERAL PHOTOGRAPHY

Cameras in this group are designed for hand-held operation although they can, of course, also be used with a tripod. They are adaptable to both wide-angle and telephotography. Many, though not all, are suitable for close-up photography. Most feature interchangeability of lenses.

The rangefinder camera (RF camera)

This is the fastest camera design, the one best suited to photographing people and action. Drawbacks: the extent of sharpness in depth cannot be checked in the finder; small size finder image makes composition difficult; those who wear glasses sometimes find it difficult to use a rangefinder; some RF cameras do not provide adequate parallax compensation; all 35-mm RF cameras are suitable to close-up

photography only in conjunction with an auxiliary reflex housing. RF cameras are available in sizes from 35-mm up to 5 x 7 inches.

The single-lens reflex camera (SLR camera)

This is the most universally useful type of camera design. In addition to being especially well suited to close-up and telephotography, it is particularly good for photographing dynamic subjects. Although somewhat slower to focus than a range- p. 17 finder camera, it is today's most popular camera design because it combines the readiness of the RF camera with the following advantages: large negative-size finder image, freedom from parallax, direct visual control of the extent of sharpness in depth, no need for costly accessories such as special viewfinders and reflex housings for close-up, wide-angle, or telephotography. Drawbacks: the upswinging mirror makes the use of extreme wide-angle lenses either difficult or impossible (but exceptions exist); "mirror shock" may cause blurred negatives, particularly in larger SLR cameras; and the finder image becomes progressively darker and focusing increasingly difficult as the diaphragm is stopped down, unless the camera is equipped with an automatic or preset diaphragm. SLR cameras are available in sizes from 35-mm to 5 x 7 inches (the latter size available only in discontinued models).

A special version of the reflex camera design is the twin-lens reflex camera (TLR camera); the best known is the Rolleiflex. This design has two unique advantages: its bright, large, negative-size viewfinder image is continuously visible, even *during* the exposure, and it stays bright no matter how much the lens is stopped down. Drawbacks: cameras are larger and heavier than SLR cameras of corresponding negative size; most models do not allow for interchangeability of lenses, and those that do lack some of the desirable automatic features of those that do not; visual observation of sharpness in depth is normally not possible, and the usefulness of all models for close-up photography is severely restricted either because of limited focusing range or because of parallax problems. For general photography, provided that the restrictions listed are not objected to, this is the most suitable camera design for the average amateur and, in my opinion, it is unsurpassed for the beginner.

SEMI-SPECIALIZED CAMERAS

Cameras in this group are particularly suitable for specific types of photographic work, but they have certain limitations which will be pointed out in the following survey. *They are not suitable for general photography,* and anyone considering

the acquisition of one should be aware of its uses and limitations to avoid disappointment.

View cameras

p. 16 They are as unsurpassed for photographing static subjects as they are unfit for photographing dynamic subjects. A view camera is the best choice for anyone wishing to specialize in commercial, architectural, industrial, or interior photography. It is unsurpassed for copy work and the reproduction of works of art (an 8 x 10-inch view camera is ideal for making color transparencies of paintings), catalogue work, and for technical photography.

The most serious limitation of the view camera design is that the cameras must be mounted on a tripod. Other drawbacks are size, weight, slowness of operation, and relatively high cost of film. However, they have a number of outstanding and even unique advantages which makes them the most flexible of all camera designs. The most advanced view cameras are constructed according to the module or building-block principle: their basic components—track, bellows, lens support, back, etc.—are detachable and interchangeable with other parts of similar function but different construction or dimensions. As a result, a photographer can assemble his own camera from standardized parts to fulfill the specific requirements needed for a particular type of work. The following features are offered by the best cameras of this design:

Use of lenses from extreme wide-angle to extreme telephoto; choice of film sizes from 35-mm to 8 x 10-inch which can be used in the same camera; unlimited extension from lens to film (by adding or subtracting units of bellows and track, any desired extension can be achieved); choice of bellows of different design: parallel, tapered (to connect the standard front with backs of different sizes for use with different sizes of film), or flexible and highly compressible for use with
p. 71 the most extreme wide-angle lenses; choice of shutters: between-the-lens or focal-plane, or both for alternating use; individual front and back adjustments: tilts,
p. 287 swings, and slides for complete perspective control and unlimited extension of
p. 289 sharpness in depth in certain kinds of oblique shots; choice of front or back focusing, the latter almost a "must" in close-up photography; revolving or reversible back panel for instant change-over from vertical to horizontal picture; and, of course, a negative-size groundglass focusing panel which is the most accurate and reliable of focusing devices because it is free from parallax under all conditions and permits the photographer to check his picture for composition, focus, sharpness in depth, and the extent and degree of intentional unsharpness.

Polaroid Land cameras

The limitations of this camera design are severe: Polaroid Land cameras cannot be used with standard brands of film available anywhere, but *only* with Polaroid Land films. Most (though not all) Polaroid Land films do not produce a usable negative, and when such films are used, duplicate prints can only be made by copying the original. These cameras, at least at the time of writing, don't permit interchangeability of lenses. However, special Polaroid Land film holders are available which, like an ordinary rollfilm adapter, can be used with most 4 x 5-inch and some 2¼ x 2¼-inch cameras, which make it possible to use the Polaroid Land process with different lenses. The advantage of the Polaroid Land process is, of course, that finished black-and-white or color prints are available only seconds after the exposure. This makes a Polaroid Land camera or accessory back ideal for an amateur who wishes to see results immediately so that he can take another shot if the first did not please him, or for a professional photographer to make a test shot of a difficult subject and to make courtesy pictures for those who helped him on a job.

Box-type cameras

This type of camera which is simple and relatively inexpensive was specifically designed to fill the needs of those who wish to make pictures with the least expenditure of effort, money, and technical know-how. Its potential is, of course, extremely limited.

HIGHLY SPECIALIZED CAMERAS

Cameras in this group are suited to only one type of work but cannot be used for any other purpose. Ambitious and versatile photographers acquire such cameras to broaden the scope of their work and to get the edge over their less imaginative and well-equipped competitors.

Super wide-angle cameras

The following super wide-angle cameras are available at the time of writing:

Hasselblad Superwide 2¼ x 2¼-inch equipped with 38-mm f/4.5 Zeiss Biogon; angle of view is 100 degrees.

Plaubel Veriwide 2¼ x 3½-inch equipped with 47-mm f/8 Schneider Super Angulon; angle of view is 100 degrees.

Nikon F SLR camera 35-mm equipped with 8-mm f/8 Nikkor Fisheye lens; angle of view is 180 degrees; perspective is spherical. p. 316

Panoramic cameras

These are equipped with moderate wide-angle lenses that swing in an arc during exposure, scanning the film. They cover the relatively enormous angle of view of 140 degrees. Perspective is cylindrical: straight lines that run parallel to the plane of the arc appear as more or less pronounced curves, a phenomenon which will be dealt with later. Although this perspective is often objectionable in architectural photographs, it is not noticeable in pictures of subjects which don't contain straight lines, making this camera design particularly suitable for photographing outdoor scenes and events whenever an exceptionally large angle of view must be covered.

p. 316

pp. 294-297

Representatives of this design are the Panon and Panox (designed to take 120-size rollfilm) and the Widelux 25 x 60-mm camera equipped with a 26-mm f/2.8 lens which uses regular 35-mm film.

Aerial cameras

Because their lenses are permanently focused at infinity, they cannot be used for any other purpose. Often, "surplus" aerial cameras are advertised at fantastically low prices; but they are not bargains unless one needs an aerial camera or lens because it is virtually impossible to convert them to any other use.

"Big Berthas"

pp. 70-77 These are 4 x 5- or 5 x 7-inch Graflex boxes (reflex design) equipped with extreme telephoto lenses with focal lengths up to 60 inches. They are designed for covering sports events, particularly baseball, football, and track meets, and permit the photographer to cover the entire event from a single vantage point and get close-ups of the participants. Their enormous size and weight make them obsolete by today's standards.

Subminiature cameras

Many of the cameras in this category are precision instruments equipped with all imaginable refinements. They are invaluable when such smallness and lightness are essential, and otherwise virtually useless.

Between the subminiature and the standard (or double-frame) 35-mm cameras are the so-called single-frame 35-mm cameras which produce negatives half as large (18 x 24 mm) as the standard (24 x 36 mm) 35-mm negative. These cameras are somewhat smaller, lighter, cheaper, and usually less versatile than the average standard 35-mm camera.

The quality of the workmanship determines the technical performance and reliability of a camera

No craftsman can do good work with tools of inferior quality, and a photographer is no exception. High-quality photographic equipment lasts longer and is less liable to break down than similar equipment of lower quality. Consequently, it is sensible to get the best equipment available, and be satisfied with a few pieces of highest quality rather than buy many of low quality.

The price a photographer pays can buy much or little

It may seem that the more equipment costs, the more one can expect from it in quality and performance. Unfortunately, this is not necessarily true, for two reasons:

Photo stores are full of "like new" used equipment of high quality which sells for considerably less than factory-fresh merchandise of the same kind. If a photographer buys a used camera from a dealer who guarantees it, there is no doubt that he will get more value for his money than if he were to buy a new camera for the same amount since it would pay for only one of lower quality.

An expensive camera is not necessarily more desirable than a cheaper one, because a cheaper camera may work as well for the same purpose. For example, a 35-mm camera with an f/1.4 lens is much more expensive than the same camera with an f/2.8 lens. How often would the average photographer need the full speed of the f/1.4 lens? Is it worth the extra cost? And for commercial or architectural photography, a second-hand 4 x 5-inch view camera with an "old-fashioned" slow but sharp lens is much better than the latest 35-mm camera equipped with the fastest lens which might cost up to ten times as much! This comparison may be thought extreme but it illustrates an unfortunate fact: that money is often spent foolishly by photographers.

HOW TO OPERATE A CAMERA

Modern cameras vary so widely in details of design and construction that it is impossible to give instructions for their use in this book. Therefore, I suggest that the reader have a number of suitable cameras demonstrated at a photo store. This will give him a chance to compare different models and "get the feel" of them, which is the only way to find one that suits him. Once he has made his decision, the manufacturer's instruction booklet that accompanies every new camera will tell him how to operate it correctly and get the full benefit from its particular features.

THE LENS

A recently published list of interchangeable lenses currently available for 35-mm and 2¼ x 2¼-inch cameras contains over 600 different entries. To choose a lens from such a number may seem an overwhelming task. Actually, it is not nearly as difficult as it seems, because all lenses, simple or complicated, have certain properties in common and are subject to the same optical laws. To make an intelligent choice, one does *not* have to know how a lens produces an image or what such terms as "node of emission," "spherical aberration," "coma," "curvature of field," or "astigmatism" mean. All one needs to know is the meaning of the following terms:

Focal length
Relative aperture ("speed")
Covering power

which designate the three fundamental properties of *any* lens.

Focal length

The focal length of a lens, normally engraved on the lens mount, is measured in millimeters, centimeters, or inches. It is the distance from approximately the center of the lens to the film at which the lens produces a sharp image of an object that is infinitely far away, for example, a star.* It is the shortest distance between lens and film at which the respective lens can produce a sharp image.

The focal length determines the image size on the negative; regardless of the size of the negative, the longer the focal length, the larger the image. Focal length and image size are directly proportional: a lens with twice the focal length of another produces an image that is twice as high and wide as that produced by the lens of half its focal length. If a photographer wishes to increase the scale of rendition (without shortening the distance between subject and camera), he must use a lens with a correspondingly longer focal length.

According to their focal lengths, lenses are frequently referred to as standard, short-focus, or long-focus lenses. Such a differentiation, however, is relative. A lens that has a *relatively* short focal length when used with one negative size, has a *relatively* long focal length when used with a smaller negative size (although

* In technical language, it is the distance between the node of emission (which normally lies slightly behind the center of the lens) and the film, when the lens is focused at infinity. In telephoto and retrofocus wide-angle lenses, the node of emission lies outside the lens.

its *actual* focal length is, of course, unchanged). For example, a wide-angle lens that covers an 8 x 10-inch negative may have a focal length of 6 inches (which, obviously, is rather short *relative* to the size of the negative). If used on a 4 x 5-inch camera, the same lens, however, would *behave* like a standard lens (because the normal focal length of a standard lens for 4 x 5-inch film is 6 inches), thus making it *in effect* a lens of standard focal length. And if used with a 2¼ x 2¼-inch SLR camera, the same 6-inch lens which was designed (and still is) a wide-angle lens, would now *behave* like a long-focus or telephoto lens since the standard focal length of a lens for use with 2¼ x 2¼-inch film is 3 inches (and 6 inches is obviously *relatively* long in comparison to 2¼ x 2¼ inches). A *standard lens* is customarily defined as a lens with a focal length equal to (or *slightly* shorter or longer than) the diagonal of the negative with which it is to be used.

Relative aperture or "speed"

The relative aperture is a measure of the light transmission of a lens. The term includes the word "relative" because it is a function of two factors—focal length and effective lens diameter—which it relates to one another for the purpose of measuring the "speed" of the lens. It is expressed in the form of a ratio: focal length divided by effective diameter equals relative aperture. For example, if the focal length of a lens is 50 mm (the standard focal length for many 35-mm cameras) and its effective diameter is 25 mm, its relative aperture is found by dividing 50 by 25, making the relative aperture of this lens 2. In practice, the relative aperture is expressed in f-numbers, and the proper designation of this lens would be f/2 which, as any photographer knows, designates a "fast" or high-speed lens.

In another instance, the focal length of the lens may be 150 mm and its effective diameter 23½ mm, data characteristic of many old-fashioned standard lenses designated for use with 4 x 5-inch cameras. In such a case, the effective aperture of the lens would be 150 divided by 23½ which equals 6.3—f/6.3—which, as any photographer knows, designates a rather "slow" lens.

It may seem confusing especially to the beginner, that an f/2 lens is *faster* than an f/6.3 lens although its f-number is *lower*. To understand why lenses are numbered in this way, the following analogy may be helpful.

Imagine the lens as a circular window that has a 3-foot diameter. This window illuminates a small room; the distance between the window and the opposite wall (corresponding to the film) is 9 feet. Then imagine a second room, also illuminated

by a circular window 3 feet in diameter; but in this case, the distance between the window and the opposite wall should be 18 feet. Although both windows are equal in size, the wall of the second room, because it is farther away, will obviously receive less light than the wall of the first room. Since the wall in the second room is twice as far from the window, and since the effective illumination is inversely proportional to the square of the distance between the source of illumination (the window) and the illuminated object (the wall), although the wall in the 18-foot room is only *twice* as far from the window, it will receive only *one-fourth* as much light as the wall in the 9-foot room. In other words, although the diameter of the two windows is the same, the window (the lens) of the 9-foot room, in relation to the amount of light it throws on the wall (the film), is *in effect four times as fast* as the same window (lens) in the 18-foot room.

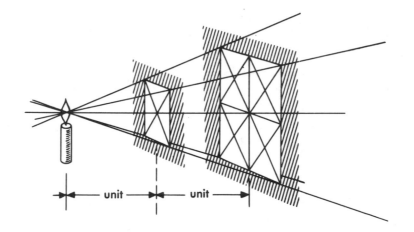

This example should make it clear why the formula for the "speed" of a lens *must* include two factors: diameter and focal length. By itself, the diameter does not tell the speed of a lens. We must also know its focal length—the distance which separates the lens (window) from the film (wall)—to compute the amount of light that will reach the film (the wall) and on the basis of this factor determine the exposure. The simplest way to express the value of *both* lens diameter and focal

length in *one* formula is in the form of a ratio: focal length divided by effective lens diameter. Expressed in this form—as an f-number—the relative aperture of the 3-foot window in conjunction with the 9-foot room would be 9 divided by 3, or f/3, and that of the 3-foot window in conjunction with the 18-foot room would be 18 divided by 3, or f/6. This is the reason that the smaller f-number (f/3) represents a *higher* level of illumination (greater light transmission) than the larger f-number (f/6).

This sample will also explain another thing which confuses the beginner, namely why a relative aperture with a number *twice* as high as another, demands a *fourfold* increase in exposure (instead of a two-fold increase). For example, if light conditions permit an exposure of 1/200 sec. at f/8, the corresponding exposure at f/16 is NOT twice as long (or 1/100 sec.) but *four times as long* (or 1/50 sec.). It is *four* times as long because the intensity of the incident light is inversely proportional *to the square* of the distance between light source and illuminated object.

The concept of f-stops

The relative aperture of a lens is equivalent to its largest *effective* diameter (or its highest possible speed). However, it is often not desirable to use a lens at its highest possible speed for three reasons:

1. The smaller the effective diameter of a lens, the greater the extent of the sharply covered zone in depth.

2. The smaller the effective diameter of a lens, the less light is admitted to the film. Now, many modern films are so "fast" that if a picture is taken in bright light with the lens wide-open, overexposure results because the fastest available shutter speed is still too slow to produce a correctly exposed color transparency or negative.

3. Most lenses produce sharper pictures when they are NOT used wide-open but slightly stopped down.

"Stopping down" a lens means reducing its effective diameter. A lens is stopped down by the diaphragm, a variable aperture built into the lens mount. It is calibrated in f-numbers (usually called "stops") that are computed by dividing the focal length of the lens by the diameter of the respective diaphragm opening. These f-numbers or stops are calibrated in such a way that each consecutive f-number requires *twice the exposure of the preceding larger diaphragm opening,* i.e., the preceding *smaller* f-number. In other words, *as the diaphragm opening is reduced*

from one f-number to the next, the exposure must be doubled if the result—the exposure—is to remain constant.

The following table shows the relationship between f-numbers and comparative exposure factors and indicates the resulting effects.

The American f-number system	f/1	f/1.4	f/2	f/2.8	f/4	f/5.6	f/8	f/11	f/16	f/22
Comparative exposure factors	1	2	4	8	16	32	64	128	256	512

Diaphragm opening gets larger
Stop numbers get smaller
Sharpness in depth decreases
Exposure time decreases
Groundglass image brightens

Diaphragm opening gets smaller
Stop numbers get larger
Sharpness in depth increases
Exposure time increases
Groundglass image darkens

The ratio between exposures at different f-numbers is equivalent to the ratio of the f-numbers multiplied by themselves.

For example, the ratio of, say f/3.5 to f/8 is equal to (3.5 x 3.5) : (8 x 8) which is equivalent to 12.25 : 64 or 1 : 5.22. Therefore, if an exposure of 1/100 sec. at f/3.5 is correct, but for greater extension of sharpness in depth the lens must be stopped down to f/8, the exposure must be increased by a factor of 5.22 (1/100 sec. x 5.22 equals approximately 1/20 sec.) to get a negative with the same density or a transparency with the same color.

F-numbers are indicators of the brightness of the image on the groundglass or on the film. The same f-number, say 5.6, indicates *for most practical purposes* (because there are slight but normally negligible differences due to manufacturing tolerances and also differences in the construction of lenses) the same brightness of the image, no matter whether the image is produced by an f/5.6 lens "wide-open," or by an f/1.4 lens stopped down to f/5.6. Nor does it make much difference whether the lens is a huge telephoto lens for a 5 x 7-inch "Big Bertha" or a tiny wide-angle lens for a 35 mm camera. As long as each has a relative aperture of, say, f/5.6, or is stopped down to f/5.6, there is virtually no difference between the two as far as image brightness is concerned.

However, in cases in which highest accuracy is desirable as, for example, in motion-picture work where intercutting is used, all differences can be eliminated by calibrating lenses by a relatively new method based upon actual light transmission rather than theoretical computations, the T-stop system ("T" stands for "transmission"). This method accurately measures and takes into account all light losses due to reflection and absorption. As a result, T-stops of identical numbers always indicate identical degrees of brightness, whether the lens consists of two thin or ten thick individual components. Unfortunately, this method of lens calibration has not been accepted by lens manufacturers, but there are laboratories that will recalibrate f-stops to T-stops.

Lens speed and close-up

The value of a specific f-stop is *not* absolute but changes in proportion to changes in the distance between lens and film. This, of course, is to be expected since this distance (in the form of the focal length of the lens) plays a decisive role in establishing the light-transmitting ability of the lens at full aperture as well as at any f-stop. As explained before, the focal length signifies the distance between lens and film when the lens is focused at infinity—the shortest distance at which it will produce a sharp image. When the subject is *not* at infinity but closer, the distance between lens and film must be increased correspondingly to bring the subject into focus and render it sharp in a picture. However, when the distance between lens and film is greater than the focal length of the lens, the formula according to which the speed of the lens was computed is obviously no longer valid; and the result is that the *true* value of the lens aperture (in contrast to its value *indicated* by the f-stop number engraved on its mount) decreases: *as the distance between lens and film increases, the lens becomes increasingly slower,* whether used at its maximum aperture or stopped down. To be precise, its speed decreases inversely proportional to the square of the distance between lens and film.

Minor increases in the lens-to-film distance can be disregarded because the corresponding loss in lens speed is so small that it is absorbed by the exposure latitude of the film. But the closer the camera is to the subject, the greater the distance required between lens and film to bring the subject into focus, and beyond a certain point, the loss in lens speed cannot be ignored because underexposure of the film would result. This point arrives *when the distance between subject and lens becomes shorter than approximately five times the focal length of the lens.*

In close-ups, how much the exposure determined with an exposure meter must be p. 309

increased—the factor by which it must be multiplied—depends on the lens-to-film distance after focusing. It can be computed by using the following formula:

$$\frac{\text{lens-to-film distance}}{\text{focal length of lens}} \times \frac{\text{lens-to-film distance}}{\text{focal length of lens}} \quad \text{or} \quad \left(\frac{D}{F}\right)^2$$

For example, a photographer wishes to make a close-up, using a lens with a focal length of 6 inches. After focusing, the distance between lens and film measures 10 inches. He can find the corresponding exposure factor by using the following equation:

$$\frac{10 \times 10}{6 \times 6} \quad \text{equals} \quad \frac{100}{36} \text{ , or approximately 3}$$

This means that he must expose the subject three times as long as his exposure meter indicated to get a correctly exposed negative or transparency. If the meter indicated an exposure of one second at f/32, he now must multiply this time by a factor of 3, and instead of one second he must expose the subject for three seconds at f/32.

A practical aid for immediate determination of the exposure factor for close-ups is the Effective Aperture Kodaguide published by Kodak. It is a card with an attached dial that, after proper setting, gives both the effective aperture and the respective exposure factor and the scale of reduction or magnification of the image on the film.

Covering power

The covering power of a lens determines whether it can or cannot be used with a specific negative size. The greater the covering power of a lens, the relatively larger (relative in comparison to the focal length of the lens) the size of the negative it will cover evenly and sharply from corner to corner.

Covering power has very little to do with focal length. A lens with a long focal length may have very little covering power, and vice versa. For example, most 135-mm telephoto lenses designed for use with 35-mm cameras will only cover a 1 x 1½-inch negative, whereas there are several 90-mm wide-angle lenses that will cover a 4 x 5-inch negative.

Most lenses produce a circular image whose quality in terms of sharpness and evenness of light distribution is not uniform: it is always sharpest and brightest

A new form of seeing. Drawing inspiration from Marcel Duchamp's famous painting "Nude descending a staircase," *Gjon Mili* used repetitive electronic flash to show by means of multiple exposure the rhythmic flow of motion as a young woman walks down some steps.

More on pp. 304 and 328

Imaginative use of color. In this photograph from an essay on Isaac Newton, *Erich Lessing* enlivened the drabness of a page from one of Newton's notebooks by suffusing it with the rainbow hues of the spectrum

produced by a prism suspended outside the field of view of the lens. Color serves here both as a symbol (Newton's discoveries in regard to the nature of light) and as a device to attract the reader's attention.

More on pp. 271 and 333

91

Graphic impact. An outstanding example of good composition, *Provocative Girl* by *Al Francekevich* (Courtesy of *Popular Photography*) derives its effect from the bold use of black and white

and from the arrangement of the figure which, contrary to academic tra-
dition, faces away from the center of the photograph. As a result, the girl
appears to walk right out of the picture, daring the observer to follow her.

More on pp.
282 and 305

Color in portraiture. Two photographs by *Robert Freson* show how color can lend added significance to a portrait. In the left picture, the lacquer red forms, suggesting Chinese characters by their shape

and color, accentuate the Chinese ancestry of the girl. And in the right picture, related greens and blues, culminating in the brilliant blue of the eyes, add up to a vivid portrait of an English miner.

More on pp. 56, 271 and 272

Portraits of professionals, by *Andreas Feininger.* In portraiture, it is sometimes possible to add greater significance to the picture by including subject matter related to the occupation of the

depicted person. Here, the oxygen mask of the fighter pilot and the unmistakable shape of the sculpture by Alexander Calder give added meaning to the picture by relating the man to his work.

More on pp. 43, 283 and 333 to 338

Motion symbolization. Motion is an intangible quality which, in a photograph, can only be expressed in symbolic form. Here, *John Bryson* used the technique of panning to express speed with photo-

graphic means as two dragsters race down the course. In this case, the impression is similar to that received by the eye following the racers: they appear sharp while the background appears blurred. *More about this on pp. 49, 299 and 302*

Motion symbolization. Picasso "painting" with a flashlight, photo-
graphed by *Gjon Mili*. Combination of time and flash exposure
results in a rendition which, though perfectly sharp, implies motion.

Motion symbolization. Children on a swing, photographed by *Hugo Lundberg.* Blur—the result of panning in conjunction with a relatively slow shutter speed—expresses action and vibrant life.

More on pp. 299 and 303

Motion implied. To express symbolically their soaring upward thrust, *H. Landshoff* made this multiple exposure of Manhattan's midtown towers by raising the lens of his view camera exactly the same

amount after each shot. The golden glow of the rising sun seems to turn the buildings into ingots of gold—a city of promise and opportunity. Color, creatively used, adds meaning to the picture.

More on pp. 271, 304 and 328

More on pp. 305 and 333

Creative use of grain. Better than a slick rendition, the coarseness of the negative grain expresses the grime and exhaustion in the face of this football player photographed by *Al Francekevich*.

near the center, becoming progressively less sharp and bright toward the rim of the circle. For photographic purposes, of course, only the inner part of the circle is of use. For this reason, the negative size must always fit within the useful part of this circle, the diameter of which must never be smaller than the diagonal of the negative.

The covering power of most lenses is just sufficient to sharply cover the negative size for which they are designed. This is satisfactory when such lenses are used in cameras without independent front and back adjustments (swings, slides, and tilts). However, *lenses intended for use in cameras with such adjustments must have greater than average covering power.* Otherwise, use of these adjustments will cause part of the film to be outside the sharply covered circle, and that part will be rendered unsharp or blank. To avoid this, it is advisable, instead of using a standard lens designed for the respective negative size, to *use a wide-angle lens of equal focal length designed to cover the next larger film size.* For example, with a 4 x 5-inch view camera, instead of using the regular 6-inch standard lens, use a 6-inch wide-angle lens designed to cover 5 x 7-inch film—the next larger size. The focal length of both lenses would be identical—producing images of identical scale —but the additional covering power of the 6-inch wide-angle lens would permit the photographer to make fullest use of the swings, slides, and tilts of the view camera. pp. 78, 287

The covering power of most lenses increases somewhat as the diaphragm is stopped down. In certain lenses (for instance, the Goerz Dagor), this increase is so great that the fully stopped down lens will cover a negative one size larger than the size it covers at full aperture, making such lenses particularly suitable for use with swing-equipped cameras.

The covering power of any lens increases in direct proportion to increases in the distance between lens and film. This phenomenon is especially useful for the making of close-up photographs in near-natural, natural, and more than natural size. When the available focusing range of a camera is not sufficient to allow the necessary lens-to-film distances required for such close-ups with a standard lens, the problem may be solved by using a lens with a shorter focal length. With a 4 x 5-inch camera, lenses of 1 to 3 inches in focal length are particularly good for close-up photography. For example, a lens with a focal length of 1 inch, designed to cover nothing larger than a 16-mm motion picture frame, will sharply cover a 4 x 5-inch negative at a distance of 10 inches from the film, and produce an image in nine times natural size. p. 309

LENS QUALITY AND PERFORMANCE

The performance of any lens depends on five factors:

> The degree of sharpness
> The degree of color correction
> The degree of flare and fog
> The evenness of light distribution
> The degree of distortion

Sharpness

The degree of sharpness which a lens is capable of producing depends on the degree to which the lens designer was able to correct the five main faults (abberations) inherent in any lens design: spherical and chromatic aberration, curvature of field, astigmatism, and coma. What these terms mean, or how these faults can be corrected, is immaterial here. What *is* of practical value to any photographer is the following:

Sharpness is essentially incompatible with high lens speed and great covering power: the higher the speed, or the larger the angle of view encompassed by a lens, the more difficult it is to satisfactorily reduce its inherent faults to an acceptable level. As a result, *the sharpest lenses are almost always characterized by limited covering power and relatively slow speed.*

At full aperture, most lenses produce negatives in which sharpness is unevenly distributed: sharpness is greatest in the center, decreasing toward the edges and corners. The most common cause of uneven distribution of sharpness is curvature of field which manifests itself in an image that is not flat (like the plane of the film) but concave—three-dimensionally curved like the inside of a saucer (we say the lens does not have a flat field). This fault, which is quite common in high-speed lenses at full aperture, is most obvious in head-on shots of flat subjects (a brick wall or a page of newsprint) but—and this is important—it is much less noticeable in pictures of subjects that have depth. Photographers not familiar with this fact frequently reject otherwise fine lenses because they perform poorly when subjected to the traditional test: a photograph of a brick wall or a page of newsprint. The *practical* value of such lenses, however, is determined by the degree of sharpness in the center of the image at full lens aperture (the sharper, the better), the amount of stopping down (the less, the better) needed to produce even distribution of sharpness, and the degree of sharpness of the image made by the lens moderately stopped down.

The sharpness of almost any lens improves as the diaphragm is stopped down, usually reaching an optimum two to four stops beyond the maximum aperture of the lens. Beyond this, sharpness remains more or less constant up to a point at which it declines again, although sharpness in depth, of course, continues to increase the more the diaphragm is stopped down. If the diaphragm aperture were to be made excessively small, sharpness would radically deteriorate through light refraction and the entire picture become fuzzy.

Ordinary photographic lenses are computed to produce maximum sharpness at average subject distances (somewhere between 10 and 50 feet). Aerial lenses are corrected for maximum sharpness when focused at infinity. Lenses specifically designed for copy work—process lenses—are computed for maximum sharpness at distances of a few feet. And special close-up lenses—for example, the Bausch & Lomb and Carl Zeiss Micro-Tessars and Luminars—are corrected to perform best at subject distances measured in inches.

Resolving power

The ability of a lens to distinctly record a certain number of lines per millimeter, is, in my opinion, the least reliable indicator of lens sharpness. Meaningful evaluation of a test designed to establish the resolving power of a lens is very difficult because too many factors are involved: the contrast gradient and graininess of the film used, the exposure, the method of film development, and last but not least, the personal opinion of the one who evaluates the test.

Color correction

Light of different wave lengths (color) is not uniformly bent (refracted) by glass. As a result, a simple lens (such as a magnifier or positive spectacle lens) produces an image in which different colors located at the *same* distance from the lens are brought into focus at *different* distances behind the lens. If such lenses were used in photography, they would produce pictures that are unsharp in black and white and fringed with bands of color in color photography.

All photographic lenses are color-corrected to some extent, the degree varying with the design of the lens. There are two groups: achromatic lenses which are corrected for two spectral colors (usually blue and green), and apochromatic lenses which are corrected for three spectral colors (blue, green, red). Achromatic lenses, the group to which most modern photographic lenses belong, are sufficiently color-corrected for average black-and-white and color photography. But for critical purposes—top-quality color photography for purposes of reproduction, the mak-

ing of color separations for color prints, and photo-engraving—only apochromatic lenses will give satisfactory results.

Flare and fog

Not all the incident light that is transmitted by a lens reaches the film in the form of an image. Some of it is reflected by the surfaces of the lens elements, the inside of the lens mount, or the inside of the camera, bounced back and forth inside the lens, and eventually falls on the film in the form of flare and fog.

Flare manifests itself as light-spots on the negative which can have almost any size and shape but are most frequently circular, crescent-shaped, oval, or repeating the shape of the diaphragm aperture. Their origin is a light source within (and sometimes outside) the field of view of the lens. Flare is the reflected and distorted image of this light source.

Fog, which is in effect over-all flare, degrades a negative by lowering its contrast: areas which should have been perfectly transparent because they should have received no light have a more or less pronounced density from being exposed to light scattered within the lens.

p. 83 The higher the speed of a lens, the more glass-to-air surfaces it contains, and the more sharply curved its elements, the greater the likelihood that it will produce flare and fog. The modern practice of antireflection-coating all photographic lenses has greatly reduced (although not entirely eliminated) this danger, but many "old-fashioned" lenses are subject to this fault.

Evenness of light distribution

Almost all lenses deliver proportionally less light to the edges of the negative than to the center. In lenses of moderate covering power this illumination fall-off is p. 88 usually insignificant and can be ignored. But the greater the covering power of a lens, the greater, as a rule, the difference in the amount of light received by the center of the film and the edges, the discrepancy reaching a maximum in extreme wide-angle lenses. (In the Goerz Hypergon wide-angle lens which covers an angle of view of 140 degrees, this unevenness of light-distribution is so pronounced that these lenses had to be equipped with a star-shaped spinner driven by an air pump. Mounted in the center of the lens, the function of this spinner is to keep the light off the center of the film during part of the exposure to give the edges sufficient exposure without overexposing the center).

Uneven light distribution manifests itself in prints and transparencies as edges, and

particularly corners, that are darker than the center. In black-and-white photography, uneven light distribution can usually be corrected during enlarging by dodging—exposing the center of the print for a longer time than the corners. However, photographers who work with reversal-type color films have no such p.120 remedy and they are advised not to use lenses that produce markedly uneven light distribution.

Distortion

This lens fault, which is inherent in many wide-angle and zoom lenses (not to be pp. 111, 113 confused with so-called wide-angle or perspective distortion which will be dis- p. 315 cussed later), manifests itself by reproducing straight lines as curves. The farther the image of the straight line from the center of the picture (where straight lines are rendered straight), the more pronounced the effect. There are two different types of distortion: pin-cushion distortion and barrel distortion. In the first, a square appears as if its sides were curving inward; in the second, as if they were bulging.

HOW TO SELECT YOUR LENS

Most cameras are sold complete with lens. This might seem to make a special chapter on lens selection superfluous. But many cameras are available in different models equipped with different types of lenses from which a choice must be made. In addition, many cameras provide for interchangeability of lenses, and sooner or later the owner of such a camera will wish to buy another lens for work that is beyond the scope of the original lens.

Suitability

Neither performance, speed, brand name, nor price is of the slightest importance if a lens is not suited to the particular work to be done. A lens can be excellent and yet, *because it is unsuitable,* be of less use than a much cheaper lens which is suitable.

A mistake constantly made, in particular by amateurs, is the buying of a lens that is unnecessarily fast. Either they are motivated by snobbishness or they believe that "speed" is a valuable reserve. They forget, or don't know, that fast lenses have p. 83 serious disadvantages: aside from being bigger, heavier, and much more expensive than slower lenses of the same focal length, many are also less sharp when stopped down to comparable diaphragm stops. Since the overwhelming majority of photographs are taken with the lens stopped down to f/3.5 or more, a very fast lens is, as a rule, not a necessity.

Second-hand lenses

A good way to save money on lenses is to buy them second-hand. Lenses don't wear out with use and, properly treated, a ten-year-old lens is as good as a new one that costs twice as much. Some of my favorite lenses for my large cameras —Zeiss Tessars, and Tele-Tessars f/6.3 in different focal lengths—are thirty to forty years old and, as far as sharpness is concerned, still unsurpassed. The only part of a lens that can wear out is the shutter. But lenses for small cameras don't usually have built-in shutters, and good lenses for large cameras are always mounted in good shutters which, if necessary, are worth cleaning, adjusting, or repairing. Generally, the cost of a second-hand lens plus shutter repair is still considerably lower than the cost of a comparable lens that is new.

Lenses for different purposes

According to their purpose, lenses can be divided into the following groups:

Standard lenses High-speed lenses	— standard focal length
Wide-angle lenses	— short focal length
Process lenses Soft-focus lenses	— medium focal length
Telephoto lenses	— long focal length
Zoom lenses Convertible lenses Auxiliary lenses	— variable focal length

p. 82
p. 88 **Standard lenses** have a focal length more or less equal to the diagonal of the negative they must cover, moderate covering power encompassing an angle of view that ranges from 55 to 60 degrees, and speeds that range from around f/2.8 (35-mm and 2¼ x 2¼-inch cameras) to f/5.6 and slower (larger cameras). Their design comprises good sharpness with reasonable covering power and fairly high speed.

The standard lens is the photographer's "work horse," the lens most suitable for the greatest number of different tasks.

High-speed lenses are similar to standard lenses in focal length and covering p. 83 power but are superior in speed though often inferior in sharpness. Designwise, they emphasize speed. To achieve speed, other qualities had to be sacrificed: in

110

comparison to standard lenses, high-speed lenses are considerably bigger, heavier, more expensive, often less sharp at comparable diaphragm stops, and subject to flare and fog. At present, the fastest, generally available lenses for 35-mm cameras have relative apertures ranging from f/0.95 to f/2.5.

High-speed lenses are, in my opinion, not suited to general photography and should be used only when their full inherent speed is needed: when illumination is marginal, when highest shutter speeds must be used, or when it is desirable to keep the sharply covered zone in depth very shallow.

Wide-angle lenses are specialized designs that emphasize covering power. To achieve this, other qualities had to be sacrificed: their speeds are moderate to slow (although fast wide-angle lenses have lately been designed for use in 35-mm cameras); their light distribution is uneven with more or less marked fall-off toward p. 108 the edges of the picture; and most of them are subject to distortion, i.e., straight lines may be rendered slightly curved, increasingly so the farther away they are from the center of the picture. The angle of view encompassed by ordinary wide-angle lenses ranges from slightly larger than that of a standard lens to a maximum of 100 degrees. In addition, there are two wide-angle lenses that have considerably greater coverage: the 8-mm f/8 Nikkor Fisheye lens which covers an angle of view of 180 degrees and produces pictures in which perspective is "spherical," p. 316 i.e., most straight lines appear as curves; this lens can only be used in the 35-mm Nikon F SLR camera. And the 65 and 75-mm Goerz Hypergon lenses which cover an angle of view of 140 degrees and produce pictures in which perspective is rectilinear (straight lines are rendered straight); these lenses are designed for use p. 285 with 5 x 7- and 8 x 10-inch film.

Wide-angle lenses should be used only when the distance between subject and camera is so short that a standard lens would render only part of the subject, or when the effect of wide-angle perspective is desired. p. 315

Process lenses are specialized lenses with emphasis on sharpness. To achieve this, other qualities had to be sacrificed: process lenses are relatively slow (with a maximum aperture of f/9); they have comparatively little covering power (their focal length is always longer than the diagonal of the negative they must cover); and they are relatively expensive. Process lenses are computed for maximum sharpness at near distances and they have an unusually flat field, i.e., particularly even distribution of sharpness over the entire negative.

Process lenses are unrivaled for making reproductions of two-dimensional subjects.

If there is no objection to their slow speed, they are also excellent for commercial photography (particularly color) and, if cameras with sufficiently long bellows extensions are used, for close-ups.

p. 309

Soft-focus lenses produce images that are neither sharp nor unsharp in the ordinary sense of the word. They produce a rendition in which a fairly sharp nucleus is surrounded by a halo of unsharpness, an effect that is most pronounced and beautiful in backlighted shots. This is an "old-fashioned" type of lens which, however, still ranks high with some pictorialists. Typical representatives are the Rodenstock Imagon lenses (which permit control of the degree of softness from sharp to very diffused) designed for use in 2¼ x 2¼-inch and larger cameras; and the Thambar lens for the Leica. Auxiliary soft-focus devices are also available which, used with a standard lens, temporarily transform it into a soft-focus lens.

p. 261 Soft-focus lenses are most suitable for backlighted shots in which contrast is high, and for portraiture if a diffused effect is desired. They are totally unsuited to general photography and in the hands of a tyro, an invitation to disaster.

Telephoto lenses are specialized designs that emphasize image magnification. Used from the same camera position as a standard lens, a telephoto lens shows less subject area, but what is shown is rendered in correspondingly larger size. They are unique insofar as they require less extension when focused at infinity than their focal length indicates. For example, a Zeiss Tele-Tessar of 32 cm focal length, focused at infinity, requires a bellows extension of only 20 cm as compared to the 32 cm required by a lens of ordinary design of the same focal length. This compactness, of course, gives telephoto lenses a valuable practical advantage over ordinary lenses of equal focal length (long-focus lenses), but it is partly cancelled by two disadvantages: in comparison to ordinary long-focus lenses of equal focal length, telephoto lenses cover only a much narrower angle of view and thus can be used only with correspondingly smaller negative sizes; and some telephoto lenses are less sharp.

Telephoto lenses designed for use with 35-mm and 2¼ x 2¼-inch cameras are available in focal lengths ranging from approximately 85 mm to 2000 mm (approximately 80 inches) and longer.

Telephoto lenses are used when distance between subject and camera is so great that a lens of standard focal length would render the subject too small or when

p. 60 the special effect of a telephoto perspective is desired.

Monoculars, a special type of telephoto lens, are one-half of an ordinary prism-

binocular. Their focal lengths range from somewhere around 350 to 3000 mm (approximately 120 inches). As their focal lengths increase, the value of their respective apertures decreases proportionally with the result that a monocular may have a speed of, say, f/12.7 at a focal length of 750 mm and f/50 at a focal length of 3000 mm. In comparison to good telephoto lenses, monoculars are less sharp. On the other hand, they are much more compact and, particularly in the longer focal lengths, their weight and cost is only a fraction of that of telephoto lenses of comparable focal lengths.

Catadioptric lenses, a relatively new type of telephoto lens, are mixed lens-mirror systems which use the principle of the reflecting telescope and employ a parabolic mirror as the main component of their design. Advantages are extreme compactness and lightness; for example, the Field Model Questar (see below) weighs only 2 pounds 14 ounces as compared to the 40 to 50 pounds of a comparable telephoto lens of conventional design. The disadvantage of this design is that it prohibits use of a diaphragm. As a result, all pictures must be taken at full aperture, exposures must be regulated either by the shutter speed or a neutral density filter, and the sharply rendered zone in depth is extremely shallow.

Catadioptric lenses range in focal length from 500 mm (20 inches) to 150 inches and more. The ultimate in catadioptric lenses is the Questar, a variable-focus telescope for use with 35-mm SLR cameras. With the Questar and an 80x eyepiece, magnification equivalent to a focal length of 31 feet can be achieved. At this scale, the moon would be 2 feet in diameter.

Zoom lenses are unique inasmuch as they have *variable* focal lengths which permit a photographer to make quick transitions from over-all to close-up shots without moving the camera. Depending upon the respective lens design, their maximum focal length is two or three times as long as their minimum focal length. For example, by using only three Nikkor-Zoom lenses with focal lengths of 43-86, 85-250, and 200-600 mm, respectively, a photographer can cover every focal length between 43 and 600 mm.

Unfortunately, this advantage is partly offset because, in comparison to most other lenses of corresponding focal lengths, zoom lenses are somewhat less sharp, considerably larger and heavier, and subject to distortion which makes straight lines p. 109 appear slightly curved in the photograph, increasingly so the farther they are from the center of the picture.

Convertible lenses combine two or three fixed focal lengths within one unit. For

example, the Cooke Convertible Series XV, an asymmetrical convertible lens, has a focal length of 12½ inches at f/6.8; used alone, its front and rear elements have focal lengths of 26½ and 19 inches at f/16 and f/12.5, respectively. If a convertible lens is symmetrical in design, its front and rear elements each have twice the focal length and one-quarter the speed of the complete lens. These "old-fashioned" convertible lenses are suitable for use only with large groundglass-equipped cameras.

A modern type of convertible lens designed for use with 35-mm SLR and reflex-housing-equipped RF cameras is the German Novoflex Fernobjektiv. It consists of a negative rear element that can be combined with either one of two different, positive front elements, the combination having focal lengths of 400 mm at f/5.6 and 640 mm at f/9, respectively.

Auxiliary lenses are designed to be attached to the front of ordinary lenses; they shorten or increase the focal lengths of these lenses. In comparison to good lenses of equivalent focal lengths, the combination of an ordinary lens and an auxiliary lens is somewhat inferior in sharpness, a disadvantage that can be mitigated or eliminated by stopping down the lens. This shortcoming is offset by the fact that most auxiliary lenses cost only a fraction of the price of an additional lens with a focal length that corresponds to the combination of auxiliary lens and regular lens.

Auxiliary lenses are designed primarily for use with cameras (including TLRs) equipped with fixed lenses with which they provide, to a limited degree, the advantages of lens interchangeability; they can, of course, also be used with interchangeable lenses.

Auxiliary lenses of recent and greatly improved design are the two Mutars designed for use with Rolleiflex cameras 6 x 6 cm. One Mutar provides a 1.5 increase, the other a 0.7 reduction, in the focal length of the taking and viewing lenses. Their performance is much higher than that of other auxiliary lenses, and so is their price.

Another type of auxiliary lens is the focal length extender that fits between the body of a 35-mm SLR camera and any lens that can be used with this camera except a wide-angle lens. Depending upon the design, it increases the focal length of a lens by a factor that varies from 1.85 to 4, with a corresponding reduction in the effective f-stop value. For example, an extender with a factor of 1.85 transforms a 135-mm lens into a 250-mm lens. The resulting definition is acceptable for average purposes.

THE FILM

Modern films are produced in a great variety of different types, each designed for a specific purpose. However, different types of film can be classified as variations of the following basic qualities:

Type and base
Size
Color sensitivity
Speed
Definition
Gradation

Once a photographer is familiar with these qualities, he will be able to evaluate any type of film and determine which is best for his kind of work.

TYPE AND BASE

Film is available in four different types which have the following characteristics:

Rollfilm and 35-mm film. Long strips of film wound on a spool containing material for six to thirty-six or more exposures, depending on the size of the individual negative, the type of camera, and the capacity of the film magazine.

Rollfilm and 35-mm film is the most practical type of film. It is easily loaded in daylight and easier to use and process than any other type. Disadvantages: individual shots cannot be processed individually (which makes it inadvisable to photograph very different subjects together on the same roll); impossibility of changing from one film type to another (for example, from black and white to color) in the middle of a roll without sacrificing the remaining film (unless the camera provides for interchangeability of backs, or an accessory rollfilm adapter can be used).

Filmpack. Sixteen individual sheets of film (Kodak) on a thin base packed flat in a container called a "cassette." Available only in a few black-and-white emulsions but not in color. Most common sizes are 4 x 5 and 3¼ x 4¼ inches. Filmpack combines the ease of handling of rollfilm with the advantage that individual shots may be processed individually and exposed sheets may be taken from the pack without sacrificing the remainder. It can be loaded and unloaded in daylight, and change to another type of black and white or a change to color sheet film is possible without sacrificing unexposed film. Disadvantages: filmpack is the most expensive form of negative material, dampness may cause the film to buckle out of the plane of focus and produce partly unsharp negatives.

Sheet film. Individual sheets of film on a relatively heavy base. Available in a large variety of different emulsions, including color, and in sizes ranging from 2¼ x 3¼ inches to 8 x 10 and larger. Individual shots may be processed individually.

Sheet film is less expensive per exposure than filmpack and usually stays flatter in the holder. This makes it preferable for use with lenses of great focal length or high speed when flatness of film is most critical. Disadvantages: film must be loaded in the darkroom one sheet at a time; each holder takes only two sheets, one on each side (the Grafmatic rapid-change film magazine holds six sheets of film); weight and bulk—film and holders for only a dozen shots take almost as much space as the camera.

Glass plates. Now only used for diapositives (positive transparencies for projection), color separation negatives (where dimensional stability is important), photo-engraving, and scientific purposes.

SIZE

Different sizes of film have different advantages and disadvantages. For those photographers who still have not decided whether to buy a large, medium, or small camera, the following summary may be of aid in making a choice:

Large film sizes have the following advantages over smaller sizes:

Sharper pictures because large negatives need proportionally less magnification during enlarging than small negatives.

Better tone values, smoother transitions, and less danger of film grain, because degree of enlargement is usually low.

Higher effective film speed because standard developers can be used. In comparison to many fine-grain developers, these developers do not demand increases in exposure.

Compositional advantages. Because film size is large, relatively small sections of a negative can be enlarged to become effective pictures—a simple substitute for a telephoto lens. Cutting off superfluous subject matter strengthens the composition and increases the impact of a picture.

Processing and printing are easier. Specks of dust and small scratches do not show nearly as much as in enlargements made from smaller negatives where magnification is much higher. "Spotting" and retouching is much easier.

116

The sales appeal of large color transparencies is higher than that of small ones.

Against these advantages, the following disadvantages must be weighed:

Higher cost per exposure.

Bulk and weight. Two sheets of 4 x 5-inch film in a holder take about as much space, and weigh as much, as material for one hundred shots on 35-mm film.

Larger, heavier, and more conspicuous cameras are, of course, needed for larger film sizes. Slower operation restricts the photographer's choice of subject.

Small film sizes have the following advantages over larger sizes:

Lower cost per exposure.

More pictures can be taken of each subject since film cost is relatively low. This insures more complete coverage and reduces the danger of missing important shots.

Cameras are compact and light and therefore permit inconspicuous and fast shooting.

Lenses of much higher speed are available for small cameras than for large cameras.

Superior sharpness in depth at any given diaphragm stop because lenses of shorter focal lengths cover the smaller film sizes.

35-mm film for a hundred exposures takes less space than a package of cigarettes.

Against these advantages, the following disadvantages must be weighed:

Inferior sharpness of the picture.

Inferior tonal gradation caused by higher negative magnification which makes the film grain apparent.

Lower effective film speed because slow fine-grain films or speed-reducing fine-grain developers must be used if grainless prints are desired.

More critical processing because higher magnification emphasizes specks of dust and small scratches, etc.

The sales appeal of small color transparencies is lower than that of larger ones.

A large film size (4 x 5-inch) is recommended for those who specialize in static subjects, the deliberate worker, the perfectionist who insists on highest technical quality and has great feeling for sharpness, texture, and detail.

A small film size (35-mm) is recommended for those with quick temperaments, the fast impulsive worker, the reporter who looks for action rather than technical quality, and the traveler who wishes to travel light.

A medium film size (2¼ x 2¼- or 2¼ x 3¼-inch) is recommended for the majority of photographers and particularly for beginners.

COLOR SENSITIVITY

Black-and-white films

In black-and-white photography, subject colors are, of course, translated into shades of gray. To obtain pictures that look as natural as possible, the brightness p. 276 values of these gray shades must normally (though not always, as we will see later) correspond as nearly as possible to the brightness values of the colors they represent. For example, yellow, a light color, must be rendered as a lighter shade of gray than blue which to the eye appears darker. To translate colors into specific shades of gray, black-and-white films are color-sensitized. Response to color, however, varies considerably, depending on the sensitizing of the film. In this respect, one must distinguish between four main groups of black-and-white films with the following characteristics:

Blue-sensitive films which contain no color-sensitizing dyes, are sensitive only to the blue and ultraviolet components of "white" light and are "blind" to all other colors. They render blue (or any color containing blue) too light, and they render red, orange, and yellow as black. For ordinary photographic purposes these films are, of course, completely unsuitable.

Orthochromatic films are sensitive to green and yellow in addition to blue and ultraviolet but insensitive to red. In the form of sheet films, they are primarily used in certain types of industrial photography (particularly if the subject contains large masses of dark or black areas, machinery, etc.), and in portraiture for photographing men.

Panchromatic films are sensitive to all colors and ultra-violet, although they differ somewhat in their response; those that have a relatively high sensitivity to green are sometimes referred to as Type B, and those that are especially sensitive to red, as Type C, panchromatic films.

Because panchromatic films are sensitive to all colors, they must be developed in p. 184 what amounts to total darkness (a very weak, dark green, over-all darkroom illu-

mination is permissible) by the time-and-temperature method. Since sensitivity to p. 195 all colors is a most desirable quality, panchromatic films are the best general purpose films.

Infrared films have panchromatic emulsions whose sensitivity to red has been ex- p. 129 tended beyond the visible spectrum into the infrared. Since infrared has extraordinary haze-penetrating power, infrared films are primarily used in aerial and telephotography. Other common uses include law-enforcement, criminology, detection of forgeries, and fake moonlight scenes shot in daylight. Infrared film is not suitable for general purposes because of the unnatural way in which color may be rendered. For example, it renders blue water and blue sky dead-black, while green foliage and grass appear snow-white. These strange forms of rendition, however, are determined not by actual subject color but by whether the subject reflects or absorbs infrared radiation. Since infrared radiation is invisible, there is no way to predict how light or how dark a color will appear when photographed on infrared film. Blue water and blue sky appear black in infrared pictures, *not* because they are blue, but because they strongly absorb infrared; and foliage and grass appear white, *not* because they are green, but because chlorophyll strongly reflects infrared radiation.

Because infrared emulsions are also sensitive to visible light, it is necessary to use special filters to get the typical infrared effect; these filters will be discussed later. p. 142 Used without filters in daylight, infrared sensitized films produce pictures very similar to pictures taken on contrasty panchromatic film. If infrared film is used in darkness in conjunction with infrared flashbulbs a filter is not needed.

Because the wavelength of infrared radiation is longer than that of visible light, the image produced by it lies at a greater distance from the lens than that produced by visible light. Therefore, to insure sharpness of the infrared image, ordinary photographic lenses must be moved forward slightly after focusing. The average increase in distance between lens and film is one-quarter of one percent of the focal length of the lens, although this varies somewhat depending on the lens design. Some lenses intended for use with 35-mm and 2¼ x 2¼-inch cameras have special infrared markers (usually, a red line marked by an "R" or a red dot). To make a photograph by infrared radiation using an infrared filter (either in front of the lens or in front of the lamp), focus visually, note the subject distance that the regular footage scale indicates, then turn the focusing ring until this point is opposite the infrared marker on the lens mount.

COLOR FILMS

There are two different groups of color films:

Reversal color films. These yield positive color transparencies suitable for direct viewing, projection by transmitted light, and reproduction by photo-mechanical methods. They can also be used to make color prints on paper, although, at present, negative color films are preferable for this purpose. Their advantages and p. 38 disadvantages over negative color films were discussed before.

Negative color films. These yield color negatives in the complementary colors of the subject. Like ordinary black-and-white negatives, such films must be printed before they yield finished pictures. The advantages and disadvantages of this type p. 38 of color film were discussed before.

The balance of color films

Color films are made with different types of emulsions, each emulsion designed to produce optimum color reproduction when exposed to one specific type of light. Unless a color photograph is made on the appropriate type of film—the type which is "balanced" for the light in which the picture is made—the color of the finished picture will *not* correspond to the color of the subject as it appeared to the eye in white daylight.

pp. 252-257 As we will see later, there are many different types of light in which color pictures are likely to be made, each with its own color (spectral composition). To be sure that color pictures taken at least in the most common of these types of light have colors that appear natural, color films are made in three different types:

pp. 256, 151 **Daylight type** color film for use with daylight and speedlight.

p. 146 **Type A** color film for use with amateur photoflood lamps of 3400 K.

p. 146 **Type B** color film for use with professional tungsten lamps of 3200 K.

(NOTE: No brand names of color films are given because changes in designation, color response, and film speed are made so frequently that data of this kind becomes obsolete in a relatively short time. Consult your photo dealer for the latest information.)

The response of color films to different kinds of light can be changed through the pp. 138-141 use of filters. This makes it possible to produce acceptable color rendition on, for example, daylight type color film when pictures are taken in photoflood illumination, or when a Type B color film is used with daylight. However, such conversions

should normally be avoided because they involve a loss of film speed (the conversion filter absorbs a certain amount of light) and because the color rendition is often not as good as it is when a color film specifically designed for the respective type of light is used. Specific information on color conversion filters will be given later.

Mode of processing

At the time of writing, two groups of color films exist: films requiring highly complicated processing techniques that can *only* be processed by the film manufacturer or an authorized color lab and films that can also be processed by the photographer. If you wish to process your films, consult your photo dealer to be sure you get the right type of film.

The variables

Variations in color balance and in speed of color films of the same brand and type are unavoidable despite controls used in manufacture and tests given the finished film. In addition, other often even more serious deviations from standard are caused by unsuitable storage before and after exposure and particularly by variations in the processing of color films. Together, these may cause greater changes in color rendition than those changes caused by normal fluctuations in the quality of the light for which the film is balanced. Therefore, use of corrective filters would be illusory unless the photographer first establishes the extent of the *unavoidable variables* and corrects them by suitable means, and eliminates the *avoidable variables* by correct storage, handling, and processing of his film. To do this, he must consider the following:

Variations due to manufacture. These are generally greater in emulsions from different batches than in films that have the same emulsion number. Film emulsion numbers are stamped on the film boxes and embossed on the margins of sheet films. When a series of related pictures must be taken, it is good practice to use film of the same emulsion number to minimize variations in color rendition.

The only way to find out if color film conforms to standard—and if not, the extent to which it deviates—is to test it (see later). The supplementary data sheets packed p. 123 with color sheet film, which contain specific information pertaining to the particular film emulsion, are an aid in testing. However, experience has shown that these data, which were undoubtedly correct at the time the film was tested by the manufacturer, do sometimes no longer apply when the photographer buys the film and, therefore, they should be considered only as guides in making the test.

Variations subsequent to manufacture. Color films are damaged more easily than black-and-white films by heat and humidity which, affecting the individual color layers differently, upset the color balance of the film and cause changes in color response and speed. To minimize these, observe the following:

Age of film. No matter how suitable storage conditions are, color film gradually deteriorates with age. The effect is cumulative—the longer the time between manufacture and processing, the greater the danger of changes in the characteristics of the film. For this reason, an expiration date is stamped on every film package. Check it when you buy film and reject outdated emulsions.

Heat protection. Color film should not be stored at temperatures above 70 degrees F. The deteriorating influence of heat is best illustrated by Kodak's information regarding the storage of Kodak color films: these will keep for two months at temperatures up to 70 degrees F, for six months at temperatures up to 60 degrees F, and for twelve months at temperatures up to 50 degrees F.

Film that must be kept for any great length of time is best stored *in moisture-proof containers* (see below) in a refrigerator or deep-freeze unit. I keep my color film in a portable icebox when I travel in warm zones. To prevent condensation of moisture on the cold surfaces of the film, *film stored under refrigeration must be given time to warm up before the package is opened.* This may take anywhere from one to five hours depending primarily upon the thickness of film bulk. Unstacked boxes of sheet film thaw faster than boxes that are stacked. Rolls take longer, and 100-foot rolls take *very* long.

Moisture protection. Color film in its original wrapper is adequately protected from humidity (but *not* from heat!). However, exposed film (and 35-mm and roll-film taken out of their packages) must be placed in a moisture-proof container—a glass jar or a tin can, its lid sealed with waterproof surgical tape, or a waterproof plastic freezer bag—before the film can be safely stored in an icebox, refrigerator, or freezer. Under exceptionally humid conditions, especially in the tropics, the use of a desiccating agent may be necessary. For such occasions, explicit instructions can be found in the Kodak Color Data Book *Kodak Color Films.*

Vapor and X-ray protection. The vapors of moth balls, cleaning fluids and solvents, motor exhausts, and the fumes of formaldehyde, ammonia, acetic acid, are harmful to color films. If necessary, store films in sealed jars or tins as described above. In hospitals, doctors' offices, and laboratories where X-ray equipment or radioactive material is used, damage from X-ray radiation must be considered. If

film must be stored in or near such places, test the safety of storage spaces by first developing a few test sheets of unexposed film that have been stored there for several days.

Exposed color film, because it is more susceptible to harmful influences than unexposed film, should be developed as soon as possible. It should also be kept refrigerated (if necessary, in a portable icebox) until it can be processed or shipped to a processing laboratory. Shipping by air is advisable to cut time between exposure and development.

How to test color film

In view of the fact that color film is basically unstable, many photographers may wish to know *exactly* what the qualities of the color emulsions they will use are in regard to color balance and speed. As previously mentioned, to satisfy this demand, individual data slips are packed with color sheet films. These slips supplement information that applies in general to the type of film, by indicating, if necessary, the type of filtration a special emulsion demands when used with a specific type of light. When necessary, they also give deviations from standard film speed for average as well as exceptionally long (time exposure) and short (speedlight) exposures.

As valuable as such information is, the fact remains that, for reasons stated before, the film may have undergone certain changes since it was tested by the manufacturer. Besides, such data slips are *not* packed with 35-mm film and rollfilm. Consequently, the only way to determine whether changes have occurred, and to what extent such changes affect the color balance and speed of the film, is to make a test. Such tests must be made under strictly standardized conditions. This necessitates standardization of the test object, illumination, lens, diaphragm stop, and shutter speed. In the *Life* color lab, for example, every new color film emulsion is tested in the following way:

The permanently installed testing stand not used for any other work includes a camera with accurately calibrated shutter and a test object consisting of a color chart and a large, printed, paper gray-scale. The distance between lens and test object, and between light source and test object, is fixed. Diaphragm stops and shutter speeds are always the same. For permanent accurate identification, all data—type of film, emulsion number, type of correction filter (if used), and date of test—are written on a card mounted next to the test object and photographed on the test film.

This setup is used to test all types of color film. Tungsten-type color film is, of course, tested in illumination of the type (3200 or 3400 K) for which the film is balanced. Daylight color film is tested indoors because often tests must be made on very short notice and the right kind of daylight is not always available. Illumination for daylight color film tests is provided by a No. 50 General Electric flashbulb used with a Kodak Wratten Filter No. 80A and a Kodak Color Compensating CC-10Y Filter. While this combination of flash and two filters may not be ideal, its

p. 172 results are accurate enough for comparative evaluations. A number of bracketed exposures is made, differing from one another by one-half diaphragm stops, to produce a series of transparencies ranging from slight overexposure to slight underexposure to determine not only the color response, but also the true speed and the exposure latitude of the respective emulsion. The developed test films are mounted side by side in a cardboard frame for examination in transmitted light and filed for reference.

If one makes such a test, its evaluation should be based mainly upon the rendition of the gray-scale. The cleaner and more neutral the steps of gray, the better the color balance of the film. If white or gray have a color cast, view the test against a pure white surface through a Kodak Color Compensating Filter in the complementary color until you find a filter through which the gray appears neutral; then make another test using this type of filter *but one shade lighter*. The second test is necessary because the eye and color film react differently, and a visual match does not guarantee a similar result on film.

SPEED

To make accurate calculations of exposure possible, all films have specific speed numbers which provide the basis for setting the dial of the exposure meter. These speed numbers express the film's sensitivity to light: the higher the number, the more sensitive (the faster) the film. Other factors being equal, the faster the film, the shorter the exposure and, consequently, the less danger of blur due to accidental camera movement; the smaller the diaphragm stop that can be used, and the greater the extent of sharpness in depth. For these reasons it may seem that fast films are preferable to slow films. However, in comparison to slow films, fast films, both color and black and white, have certain less desirable qualities which become

p. 126
p. 127 more pronounced as film speed increases: their grain structure is coarser (most objectionable in enlargements made from small negatives) and their gradation is softer (most objectionable if subject contrast is low). For this reason, the "best" film is frequently *the slowest film* that is fast enough to do a perfect job.

Unfortunately, no speed number system is used internationally; several different film rating speeds are in use of which the American ASA (American Standard Association), the British B.S. (British Standard) numbers, and the German DIN (Deutsche Industrie Normen) are the most important. Because more and more foreign films become available in this country, in the following table I give equivalent speed ratings for the three different systems:

American ASA and British B.S. film speed numbers

800	640	500	400	320	250	200	160	125	100	80	64	50	40	32	25	20
30°	29°	28°	27°	26°	25°	24°	23°	22°	21°	20°	19°	18°	17°	16°	15°	14°

equivalent German DIN film speed numbers

(*NOTE:* Different systems use different methods by which to rate the "speed" of a film, as a result of which it seems doubtful that any reliable conversion table can be compiled. The above values must, therefore, be considered only as approximations which have to be confirmed or corrected by individual tests.)

Not long ago, panchromatic films had two different speed numbers, one for daylight and one for tungsten illumination. However, experience has shown that the response of photo-electric exposure meters to these two types of light is, as a rule, so similar to the response of panchromatic films that the same speed number can safely be used for both types of light. With blue-sensitized and orthochromatic p. 118 films it is, of course, still necessary to use lower speed ratings for tungsten illumination than for daylight because these films are primarily sensitive to blue, and tungsten light contains less blue than daylight.

Film speed ratings are not absolute. They are intended primarily as guides which may have to be modified to suit a photographer's preferences and way of working. In addition, the *effective* speed of a film (as compared to its *rated* speed) is subject to two factors that must be considered when the exposure is computed:

Type of developer. Some fine-grain developers used in black-and-white pho- p. 187 tography demand increases in exposure, the exact factor depending on the type of developer used. A few developers actually boost effective film speed.

Duration of development. Prolongation of development beyond normal ("pushing" or "forcing" a film) is in effect equivalent to increasing the speed of a film and also, of course, its contrast. Color film which can be processed by the photographer can, if demands are not too critical, yield good results when exposed at

twice its rated speed *if subject contrast is relatively low.* In black-and-white photography, if a photographer is willing to accept some loss in print quality, even higher gains in effective film speed can be attained by forcing the negative during development, particularly if subject contrast is low.

(NOTE: A table of rated speeds of specific brands of film is not given here because such ratings are always subject to revision. The currently recommended speed number of a film is always given with the film.)

DEFINITION

The higher the definition of a film, the more fine detail can be distinguished in the photograph. Definition is, as a rule, higher in slow, contrasty films than in fast, less contrasty films. Definition is the result of two film qualities:

Grain. The light-sensitive component of photographic emulsions consists of innumerable tiny particles of metallic silver which form the negative; the denser the layer of silver grains, the darker the image. The individual grains are so small that they can be seen only with a microscope. However, under certain conditions, the grains clump together in the negative and become visible in the enlargement. When this happens, the picture appears "grainy." Grain is always most apparent in the medium shades which lose their smoothness, and in black-and-white photography acquire a sandpaper-like texture.

Acutance. It is a measure of sharpness. But whereas "sharpness" is a subjective impression almost impossible to define (where, actually, does sharpness end and unsharpness begin?), acutance is based upon exact measurements: a knife edge is laid on the film, the film is exposed to light, developed, and the silhouette of the knife edge is examined under a microscope. Because light is scattered within the film emulsion, the transition from light to dark is not clearly defined but somewhat gradual. It is the zone between pure white and pure black which, microdensitometrically evaluated, is the measure of the acutance of a film: the narrower it is, the higher the acutance. Acutance is highest in thin and lower in thick emulsions. It is also affected by exposure: overexposure, which promotes light-scattering within the emulsion, lowers the acutance.

Sharpness. In practice, the impression of sharpness is influenced by the following factors:

p. 128 *Thickness of the film emulsion:* the thinner, the sharper.

Film grain: the finer the grain, the more detail can be distinguished. However,

126

grainy negatives often produce pictures that *appear* sharper than pictures made from fine-grain negatives that actually show more detail but offer the eye nothing definite to focus on because outlines of their images seem less distinct than the hard specks of grain in a grainy print.

Exposure: the denser the negative, the less sharp the print. Overexposure is a very common cause of unsatisfactory sharpness. It is most harmful in small negatives.

Development: overdevelopment, which promotes film grain clumping and excessive density, is another common cause of unsharpness.

The gradation of the paper: printed on contrasty paper, a negative always pro- p. 193 duces a print which makes a sharper impression than a print made from the same negative on paper of softer gradation, particularly if grain is apparent in the contrasty print.

Other factors that affect the sharpness of a picture will be discussed later. pp. 160-162

GRADATION

The gradation of a film determines its tonal range. There are films of normal, soft, and hard gradation (normal, long, and short tonal range).

If we photograph a gray-scale—a strip of monochromatic shades in regularly spaced steps of increasing depth of tone from white to black—and used a film of *normal* gradation, we would get a picture that faithfully reproduces every tone of this scale: contrast would be *the same* as in the original. If we used a film of *soft* gradation (low contrast gradient), we would get a picture in which the dark tones are rendered lighter and the light tones darker than they were in the gray-scale, and white and black are rendered as shades of light and dark gray: contrast would be *lower* than in the original. And if we used a film of *hard* gradation (high contrast gradient), we would get a picture in which the entire gray-scale would appear compressed because differentiation at the light and dark ends of the gray-scale would be lost, the light steps merging into white and the dark steps merging into black: contrast would be *higher* than in the original.

Generally (exceptions exist), the higher the speed of a film (color or black and p. 124 white), the softer its gradation; and vice versa. Differences in gradation are much greater among black and white than among color films. Films that have the hardest gradation (highest contrast gradient) are found among orthochromatic and panchromatic process films designed for line-copy work followed by thin-emulsion and fine-grain films of low to moderate speed. Films designed for general photography

have normal gradation. Films that have the softest gradation (lowest contrast gradient) are found among the fast panchromatic films.

Gradation, however, is not an unalterable characteristic of black-and-white films (gradation of color films cannot be changed without changing the color rendition). Regardless of the contrast group to which a black-and-white film belongs, its grada-

p. 281 tion is subject to these influences:

Exposure: overexposure decreases, and underexposure increases, the contrast of the negative in comparison to a normally exposed negative, other factors being equal.

Development: prolongation of development beyond the normal time increases, and shortening the time of development decreases, the contrast of the negative in comparison to a normally developed negative, other factors being equal.

HOW TO CHOOSE YOUR BLACK-AND-WHITE FILM

For practical reasons, it is advisable to classify black-and-white films in four groups:

Thin-emulsion films
General-purpose films
High-speed films
Special-purpose films

p. 124 **Thin-emulsion films** have very low speeds (16 to 64 ASA), extraordinary sharpness, unsurpassed definition, and no visible grain. As a result, they are ideal for 35-mm photography provided that their speeds are not too slow for the job at hand, and great care is taken in their exposure and development. Because their emulsions are so thin, their exposure latitude is slight and exposures must be correct within less than one stop. For the same reason, they need special development with "compensating" developers which are free from silver solvents. If they are overdeveloped, they become so contrasty that in the print highlights are completely blocked, medium gray tones are virtually absent and what is left are areas of almost pure black and white. In capable hands these films will yield beautiful 16 x 20-inch grainless enlargements from 35-mm negatives.

All films except one belonging to this group are European imports. Among the best are Adox KB-17, Agfa Isopan F, Ilford Pan F, Kodak Panatomic X, and Perutz Perpantic 17.

128

General-purpose films have medium to high speeds (80 to 400 ASA), reasonably fine grain, and unsurpassed exposure latitude which provides a high margin of safety against incorrect exposure. They are ideal for photography with 2¼ x 2¼-inch cameras and larger, and 35-mm cameras in cases in which thin-emulsion films cannot be used because of insufficient speed. They are equally suited to outdoor and indoor photography under all light conditions and give particularly good results with speedlight and flash. Unless an extreme fine-grain or an ultra-high-speed film must be used, a photographer should select his black-and-white films from this group.

Typical representatives are Kodak Plus-X, Tri-X, and Verichrome Pan; Ansco All-weather Pan; Ilford FP-3; Agfa Isopan SS; and Adox KB-21.

High-speed films have very high speeds (500 to 1600 ASA), coarse grain, poor definition, soft gradation, and extreme sensitivity to overexposure which produces negatives so lacking in contrast that not even printing on extra hard paper will produce acceptable prints. They are totally unsuited to general photography and especially to outdoor photography in bright light. Their one redeeming feature is that under marginal light conditions, when other films fail, they are capable of producing very beautiful results. Unless their high speed is actually needed, or a grainy effect is deliberately sought, these films should not be used. p. 305

Typical representatives are Kodak Royal-X Pan, Ilford HP-S, Agfa Rekord, Ansco Hypan, Perutz Peromnia 25, and Polaroid's 3200 and 10,000 speed films.

Special-purpose films. A whole group of films exist which are little known to the average photographer because they are unsuited to general photography. Here are a few examples:

Infrared sensitized films are intended primarily for aerial and telephotography. p. 119 Their ability to penetrate atmospheric haze improves the clarity and definition of such pictures. In addition, these films are widely used for scientific, technological, and military purposes.

Fluoroscope recording films are ultra-sensitive to blue. They record images from television and cathode-ray tubes, oscilloscopes, and fluorescent screens.

Document copy films are used to copy line material that has no middle tones. They have very high contrast, unsurpassed definition, and extremely fine grain. They are available in both orthochromatic and panchromatic emulsions.

Kodak Fine Grain Positive Film produces from black-and-white negatives positive

transparencies used mainly for display in transmitted light and as slides for projection.

Kodak Direct Positive Pan Film is a reversal film which yields positive transparencies in black and white instead of negatives. It is suitable for making slides and "negative prints."

Photographers interested in these films, which also offer tempting opportunities for experimentation, are advised to obtain special literature through their photo dealer.

HOW TO CHOOSE YOUR COLOR FILM

p. 38 Should reversal or negative color films be used? Does the photographer wish to make positive transparencies or color enlargements on paper? Will he take pp. 37, 117 photographs for his own pleasure or for sale (unless he already has a camera, p. 116 this may decisively influence his choice of film size).

In addition, there is the question of whether the photographer wishes to process his films or whether he will have someone else process them. Again, this may limit his choice.

When choosing color film, its speed should be considered. A film that is slow is not suited to certain types of work. On the other hand, the faster the color film, the more pronounced the grain and the less sharp the transparency or color print; this is particularly noticeable in small film sizes. The "best" film is usually the slowest film that is fast enough for a specific job.

Different brands of color film respond differently to color. Some produce transparencies that are characterized by brilliant, highly saturated colors; others by colors less saturated and more natural. Some brands of color film are "warmer" (more toward yellow and red); others are "colder" (more toward blue and purplish shades). If close-ups of people are to be made, the warmer films may be preferable because they render skin in more natural tones. Some color films are weak in red or yellow, colors in which other color films excel. And so on. Comparative surveys of the different brands of color films are periodically published in completely up-to-date form in the various photo-magazines.

And finally, there is the question of contrast rendition and exposure latitude. As a rule, the more contrasty the film and the more brilliant the colors, the more limited the exposure latitude, i.e., the more accurately it must be exposed for satisfactory

results. Some color films will produce acceptable (though never first-class) transparencies if overexposed up to two and one-half and underexposed one and one-half diaphragm stops; others can hardly stand over- or underexposure by half a stop. The more contrasty the subject and the less experienced the photographer, the greater the exposure latitude of the color film should be. Negative color films p. 120 have a much greater exposure latitude than reversal color films.

That any color film must be suited to the type of light in which it is used (daylight p. 120 and electronic flash, photoflood, professional tungsten lamps) goes, of course, without saying.

(NOTE: Because manufacturers of color films constantly strive to improve their product, film characteristics are subject to changes. Therefore, specific color films are not named. Consult your photo dealer or the test reports on color films which photo-magazines publish periodically.)

The best film. Although their characteristics may differ, all films made by reputable manufacturers are of high quality. In the hands of an expert, any of these films will give good results. Experiment with different films to find the one you like best, *then stick to it,* because it is *your knowledge* of this film's characteristics—both good and less desirable—which makes this film better than any other film on the market *for you.*

TEN DO'S AND DON'TS

1. Do not touch the film emulsion with your fingers or hands; if you do, indelible marks may appear.

2. Hold films or negatives by the edges only, for the reasons stated above.

3. Dampness and heat quickly destroy unexposed film and slowly deteriorate negatives and color transparencies. To avoid these consequences, both unexposed and developed films must be stored in a cool and dry place (dryness is more important than coolness). In summer, don't keep film in the glove compartment or trunk of a car.

4. Always load your camera in the shade. No "daylight-loading" film is so lightproof that it can stand direct exposure to the sun without fogging along the edges. If there is no shade, turn your back toward the sun and load the camera in the shade cast by your body.

5. When buying film, check the expiration date stamped on the package; it is your guarantee of freshness. Outdated film has lost some of its speed, is less con-

trasty, may be partly or wholly fogged, and, in the case of color film, it may produce unsatisfactory color.

6. Be sure that rollfilm is always wound tight (but never "cinch" a roll by holding the spool tight and pulling the paper leader—this will cause marks on the emulsion). Don't allow the film to loosen in loading a camera—if it does, it may become light-struck. Thread the end of the paper leader or film carefully into the slot of the take-up spool, fold it over sharply so that it does not form a bulge—if it does, the film may later become light-struck.

7. Filmpacks are delicate; hold them only by their edges. Don't squeeze their flat sides—if you do, light may get into the pack and fog the film.

8. Pull film tabs s-l-o-w-l-y. If you don't, friction may generate static electricity which causes marks on the film. Such marks may also be caused by excessively fast operation of rapid winders and motor drives. Static marks appear in the negative as small black wiggles, star shapes, or rows of dots. They are most likely to occur when the air is cold and dry.

9. When loading sheet film holders, be sure that the emulsion side faces the slide. All sheet film has identification notches in one corner. These differ with each make and emulsion type and can be distinguished in the dark by feeling. *The emulsion side faces you if the film is held vertically and the notches are in the upper right-hand corner.*

10. When shooting pictures in bright light, don't leave the camera uncovered longer than necessary. If you use filmpack or sheet film, to prevent light from fogging the film shade the slot of the holder with the slide or cover it with the focusing cloth when the slide is pulled.

EXPOSURE METER

A prerequisite for technical excellency is a correctly exposed negative or color transparency. To make an exposure by guesswork or experience is *not* a mark of a seasoned photographer but an evidence of foolishness. The human eye is not a good instrument for measuring light intensities. It adapts so quickly and automatically to small changes in brightness that they are usually unnoticed. Professional photographers are aware of this and use exposure meters. They cannot afford to miss an exposure. Amateurs will do well to follow their example.

Exposure tables, guides, or charts don't measure light intensities. They interpret light conditions in terms of everyday experience. They are reliable only within

the limits of their applicability. Because of their simplicity, they are often more useful to the beginner than an exposure meter which is much more accurate but also more difficult to use. Exposure charts are included with every package of film.

Extinction-type exposure meters can be used to measure any kind of illumination except speedlight and flash, but their accuracy depends to a high degree on the skill and experience of the user.

Photo-electric exposure meters are completely automatic. Meters based on two different photo-sensitive cells are available:

The selenium cell meter. Light entering the meter through a honeycomb lens and a baffle which restrict the angle of acceptance to an angle approximately that of a lens of standard focal length, strikes a photo-sensitive selenium cell which generates electric current proportional to the incident light. The current is fed into a galvanometer which moves a pointer in accord with the current generated.

An advantage of a selenium cell exposure meter is that its spectral response is very close to that of panchromatic film. In addition, because it does not employ batteries, this type of exposure meter lasts virtually indefinitely. Its disadvantages are that a selenium cell generates current not only in proportion to the intensity of the incident light, but also in proportion to its own size: the larger the cell, the more current, which explains why good selenium cell exposure meters are so large. Also, the weakness of the current generated by a selenium cell demands a measuring unit that is very sensitive and delicate which makes this type of meter quite sensitive to shock.

The cadmium sulfide (or CdS) cell meter. Light striking a pea-size CdS cell controls the flow of current from a tiny mercury battery into a galvanometer which moves a pointer in proportion to the current admitted. As light strikes the CdS cell, its electrical resistance changes inversely proportional to the intensity of the incident light: the brighter the light, the lower the resistance of the cell, the greater the amount of current that passes through it from the battery to the galvanometer, and the higher the "reading."

The advantage of the CdS cell exposure meter is that a relatively large amount of current is available to activate the galvanometer because this current is supplied by a battery. This type of meter can be built more ruggedly than a selenium cell meter because the galvanometer does not need to be as sensitive, and the meter can be much smaller because a very small light-sensitive cell suffices. Such a meter can be built into a 35-mm camera body without increasing its size.

A disadvantage of some CdS cell exposure meters is their spectral response: most CdS cells are very sensitive to green and yellow and relatively insensitive to blue —they are least sensitive to that part of the spectrum to which black-and-white film responds most strongly. Such deficiencies are nowadays usually corrected with built-in filters. Furthermore, if a CdS cell is exposed to bright light, it reacts similarly to the human eye: it gets "blinded" temporarily and needs time to recover before it will again produce accurate readings; and if the cell is accidentally exposed to direct sunlight, it may take hours or days before it will again respond correctly to dim light. Unlike a selenium cell which responds almost instantly, even at average light levels a CdS exposure meter has a noticeable time lag, and in dim light, fifteen seconds may elapse before the pointer gives a correct reading. And finally, its tiny mercury battery is exhausted in approximately a year.

Photo-electric exposure meters are available in the following forms:

p. 169 *Meters that measure reflected light.* These must be *pointed at the subject* to measure the intensity of the light it reflects. Their great advantage is that they permit separate readings of specific subject areas to establish contrast range.

p. 172 *Meters that measure incident light.* These must be *pointed at the camera*, preferably from a position directly in front of, or at least very close to, the subject. These meters measure the light that falls on the subject. This, however, is not necessarily indicative of the light available for the exposure. For example, in identical light, readings taken from in front of a light yellow and a dark brown dress would be identical. Consequently, with this type of meter contrast range of a subject cannot be accurately checked.

Meters for spot-readings. These meters, which measure reflected light, are in effect a combination of a simple SLR camera and a CdS exposure meter. The image of the subject and the meter dial with pointer are visible simultaneously on a groundglass that has a small circle in its center. The meter "reads" the subject area visible within the circle which corresponds to an angle of acceptance of three degrees. As a result, very small subject areas can be measured for brightness with a high degree of accuracy. The advantage of this is obvious. The disadvantages of spot-meters are those of all CdS cell exposure meters plus the possibility that lens flare may produce a false reading if very bright subject areas are part of the image visible on the groundglass.

Strobe meters are specifically designed for use with electronic flash. They have their own power supply and provide the only accurate means for determining

speedlight exposures that involve more than one light. They are large, heavy, and quite expensive.

How to use an exposure meter will be discussed later. p. 169

COLOR FILTERS

A color filter changes the response of a photographic emulsion to light and color. Its function is to alter the rendition of color in terms of either black and white or color to produce a picture that is clearer, more accurate, more interesting, or more beautiful than it would be if no filter were used.

A filter permits light of certain wavelengths to pass through it and absorbs light of other wavelengths; which will be transmitted and which will be absorbed depend primarily on the filter's color. Roughly stated, a filter transmits light of its own color and absorbs light of a complementary color. Complementary color pairs are:

> red and blue-green
> orange and blue
> yellow and purple-blue
> green-yellow and purple
> green and red-purple

Use of a filter affects a photograph in three ways:

A filter affects the response of the film to light and color, as stated above.

A filter affects the exposure. Since every filter absorbs a certain amount of light, when a filter is used, the exposure reading given by an exposure meter must be increased to compensate for the light loss if underexposure is to be avoided. The increase required depends upon four factors:

The color sensitivity of the film (orthochromatic, panchromatic Type A, panchromatic Type B, etc.) p. 118

The spectral composition (color) of the light (daylight, tungsten light, etc.)

The color of the filter (red, yellow, blue, etc.)

The density of the filter (light, medium, dark, etc.)

To give a photographer a basis for calculating exposures, filter manufacturers assign specific factors to each filter by which the exposure must be multiplied when the filter is used with specific types of film and light. For example, if the correct exposure without a filter is 1/100 sec. at f/16 and a filter is used that in conjunc-

tion with the respective type of film and light has a factor of 2, the exposure would be either 1/50 sec. at f/16 or 1/100 sec. at f/11.

The following table lists the filter factors that apply to Kodak Wratten Filters in conjunction with most *panchromatic* films. Filters made by other manufacturers may have slightly different factors; consult the instruction slips that are packed with each filter.

Filter color	Light yellow	Medium yellow	Light green	Medium green	Orange	Medium red	Deep red	Blue
Wratten designation	K1	K2	X1	X2	G	A	F	C5
Filter factor — sunlight	1.5	2	4	5	3	8	16	5
Filter factor — tungsten	1.5	1.5	3	4	2	4	8	10

The following table shows the relationship between exposure factor and diaphragm stop. The figure below each factor indicates *the number of stops the diaphragm must be opened* when a filter of this factor is used, if underexposure is to be avoided:

Filter factor	1.2	1.5	1.7	2	2.5	3	4	5	6	8	12	16
Open diaphragm by the following number of f-stops	⅓	⅔	⅔	1	1⅓	1⅔	2	2⅓	2⅔	3	3⅓	4

If the filter factor is very high, it is often advisable to divide the required exposure increase between the f-stop and the shutter speed settings. For example, if the required exposure without a filter is, say, 1/100 sec. at f/16 and the filter has a factor of 8, instead of opening the diaphragm 3 stops and exposing 1/100 sec. at f/5.6 (which might make the zone of sharpness in depth unacceptably shallow), or shooting 1/12 sec. at f/16 (which might cause unsharpness through camera or subject motion), the photographer can "split the difference" and expose 1/50 sec. at f/8 or 1/25 sec. at f/11. The easiest way to find the best equivalent combination of diaphragm stop and shutter speed is with the aid of the exposure meter: if the meter-indicated dial setting is reduced by the respective number of f-stops, any indicated combination of f-stop and shutter speed will automatically take the filter factor into consideration and yield a correctly exposed negative.

A filter affects the contrast gradient of a black-and-white negative. As a rule, a red filter produces a strong increase in contrast and a yellow filter a moderate increase in contrast whereas a blue filter reduces contrast in comparison to an unfiltered shot, other factors being equal.

The designation of filters

Unfortunately, manufacturers of filters use designations which give no clue to the color or properties of a filter. For instance, yellow filters that are almost identical are designed by Kodak as Wratten Filter K2, by Enteco as G15, by Lifa as G2, and by Tiffin as 8. The only recourse is to study the filter manufacturer's literature.

The material of filters

Filters are made from different materials and in different forms, each having specific advantages and disadvantages:

Gelatin. The filter dye is applied to a thin foil of gelatin. Because of their extreme thinness, gelatin filters have excellent optical qualities which make them particularly suitable for use with high-speed and extreme telephoto lenses which might, if used with filters of lower quality, produce pictures of less satisfactory definition. Gelatin filters are sensitive to abrasion, scratching, and finger marks, and they are easily damaged by moisture (one should never breathe on a gelatin prior to cleaning it). The least expensive type of filter, it is available in the greatest number of different colors.

Gelatin cemented between glass and other laminates. Depending upon the quality of the glass, the optical qualities of this type of filter range from excellent to poor. Such filters are much less sensitive to damage and they are easier to handle and clean than gelatin filters. They are also more expensive.

Solid glass filters. The filter dye is incorporated in the glass. This kind of filter comes in two types: optical flats of superb performance characteristics, which can be recognized by their unusual thickness (up to ¼ inch); and relatively inexpensive, thin filters whose performance is often rather poor. Because of difficulty in manufacture in regard to color control (spectral absorption), the number of different solid-glass filters is quite small.

Acetate. This type of filter is suitable only for use in safelights, enlargers (used between light source and negative for making color prints), and with photo-lamps to change the over-all color of light at its source. Filters of this type, stapled to wooden frames and placed in front of the lamp, are professionally known as

"gelatins." If used at the camera, acetate filters, because of their poor optical qualities, would cause unsharpness.

The effects of reflection

Not all light that strikes a filter is transmitted or absorbed; some is lost through reflection from the front and back surfaces of the filter. The minimum light-loss through reflection is 4 per cent per filter; often, it is considerably higher. In glass filters, light-loss can be reduced through anti-reflection coating. Reflected light p. 108 may also contribute to flare and attendant decrease in contrast of the transparency or the negative. Consequently, it is important to use as few filters simultaneously as possible (in color photography, and especially in color printing, simultaneous use of several filters is often necessary for proper light balance).

Color stability of filters

The dyes used in the manufacture of gelatin filters, like the dyes used in color films, are organic—and all organic dyes are basically unstable and subject to gradual deterioration. To prevent premature fading, filters should not be exposed unnecessarily to bright light, dampness, and heat.

Filters for different purposes

Filters designed for color photography are usually rather pale, some appear almost colorless, and a few are entirely colorless; many of these filters, if used with black-and-white films, would produce no noticeable effect. On the other hand, most filters designed for black-and-white photography have strong, saturated colors, and if used with color films, would produce transparencies which would be monochromes in the color of the respective filter. A few filters can be used for both black-and-white and color photography.

Filters for color photography only

Light-balancing filters. The purpose of these filters is to achieve the most faithful color reproduction possible by changing the color (spectral composition) of unsuitable types of light to conform to the type of light for which the color film is balanced. For this purpose, there are two series of Kodak Wratten Filters: blue filters (No. 82 in four different densities) which in effect raise the color temperature of the light; and red filters (No. 81 in six different densities) which in effect lower the color temperature of the light.

The task of determining the correct light-balancing filter has recently been simplified through a filter classification system based upon decamired values. These

values are equivalent to color temperature values expressed in the mired (micro-reciprocal-degree) scale divided by 10. To find the mired value of a light source, its color temperature in degrees Kelvin is divided into 1,000,000. For example, a p. 253 professional tungsten lamp with a color temperature of 3200K corresponds to 1,000,000 divided by 3200, which is equivalent to 313 mireds. To get its decamired value, 313 must be divided by 10; thus, the decamired value of a 3200K lamp is 31.

For practical purposes, different types of light and color film are designated by their respective decamired values. For example, as mentioned above, the deca-mired value of 3200K tungsten light is 31; consequently, the decamired value assigned to tungsten-type color film (Type B color film) is also 31. The two follow-ing tables show the decamired values of different types of color film and light:

Decamired values for color films

Daylight type	18
Type A (3400K photoflood lamps)	29
Type B (3200K tungsten lamps)	31

Decamired values for light sources

Clear blue sky	4
Shadows under a clear blue sky	8
Hazy blue sky	11
Lightly overcast sky	13
Overcast sky	15
Speedlight (approximately)	15
Sunlight plus skylight	18
Sunlight before 9 A.M., after 4 P.M.	20
Clear-glass flashbulbs (approximately)	26
Photoflood lamps, 3400K	29
Professional tungsten lamps, 3200K	31
Household lamps, 100 watts	35
Household lamps, 40-60 watts	36
Candle flame	52

To find the correct light-balancing filter, calculate the difference between the decamired values of the film you wish to use and the type of light in which you wish to use it. This figure is the decamired value of the filter you must use. If the *light* has a *higher* number than the film, you need a *blue* filter of that value (Kodak Wratten Filter No. 82 in the correct density); if the *film* has a *higher* number than

the light, you need a *red* filter of that value (Kodak Wratten Filter No. 81 in the correct density). The decamired values that correspond to the Kodak light-balancing filters are listed in the following table:

Wratten Filter	Conversion power in decamireds		Exposure increases in f-stops (approx.)
blue filters			
82C plus 82C	−9	(−8.9)	1⅓
82C plus 82B	−8	(−7.6)	1⅓
82C plus 82A	−7	(−6.5)	1
82C plus 82	−6	(−5.5)	1
82C	−5	(−4.5)	⅔
82B	−3	(−3.2)	⅔
82A	−2	(−2.0)	⅓
82	−1	(−1.0)	⅓
red filters			
81	1	(1.0)	⅓
81A	2	(1.8)	⅓
81B	3	(2.7)	⅓
81C	4	(3.5)	⅓
81D	4	(4.2)	⅔
81E	5	(4.9)	⅔
81EF	6	(5.6)	⅔
81G	6	(6.2)	1

(NOTE: The decamired values in the first row are approximations only; they are sufficiently accurate for average purposes. The numbers in parentheses are accurate values).

If a decamired filter of relatively high value is needed but not available, it is possible to produce the same effect by combining two or more filters of lower value. For example, instead of a 9 filter, a 2 and a 7 can be used together, or a 5 and a 3 and a 1. However, for reasons stated before, it is desirable to use as few filters as possible.

p. 138

Color conversion filters. The purpose of these filters is to enable a photographer, in an emergency, to use a specific color film with a type of light for which it is not balanced, for example, daylight film with photoflood light, or an indoor-type film outdoors. As a rule, it is preferable to convert indoor-type film to outdoor use. To convert a Type B color film designed for use with professional 3200K tungsten lamps to daylight photography, use a Kodak Wratten No. 85B Filter; to convert a Type A color film designed for use with 3400K photoflood lamps to outdoor photography, use a Kodak Wratten No. 85 Filter. A daylight color film can be converted for use in photoflood illumination by using a Kodak Wratten No.

80B Filter, and for use with clear flash lamps by using a Kodak Wratten No. 80C Filter.

Color compensating filters. Kodak color-compensating filters, designated as Series CC filters, are available in the colors yellow (Y), magenta (M), cyan (C), red (R), green (G), and blue (B), most in six and some in seven different densities. Their purpose is to change the over-all color balance of color transparencies. Such changes may be necessary for the following reasons: to compensate for reciprocity failure caused by abnormally short (speedlight) or abnormally long exposure times; to compensate for deviations from normal color balance of a specific color emulsion which, if uncorrected, would give the transparency an over-all color cast; to correct deficiencies in the illumination caused by, for example, a greenish condenser lens, a heat-absorbing or opal glass in the optical system of an enlarger, etc.; or to purposely change the over-all color balance of a transparency to achieve a specific effect.

Filters for black-and-white photography only

Correction filters. The purpose of a correction filter is to change the response of a *panchromatic* film so that *all* colors are rendered in approximately the same p. 118 brightness values as those seen by the eye. Although panchromatic films are *sensitive* to all colors, they do not necessarily record color in gray shades that *correspond in brightness* to the brightness seen in reality. All panchromatic films are unproportionally sensitive to blue and ultra-violet, and Type C pan films are also unproportionally sensitive to red. Unless this excessive sensitivity is reduced proportionally, blue and red are rendered unproportionally light in the print.

The following table lists the correction filters which must be used with Kodak panchromatic films if accurate translation of color into gray shades of corresponding brightness is desired:

Panchromatic film	Illumination	Wratten Filter	Filter factor
Pan Type B	Sunlight	K2	2 x
	Tungsten	X1	3 x
Pan Type C	Sunlight	X1	4 x
	Tungsten	X2	4 x

Contrast filters. The purpose of a contrast filter is to change the response of a film so that it will render a specific color either lighter or darker than it would have

141

p. 276 been rendered if no filter were used. When such changes in rendition are desirable will be discussed later.

To render a color *lighter in the print,* use a filter of *the same* (or a closely related) color; to render a color *darker in the print,* use a filter of *the complementary* (or a nearly complementary) color. The following table shows how Kodak Wratten contrast filters affect the principal colors. If several filters are listed, the first will make the least change and the last the greatest change in color rendition.

Color of subject	Wratten Filter that will make color lighter	Wratten Filter that will make color darker
Red	G, A, F	C5, B
Orange	G, A	C5
Yellow	K2, G, A	80, C5
Green	X1, X2, B	C5, A
Blue	C5	K2, G, A, F
Purple	C5	B

[NOTE: The Wratten Filters A (light red), F (deep red), and B (green) can *only* be used with panchromatic films.]

p. 119 **Infrared filters.** As mentioned before, to make use of the typical characteristics of this medium, infrared sensitized films must be used with special filters that transmit infrared radiation and absorb most or all visible light. For many purposes, and particularly in making hand-held shots with an SLR camera, red filters (Wratten A or F) are sufficient. These filters, which completely absorb blue and most of blue-green and green, transmit red and infrared. Their advantage is that, although a monochrome in red, the SLR finder image is visible, whereas it would not be if one of the infrared filters which absorb all visible light were used.

If the picture is to be taken entirely by infrared radiation, a Wratten Filter No. 87A, 87B, 88A, or 89B must be used unless the shot is made in darkness or by infrared flashbulb illumination. To the eye, these filters appear black.

Filters for color and black-and-white photography

Ultraviolet filters. All photographic emulsions are sensitive to ultraviolet radiation which is invisible. Ultraviolet radiation increases with altitude and contributes to the bluish haze that veils distant views when the day is clear (this haze must not be confused with mist and fog which are white). In black-and-white photog-

142

raphy, the effect of ultraviolet radiation manifests itself in unexpectedly dense negatives and in distance views in which detail is obscured and sharpness is inferior (this is particularly objectionable in small negatives); in color photography, in distant views that appear abnormally blue.

These effects can be mitigated or eliminated through use of filters which absorb ultraviolet radiation, among others the Kodak Wratten Filters Nos. 1A and 2B.

Polarizing filters. The purpose of this kind of filter is to mitigate or eliminate glare and reflections. The reader is probably familiar with Polaroid sunglasses and the way they reduce glare. Polarizers work in the same way. Through their use, unwanted glare and reflections can be partly or completely eliminated from a photograph, the degree of reduction depending on the angle of the reflected light. At angles of approximately 30 degrees, glare reduction is more or less complete; at 90 degrees, glare is not affected at all; at intermediate angles, glare is partly eliminated. However, only glare and reflections that consist of polarized light are affected by polarizing filters. Most reflecting surfaces polarize light as they reflect it—water, glass, glossy paper, paint, varnish, polished wood, etc. Metallic surfaces, however, do not polarize light as they reflect it, and consequently, highlights and reflections from metallic surfaces are generally not affected by polarizers. Exceptions: the reflected image may consist of polarized light, for example, an area of blue sky.

In color photography, use of a polarizing filter is the only method by which a pale blue sky can be darkened. Maximum effect is evident in that part of the sky which is at right angles to the rays of the sun.

To produce the desired effect, a polarizing filter must be used in the correct position. Hold the polarizer to your eye and look through it at the subject (if you use an SLR camera, place the polarizer in front of the lens and observe the image on the groundglass), slowly rotate the polarizer and notice its effects on highlights, reflections, and glare. When the desired degree of extinction is reached, place the polarizer in front of the lens *in exactly the same position as you held it*. Do not accidentally rotate the polarizer while transferring it to the lens; if you do, the effect will be changed.

It is neither necessary nor advisable to always use a polarizer in its position of maximum efficiency. Sometimes it is better to reduce glare to a moderate level because complete extinction of glare often produces a dull, lifeless effect.

Polarizers and color filters can be used together. This makes it possible to control

color rendition and reflection simultaneously, and very often one will act as an aid to the other. Thus, elimination of glare will bring out colors that were obscured by reflections, while a color filter will translate them into shades of gray of desired brightness.

The filter factor for most polarizers is 2.5. If a polarizer is used with a color filter, the factor of one must be *multiplied* by the factor of the other to determine their combined factor. The exposure as indicated by the exposure meter must then be increased in accordance with this factor.

Neutral density filters. The purpose of this kind of filter is to reduce brightness without affecting the color rendition of the subject. Such filters are commonly used in motion picture photography but they are equally useful in still photography when high-speed film is in the camera and a bright scene must be photographed with a large diaphragm aperture to limit extension of sharpness in depth. Under such conditions, when the fastest available shutter speed is not fast enough to prevent overexposure, a neutral density filter will.

Kodak Wratten ND Filters No. 96, available in thirteen standard densities, are neutral gray in tone which makes them suitable to color photography. A difference in neutral density of 0.30 is equivalent to one full stop.

LENS SHADE

Ideally, only light reflected by the subject or emitted by a source within the field of view of the lens should fall upon the lens and produce the picture. All other p. 108 light is potentially dangerous as a source of lens-flare and fog and it should be kept from striking the lens by a lens shade.

To be effective, a lens shade must be long enough to shield the lens from unwanted light (most lens shades are too short for this purpose); on the other hand, it must not be so long that it cuts off part of the picture. To be practical, it must permit use of a color filter. Some lenses, especially the more expensive telephoto lenses, have built-in lens shades. But as a rule, the photographer must supply his own lens shade. A good shade will protect the lens not only from unwanted light but also from raindrops, snowflakes, and accidental fingerprints.

CABLE RELEASE

Movement of the camera during the exposure is one of the most common causes of unsharp pictures. To avoid movement, exposures longer than 1/25 sec. should

144

be made with the camera mounted on a tripod or supported by another firm base. However, in conjunction with relatively long exposures, even when the camera is firmly supported unsharp pictures can result if it is accidentally jarred when the shutter release button is pressed. This can be avoided if a cable release is used to operate the shutter.

TRIPOD

A tripod permits a photographer to greatly increase the scope of his work. Time exposures at night; close-up work in which fractions of an inch make the difference between sharp and unsharp pictures; interior shots made with wide-angle lenses, small diaphragm stops, and correspondingly long exposure times; architectural photography in which perspective is controlled by camera "swings"; telephotography with extreme long-focus lenses that need a firm support; time exposures by artificial light; copy work and the making of reproductions—all these require a tripod.

The best tripod is the strongest, most rigid tripod; unfortunately, it is also the heaviest and the most expensive. Unless the tripod is to be used only in the studio or at home, weight is a problem. Consideration should also be given to the height to which a tripod can be extended. Height in a tripod is generally proportional to its weight and bulk. I like a center post (elevator) which can be raised or lowered either manually or by a crank. It makes precise adjustments in height much easier, which is particularly appreciated in close-up photography. In addition, a center post extends a tripod's useful height.

Most tripods have what I consider a serious defect: they provide no means for leveling the camera laterally; this must be done by adjusting the tripod legs. For leveling relatively light cameras, a heavy-duty universal joint can be mounted on the tripod. But for heavier and larger cameras, only a special leveling adjustment which is part of the tripod will do, like the lateral tilt of the *Tilt-all* tripod.

A versatile support for cameras up to 2¼ x 2¼-inch size is the Leitz Table Tripod. It has three rigid, nonretractable legs joined together by a center bolt. This tripod, which measures less than 8 inches when folded, takes very little space. Equipped with a ball-and-socket head, it can be set up on any hard, reasonably level surface, or pressed tightly against any rigid surface, vertical or slanting—a wall, a tree trunk, a telephone pole, a rock. It also can be held against the chest, making hand-held exposures with extreme long-focus lenses or relatively slow shutter speeds possible without moving the camera.

LIGHTING EQUIPMENT

Photographic lighting equipment can be classified as follows:

Lamps producing continuous light

> Floodlamps
> Spotlights
> Fluorescent lamps

Lamps producing discontinuous light

> Flashbulbs
> Speedlights

Floodlamps have high light output and relatively short life. They produce continuous and rather evenly distributed light suitable for both black-and-white and, if used at rated voltage, color photography with Type A and B color films. Floodlamps are equally suitable as main lights and as fill-in lights and are available in five different types:

p. 175

Photoflood lamps (3400K) look like ordinary frosted household bulbs, but they produce considerably more light per watt. Because they are overloaded, they burn out in a few hours. They are the least expensive source of high-intensity photo-illumination. For maximum efficiency, they must be used in suitable metal reflectors. They are designed for use with Type A color films.

Professional tungsten lamps (3200K). In appearance and use, these lamps are similar to photoflood lamps, but since they are less overloaded, their light is slightly more yellow and their light-output is somewhat more constant in color and brightness throughout the lamp's life, which is longer than that of a photoflood. They must be used in suitable metal reflectors and are designed for use with Type B color films.

Blue photoflood lamps (4800K). These are ordinary photoflood lamps which have blue instead of colorless glass bulbs. They are intended mainly as fill-in and supplementary lamps for use with daylight color film in daylight color shots of interiors in which the main illumination is provided by daylight coming through windows. They must be used in metal reflectors. If they provide the sole source of illumination, because their light is slightly more yellow than standard daylight, photographs taken with blue photofloods on daylight color film have warmer, more yellow tones than photographs taken in daylight, an effect which can be very pleasing. Used with panchromatic films, blue photoflood lamps render red

146

and reddish tones somewhat darker than regular photofloods, an effect which makes these lamps particularly suitable for taking portraits of men.

Reflector floods and reflector spots. Lamps of this type have their own reflector built into the bulb. This, of course, makes them very convenient when one is traveling because it reduces the amount of equipment to be carried. They come in a number of different makes and models that give a photographer a choice of floodlight and spotlight effects, and larger and smaller lamps with higher or lower light output. Lamps of this type are available with color temperatures of either p. 253 3400K or 3200K for use with Type A and B color films, respectively.

Quartz-iodine lamps (also called "iodine-quartz" or "halogen" lamps). These lamps have a tungsten filament mounted inside a Vycor or quartz tube filled with iodine gas. A tungsten filament glowing at high temperatures in an atmosphere of nitrogen gas evaporates a continuous stream of microscopic particles which are deposited on the inside of the glass bulb, darkening it with age. Iodine gas prevents this darkening and the light output of the lamp remains constant during its twenty-five to thirty-hour life. Quartz-iodine lamps produce an intensely bright light. They are powered either by A.C. house current or by a battery pack which makes it possible to use such lamps outdoors as fill-in lights. Quartz-iodine lamps are available in two types: those that produce light of 3400K for use with Type A color films, and those that burn at 3200K for use with Type B color films.

Spotlights concentrate the light of a projection-type filament lamp by means of a spherical mirror behind, and a condenser or Fresnel lens in front of, the bulb. All better spotlights can be focused, i.e., the light can be varied from a narrow beam to a broad cone by adjusting the lamp and reflector in relation to the condenser. Spotlights give a sharper and more intense illumination than floodlamps and their light makes harsher and more sharply defined shadows. They are good main lights and accent lights; they cannot be used as shadow fill-in lights. Most p. 175 spotlights are suitable for color photography with Type B films if they are equipped with a 3200K lamp. A spotlight with a greenish condenser lens may cause a slightly greenish color cast; this can be prevented if a suitable CC filter is used (the right p. 141 filter must be determined by test). Spotlights come in many sizes from tiny baby spots of 150 watts for table-top photography to the huge 5000-watt lights used in commercial studios for lighting sets.

Fluorescent lamps emit light that differs from ordinary types of light (daylight, tungsten light) in that it has a line spectrum superimposed upon a continuous spec-

147

trum. This is of no consequence in black-and-white photography, but it is in color photography. The same colors seen in daylight and in fluorescent light may appear identical to the eye, but differences in the spectral composition of these two types of light would make these colors appear different if photographed on color film. For this reason, fluorescent lamps are basically unsuited to color photography.

On the other hand, since fluorescent light is becoming more and more widely used, taking color photographs in fluorescent light is often unavoidable. Recognizing this, Kodak has suggested the following light and filter combinations and accompanying exposure increases for use with Kodak color films which, however, are only intended as a starting point for test series to be made by the individual photographer. In mixed daylight and fluorescent light illumination, suitable filtration is very difficult and may even be impossible to achieve.

| Kodak color film type | Daylight | Type of fluorescent lamp | | |
		White	Warm white	Cool White
Daylight Type	20M + 20Y + ⅔ stop	Not recommended	Not recommended	Not recommended
Type B and Type L	85B + 30M + 30Y + 1 stop	20M + 20Y + ⅔ stop	20M + 20Y + ⅔ stop	40M + 50Y + 1⅔ stop
Type A	Not recommended	30M + 10Y + 1 stop	30M + 1 stop	30M + 40Y + 1⅓ stop
Type S and Kodacolor	Not recommended	20M + 10Y + ⅔ stop	20M + 10Y + ⅔ stop	30M + 20Y + 1 stop

NOTE: This table does not apply to deluxe fluorescent lamps.

Fluorescent light has a softly diffused quality and is, particularly if a number of fluorescent tubes are mounted together in a bank, virtually shadowless. In black-and-white photography this makes fluorescent lamps unsurpassed for shadow fill-in and for subjects which require shadowless illumination.

Flashbulbs give an intense light for a fraction of a second, then burn out. Most flashbulbs are designed for use with synchronizers that time the instant of ignition so that the lamp's peak (the moment of maximum light output) coincides with the instant the shutter is wide open. Synchronizers providing different time-lag settings (M for Class M flashbulbs and X for speedlights) must be set correctly or flash and shutter will not synchronize.

Flashbulbs differ in the following respects:

Color. There are two types: clear-glass flashbulbs designed for black-and-white photography. Their color temperature is 3800K.

Blue (lacquered) flashbulbs designed to provide supplementary light (primarily for shadow fill-in) for use with daylight color films. Their color temperatures range between 6000K and 6300K. However, their spectral energy distribution *does not accurately match* that of daylight, and the color rendition of transparencies taken entirely with blue flash will be different from those of the same subject taken in daylight on daylight color film. Instructions for the use of blue flashbulbs to supplement daylight will be given later. p. 280

Time to peak and base. Distinguish between four classes:

Class MF glass-base midget flashbulbs are designed for synchronization with all popular box cameras; with X or F settings, use a shutter speed of 1/25 or 1/30 sec.; with M setting, any shutter speed. Time to peak is about 15 ms (15 milliseconds or 15/1000 sec.).

Class M (medium peak) bayonet base flashbulbs are designed *for synchronization with between-the-lens shutters.* They can be synchronized at any shutter speed. Time to peak is about 20 ms.

Class S (slow peak) screw-base flashbulbs can be synchronized with special shutters at 1/25 or 1/50 sec. but are normally *suitable only for open flash:* set shutter on B, open shutter, fire flashbulb, close shutter. These are large and powerful flashbulbs providing up to 200,000 lumen-seconds each. Time to peak is about 30 ms.

Class FP (focal-plane) flashbulbs are *suitable only for synchronization with focal-plane shutters.* These flashbulbs have a relatively long peak of more or less uniform intensity which exposes the entire negative evenly while the opening in the shutter curtain scans it. Time to peak is about 15 ms; duration of peak is from 20 ms to 40 ms, depending on the respective flashbulb.

Light output. The larger the flashbulb, the higher its light output. The total light output of flashbulbs is measured in lumen seconds and, depending upon the type of flashbulb, it ranges from 2000 to approximately 200,000 lumen seconds.

Exposure with flashbulbs

To provide a basis for calculating an exposure, flashbulb manufacturers assign specific guide numbers to their products. This method, which is simple and accurate, is based upon the relationship between film speed, shutter speed, diaphragm stop, light output of the flashbulb, reflector efficiency factor, and distance between

subject and bulb. In any given case, five of these six factors are either constant —the film speed, the light output of the flashbulb, and the reflector efficiency factor—or can easily be determined—the shutter speed that will be used and the distance between subject and flashbulb. Only the diaphragm stop number has to be determined. This can easily be done by using the following formula:

p. 85

$$\text{f-stop number equals } \frac{\text{guide number}}{\text{distance in feet between subject and flashbulb}}$$

For example: if the guide number for a specific combination of film, flashbulb, and shutter speed is 110 and the distance between subject and flashbulb is 10 feet, divide 110 by 10 and you have 11 as the correct f-stop number.

(NOTE: Guide numbers are not given here because the number of different flashbulbs is very large and guide numbers change when a film or flashbulb manufacturer changes his product. Guide number tables, available at photo stores, contain the latest information. Such tables are given away.)

F-stop values established with the aid of guide numbers apply only if a single flashbulb is used and if subjects with average colors are photographed in a room of medium size that has light (but not white) walls and a white ceiling. Under all other conditions, the following corrections must be made:

If subjects are predominantly light, decrease the diaphragm opening by one-half stop if color film is used, by one full stop if black-and-white film is used.

If subjects are predominantly dark, increase the diaphragm opening by one-half stop if color film is used, by one full stop if black-and-white film is used.

In small rooms with white walls and ceiling, decrease the diaphragm opening by one full stop.

If two flashbulbs are used side by side, decrease the diaphragm opening by one full stop or multiply the guide number by 1.4.

If three flashbulbs are used in a cluster, decrease the diaphragm opening by 1½ stops or multiply the guide number by 1.7.

If four flashbulbs are used in a cluster, decrease the diaphragm opening by 2 full stops or multiply the guide number by 2.

Multiflash exposures

If two identical flashbulbs are placed at equal distances from the subject—one

150

lamp at the camera (for shadow fill-in light) and the other at an angle of 45 degrees to the subject-camera axis (acting as a main light)—decrease the diaphragm opening by one full stop.

If two or more flashbulbs of the same type are used to evenly illuminate a large area—each bulb illuminating a separate area with very little overlap of illumination—the exposure must be computed as if a single flashbulb were used.

If two or more of the above conditions apply, they must be considered together.

Speedlights

Speedlight (or electronic flash or EF) has the following advantages over conventional flashbulbs: a repeating-type flashtube which provides thousands of flashes before it must be replaced; extremely short flash duration ranging from 1/300 sec. to 1/5000 sec. in regular models and as short as 1,000,000 sec. in speedlights designed for special purposes; a flash so short that it is almost invisible which, in portraiture, is much easier on the eyes of the sitter; and a soft light which makes speedlight particularly good for color photography since it decreases subject contrast. Drawbacks: The main factor is weight. Other disadvantages are: relatively low light output (for small portable units, light output is comparable to that of the smallest flashbulbs); voltage up to 10,000 volts combined with an amperage which, in the larger units, is sufficient to cause lethal shocks; and a relatively high price (though operational cost is lower than it is for flashbulbs).

The light of an electronic flash tube is supposed to match daylight but it is often more bluish, having a color temperature of around 7000K. Consequently, in taking photographs on daylight color film, a pale red light-balancing filter may be required. If electronic flash is used outdoors as a fill-in light, it is advisable to place the filter in front of the lamp instead of the lens, otherwise it would change the effective color of the daylight. Some speedlights have a built-in filter or are equipped with a tinted reflector. Whether a filter is needed, and if so, what its color and density should be, can only be determined through testing. p. 253
p. 138

The light output of a speedlight is primarily governed by the capacity of its condensers. (Other factors are: voltage, resistance, tube design, and reflector efficiency.) It is usually given in watt-seconds.* However, since this capacity is de-

* One watt-second corresponds to the amount of energy necessary to maintain a current of one ampere against a resistance of one ohm for the duration of one second. It is equivalent to one joule which is equivalent to 10 million erg. The erg is the basic unit of energy.

151

pp. 149-150

termined by a mathematical formula which does not take into consideration the efficiency of the flashtube or the reflector, it is not uncommon that units of the same listed watt-second rating differ noticeably in light output, guide number, and, of course, exposure. Again, tests are required to establish the *effective* (as compared to the *listed*) guide number of the respective unit in conjunction with a specific type of film.

An important consideration in buying a speedlight is its recycling time—the time needed for the condenser to recharge to capacity and be ready to deliver the next burst of energy. Depending upon the circuitry, the capacity of the condenser, and the type of battery used (see below), recycling time varies from one to fifteen seconds and more. The time needed increases as voltage of the batteries goes down with age and use. Usually, a neon lamp lights when the unit is ready to fire. However, this light often goes on before the condenser is fully charged and under-exposure may result. Consequently, if possible, it is good practice to wait a few additional seconds before flashing again to be sure that the condenser will deliver a full charge.

Speedlights are powered either by A.C. house current or by batteries. Different speedlight manufacturers use different types of batteries, each having certain advantages as well as disadvantages. The following are those most commonly used at this time:

Nickel cadmium cells are the most economical. They can be recharged more than 500 times. They deliver from seventy to a hundred flashes per charge.

Mercury cells cannot be recharged, but they have a higher capacity than any other battery of comparable size. One of their characteristics is that voltage remains constant until they fail. Another is their relatively high price.

Manganese-alkaline cells produce more flashes than any other low-voltage battery, almost ten times as many as ordinary D-type flashlight cells; and although their initial cost is considerably higher, their cost per flash is less. They have a shelf life of approximately three years.

Zinc-carbon cells (D-cells) are ordinary flashlight batteries. Their advantages are that they are cheap and available anywhere; their disadvantages are that they are unreliable at low temperatures and that they have a shelf life of only one year.

High-voltage batteries are made of the same basic components as zinc-carbon cells and consequently have their faults: poor low-temperature performance and

152

a shelf life of about a year. On the other hand, they permit simpler and more effective circuits, eliminate the need for transformers, and have exceptionally short recycling times of only a second or two and are thus ideally suited to sequence and action photography.

Exposure with speedlights

Speedlight exposures are calculated according to the same guide number method pp. 149-150 as that used for flashbulb exposure calculation, except that the shutter speed can be disregarded as a factor because the duration of speedlight exposures is determined by the duration of the flash, not the shutter speed. Before the reader accepts the manufacturer's listed guide number, I suggest that he make a test to confirm or revise it because different types of color film, depending on their characteristics, respond differently to short exposures.

SOME PRACTICAL SUGGESTIONS

The type and number of lamps a photographer needs depends, of course, on the kind ot work he intends to do. He should, however, consider the following:

Lamps that produce continuous light have the great advantage that the photographer can see exactly what he is doing: he can avoid overlighted areas; he can use an exposure meter to check the contrast ratio of his subject to produce printable negatives or well-balanced color transparencies; he can see which part of the subject will catch the light and which will be in shade; and he can control the position of shadows. Disadvantages of this type of light are its relatively low intensity which prohibits the use of action-stopping high shutter speeds, and the large amount of heat generated by floodlamps and spotlights which, if placed too close, can scorch paper and wood and blister paint.

Lamps that produce discontinuous light have, of course, the great advantage that they enable a photographer to render motion sharp. In this respect, although electronic flash is superior for stopping action, flashbulbs have the edge over speedlights in that they are much more efficient when high-intensity illumination is needed; flashbulbs provide it at a fraction of the cost, weight, and bulk that an equally effective speedlight setup would entail. On the other hand, a speedlight has the advantage of being a repetitive light source—no time is wasted as it is in changing flashbulbs. The main disadvantage of all lamps that produce discontinuous light is, of course, that the photographer cannot know precisely how light and shadow will be distributed in the picture. (Some electronic flash lamps incor-

porate small incandescent modeling lights to facilitate setting up the lights.) Nor can he measure his subject's contrast range.

Reflectors. Their design has a considerable influence upon the quality of the light. Equipped with the same kind of lamp, a reflector that is small in diameter produces a harsher, more concentrated light than a reflector that is large in diameter which produces a softer illumination with less sharply defined shadows. Equipped with the same kind of bulb, a smooth or highly polished reflector produces a harsher, more concentrated illumination than a satin-finish reflector or one that has pressed-in ridges which produce a softer and more diffused illumination. If incorrect exposures are to be avoided, one must remember that guide numbers for flashbulbs always relate to specific types of reflectors. Reflectors that "stack" take considerably less space than those that do not.

Light stands. Consider their length when collapsed—they should not be too long to fit in your traveling case. A boom extension arm that fits on a light stand is invaluable. Clamp reflectors or Gator Grip clamps are good substitutes for additional light stands and they take less space.

Advice on the use of electric power

Ordinary home wiring is dimensioned for average household needs. In comparison, photographic lights take relatively large amounts of power. To know how many lamps can safely be connected to one circuit, multiply the voltage of the powerline by the number of amperes of the fuse. The result is the number of watts that can be safely drawn from the circuit. For example, if the line carries 120 volts and the fuse can take a load of 15 amperes (this is the most common combination), multiply 120 by 15. The result is 1800 watts, the maximum load that may be drawn from the circuit without the danger of blowing a fuse. This means that you can simultaneously use three 500-watt bulbs, or two 500-watt and three 250-watt bulbs, or one 500-watt and five 250-watt bulbs, or seven 250-watt bulbs; this leaves 50 watts available for other purposes, for example, a weak room or ceiling light for general illumination between shots.

To avoid blowing a fuse, additional lights must be connected to a different circuit. You can determine the different circuits by connecting lamps to different outlets and unscrewing fuses one by one. All the lamps that go out when a certain fuse is unscrewed connect to the same circuit, while the lamps that remain lit are controlled by a different fuse.

The fuse is the safety valve of the powerline. It is an artificial weak link designed

to break under overload to protect the line from destruction. If you accidentally blow a fuse, do not replace it with a stronger fuse, a coin, or a wad of aluminum foil instead of the fuse. If you do, it will be the powerline itself that melts, and the resulting short-circuit may start a fire that can burn the house down.

The chances of accidentally blowing a fuse can be virtually eliminated by following these suggestions:

When buying electrical equipment or wiring, preference should be given to those items that carry the UL (Underwriters Laboratories) label. It is a guarantee that they meet certain safety standards which merchandise that lacks this label may not meet.

Do not reconnect equipment that caused a fuse to blow without first finding and eliminating the cause of the short-circuit.

Do not use electric wires with cracked, frayed, gummed, or otherwise damaged insulation or broken plugs. When disconnecting an electric cord, do not grab the wire and jerk but grip the plug and pull it out straight.

Be sure to place your temporarily strung wires so that people do not trip over them. Place them along the walls or furniture or cover them temporarily with a rug.

Do not nail or staple ordinary rubber-insulated electric wires to baseboards, walls, or ceilings. This type of wire is not meant for permanent installations. Depending on the local building code, only metal-sheathed cable or Flex should be used for fixed installations, and it should be installed by a qualified electrician.

If you have to splice a wire, first solder both connections, then insulate each of the two strands separately with moisture-proof tape before you tape the entire splice. It is better still to make a plug connection.

Do not overload wires. Be sure your wires are of sufficiently heavy gauge to carry the intended electrical load; ask the clerk at the hardware store for the right gauge. Touch the wire after the equipment has been in use for a while; it may get warm but it should never get uncomfortably hot.

Do not indiscriminately fire flashbulbs with house current (for example, in an attempt to simulate light from a table lamp). Although they may fit a lamp socket, most flashbulbs will blow the fuse. Flashbulbs that can be safely fired with house current up to 125 volts are General Electric's Nos. 22 and 50 and Sylvania's Nos.

155

2 and 3. If several flashbulbs have to be fired simultaneously, connect a large incandescent bulb in series to absorb shock and avoid blowing a fuse.

p. 253 **Voltage control.** The rated color temperature of photo-lamps applies only if the lamp is operated at the voltage specified by the manufacturer. Even changes of a few percent in line voltage are sufficient to alter the effective color temperature of the lamp. For example, a line fluctuation of 5 volts in a 120-volt circuit, applied to a high-efficiency photo-lamp, changes the color temperature by about 50K, the light output by about 12 per cent, and the life of the lamp by a factor of 2. In general, within the normal limits of voltage fluctuation, it can be assumed that the color temperature of a photo-lamp intended for operation at 115 volts increases or decreases, respectively, about 10K with each increase or decrease in line voltage of one volt.

Color changes in transparencies due to changes in line voltage are most noticeable in pastel colors of low saturation and in neutral grays. If such colors predominate, a change in color temperature of only 50K may produce noticeable changes in color. If highly saturated colors predominate, color temperature changes up to 100K produce no serious color changes.

Specifically, below-normal voltage causes a color shift toward yellow and red, while a rise in voltage above the specified rate produces transparencies with a cold bluish cast in addition to shortening lamp life.

Fluctuations in line voltage are usually caused by abnormally high or low consumption of electric current (during peak hours, line voltage is most likely to drop to serious lows). Fluctuations which originate in the same building in which the studio is located (elevators, refrigerators going on and off) can be avoided through the installation of a direct line between the studio and the power main in the street. However, voltage fluctuations may also be caused by improperly dimensioned wiring and, on occasion, by temporary overloading with electric equipment.

If the line voltage is *consistently too low,* the simplest way to compensate for voltage deficiency is to measure accurately the color temperature of the lights under actual working conditions (with all lights turned on simultaneously), and to correct the yellowishness of the illumination with the aid of the proper blue light balancing filter. If the voltage *fluctuates constantly,* the only way to get consistently good color rendition is to stabilize the voltage through the installation of special voltage-control equipment.

How to Take a Photograph

Mastery of photo-technique is the first requirement for making good photographs. A photographer may be highly sensitive to beauty; he may perceive a truth which others fail to see; he may suffer with the oppressed or be privileged to witness great events—but his gifts and experiences will be of no avail unless he knows how to express them on film and sensitized paper.

Most students of photography make the mistake of expecting too much too soon. They want results without practice. They may remember periods of learning which required hard work and entailed frustration. If photography is their hobby, they want to encounter nothing of that sort. They think a hobby should provide fun and relaxation. But it is neither amusing nor relaxing if poor photo-technique makes pictures disappointing. To avoid this, one must start with fundamentals and systematically learn the elements of the craft. They are presented in the following sections.

This is what happens when you make a photograph

Light strikes the subject, is reflected by it, and makes it visible to the eye as well as to the lens.

The lens refracts the light reflected by the subject, forms an image of the subject, and projects it onto the light-sensitive film.

The film responds to the light to which it is exposed in proportion to the intensity of the light. A latent, i.e., invisible, image is formed by chemical interaction of the light with the molecules of the sensitized emulsion.

Development transforms the latent image into a visible image. Depending on the type of film, this image is either negative or positive: negative in ordinary black-and-white photography and if negative color film is used; positive if reversal color film is used. In a negative image the values of light and dark are reversed; in a color negative subject color is represented by complementary color. The developed film must be made impervious to further exposure by fixing in a chemical solution. To make it permanent, it must then be freed from all processing chemicals by washing or other stabilizing process before it can be dried.

Printing reverses the tone values of the image—the negative becomes a positive image. Printing—contact-printing or enlarging—of black-and-white and negative color film is essentially a repetition of the process of exposing and developing a film: the image contained in the negative is projected onto the light-sensitive emulsion of the paper, where interaction between light and emulsion produces a latent image which, after being developed, fixed, and washed, becomes the final picture.

The technically perfect negative or color transparency

The first requirement for any good photograph is a technically perfect negative or color transparency. Such a negative or transparency combines sharpness of rendition (or a deliberately chosen degree of unsharpness or blur) with the right degree of density (or proper color balance) and contrast. And, of course, it is also absolutely clean—free from spots, specks of dust, scratches, and fingermarks.

Three vital operations

The three operations that determine whether a negative or color transparency will be technically perfect are

> focusing
> exposing
> developing

How these operations, their controls, and the results they produce, are interrelated, is shown in the diagram on the opposite page.

Three kinds of sharpness

Notice that three kinds of sharpness are listed in the opposite diagram:

Sharpness of focus is essentially two-dimensional sharpness more or less limited to the plane on which the lens was focused. It is a function of focusing.

p. 160

Sharpness in depth is three-dimensional sharpness which, in the picture, extends in front of and behind the plane of focus. It is the combined results of focusing (which places the plane of focus at the desired distance from the camera) and diaphragm stop (which extends the depth of the sharply covered zone to the desired degree).

pp. 162-163

Sharpness of motion means that a subject in motion has been rendered sharp instead of blurred. This is done by accurate focusing—by placing the plane of focus at the distance from the camera where the moving subject is located—and using a shutter speed high enough to "stop" the subject's motion in the picture.

p. 302

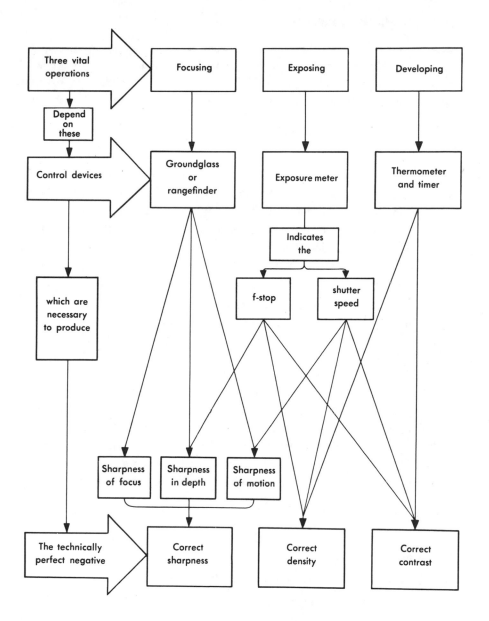

Three vital operations → Focusing Exposing Developing

Depend on these

Control devices → Groundglass or rangefinder Exposure meter Thermometer and timer

Indicates the

f-stop shutter speed

which are necessary to produce

Sharpness of focus Sharpness in depth Sharpness of motion

The technically perfect negative → Correct sharpness Correct density Correct contrast

HOW TO FOCUS CORRECTLY

Focusing means adjusting the distance between lens and film in accordance with the distance between lens and subject to produce a sharp image. Sharpness is relative. Most negatives have areas that are sharp and areas that are less sharp but not really unsharp. Where actually does sharpness end and unsharpness begin?

Definition of sharpness

Theoretically, sharpness is when a point-source of light (for example, a star) is rendered in the negative as a point. Practically, of course, this rendering is impossible because even the smallest image of a star is not a point (which has a diameter of zero) but a circle. Similarly, the image of a subject is not composed of an infinite number of points, but of an infinite number of tiny overlapping circles called "circles of confusion." The smaller these circles of confusion are, the sharper the image appears.

For practical purposes, the definition of sharpness has been related to negative size for the simple reason that small negatives must be sharper than large negatives because they must be able to stand higher degrees of magnification during enlarging. Generally, depth-of-field scales and tables (that give the extension of the sharply covered zone in depth at different diaphragm stops in conjunction with different subject-to-camera distances for lenses of different focal lengths) are computed on the basis that negatives 2¼ x 2¼ inches and larger are "sharp" if the diameter of the circle of confusion is no more than 1/1000 of the focal length of the lens standard for the negative size. And a 35-mm negative is considered "sharp" if the diameter of the circle of confusion is not more than 1/1500 of the focal length of the standard lens which corresponds to a diameter of 1/750 inch.

p. 165

Causes for unsharpness

Whether or not this degree of sharpness is achieved depends upon the following factors:

The sharpness of the lens, see pp. 106-107.

The sharpness of the film, see pp. 126-127.

Subject movement. If a subject in motion is photographed, the image of the subject moves across the film during the exposure with the result that it will be rendered more or less blurred unless the photographer uses a shutter speed high

enough to "stop" the motion of the image on the film. How high the shutter speed must be depends on the speed of the subject, its distance from the camera, and the direction of its motion in relation to the optical axis; consult the table on p. 302.

Camera movement. In practice, it makes no difference whether the subject moves during the exposure and the camera is motionless or whether the subject is motionless and the camera moves; both will blur the picture unless, of course, a sufficiently high shutter speed is used. To avoid blur due to camera movement, a photographer must learn to hold his camera perfectly still while making the exposure. He should brace himself—feet slightly apart and elbows tight against his ribs—press the camera firmly against forehead and cheek, hold his breath, and gently "squeeze" the shutter release button as carefully as a sharpshooter squeezes the trigger of his rifle in order not to spoil his aim. In this way, most people can hand-hold exposures as long as 1/25 sec. without moving the camera. For longer exposures, or when telephoto lenses are used, the camera must be more firmly supported, either pressed tight against a rigid support or mounted on a tripod, if unsharpness due to camera motion is to be avoided.

Rangefinder out of synchronization. To check, make the following test: Take a magazine page in which printing is clear and sharp. With a grease-pencil or ballpoint pen, at approximately the center of the page, draw one line above, another below the same line of print. Tape this page to a wall so that its lines run *vertically* and use it as a test object. Mount your camera on a tripod, the lens axis horizontal and its height that of the center of the printed page. Place your tripod to one side of the magazine page three to four feet from it *at an angle of approximately 45 degrees* (this is not critical). Sharply focus on the type between the two lines you drew and take a picture at full lens aperture. Examine the developed negative with a magnifying glass. If the type between the lines is sharpest and all else is more or less unsharp, the rangefinder and the lens are correctly synchronized. If a line of type before or behind the line on which you focused is sharpest, the rangefinder and the lens are out of sync and they must be correctly synchronized by a competent repair man before the camera can produce sharp photographs.

Dirty lens. Fingermarks on the glass, or a filmy deposit of grease and dust particles, act as diffusers and produce over-all softness of the image. To correctly clean a dirty lens, use a soft camel's hair brush to remove all traces of dust and grit from both surfaces; breathe on the glass and, with a piece of lens-cleaning

tissue, gently wipe it clean. To avoid scratching the anti-reflection coating, don't press too hard. Make it a habit never to touch the glass with your fingers—the ever-present acid sweat might leave indelible marks.

A dirty filter has the same effect as a dirty lens.

Inferior filter quality, see p. 137.

Overexposure and overdevelopment of the film, see pp. 167 and 195.

Buckling film. Film is not always flat in the camera. Under humid conditions, film, which is very hygroscopic, absorbs moisture and may buckle out of the plane of focus, the tendency to buckle increasing with film size. Particularly when using filmpack, to minimize the danger of partial or total unsharpness it may be necessary to stop down the diaphragm beyond normal to create a "safety zone" of extended sharpness in depth.

Turbulent air (heat waves), see p. 314.

Focus shift of the lens. A lens otherwise excellent may shift the plane of focus with a change in diaphragm stop. (A red filter will have the same effect if the lens is insufficiently color corrected.) If a photographer focuses such a lens with the diaphragm wide-open (or without the red filter in place) and then stops down (or places the red filter in front of the lens) without refocusing, the negative will be unsharp. To get sharp pictures with such a lens it must be focused with the same diaphragm stop with which the picture will be made (or with the red filter in position).

How to get sharpness in depth

Most photographic subjects are three-dimensional: in addition to height and width they have depth. This fact immediately raises two questions: Which depth zone of the subject shall be chosen to focus on? How can sharpness be extended beyond the plane of focus to cover the entire depth of the subject?

An experiment . . .

The simplest and most instructive way to learn how to create sharpness in depth is to mount an SLR or a groundglass panel-equipped camera on a tripod and focus it obliquely on a subject that has great extension, for example, a picket fence.

With the diaphragm wide-open, focus on a pale about 3 feet from the camera. Notice that the pale focused on is perfectly sharp, that the pale in front of it and two or three behind it appear reasonably sharp, and that all the others are un-

sharp, appearing increasingly blurred the farther they are from the plane of focus, i.e., the pale focused on.

With the diaphragm wide-open, focus on a pale about 30 feet from the camera. Notice that now quite a number of pales in front of the one focused on appear sharp and that beyond the plane of focus everything appears sharp.

Focus on a pale about 10 feet from the camera and, while gradually closing down the diaphragm, observe the image on the groundglass. Notice that, as the diaphragm opening is decreased (and the image darkens), more and more pales become sharp.

. . . and its evaluation

Such an experiment will lead to the following conclusions which, incidentally, contain the "secret" of creating sharpness in depth:

1. A certain amount of sharpness in depth is inherent in any lens. The slower the lens, the shorter its focal length, and the farther the plane of focus from the camera, the deeper the inherent zone of depth.

p. 83

2. Normally, the "inherent depth" of a lens is insufficient to cover the entire depth of the subject. It then becomes necessary to artificially increase the zone of sharpness in depth. The means for this is the diaphragm.

3. The more the diaphragm is stopped down, the more extensive the zone of sharpness in depth.

4. Also, the more the diaphragm is stopped down, the darker the image and the longer the exposure necessary, with all the attendant disadvantages. Consequently, practical considerations make it desirable to create a maximum of sharpness in depth with a minimum of stopping down.

5. Stopping down the diaphragm creates a zone of sharpness in depth in front of and behind the plane of focus. Consequently, it is wasteful to focus on either the beginning or the end of the depth zone that must be rendered sharply and then stop down the lens accordingly. For example, focusing on infinity and stopping down the lens is wasteful because depth beyond infinity is useless.

6. Stopping down the diaphragm creates proportionally more sharpness in depth behind the plane of focus than in front of the plane of focus. This being the case, the best way to cover a three-dimensional subject in depth is to

> focus the lens on a plane situated approximately
> one-third within the subject's depth

and to stop down the diaphragm until the entire subject is covered sharply.

163

How much to stop down

The simplest way to determine the diaphragm stop necessary to cover a given zone in depth is to observe the image on the groundglass. Cameras that do not permit this are usually equipped with a depth-of-field scale on the lens or on the focusing knob. To use this scale to fullest advantage, focus first on the closest, then on the most distant part of the subject which must be rendered sharply, to determine their distances from the camera. Note each distance as registered on the foot-scale. Refocus the lens until identical diaphragm stop numbers appear on the depth-of-field scale opposite the foot-numbers that correspond to the beginning and the end of the zone that must be sharply covered. Leave the lens as focused and stop down the diaphragm to the f-number that appears opposite the foot-numbers that correspond to the distances at the beginning and the end of the subject-depth. In this way a maximum of sharpness in depth is achieved with a minimum of stopping-down.

To recapitulate: The smaller the diaphragm aperture, the greater the extent of the sharply covered zone in depth. The actual extent of this zone—the *depth of field*—is dependent upon:

The distance between subject and camera. The farther away the plane of focus, the greater the extent of the sharply covered zone in depth created by a given diaphragm stop; and vice versa. For this reason, close-ups generally require smaller diaphragm stops than long shots, because at short subject distances stopping-down is "less effective."

p. 82 **The focal length of the lens.** In practice, the shorter the focal length of the lens, the greater the extension in depth sharply covered by a given diaphragm stop. However, this is true only as long as lenses of different focal lengths are used from the same working distance. If identical f-stops are used and if the image size on the film (scale of rendition) is the same, the extent of the sharply rendered zone in depth is also the same, *regardless of the focal length of the lens*. For example, if a portrait is taken with a lens of 50 mm focal length from a distance of 3 feet, and another shot is made with a lens of 200 mm focal length from a distance of 12 feet, the scale of both images will, of course, be the same. And if both pictures are made with identical diaphragm stops, depth of field will also be the same in both, although one was made with a short-focus and the other with a long-focus pp. 291-293 lens. However, as we will see later, the perspective of the two pictures would be different.

164

A snapshot system

The interrelationship between subject-to-camera distance, focal length, and f-stop makes it possible to adjust the camera controls in such a way that a maximum of depth is sharply covered with a minimum of stopping down. Accordingly, by presetting the camera, a photographer can considerably increase his readiness for sudden events and still render his subjects sharply. In the following table such data is given for four different film sizes. Provided that the respective camera has a lens of standard focal length and the camera is correctly preset, negatives and color transparencies will be sharp. Shutter speeds must be preset in accordance with light conditions.

Camera settings for medium distances				Camera settings for hyperfocal distances		
f-stop	focus at	depth of field	film size and focal length	f-stop	focus at	depth of field
f/8	10'	8'-13'	35 mm F/2"	f/0	30'	15'-∞
f/11	15'	10'-30'		f/11	20'	10'-∞
f/8	10'	8½'-15'	2¼ x 2¼" F/3"	f/8	32'	16'-∞
f/11	15'	11'-32'		f/11	22'	11'-∞
f/8	10'	10'-15'	2¼ x 3¼" F/4½"	f/8	46'	23'-∞
f/11	15'	12'-20'		f/11	34'	17'-∞
f/8	15'	13'-18'	4 x 5" F/6"	f/8	62'	31'-∞
f/11	15'	11'-22'		f/11	44'	22'-∞

I suggest that the reader copy in his camera case with India ink those data that will be useful to him.

The hyperfocal distance

It is often necessary that a photograph be sharp from a specific distance from the camera to infinity. To achieve this with a minimum of stopping down, the lens must be focused on hyperfocal distance.

When a lens is focused on infinity, sharpness extends from infinity for a certain distance toward the camera (the exact distance varies with the focal length of the lens, the diaphragm stop, and the accepted circle of confusion). The distance from the camera at which sharpness begins is called the "hyperfocal distance." If the lens is refocused at the hyperfocal distance and the f-stop remains the same,

p. 160

165

sharpness in the picture extends from half the hyperfocal distance to infinity.

The hyperfocal distance can be determined by the following formula:

$$\text{Hyperfocal distance equals } \frac{F^2}{f\,d} \text{ inches.}$$

p. 160 In this formula, F is the focal length of the lens in inches; f is the diaphragm stop number; d is the diameter of the accepted circle of confusion in fractions of an inch.

For example, a photographer wishes to make a picture in which sharpness in depth will extend from infinity to as close to the camera as possible, using a 5-inch lens stopped down to f/22. Sharpness of the negative should be governed by the requirements stated previously according to which the diameter of the circle of confusion must not exceed 1/1000 of the focal length of the lens. In this case, this would be 5/1000 or 1/200 of an inch. To produce the maximum extent of sharpness in depth, the lens must be focused at hyperfocal distance. Then everything from half that distance to infinity will be rendered sharp. The hyperfocal distance can be found by the formula given above which leads to the following equation:

Hyperfocal distance equals

$$\frac{F^2}{f\,d} = \frac{5^2}{22 \times 1/200} = \frac{25}{22} \times 200 = 227 \text{ inches} = \text{approximately 19 feet.}$$

Accordingly, by focusing the lens at 19 feet and stopping down to f/22, a sharply rendered zone can be created which begins at 9½ feet from the camera (half the hyperfocal distance) and extends to infinity.

The f-stop number that will result in the sharp rendition of any depth zone from infinity to a given distance from the camera can be found by the following formula:

$$\text{f-stop number equals } \frac{F^2}{H\,d}$$

Here, F is the focal length of the lens in inches; H is the hyperfocal length in inches; d is the diameter of the accepted circle of confusion in fractions of an inch.

For example, a photographer wishes to shoot a picture in which sharpness extends from infinity to 25 feet from the camera. He uses a 5-inch lens and accepts a circle

166

of confusion with a diameter of 1/1000 of the focal length of the lens or 1/200 inch. He knows that to get a maximum of depth with a minimum of stopping-down he must focus the lens at twice the distance at which sharpness in the picture should begin or, in this case, at 50 feet from the camera. But how far must he stop down the diaphragm to create a zone of sharpness in depth sufficiently to cover the distance from 25 feet to infinity? Here is the answer:

$$f = \frac{F^2}{H\ d} = \frac{25}{600 \times 1/200} = \frac{25}{600} \times 200 = \frac{5000}{600} = 8.3$$

Accordingly, by focusing the lens at a distance of 50 feet and stopping down to f/8.3, he can create a sharply covered depth zone which begins at 25 feet (half the hyperfocal distance) and extends to infinity.

With the aid of these two formulas, anyone can easily compute a table of hyperfocal distances for his lenses at different diaphragm stops. Such a table will prove invaluable when a maximum of depth must be covered with a minimum of stopping-down to conserve lens speed and reduce exposure times.

HOW TO EXPOSE CORRECTLY

One of the requirements for a technically perfect negative or color transparency is correct exposure.

A correct exposure results when the exact amount of light necessary to produce negatives with the right density and color transparencies with pleasing colors is admitted to the film.

Overexposure (caused by too much light) produces negatives that are too black and too dense and transparencies in which color is too light or completely washed out. Highlights (the darkest areas in a negative and the lightest areas in a color transparency) are frequently surrounded by haloes which will spill over into adjacent parts of the image. In black-and-white photography, overexposure also decreases sharpness through light-diffusion within the film emulson, promotes graininess, and produces negatives in which over-all contrast is abnormally low.

Underexposure (caused by too little light) produces negatives that are too thin and transparencies in which color is too dark. Shadows lack detail and overall contrast is abnormally high.

The two devices which control exposure are the diaphragm and the shutter, each of which has a double function:

The diaphragm controls
- the amount of light admitted to the film
- the extension of sharpness in depth

The shutter controls
- the time light is admitted to the film
- the sharpness of subjects in motion

The interrelationship between diaphragm and shutter

A larger or smaller diaphragm aperture admits a wider or narrower beam of light to the film, while a higher or lower shutter speed permits this beam of light to affect the film for a shorter or longer time. Through this dual control, we can produce a correct exposure in many different ways because, as far as the exposure itself is concerned, the effect is the same if we combine a large diaphragm aperture and a high shutter speed (and admit a large amount of light for a short time), or a small diaphragm aperture and a low shutter speed (and admit a small amount of light for a long time).

To produce photographs that are not only *technically* perfect, but also *pictorially* and *graphically* pleasing, the most suitable combination of diaphragm aperture and shutter speed must be found. The basis for its determination is the data furnished by an exposure meter whose dials, correctly adjusted, simultaneously show all the possible combinations of diaphragm aperture and shutter speed which, under the prevailing light conditions, will produce a correctly exposed negative or color transparency. The combination chosen depends upon three factors:

p. 132

Hand-held or tripod-mounted camera. Few people can hold a camera perfectly still for more than 1/25 sec. Accordingly, to avoid accidental unsharpness through camera movement, if a picture must be taken with the camera handheld, a shutter speed of 1/25 sec. or higher should be used and the diaphragm aperture adjusted accordingly. If the camera is mounted on a tripod, accidental camera movement is not a consideration and which shutter speed should be used will be determined by other factors.

Subject motion. If a subject in motion must be rendered sharp, a shutter speed high enough to "stop" its motion must be used and the diaphragm aperture adjusted accordingly. A table relating subject motion and shutter speed is given on p. 302.

Sharpness in depth. If this is important, a correspondingly small diaphragm aperture must be used and the shutter speed adjusted accordingly. How small the diaphragm aperture should be can be determined with the aid of the depth-

of-field scale engraved on the lens mount or the focusing knob of the camera or, lacking these, by direct groundglass observation or by consulting the depth-of-field table that applies to the respective lens.

How to use an exposure meter correctly

Exposure tables are sufficiently accurate for average demands under average conditions, but an exposure meter is necessary for precision work. Exposure meters not only permit a photographer to precisely measure the over-all illumination of a scene and detect minor fluctuations in brightness, but they alone enable him to accurately evaluate the contrast range of a subject through measurements of its lightest and darkest areas and, if photographs are taken indoors, to appropriately adjust the lights. Shadows and backgrounds that are too dark can thus be detected and lightened with fill-in illumination, and overlighted areas that would appear burned out in the picture can be toned down.

How to use a reflectance-type exposure meter

Begin by setting the film speed dial at the rated speed of the film to be exposed. Orthochromatic films have different speeds in daylight and tungsten light; be sure you use the right speed rating. Also be sure that the film speed rating and the exposure meter calibration conform to the same system. Foreign films may not use the ASA system, in which case their ratings must be converted to ASA ratings before the exposure for a foreign film can be established with an ASA-calibrated exposure meter; see table comparing ASA, B.S., and DIN ratings given on p. 125.

Over-all readings. To take an over-all reading, the photographer must *aim the meter at the subject from the camera position*. However, he must keep in mind that any abnormally bright area or light source within the acceptance angle of the meter will raise the reading and cause underexposure of the dark subject areas. Accordingly, outdoors, over-all light measurements must be made with the meter aimed at a point halfway between the horizon (or subject) and the foreground to prevent excessive sky light from inflating the reading. This is particularly important on overcast days when brightness of the sky is abnormally much higher than that of the landscape. Views that include white sand, large patches of snow, brilliant reflections on water, a strong source of light (backlighted scenes and city views at night), or unusually bright foreground matter such as a sunlit cement walk, if incorrectly measured, will inflate the meter reading.

Selective readings. The great advantage a reflectance-type light meter has over an incident light meter is that it permits a photographer to measure the bright-

ness of specific subject areas. This is particularly important when subject contrast is so high that it exceeds the contrast range of the film and accurate rendition of both the lightest and the darkest parts of the subject is impossible. Under such conditions, by selectively measuring the brightness of the most important part of the subject and adjusting the exposure accordingly, a photographer can at least be sure that the most important area of his subject will be exposed correctly.

To take a selective brightness reading, hold the meter 6 to 8 inches from the subject but be sure that neither the meter nor your hand casts a shadow upon the area measured, for it would falsify the reading and cause overexposure.

pp. 277-280 By taking selective brightness readings of the lightest and darkest areas of the subject, a photographer can establish its contrast range. However, in doing this, *he must disregard white and black and measure only those areas which must show detail in the picture.* For reversal color film, the maximum contrast range should not exceed 8:1 (corresponding to a three-stop difference); for negative color film, 16:1 (four stops); for black-and-white film, 64:1 (six stops).

If subject contrast exceeds the contrast range of the film, a photographer has several alternatives:

p. 280 If he has control over the illumination, he can rearrange the lights, use fill-in illumination to lighten shadows, add extra lamps to lighten the background, or increase the distance between lamp and subject to tone down overlighted subject areas. Outdoors, if subject distance is not too great, he can use daylight fill-in flash or speedlight illumination, or reflectors consisting of boards covered with crinkled aluminum foil, to lighten shadows that are too dark and thus make the contrast range of the subject compatible with the contrast range of the film.

If the photographer cannot control the illumination and subject contrast exceeds the contrast range of the film, he can do one of three things:

p. 120 If he uses reversal color film, he can set the arrow of the meter dial one and one-half diaphragm stops *below the value that corresponds to the highest brightness* p. 120 *reading* (two diaphragm stops if he uses negative color film; three diaphragm stops if he uses black-and-white film). This will give good rendition in contrast and color from the brightest subject areas on down, but dark subject areas and dark colors will be rendered too dark and will show little or no detail. This method, called "exposing for the highlights," is usually *the best compromise if reversal color film is used.*

Conversely, if he uses reversal color film, he can set the arrow of the meter dial

one-and-one-half diaphragm stops *above the value that corresponds to the lowest brightness reading* (two diaphragm stops if he uses negative color film; three diaphragm stops if he uses black-and-white film). This will give good shadow detail, color from the darkest color on up will be rendered correctly, but highlights will be overexposed or burned out entirely and light subject colors will appear too light or white, and in the negative, light subject areas will be rendered excessively dense. This alternative, called "exposing for the shadows," is usually *the best compromise if negative color or black-and-white film is used.*

And finally, he can settle for an intermediate exposure which will render all the intermediate tones and colors correctly but will render dark subject areas and colors too dark and detailless, and light subject areas and colors too light or burned out. Unless excessively light and dark subject areas are small and unimportant, this method gives the least satisfactory results.

Gray card reading. By measuring the brightness of a gray card instead of that of the subject, a photographer can in effect make incident light measurements with a reflectance-type exposure meter. To do this, he must hold a Kodak Neutral Test Card (which has the required reflectance of 18 percent) close to the subject so that it faces the camera* and take a brightness reading from it from a distance of 6 to 8 inches. Thus, by indirectly measuring the light that falls on the subject (instead of measuring the light reflected by it), if he takes card readings in both lighted and shaded subject areas, a photographer can establish the *lighting contrast ratio* of a scene. With reversal-type color film, the lighting contrast ratio should not exceed 3:1. However, if subject *color contrast* is below normal, i.e., if all subject colors are either light, medium, or dark, a lighting contrast ratio of 6:1 is still permissible. For negative color film, the lighting contrast ratio can vary from 4:1 to 8:1, and for black-and-white film, from 8:1 to 16:1, the higher figure applying when subject contrast is low. For an explanation of the terms "subject contrast," "lighting-contrast ratio," and "reflectance ratio" see p. 278.

White card reading. In dim light it may be impossible to get a reading with any of the methods so far described. It may, however, be possible to get a reading if a white card (having a reflectance of about 90 percent) is used; the reverse side of the gray Kodak Neutral Test Card can be used, or any card or piece of white paper with a similar reflectance such as the back of white enlarging paper.

* Strictly speaking, this position of the card applies only to front light, i.e., light coming more or less from the camera position. If the subject is illuminated by sidelight, the card must be held so that it faces halfway between the camera and the light source.

Since such a card reflects approximately five times as much light as an 18 percent gray card, *the reading taken from it must be divided by 5.* The most practical way to do this is to divide the film speed by 5 and set the film speed dial of the exposure meter accordingly, or to expose the film five times as long as indicated by the normally set meter (for example, 1/20 sec. instead of 1/100 sec.). If the subject is relatively dark, exposure must be further increased half a stop for reversal color, and one full stop for negative color and black-and-white film.

Hand reading. When it is impossible, impractical, or undesirable to take a close-up brightness reading of the subject, one can take a meter reading of the palm of one's hand at the camera position *if the illumination is the same for both subject and hand.* This method gives fairly accurate results if light and middle tones and colors dominate the scene, or in portraiture where the brightness of a face closely matches the brightness of the hand. If darker colors dominate, if shadow detail is important or if subject contrast is high, exposure must be increased by one-half stop for reversal color film and one full stop for negative color and black-and-white film.

How to use an incident light exposure meter

Set the film-speed dial as described before. The reading must be taken from a position immediately in front of the subject *with the light collector hemisphere of the exposure meter aimed at the camera position.* Outdoors, if the illumination is the same at both the subject and the camera positions, the reading can be taken from the camera position with the meter held in front of the camera in line with the subject, its collector hemisphere facing the lens. If the subject or scene is *lighter than average,* exposure must be *decreased* one stop for black and white and one-half to one stop for color film. Conversely, if the subject or scene is *darker than average,* the exposure must be *increased* by the same amounts.

Bracketing

The surest way to get a correctly exposed negative or color transparency is to take a series of different exposures of the subject under otherwise identical conditions, grouped around an exposure that according to the meter and previous experience is most likely to be correct. This method is called "bracketing." For reversal color film, vary exposures by one-half stop intervals. For negative color and for black-and-white film, vary exposures by full stop intervals. Do not change the shutter speed. Smaller intervals are wasteful. Larger intervals may cause a photographer to miss the best exposure. Under average conditions, in addition to the supposedly

correct exposure, a second shot should be taken with a smaller, and a third shot with a larger, diaphragm aperture. Under difficult conditions—if subject contrast exceeds the contrast range of the film or if backlight provides the main source of illumination—a larger number of exposures should be made with different diaphragm stops. If reversal color film is used, the number of shorter than normal exposures should exceed the number of longer than normal exposures. Conversely, if negative color or black-and-white film is used, more longer than normal than shorter than normal exposures should be made.

How to adjust the exposure

In many cases, exposure data given by the exposure meter must be modified. In particular, the following factors must be considered:

The filter factor. If a color filter is used, exposure must be increased by the filter factor. If two or more filters are used simultaneously, their factors must be multiplied (NOT added), and the exposure must be multiplied by the common factor. See pp. 136, 140, 141.

The polarizer factor. If a polarizer is used, exposure must be multiplied by the polarizer factor. If a polarizer is used with a color filter, the factor of one must be multiplied by the factor of the other, and the exposure must be multiplied by the combined factor. See p. 144.

The distance factor. If reversal color film is used and the subject-to-lens distance is equivalent to or shorter than *eight times the focal length of the respective lens;* or if negative color or black-and-white film is used and the subject-to-lens distance is equivalent to or shorter than *five times the focal length of the respective lens,* the exposure must be increased by a factor which is determined as explained on pp. 87-88.

The developer factor. Film speed ratings are always based on development with a standard developer. In black-and-white photography, if certain fine-grain developers are to be used, exposure must be increased by the factor which applies to the respective fine-grain developer.

The reciprocity factor. Theoretically, according to the law of reciprocity, the effect upon a photographic emulsion should be the same whether the film is exposed for one second at 100 foot-candles, or for one hundred seconds at one foot-candle. Actually, however, this is true only if exposure times and light intensities are more or less normal. If exposure times are either abnormally long or short and if light intensities are either abnormally high or low, the law of reciprocity fails.

Reciprocity failure is manifest in the following way: if light intensity is very low, doubling the exposure time *does not double the density of the negative but produces less than twice that density*. And as far as very short exposure times are concerned, 1000 exposures of 1/1000 sec. each *do not produce the same density as one exposure of one full second, but rather produce somewhat less than that density*. Since different films react differently to reciprocity failure, tests alone can reveal how much exposure must be increased if exposure times are abnormally long (minutes) or short (speedlight exposures).

In color photography, additional complications arise because reciprocity failure usually affects the differently sensitized layers of color film to different degrees. As a result, the color balance of the film will be changed and the film will have an over-all color cast. To help photographers to correct, as far as possible, the effects of reciprocity failure, Ansco and Kodak include supplementary data slips with their reversal color sheet films. These data slips show the factors by which abnormally long or short exposures must be increased and, if necessary, recommend the corrective filters which must be used for best results.

The subject color factor. Exposure meters are calibrated to give correct data for subjects of medium brightness and contrast. Under certain conditions, increasing or decreasing the meter reading will give better results, as in the following cases:

If negative color or black-and-white film is used, exposure should be *increased by one full stop* if subject contrast is abnormally high, if shadow areas are important and must be fully detailed, and if the level of illumination is very low. Conversely, exposure should be *decreased by one full stop* (and, in black-and-white photography, the time of negative development should be somewhat longer than normal) if subject contrast is abnormally low, as in many snow and beach scenes, particularly if the sky is evenly overcast; many long-distance and aerial photographs, telephotographs made on hazy days, and scenes taken in rain and fog.

If reversal color film is used, exposure should be *increased* by one-half to one full stop if the photographer wishes to prdouce a high-key effect in pale, pastel color shades (shadowless illumination and light colors are best suited to this rendition which has been used with great success in fashion photography and por,raiture of women); if subject contrast is abnormally low, particularly if subject color is uniformly light as in rain, fog, or during snowfall, and in hazy aerial views. If subject color is uniformly dark or if the exposure is abnormally long, the diaphragm

should be opened by one full stop. Conversely, exposure should be *decreased* by one-half stop if the photographer wishes to produce a low-key effect with particularly rich, fully saturated colors (when shooting color transparencies for reproduction, a slightly underexposed transparency is always preferable to one that is overexposed). It is also necessary to decrease the meter-indicated exposure by one-half to one full stop if a dark and moody impression is desired and for the effective rendition of flaming sunset skies, rainbows, and sun-glittering water.

HOW TO WORK WITH ARTIFICIAL LIGHT

Natural light is a given factor over which the photographer has only limited influence. In contrast, artificial illumination is often completely within the photographer's control. Although it is frequently poorly used, natural light, because of its naturalness, can never be really bad as far as the impression given by the picture is concerned. Artificial illumination, however, because of its flexibility, almost invites misuse. Unless an artificial illumination is well arranged and controlled, the result is apt to be confused, haphazard, or meaningless. Therefore, anyone who wishes to do better, should make the following experiment in portraiture. Step by step it will teach him how to arrange an effective illumination. For this experiment four lights are needed.

Preparations

Pose the model comfortably and naturally 5 to 6 feet from a neutral background. Darken the room until there is just enough light left to see what you are doing, but not enough to interfere with the effect of the photo-lamps.

Place the main light. Its purpose is to give the subject form and to roughly fix the ratio of light to shadow. It is the most important light. The best main light is a large spotlight, approximating the effect of the sun. If you lack such a light, p. 147 a No. 2 photoflood can be used. Place the light approximately 45 degrees to one p. 146 side and 45 degrees above the head of the model. This position automatically produces a good illumination. As you become more experienced, you may wish to place the main light in other positions for more interesting effects. But in the beginning it is wise to use a safe setup. If the main light is correctly placed, it accentuates the main forms of the subject, modulates its planes with "plastic" light, casts strong and expressive shadows, and gives a graphically pleasing composition, pattern, and black-and-white effect.

Place the fill-in light. Its purpose is to slightly lighten the shadows cast by the

main light—just enough so that they will not be black but will show indications of detail in the picture—without changing the character of the illumination produced p. 146 by the main light. The fill-in light should be a well-diffused, relatively weak photoflood lamp in a large reflector. It should be placed as close to the camera as possible and slightly higher than the lens. In this position there is the least danger of producing shadows within shadows—separate criss-crossing sets of shadows made by the main and the fill-in light. Such shadows are extremely ugly and must be avoided.

Place the accent light. Its purpose is to enliven the picture by adding highlights and sparkle—in this case, to the hair of your model. The accent light should be a small spotlight that can be focused on a specific area. It is used as a backlight to highlight the outline of cheek and hair of the subject, to add texture, catchlights, and glitter. Since it must be placed somewhere in back and to one side of the subject—directed toward, but outside the field of view of the lens—it cannot cast secondary shadows. It must be prevented from shining into the lens because p. 108 this might produce flare and fog on the film. A piece of cardboard placed between the light and the lens will accomplish this.

pp. 20, 22 **Place the background light.** Its purpose is to graphically separate subject and background. A spotlight or photoflood can be used. What matters most is not the type of lamp but its correct intensity and position, both of which must be adjusted carefully by placing the light at the proper distance and angle in relation to the background it must illuminate. By lighting the background behind the shadow side of the model, and leaving it in shade on the highlighted side, the photographer graphically separates model and background and gives a feeling of depth to his picture.

The principles of good lighting

The lighting scheme described above produces what might be called a "standard illumination." Although never spectacular, it is always successful and can be used equally well to light a girl, a gadget, or a geranium. It can be used with incandescent light, flash, or speedlight illumination. It can be varied in innumerable ways by varying the position, intensity, or spread of the different lights. By changing the ratio of light to dark, one can produce pictures that are either gayer or more somber. By increasing the contrast until the shadows are pure black, one can p. 242 create the typical Hollywood glamor lighting, guaranteed to produce the most seductive effects. Once a photographer knows the purpose and effect of the dif-

ferent lights he can do anything he likes, and he will succeed as long as he observes the following basic rules that apply to any type of lighting:

Arrange the illumination step by step. Always start with the main light. Never add an additional light until the previous one is placed to your satisfaction.

Shadows that criss-cross must be avoided.

Too much light and too many lights will spoil any lighting scheme.

Concentrate your light toward the background and keep the foreground darker. A dark foreground suggests a frame and takes the eye toward the center where interest belongs.

Light is the strongest creator of mood. Arrange your illumination to fit the mood of your subject.

Don't be afraid to use pitchblack shadows if such shadows are expressive in form and placed in such a way that they accentuate the subject's form and strengthen the pattern of composition.

Low-skimming side-light or backlight brings out surface texture better than any other light.

Backlight is the most dramatic illumination, and the one most difficult to handle.

Place your fill-in light above the level of the lens so that its shadow will fall low. Placed too low, a fill-in light casts shadows which can completely spoil an otherwise clean background.

Keep your fill-in light well diffused to avoid shadows (cast by the fill-in light) within shadows (cast by the main light). Because it produces completely shadowless light, the best fill-in lamp is a ringlight—a speedlight flashtube that encircles the lens.

A fill-in light that is too weak is better than one that is too strong. A fill-in light that is too strong produces the same flat effect as a single flash at the camera. And single flash at the camera is pictorially the worst kind of illumination.

In portraiture, the most important shadow is that cast by the nose. It should never touch or cross the upper lip. If it does, the effect suggests a moustache or a beard, even if the subject is a girl.

Watch for the "blind spots" in a face and make sure they receive enough light. You find them in the corners of the eyes near the nose, in the angles between nose and mouth, and beneath the chin and jaw.

PART 6

How to Develop and Print

Having exposed his film, a photographer can do one of three things:

He can give the film to a commercial or custom photo-finisher for developing and printing. This solution should be considered primarily by those who work exclusively in color, and by professional photographers whose time is too valuable to be spent in the darkroom, particularly if they have a good custom photo-lab which specializes in individually customized work close enough to maintain personal contact with those who do the actual work.

Or he can let a commercial lab develop the film and he can do his own printing. This, in my opinion, is the best solution for the average photographer who uses both reversal color film (which does not need printing) and black and white. In this way he skips the "dirty work" and begins with clean, evenly developed negatives and yet has the fun and excitement which comes from watching one's own pictures take shape in the creative atmosphere of the darkroom.

Or he can develop and print his own films. If he works exclusively in black and white, this presents no problems. But if color work is involved, an investment in temperature and voltage control devices and in instruments for analyzing and controlling color may have to be made to produce consistently good results. This solution should appeal particularly to the creative photographer who does not trust anyone but himself with any part of his work. Time, skill, and devotion are indispensable, but the results can be extraordinarily rewarding.

The decision whether or not it is worthwhile to set up one's own darkroom will be made easier by considering the following pros and cons:

Yes—a darkroom is worth the effort. To begin, one doesn't need a permanent darkroom because first-class work can be done in improvised quarters. The main argument in favor of having a darkroom is that only by printing one's own negatives can one get *exactly* the effect one had in mind. A negative can be printed literally in hundreds of different ways, as will be shown later, and *only* the photographer can know which way it should be printed. In addition, in the long run, if all expenses including amortization of darkroom equipment are considered, doing

pp. 213-217

178

one's own developing and printing costs still less than having a photo-finisher do it. Also the work itself can be immensely stimulating, because, in a way, each print is an experiment which provides new experience, the outgrowth of which cannot fail to reflect favorably in the scope of one's work.

No—a darkroom isn't worth the effort, particularly to a photographer who works primarily in color. Color film developing and, if negative color film is used, color printing, involves some rather critical operations that are best done in an air-conditioned, temperature- and voltage-controlled laboratory equipped with instruments that are so expensive that only a large establishment can afford them and without which precision work is difficult if not impossible. Black-and-white films, too, profit from being developed in deep tanks equipped with nitrogen-burst agitation devices rather than in small reel-type tanks, where the danger of uneven development is always present. If a photographer has a good commercial photo-lab nearby and if he can have the same printer do all his work and learn how the photographer likes his negatives printed, then he may even get prints that are better than those he could make himself. If so, he doesn't have to set aside space for a darkroom, invest in equipment, and keep a stockpile of chemicals and sensitized paper which, unless used within the proper time, would spoil.

> A tip to those who have 35-mm film developed: to avoid loss through mix-ups or loss of address, photograph your name and address on one frame of each roll.

THE DARKROOM

To most beginners a darkroom seems formidable and expensive. But a workable darkroom is literally nothing but a dark room. It does NOT have to have running water, a built-in sink, and a waterproof floor. It does not even have to be permanent. It can be improvised in the corner of an ordinary room. Lack of a real darkroom is not an excuse for sloppy work or for doing no darkroom work at all. Many of our best photographers began their careers in improvised darkrooms.

Minimum requirements

A workable darkroom must be dark. If there are windows, they must be made light-tight by using opaque blinds. Black roller shades that run in channels, of the type used in lecture halls and auditoriums, are most practical but expensive. A convenient substitute is black twill fastened with thumbtacks to the top of the win-

dow frame in lengths long enough to drag on the window sill or floor. When I worked for *Life,* I unloaded and reloaded filmholders at night in hotel and motel rooms, making the windows light-tight with blankets fastened to the top of the window casing with two icepicks that I carried for this purpose. If space permits their storage, home-made blinds made of Masonite on wooden frames provide another simple means for darkening windows.

However, if all this seems too complicated or expensive, film can be loaded into the developing tank at night in a clothes closet (if the lights are turned off in the next room, cracks around the door do not have to be light-proofed); a Kodak, Agfa, or Leitz daylight-loading 35-mm-film developing tank can be used which permits one to load and process film by ordinary room light; or films can be given to a laboratory for development.

Prints can be made at night. Heavy curtains are sufficient to keep out the feeble light of street lamps and sky. Small amounts of stray light are usually harmless. To be sure the space is dark enough, make the following test: darken the room; do NOT use the safelight. Place a few coins on a sheet of sensitized paper and leave it on the working table for four to five minutes. Develop and fix this test sheet in darkness with the safelight turned off. Examine the test sheet: if the paper is uniformly white, the room is safe for printing. If the paper is gray except where the coins were placed, the room is too light and the darkening arrangement must be improved.

An electric outlet is needed for the safelight and the enlarger.

The room temperature should not be lower than 65 and not higher than 80 degrees F. If the room is colder or warmer, maintaining the correct temperature of solutions becomes too difficult. In winter an electric heater can be used to raise the temperature. In summer an exhaust fan in conjunction with light-proof louvers in the door, or better still, a room air-conditioner, permit air circulation and prevent a darkroom from getting too hot.

The water supply should not be too far away. In the darkroom itself, a pail and a tray full of water are all that is needed. Negatives and prints can be washed later under a faucet outside the darkroom.

The work table should be covered with a piece of oilcloth or Formica, which is impervious to water and photographic solutions. Several thicknesses of newspaper beneath the trays prevent accidentally spilled liquid from flooding the table or

running down to the floor. However, a careful worker rarely spills solutions, mainly because he does not fill his trays too high.

The color of walls and ceiling should be white to reflect a maximum of (safe) light and thus improve visibility.

A photographer who has the run of an entire house should have no trouble finding a place to install a permanent darkroom of modest scale. The apartment dweller, and especially one who lives in a furnished room, has to use much more ingenuity to arrange a darkroom for his work. Listed in order of their suitability are the following suggestions for the location of improvised and permanent darkrooms:

The basement. A corner of a dry, finished basement that can be partitioned off is an excellent place for a darkroom. Advantages: fairly even temperature the year round; electricity and running water are usually near by; permanency of the setup permits the gradual development of a first-class darkroom.

A large closet of the type found only in old houses can easily be made into an excellent darkroom if the problem of ventilation is solved with light-proof fan and louvers installed in or above the door. Negatives and prints can be washed in the bathroom.

The kitchen, after working hours, makes an excellent improvised darkroom. It provides water, electricity, and suitable working space. Developer and wash trays go right into the sink. And if a photographer is lucky he can appropriate a kitchen cabinet for storage of all his darkroom equipment.

The attic. Advantages are privacy and seclusion, which permit a permanent setup. However, there are often serious drawbacks: it is too hot in summer, too cold in winter, and running water may not be available on the same floor.

An ordinary room. Advantages are plenty of space and even temperature the year round. Drawbacks: before he can start work, a photographer must darken the windows, clear a table, set up his equipment, get water from the bathroom, switch from desk lamp to safelight, etc. But once this extra work is done, operations should proceed as smoothly and efficiently as in any permanent darkroom.

The bathroom. Despite the advantages of running water and waterproof floor, this is the least suitable place for an improvised darkroom. Drawbacks: steam and moisture ruin equipment, chemicals, and sensitized material in a very short time; interruptions make concentrated work impossible.

A DARKROOM IN A CLOSET

A SMALL PROFESSIONAL DARKROOM

Efficiency and comfort of any darkroom depend upon its organization. Strict separation of dry and wet operations is essential. The best layout places the dry bench along one wall and the processing sink along the opposite wall, with a 3-foot aisle between. On the dry bench, which, for a worker of average height, should be 36 inches high, 24 inches wide, and covered with Formica (next best: linoleum), belong the dryer, trimmer, printer, storage cabinet for sensitized paper, and enlarger—in that order (working direction from left to right if the worker is right-handed, in reverse order if he is left-handed). In the processing sink will be the trays for developer, short-stop bath, fixer (hypo), and wash water. Above the sink, a shelf running the entire length of the wall provides storage space for bottles containing processing solutions. Trays, when not in use, are stored upright in racks below the sink.

The processing sink should be equipped with a drain and it should provide space for a minimum of four trays of the largest size to be used. Stainless steel (A.I.S.I. Type 316, 18-8) is best. Fiberglass bonded to marine plywood ranks next. For proper drainage, at least ¼ inch of pitch per running foot should be provided. Processing trays should be supported by wooden slats with triangular cross-section running the entire length of the sink. Hot and cold water faucets should be at a height above the sink that provides a minimum clearance of 15 inches to allow for the filling of regular 1-gallon jugs and 3½-gallon tanks. Installation of two faucets—one combination hot- and cold-water swing spout and a cold-water faucet

182

equipped with a piece of rubber hose for rinsing trays and sink—makes for greater convenience. For additional convenience—and almost a necessity in developing color film—a thermostatically controlled mixing valve is recommended to keep the water temperature constant.

Electric installation. General illumination is provided by indirect light from a large safelight suspended in the center of the darkroom that throws its light against p. 184 the white ceiling. Local illumination comes from individual safelights equipped with 15-watt bulbs; one should hang from a drop cord above the developer tray; another should be mounted near the enlarger, preferably interconnected with the enlarger lamp via a foot switch in such a way that when the enlarger lamp is on, the safelight is off, and vice versa. A well-shielded white light (small spotlight equipped with snoot) operated by a foot switch belongs above the right-hand end of the sink for inspection of prints in the fixer and washer. Another white light, which also serves as general room illumination for darkroom cleaning purposes, should be installed above the trimmer.

Because of the proximity of electric wiring to metal and water, a darkroom can be a dangerous place unless the following precautions are taken: all noncurrent-carrying metal parts of both fixed and portable electric equipment must be grounded; this applies to the contact printer, enlarger, dryer, foot switches, electric timer, safelights, etc. Furthermore, the "one-hand rule" should be strictly observed. It means that when handling any electrical equipment or operating any switch, the other hand must not touch any object or must not be in touch with any solution at all to exclude the possibility of making a direct ground connection. And an electric switch must NEVER be touched with wet hands. Electric outlets should be located above the dry bench and as close to the respective appliances as possible to eliminate the potential hazard of dangling wires.

Dust can be a source of endless annoyance in a darkroom. It gets on negatives and causes spotty prints, its effect more marked the smaller the negative. The best way to fight dust is to periodically vacuum the entire darkroom, including walls, ceiling, and the inside of the enlarger. In addition, the following precautions help to minimize the accumulation of dust:

If there is a choice, the darkroom should be ventilated by filtered air forced in under pressure rather than by an exhaust system. Use of dust-producing building material such as fiber board or fabrics should be avoided. Empty containers and waste should not be permitted to accumulate. A cement floor should be painted and waxed. Accidentally spilled solutions must be wiped up before they dry and

chemicals crystallize into powder and contaminate the entire darkroom. And to keep clean things clean, protect the enlarger and printer from dust by covering them with plastic covers when not in use. And here is a final suggestion:

> Do not smoke in your darkroom!

How much or how little to spend on darkroom equipment is almost entirely up to the photographer. Except for the enlarger, the *essential* equipment is relatively cheap. Expensive are those accessories which mainly increase the comfort and ease of operations without materially adding to the quality of the print, for example, electric timers and dryers, motor-operated print washers, printing exposure meters, dry-mounting presses, etc. The following contains only those items which, in my opinion, are essential for the successful operation of a darkroom.

BASIC DARKROOM EQUIPMENT

The safelight. Only special photographic darkroom lamps with interchangeable filters should be used. Colored-glass incandescent bulbs are not "safe." The color of the safelight filter is determined by the type of work:

Dark green (Ansco No. A-3; Kodak Wratten Filter Series 3) for panchromatic film development. However, since panchromatic film is sensitive to *all* colors, the recommended dark green filters are only safe if the lamp is at least 4 feet from the film. Its light is intended *only* for general darkroom illumination and *not* for close visual inspection of the negatives during development.

Dark red (Ansco No. A-7, Kodak Wratten Filter Series 2) for orthochromatic film development.

Green (Kodak Wratten Filter Series 7) for the development of infrared sensitized films.

Light amber (Kodak Wratten Filter Series OC and Dupont 55-x) for enlarging papers.

Dark amber (Kodak Wratten Filter Series 10) for Ektacolor and Ektachrome Paper, Ektacolor Print Film, and Panalure Paper.

Timer. A spring-driven timer with a range from one second to sixty minutes that rings at the time set is sufficient for most purposes. An electric timer that times exposures automatically to fractions of a second can be hooked up to the enlarger.

184

Thermometer. It must be accurate to half a degree. A mercury-in-glass thermometer is usually more accurate than a dial thermometer. It is best to have one of each, check one against the other, and use the dial thermometer because it is more convenient.

Graduates are used for measuring liquids (mainly developer stock solutions which must be diluted with water in prescribed proportions) and for dissolving chemicals. Glass graduates are the best. Two are needed, a small cylindrical one and a larger one with tapered sides.

Funnel for pouring solutions back into the bottle and for filtering solutions. Glass is the best material.

Stirring rods to stir dissolving chemicals; glass is the best material.

Polyethylene bottles. Brown bottles for developers, white bottles for hypo and other solutions. Their size depends upon the volume required for the photographer's work. The hypo bottle should take at least one gallon.

Filter paper or absorbent cotton to filter out emulsion particles and other impurities from used developer solutions before re-use. The glass top of a vacuum coffee maker with a layer of absorbent cotton in its bottom, placed in a laboratory ringstand, makes an excellent filtering device.

Paper towel in holder mounted to the underside of the shelf above the sink.

Sponge for scrubbing the sink and to wipe up accidentally spilled solution.

Apron to protect one's clothing—developer spots are indelible. A nonabsorbent plastic apron is the best.

Waste basket or garbage can. A large plastic can is the best.

A roll of wide, white, surgical adhesive tape. Cut it into labels, write on it, and use it to identify bottles and cans, to keep track of the age of solutions, and to record the number of rolls developed in a developer and the amount of replenisher added.

Pad and pencil to record paper exposure times, including dodging data; to list supplies needed; to jot down ideas that occur during work.

A stool is very welcome for long darkroom sessions.

Floor mats with ribbed vinyl tops and nonabsorbent cushion vinyl bottoms placed in front of the enlarger and the developer tray are a boon for tired feet.

EQUIPMENT AND MATERIAL FOR NEGATIVE PROCESSING

Film developing tank. Its size must fit the size of the film. Capacity varies; 35-mm and rollfilm developing tanks that will accommodate one, two, or more reels simultaneously are available. Some tanks have adjustable reels that can alternatingly accommodate 35-mm and size 120 films; others (Kodak, Agfa, Leitz) permit daylight loading and processing of 35-mm films. Sheet film is best developed on stainless-steel hangers in an open tank. Plastic sheet-film hangers are not recommended.

Film clips to hang up film to dry on a wire stretched wall to wall above the sink. Stainless-steel clips are the best. Each roll of film requires two clips, one at the top, the other at the bottom to prevent the film from curling.

Negative developer. Ready-mixed developers in powder form or in highly concentrated stock solutions are more practical than developers which the photographer mixes by combining the individual components of formulas. They are generally more uniform and dependable, they can be stored (in unopened bottles) almost indefinitely, and they need only to be diluted or dissolved in water to be ready for use. They eliminate the need for a scale and for storing a number of different and sometimes highly perishable chemicals in space-consuming glass jars. They also eliminate worry about purity of chemicals, omission of an ingredient, inaccuracy of measuring and weighing, faulty compounding, and waste due to deterioration, contamination, and incorrect storage.

On the other hand, developers that a photographer compounds himself are cheaper than prepared formulas, and since their exact composition is known they can, if necessary, be modified to become more suitable for a specific job.

Years of experience have taught me that it is good practice to always use the developer which the film manufacturer recommends. Perhaps nowhere in photography is there greater disagreement among photographers than in their evaluation of different developers, particularly fine-grain developers. Dozens of different formulas are on the market for which fantastic claims are sometimes made. Each has its devotees who would use no other formula. Personally, I have found that most standard developers produce a film grain virtually as fine as that produced by special fine-grain developers if development time is somewhat shortened and negatives are developed to the same low contrast as that in negatives processed in fine-grain developers. The real advantage of fine-grain developers is that they make it somewhat more difficult to overdevelop a film.

Developers can be divided into five groups from which a photographer must choose the one most suitable for his particular work:

Standard developers act fast and thoroughly, utilizing the full inherent speed of a film. They are the best developers for processing negatives 2¼ x 2¼ inches and larger.

Rapid developers, widely used by press photographers and commercial photo-finishers, act more rapidly than standard developers. They produce negatives of somewhat higher contrast than a standard developer does. They are excellent for the development of negatives with low-contrast subjects and underexposed films.

Fine-grain developers produce negatives with a relatively fine grain and are mainly intended for the development of 35-mm films. Some fine-grain developers boost filmspeeds, whereas others require increases in the exposure of the film, the factor depending on the type of the developer (consult the manufacturer's instructions). Not all fine-grain developers are equally suitable for the development of all 35-mm films. Thin-emulsion films must be developed in special compensating fine-grain developers. High-speed 35-mm films should never be developed in fine-grain developers but in standard developers.

p. 128
p. 129

Tropical developers permit development at temperatures up to 90 degrees F., at which point the gelatine of the emulsion ordinarily begins to dissolve and float off the film base. These developers should be used only when climatic conditions prohibit the use of ordinary developers.

High-contrast developers produce negatives of more than ordinary contrast and are primarily intended for the development of reproductions of line drawings, printed pages, and other subjects that are purely black and white.

Stop bath. It terminates development by neutralizing the alkalinity of the developer retained by the emulsion, protects the acidity of the fixing solution, and thus prevents its premature exhaustion. In conjunction with a hardening agent, the stop bath also hardens the gelatine of the film to prevent it from curling, reticulating, and peeling along the edges during washing.

Fixing bath, also called "hypo." It clears the negative by dissolving the unexposed silver halides (the light-sensitive particles of the emulsion) which otherwise would in time darken and obscure the image.

EQUIPMENT AND MATERIAL FOR PRINT PROCESSING

The enlarger—construction and special features

An enlarger is a camera in reverse. Like a camera, an enlarger has a lens that must be focused to produce a sharp print (enlargement) and a diaphragm that permits regulation of the brightness of the projected image and thus the exposure time of the paper. Two different lighting systems are most commonly used:

Semi-diffused illumination. The light source is a special tungsten filament opal-glass lamp; the light collector is either a double or a single plan-convex condenser. This system produces images of excellent quality, without unduly emphasizing negative grain. It is best suited to negatives up to and including 4 x 5 inches.

Cold-light illumination. The light source is a mercury vapor, fluorescent, or cold-cathode tube, usually bent to form a square grid. These enlargers produce scarcely any heat. They are used primarily for negatives larger than 4 x 5 inches. However, the peculiar quality of their light makes it difficult to focus critically without a focusing magnifier, and many, though not all, cold-light installations are unsuitable for use with variable-contrast paper and for making color prints.

Manual or automatic focusing. Manual focusing involves racking the lens in and out while visually checking the sharpness of the projected image on the paper. In automatic focusing, the projected image is supposedly always sharp, regardless of the scale of enlargement, because lens-focusing is mechanically coupled with the vertical movement of the enlarger head. Each system has advantages and disadvantages. If done with proper care, manual focusing is more accurate but takes more time. Automatic focusing is much faster but requires constant checking to detect and correct unavoidable inaccuracies of focus primarily caused by negatives that are not held perfectly flat in the plane of focus. There is also a considerable difference in price.

The lens. Enlarging lenses are specially computed for optimum performance at short distances. Sharpness of definition and flatness of field are all-important. Speed is unessential because, in the interest of manageable exposure times, most enlargements are made with the diaphragm stopped down to somewhere between f/5.6 and f/11. Among the best enlarging lenses are the Kodak Enlarging Ektars and the Schneider Componon lenses.

The diaphragm. To facilitate accurate stopping-down in the dimness of the darkroom, the diaphragm should be equipped with click stops.

188

The negative carrier. There are two types: glass plates and glassless carriers. Glass plates insure perfect flatness of the film by preventing the negative from buckling out of the plane of focus under the influence of heat. But they also have *four* surfaces to which dust can cling, and they may cause "Newton's rings," concentric bands of colored light that occur when glass and film are not in perfect contact. Newton's rings show clearly in the print and they are very difficult to avoid once the conditions for their appearance are present. Special glass is available that avoids the danger of Newton's rings. Glassless negative carriers eliminate the danger of Newton's rings but they do not hold the film as flat as glass plates; the consequence may be partially unsharp prints. In general, for negative sizes up to 2¼ x 2¼ inches (where dust is a greater problem than buckling), glassless carriers are most practical. Glass plates, despite their disadvantages, are preferable for use with enlargers with automatic focusing, and generally for larger negatives which are more apt to buckle and in which, because of normally lower image magnification in the print, dust does not show up as badly as in smaller negatives.

Special features. No enlarger can take negatives larger than the largest size for which it is designed, but many enlargers are so constructed that they can also accommodate smaller negatives. This should be considered by the photographer who owns two or more cameras that take different film sizes or who intends to get another camera of a different size. Enlargers that take different negative sizes provide for interchangeability of lenses and feature condensers that are either interchangeable or condensers that can be moved from one position to another, or they have an adjustable negative stage.

If the enlarger is to be used for color printing, it must be equipped with a heat-absorbing glass and facilities for the use of color-balancing filters. The filters are best placed in a drawer between the lamp and the negative where they cannot affect the sharpness of the image; otherwise, in a holder below the lens. Illumination must be provided by a tungsten filament lamp because "cold light" illumination, which is deficient in red, requires heavy filtration which, because it prolongs exposure times, may adversely influence the sharpness of the print. Condenser lenses should be made of colorless glass; those of greenish glass require additional filtration and they may cause differences in color between the center and the edges of the print.

If "converging verticals" in negatives of architectural subjects should be parallel in the print, the enlarger must be equipped with a tilting negative stage (this is

p. 214 the better solution) or a tilting lens stage. If the enlarging paper is then tilted accordingly, perspective distortion can be corrected and prints that are uniformly sharp produced, without stopping down the lens beyond normal.

The scale of the projected image increases as the distance between paper and lens increases (image magnification equals lens-to-paper distance divided by lens-to-negative distance). Normally, the highest degree of magnification an enlarger can produce is determined by the height to which its lens can be raised above the enlarger's baseboard. But much greater degrees of magnification can be achieved with enlargers that either permit rotating the head on the column or the entire column by 180 degrees, so that the image can be projected onto a chair or onto the floor, or which permit tilting the head into a horizontal position and projecting the image onto a wall. Enlargers that lack such features can be converted to horizontal projection by mounting a 45-degree front-surface mirror below the lens.

Some common faults. Many enlargers have a "hot spot," i.e., they produce prints in which, because of uneven light distribution, the center is darker than the edges. To check light distribution, expose a piece of paper of hard gradation without a negative in the enlarger. Time the exposure so that the "print" will have a medium gray tone. Develop, fix, and check for uniformity of tone.

A very common fault of many enlargers is insufficient rigidity of the vertical column which causes the head to shake and produce prints with double contours. The worst in this respect are enlargers with thin, tubular, vertical columns. In addition to their being wobbly, these columns get in the way in making big enlargements and they reflect light onto the sensitized paper when the lamp housing is high enough for the cone of light to hit the lower part of the column (wrapping the lower part of the column in black mat paper helps). Enlargers with inclined columns that are triangular in cross-section instead of round avoid both these faults. The most rigid enlargers are those braced by struts. In a permanent darkroom, wobbly enlargers can be made more rigid by using two guy wires to connect the top of the column to two points on the wall.

Contact printer or printing frame. The size depends upon the paper size it must accommodate. It is used primarily for making contact prints to facilitate identifying, cataloguing, and filing negatives. The usual practice is gang-printing, i.e., printing all the negatives from one roll of film side by side in strips of six (35-mm) or four (size-120 film) on one sheet of 8 x 10-inch paper. Similarly, four sheets of 4 x 5-inch film, or eight sheets of 2¼ x 3¼-inch film, can be contact-printed on one

sheet of 8 x 10-inch paper. An inexpensive contact printer can be made by hinging with inch-wide adhesive surgical tape a sheet of glass 10 x 12 inches to a 9½ x 12-inch piece of ¾-inch plywood. Sandpaper the edges of the glass to avoid cutting yourself.

A paper easel is necessary to hold the enlarging paper flat and in focus.

Developer trays in different sizes. The most practical size is one size larger than the paper that is to be developed; for example, use a 10 x 12-inch tray for an 8 x 10-inch print. Trays smaller than 8 x 10 inches are impractical even for the development of much smaller prints. The best material is stainless steel, the next best is high-impact plastic. Enameled trays chip and rust, hard rubber trays break.

Stop bath tray. Same as above.

Fixing bath tray. It should be larger and deeper than the largest developer tray. Stainless steel or high-impact plastic are the best materials.

Water tray and syphon (attached by rubber hose to faucet). For washing prints. To provide clearance for the exhaust spout, place the water tray on bricks in the processing or kitchen sink.

Focusing magnifier to ensure sharp prints. Best are those high-magnification devices that focus on the grain structure of the negative instead of on the subject detail.

Two or three print tongs to handle and agitate prints and transfer them from one solution to the next. Tongs used for developing must not come in contact with fixing solution because hypo contaminates the developer. If accidentally contaminated with hypo, the developer print tongs must be rinsed clean before reuse in the developer.

Camel's hair brush or anti-static brush, and anti-static negative cleaner or cloth, to remove dust from negatives before they are placed in the enlarger.

White petroleum jelly (Vaseline). Rubbed in minute amounts on a negative it fills abrasion marks and small scratches so that they do not show in the print.

Paper punch. A particular negative (called a "frame") on a strip of six (35-mm) or four (size-120) frames can be marked for printing by punching a semi-circular piece out of the clear edge of the film. These punch marks can easily be felt in the dark. Another way to mark negatives for printing is to apply a dash of ink to the clear edge of the respective frame with a felt-tipped ink marker.

Dodging aids. Two circular pieces of cardboard, one approximately 1½ and the other ¾ inches in diameter, attached to one end of a stiff wire approximately 10 inches long, make a good dodger for "holding back" thin negative areas during exposure to prevent them from becoming too dark. Bend both ends of the wire into circular loops the size of the respective cardboard disks and tape the disks to the loops with black photographic tape. Pieces of cardboard approximately 8 x 10 inches each with a hole of a different diameter near its center, make dodgers for "burning in" negative areas which are so dense that they need more exposure than the rest of the negative. The dense negative area receives extra exposure through the hole while the cardboard shields the rest of the picture from becoming too dark.

pp. 215-216

pp. 215-216

Barber shears—narrow-bladed scissors—are particularly good for accurately cutting developed film into strips even when individual frames are very closely spaced, for cutting negative masks, adhesive labels from strips of surgical tape, etc.

Ferrotype plates and a squeegee. They are needed to give prints made on glossy paper a high glossy finish. Matte and semi-matte prints are dried more conveniently in a *blotter roll*. Electric print dryers are much faster and more convenient but quite expensive; the best models are double-sided, thermostatically controlled.

Trimming board (cutter) for trimming the white edges from prints before drymounting.

Drymounting tissue for mounting prints to cardboard with a flatiron or an electric drymounting press.

Spotting colors and a fine watercolor brush for spotting (retouching) prints.

Negative file or glassine envelopes for storing negatives.

Paper developer. For best results, use one of the developers which the paper manufacturer recommends. Usually there is a choice: some developers produce prints in neutral-black tones, others produce blue-black, and still others produce slightly brownish tones.

Stop bath. Used as a short rinse between developer and fixer, it prevents prints from staining in the fixing bath through insufficient agitation. In addition, it fulfills the same purpose as in the development of films.

Fixing bath (hypo). Acid-hardening fixing baths are best for prints.

PHOTOGRAPHIC PAPER

Regardless of type or make, photographic papers can be classified according to four different characteristics:

Speed

There are *slow* chloride and *fast* bromide papers, and between these are medium-fast chloro-bromide papers. Chloride papers are used for contact printing because they are slow; fast emulsions would require impractically short exposures. Bromide papers are used for enlarging (projection printing) because they are fast; chloride papers would require impractically long exposures. Chloro-bromide papers can be used for either contact printing or enlarging.

Gradation (contrast capacity)

Photographic papers are made with different contrast gradients, ranging from "soft" (low contrast) through "normal" (average contrast) to "hard" (high contrast). If a negative of normal contrast range were printed on a paper of normal gradation, the print would have a normal contrast range. Printed on paper of soft gradation, contrast in the print would be lower, and printed on paper of hard gradation, contrast in the print would be higher than in the print made on paper of normal gradation. Accordingly, by selecting a paper with the appropriate gradation, a photographer can make prints that have a satisfactory contrast range from negatives in which contrast is unsatisfactory because it is either too high or too low.

The gradation of photographic papers is designated by numbers: no. 1 designates a paper of soft gradation (low contrast range); no. 2 is normal; nos. 3, 4, and 5 designate increasingly harder (more contrasty) gradations. In addition, there are variable-contrast papers which enable a photographer to produce a wide range of contrasts from the same kind of paper. This is done by using filters of different colors between the light source and the paper. The advantage of variable-contrast paper is that it makes it unnecessary to stock seldom-used grades of paper since all the normally needed gradations are included except the equivalent of no. 5 (extra hard) paper within a single box.

Surface

Photographic papers are made in a great variety of different surface textures: glossy, semi-matte, matte, and textures that imitate the appearance of fabrics,

tapestry, etc. Personally, I find such imitation textures in poor taste and prefer to use only glossy, semi-matte, and matte. Of these, glossy is richest in graphic qualities: it gives brighter whites and more lustrous blacks than any other surface; prints for reproduction should normally be made on glossy paper. To bring out the full inherent beauty of a glossy surface, the print must be ferrotyped (dried with its emulsion in close contact with a highly polished ferrotype plate); dried with their paper side facing the ferrotype plate glossy prints are not quite as shiny and sparkling but they are less sensitive to fingermarks and can thus withstand more handling. Semi-matte and matte surfaces are best for exhibition prints and photomurals because they mitigate or eliminate, respectively, surface reflections.

p. 211

Base weight

Photographic papers are made in two standard thicknesses: single-weight (abbreviated: SW), which is relatively thin, and double-weight (DW), which is about twice as thick, corresponding in thickness to a postcard. Single-weight papers are best for prints up to and including 8 x 10 inches and for larger prints that are to be mounted. Double-weight papers are preferable for unmounted prints in sizes larger than 8 x 10 inches. Single-weight paper is less expensive, washes and dries more rapidly, is easier to mount, and takes less filing space than double-weight stock. Double-weight paper does not curl so easily, stands up better under rough treatment, and is preferable for prints exposed to much handling.

For selection of all but glossy papers (which all look alike) consult the manufacturer's sample book at your photo shop. To order a specific paper, you must give the name of the manufacturer, the trade name of the paper, the gradation of the emulsion, the type and color of the surface, the weight of the stock, and the size of the paper. Here is an example: Kodak Kodabromide, normal (no. 2), glossy, white, double-weight, 11 x 14 inches.

HOW TO DEVELOP A BLACK-AND-WHITE FILM

Anyone who can read a watch and a thermometer can successfully develop a black-and-white film, for development time is determined by the temperature of the developer. If the developer is warm, development time must be shorter than if the developer is cold (the terms "warm" and "cold" cover a temperature range from 60 to 75 degrees F.; standard temperature is always 68 degrees F.). Naturally, different types of film, as well as different types of developer, require different times of development. These are given on the charts that film manufacturers provide with their films. One such chart is reprinted on the opposite page.

To use this type of chart, find the diagonal that represents the developer you wish to use. Find the horizontal that corresponds to the temperature of your developer solution. Draw a vertical through the point of intersection of the two lines. The correct time of development in minutes is given where this vertical intersects with the bottom of the chart.

The advantage of this method, which is called "development by time-and-temperature," is that it is so simple that with it even a beginner can produce consistently good results. All he needs to do is to use the developer the film manufacturer recommends, and the instruction sheet that comes with the film, to find the recommended time of development for the temperature of his developer solution. The only control instruments needed are a thermometer and a timer.

Normal (correct) development produces negatives in which the densest parts (called the "highlights") are not blocked but show differentiation, and in which the thinnest parts (the shadows) are not glass-clear but show detail. If such a negative is placed on a printed page, one should barely be able to see the type through its dark parts, while its thinnest parts should have a distinct gray tone.

Overdevelopment—caused by leaving the film too long in the developer, using a developer that was too warm, or both—produces negatives that are too dense and too contrasty. They are difficult to focus in the enlarger because the projected image is very dark, and they demand exposure times so long that heat from the enlarger lamp may cause the negative to buckle out of the plane of focus during the exposure. If such negatives are printed on paper of normal gradation, they produce prints that are, as a rule, too contrasty, too grainy, and not critically sharp.

Underdevelopment—caused by taking the film out of the developer too soon,

195

using a developer that was too cold, using an exhausted bath—produces negatives that are too thin and lacking in contrast. They appear gray and "weak." If such a negative is placed on a page of type, one can easily read the type even through the darkest parts of the negative. If underdeveloped negatives are printed on paper of normal gradation, they produce "flat" grayish prints devoid of white and black.

PRACTICAL FILM DEVELOPMENT

Habits are easy to form and hard to break. It is important, therefore, that the student of photography learn at the outset correct methods of film processing. Specific instructions are given in the following sections. A few general but equally important pointers are given below.

Do not try to "save" on material, least of all on developer, fixer, and chemicals, most of which are comparatively cheap. Replace the developer and fixer *before* they are exhausted. "Saving" on chemicals inevitably leads to waste of things much more valuable, such as irreplaceable negatives and time. It results in work having to be done twice—provided that there is a second chance.

Buy only products of reputable manufacturers. "Nameless" films, developers, and chemicals sold by certain chain stores or discount houses are admittedly cheaper. Unfortunately, often they are outdated stock bought in bulk for quick resale or they are so inferior in quality that they are worthless.

Always perform the same operation in the same way. Standardize whatever you can. Develop a system of processing films and prints, then stick to it. Do not change one developer or process for another because someone else had success with it. There is individual taste and preference in photography as in any other art or craft. Methods perfectly suited to another's temperament and ways of working may be entirely wrong for you.

Best results are invariably obtained if exposure and development of films are standardized through intelligent use of an *exposure meter, timer, and thermometer.* Negatives so produced are technically far superior to those obtained by subjective methods. In my opinion, the method of exposing films "by experience" and developing them by "visual inspection" is obsolete and inferior to the "time-and-temperature method" of negative development discussed in the following pages.

Preparations

The preliminary steps are the same for all films and developers. Consult the chart on the opposite page as you go along.

HOW TO DEVELOP A FILM

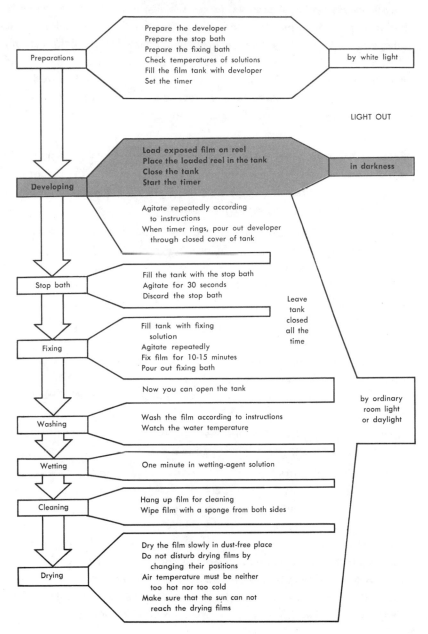

Preparations
Prepare the developer
Prepare the stop bath
Prepare the fixing bath
Check temperatures of solutions
Fill the film tank with developer
Set the timer

by white light

LIGHT OUT

Developing
Load exposed film on reel
Place the loaded reel in the tank
Close the tank
Start the timer

in darkness

Agitate repeatedly according
to instructions
When timer rings, pour out developer
through closed cover of tank

Stop bath
Fill the tank with the stop bath
Agitate for 30 seconds
Discard the stop bath

Leave
tank
closed
all the
time

Fixing
Fill tank with fixing
solution
Agitate repeatedly
Fix film for 10-15 minutes
Pour out fixing bath

Now you can open the tank

Washing
Wash the film according to instructions
Watch the water temperature

by ordinary
room light
or daylight

Wetting
One minute in wetting-agent solution

Cleaning
Hang up film for cleaning
Wipe film with a sponge from both sides

Drying
Dry the film slowly in dust-free place
Do not disturb drying films by
changing their positions
Air temperature must be neither
too hot nor too cold
Make sure that the sun can not
reach the drying films

Prepare the developer. Decide what type of developer to use by consulting the survey on p. 187. If possible, follow the film manufacturer's recommendations. Before using a fine-grain developer, see that the film was exposed accordingly, otherwise negatives may turn out too thin. Developer solutions that have been used must be filtered before reuse to eliminate particles of emulsion and sludge. Pour the solution through a funnel that is loosely stopped with a wad of absorbent cotton. Do not filter solutions that are too cold because some of their components might have crystallized and filtering would remove them from the solution, spoiling it.

Prepare the stop bath. A stop bath for negatives that has a greater hardening effect than ordinary hardening solutions can be prepared by dissolving 30 grams of granulated potassium chrome alum in 30 cc of a 5 percent sulfuric acid solution and adding water to make 1 liter.

Prepare the fixing bath. In using a prepared fixer, instructions for dissolving its components should be strictly followed; if not, the bath may spoil immediately. If you wish to prepare your own fixing bath in accordance with a published formula (which is very simple and much cheaper), observe the following rules:

Dissolve the sodium sulfite first, then the acetic acid. Add the hardener (alum) to the sulfite-acid solution. Do not mix sulfite and alum directly with each other because they would form aluminum sulfite which precipitates as white sludge. Dissolve the hypo in hot water, then let it cool. Do not mix hypo and acetic acid directly with each other. Acetic acid is sensitive to heat; do not add it to solutions that are warmer than 85 degrees F. Mixed with hypo in solution above 85 degrees F., it decomposes the hypo and the bath would become milky. A fixing bath that is milky is spoiled and must be discarded. After they have cooled below 85 degrees F., mix the sulfite-acid-alum solution with the hypo solution.

Check the temperature of all solutions. The normal temperature is 68 degrees F. Temperatures within a range of 7 degrees higher or lower may be used, provided that all solutions, including the wash water, have the same temperature. Differences in the temperature of the solutions can cause reticulation (wrinkling of the emulsion). Solutions that are too warm may melt the film emulsion and cause it to flow off its base. Solutions that are too cold act sluggishly and erratically, or do not act at all. If temperatures of solutions are higher than 75 degrees F. or lower than 60 degrees F., cool or heat by immersing the solution bottles in a pot filled either with cracked ice or very hot water. Metal developing tanks are good heat

198

conductors and respond quickly to temperature changes; handle them as little as possible in hot weather because your body heat will raise the temperature of the developer. Plastic developing tanks conduct heat poorly and respond slowly to temperature changes. They keep solution temperatures more stable, but changing temperatures by placing the tank in a hot or ice-cold water bath is more time-consuming with plastic tanks than with metal tanks.

Fill the developing tank with film developer. Be sure it is filled neither too high (or it will overflow when you immerse the film reel) nor too low (or a strip along the edge of the film will remain underdeveloped and become streaky).

Set the timer. The time of development depends on the type of film, the type of developer, and the temperature of the solution. Consult the manufacturer's chart. p. 195

Load the developing tank. If you use a daylight-loading tank (Kodak Day-Load, Agfa Rondix, Leitz Rondinax), loading can be done either in daylight or by ordinary room illumination. *Other tanks must be loaded in total darkness.* If you use a photographic darkroom, turn off the safelight, too. If you do not have a darkroom, load the developing tank in a light-tight closet or windowless space in the basement, etc., but be sure the place is *really* dark or you may fog and spoil your film. Arrange the developer-filled tank, tank cover, film reel, and film so you can find them easily in the dark. Then turn off the light and start loading in accordance with the instructions that accompanied the tank.

ROLLFILM DEVELOPMENT

Load the film on the reel. Before you risk spoiling your first exposed film, sacrifice a roll of *unexposed* film and practice loading the reel—first in daylight, then in the dark. At first, it may seem difficult, but once you have the knack, loading a reel is easy. Above all, *be sure that the film reel is completely dry.* The film will stick if it hits a wet spot, and it will have water spots or kink and pleat in the tank and you will have what is called in movie-production jargon a "film salad."

Place the loaded reel in the tank. Tap it sharply a few times against the tank bottom to dislodge air bubbles trapped between the coils of the film. Place the cover on the tank.

Start the timer immediately.

Now the white light can be turned on and left on for the rest of the operations, or the tank can be taken to an ordinary lighted room.

199

Agitate repeatedly. Correct agitation is necessary to produce uniformly developed negatives. Mechanical uniformity of agitation causes streaky development. After the film has been in the developer for a few seconds, take the tank in both hands and move it gently back and forth while tilting and rotating it simultaneously. Continue agitation for approximately five seconds; repeat at half-minute intervals during the entire development. If you use a tank that has a reel that can be turned by a rod or a crank inserted through the cover, rotate the reel gently but *unevenly* back and forth for the first minute, and for approximately five seconds every two minutes thereafter until development is completed.

When the timer rings, without removing the cover of the tank, pour the developer back into its bottle or, if a one-shot developer is used, discard it and fill the tank with the stop bath.

Stop bath. Agitate for about thirty seconds, then pour the stop bath out through the tank cover and discard it. It can be used only once.

Fixing. Pour in the fixing solution. Agitate immediately for half a minute, repeat several times until fixation is complete. Leave negatives in the fixing bath approximately twice as long as is required to clear the emulsion. A fixing bath is exhausted when the time required to clear a negative is twice that required when the bath was fresh. Although an exhausted fixing bath will clear a negative, the negatives are not permanent and they will fade within a relatively short time.

The safest way to fix negatives and prints is to use two fixing baths: use the first for the prescribed time, then transfer the negatives or prints to the second bath and fix them for five minutes. When the first bath begins to show signs of exhaustion, discard it, replace it with the second bath, and prepare a new bath for the second fixing.

Negatives and prints are not damaged if left in the fixer more than twice the time required to clear them. However, if they are left more than ten minutes in the fixer, excessive swelling and softening of the negative emulsion may result, particularly if the bath does not contain a sufficient amount of hardener, and the image of prints will begin to bleach and fade.

Now the cover can be taken off the tank.

Rinse the film on the reel under running water for a couple of minutes, then fill the tank with a hypo neutralizer solution, replace the reel for two to three minutes, and agitate constantly.

200

Wash the film. Correct washing is required for permanency of the negative. Even minute traces of chemicals left in the emulsion will in time produce discoloration or fading of the image. Rollfilm can be washed on the reel in the developing tank. First, put a piece of cork beneath the reel to make the center core opening slightly higher than the edge of the tank. Place the tank under a faucet and let a thin stream of water run directly into the center core of the reel. Another equally effective method is to connect a piece of rubber hose to the faucet and put the other end into the center of the reel. In both cases, water is forced through the core of the reel and up through the coils of the film, washing out all the chemicals that must be removed. Most other methods of washing are less effective. Washing film in a tray by running water into it and out over its edge is ineffective since hypo is heavier than water and sinks to the bottom, where it is more slowly removed. The temperature of the wash water must be within a few degrees of the temperature of the other solutions; if it is not, negatives may reticulate. Occasional temperature checks are recommended during washing. Negatives should wash for half an hour under water running fast enough to change the water in the washing vessel every five minutes.

After washing, place the film in a wetting-agent solution (Kodak Photo-Flo) for about one minute to prevent formation of water drops on the drying film.

Cleaning. Remove the film from the wetting-agent bath, place a film clip on one end, and hang the film up. Pull the film slowly between two well-soaked and wrung viscose sponges to wipe both sides simultaneously and remove all water drops and loose gelatin particles. After ten minutes, check the film. If any drops have formed, remove them, not by wiping, but by absorbing them with the corner of a moist viscose sponge.

Drying. Films must be dried slowly and evenly in clean air. Rapid drying seems to increase the size of the negative grain. If unfiltered air is used, drying under a fan is certain to spoil a film because the forced draft propels particles of dust and dirt, like tiny projectiles, into the emulsion. Films moved during the drying may dry streaky, for changes in position usually cause changes in temperature and air currents that affect the rate of drying. The part of the negative that dried faster will have a different density from the part that dried more slowly. To prevent rolls of film from sticking together when drying, space them far enough apart and weigh their lower ends with film clips. *Films must never be dried in the sun.*

As soon as films are dry, cut them apart in lengths of six frames (35-mm) or four frames (size-120) and place them in individual glassine envelopes for safekeeping.

Be sure to use *only* file envelopes that have edge seams, avoid those that have the seam in the center along the middle of the film where it may cause abrasion marks on the emulsion.

SHEET FILM TANK DEVELOPMENT

In total darkness, load the developing hangers. Lower them smoothly into the developer-filled tank and start the preset timer. Strike the hangers down hard three times to dislodge air bubbles, then agitate vertically for about five seconds. Turn the safelight on. Leave the hangers undisturbed for one minute, then lift the entire rack out of the solution, tip 90 degrees, let the developer briefly run off, then put the hangers back into the tank. Repeat this operation once every minute for the entire duration of development, draining the hangers very briefly by tipping them in opposite directions.

When the timer rings, lift the whole rack out of the tank, drain, and put the rack into a second tank filled with a stop bath. Lift and drain four or five times, drain, and transfer the hangers to a third tank filled with the fixing solution.

Agitate the negatives vertically in the fixer for half a minute, then lift and drain the hangers once every two minutes until fixation is complete. Turn on the white light.

Immerse the hangers, after a brief rinse, for two or three minutes in a hypo neutralizing solution, agitating constantly.

Wash the negatives in their hangers in a separate tank under running water for half an hour. Immerse them briefly in a wetting-agent solution, take them one by one from their hangers, wipe both sides of each negative carefully, and hang them to dry following instructions given above.

FILM PACK AND SHEET FILM TRAY DEVELOPMENT

If up to six filmpack or sheet film negatives must be developed quickly, the following method can be used if one is careful, has short fingernails, and if the temperature of the developer is not higher than 68 degrees F., otherwise the gelatin softens and becomes too vulnerable.

In total darkness immerse the film sheets, emulsion-side up, one after the other in a tray of *water* not warmer than 68 degrees F. Be sure the first film is completely immersed before you place the next on top of it, otherwise they will adhere

202

permanently. After the last film is immersed, carefully draw the bottom film out and place it on top of the pile, touching it only at its extreme edges. Be careful that its corners do not scratch the other films. Take one film after another from the bottom and place it on top until the whole stack has been leafed through twice.

Start the preset timer and transfer the films to the developer, removing one at a time from the bottom of the water tray. When all the films have been transferred, repeat the operation of slowly leafing through the films from bottom to top for the entire duration of development, turning the negatives sideways once in a while, but always keeping the emulsion-side up. After the negatives have been in the developer for a minute or so, the safelight can be turned on.

When the timer rings transfer the negatives one by one to the stop bath. Leaf through them twice as described above.

Finally, remove the negatives one by one to the fixer and, immediately after all are immersed, leaf through the pile twice. Repeat this every two minutes until fixation is complete.

Treat the negatives in a hypo-neutralizing solution as described above. Wash in a p. 200 tray equipped with a syphon for a minimum of half an hour, briefly immerse the negatives in a wetting-agent solution, and dry as described above. p. 201

HOW TO MAKE A PRINT

A contact print is identical in size to the negative from which it is made. It is a positive replica of the negative, containing most of its merits and faults. Contact prints are made in a printing frame or contact printer on slow chloride paper.

An enlargement is, of course, larger than the negative from which it is made. It is possible to control enlargements to a very high degree, and to extensively correct undesirable qualities of the negative. Enlargements are made with an enlarger on fast bromide or medium-fast chloro-bromide paper.

Aside from these differences, the processing of contact prints and enlargements is identical.

The two accompanying graphs show the steps involved in making contact prints and enlargements. Most of the operations are so simple that further explanation is unnecessary. Additional instructions are given in the following paragraphs to clarify those operations that are more complicated.

HOW TO MAKE A CONTACT PRINT

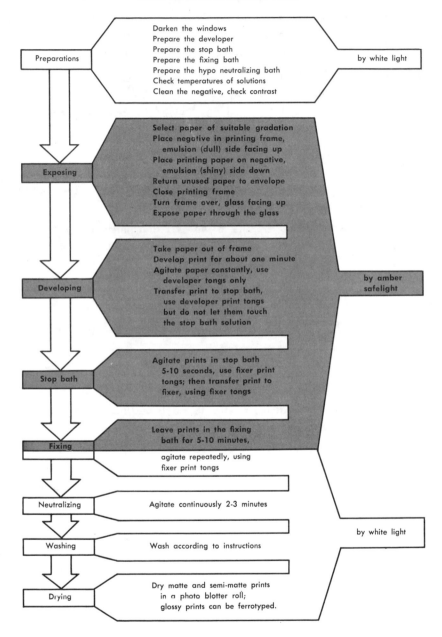

Preparations — by white light
- Darken the windows
- Prepare the developer
- Prepare the stop bath
- Prepare the fixing bath
- Prepare the hypo neutralizing bath
- Check temperatures of solutions
- Clean the negative, check contrast

Exposing — by amber safelight
- Select paper of suitable gradation
- Place negative in printing frame, emulsion (dull) side facing up
- Place printing paper on negative, emulsion (shiny) side down
- Return unused paper to envelope
- Close printing frame
- Turn frame over, glass facing up
- Expose paper through the glass

Developing
- Take paper out of frame
- Develop print for about one minute
- Agitate paper constantly, use developer tongs only
- Transfer print to stop bath, use developer print tongs but do not let them touch the stop bath solution

Stop bath
- Agitate prints in stop bath 5-10 seconds, use fixer print tongs; then transfer print to fixer, using fixer tongs

Fixing
- Leave prints in the fixing bath for 5-10 minutes, agitate repeatedly, using fixer print tongs

Neutralizing — by white light
- Agitate continuously 2-3 minutes

Washing
- Wash according to instructions

Drying
- Dry matte and semi-matte prints in a photo blotter roll; glossy prints can be ferrotyped.

HOW TO MAKE AN ENLARGEMENT

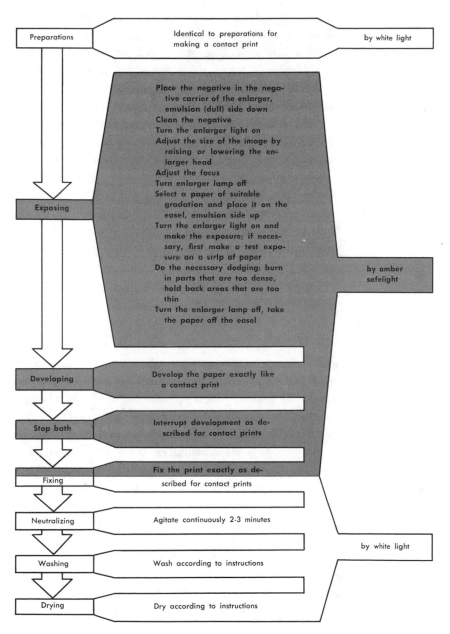

| Preparations | Identical to preparations for making a contact print | by white light |

Exposing

Place the negative in the nega-
tive carrier of the enlarger,
emulsion (dull) side down
Clean the negative
Turn the enlarger light on
Adjust the size of the image by
raising or lowering the en-
larger head
Adjust the focus
Turn enlarger lamp off
Select a paper of suitable
gradation and place it on the
easel, emulsion side up
Turn the enlarger light on and
make the exposure; if neces-
sary, first make a test expo-
sure on a strip of paper
Do the necessary dodging: burn
in parts that are too dense,
hold back areas that are too
thin
Turn the enlarger lamp off, take
the paper off the easel

by amber
safelight

Developing — Develop the paper exactly like a contact print

Stop bath — Interrupt development as described for contact prints

Fixing — Fix the print exactly as described for contact prints

Neutralizing — Agitate continuously 2-3 minutes

by white light

Washing — Wash according to instructions

Drying — Dry according to instructions

The negative

A good print starts with a good negative. A "good" print is one that is correctly exposed and developed, and also *clean*. Before a negative is put into the printing frame or the enlarger, remove particles of dust with a camel's hair brush. In cold and dry weather, this is difficult, for brushing causes the negative to become increasingly charged with static electricity which tenaciously holds the particles of dust. Under such conditions touch the negative carrier to the grounded enlarger to dissipate static electricity, brush the negative *once very slowly,* then use a small rubber syringe to blow off the remaining particles with short, sharp puffs. To determine whether a negative is clean, hold it under the light-beam of the enlarger at a steep angle, and even minute specks of dust will stand out startlingly bright against the dark background of the film. Fresh fingerprints can sometimes be removed by wiping the negative with a tuft of cotton dampened in a good film cleaner (Kodak, Ecco 1500 or 1341). Old fingermarks that have eaten into the film cannot be eliminated. Minor scratches and abrasion marks can be minimized or prevented from showing in the print by gently rubbing a thin film of white petroleum jelly (Vaseline) into them. However, this is feasible only if the negative is to be enlarged and a glassless carrier is used; otherwise, the petroleum jelly would smudge the glass or stain the contact paper. After the print has been made, the petroleum jelly should be removed with carbon tetrachloride.

In contact printing it does not matter much whether a negative is dense or thin, but if an unusually dense negative is to be *enlarged,* it must first be "reduced" (made more transparent by treating it in a reducer solution). Otherwise, exposure times would be so long that accumulated heat from the enlarger lamp would buckle the film and accumulated stray light and reflected light would fog the paper. A negative is too dense if the required exposure exceeds one minute. Before you reduce a negative that is too dense, examine its gradation: if it is too contrasty (usually as a result of overdevelopment), use potassium persulfate reducer; if it is too contrastless (usually as a result of overexposure), use Kodak Farmer's Reducer (single solution). If a negative is so thin that it requires an unworkably short exposure time, stop down the diaphragm of the enlarger lens completely; if this is not adequate, enlarge the negative on slow contact printing paper. Weak contrast and faint detail can also be strengthened by treating the negative in an intensifier bath. However, glass-clear areas are beyond improvement—no intensifier can produce detail where none exists.

> The first prerequisite for successful printing and enlarging is a
> clean negative of correct density and contrast.

The paper

Unfortunately, not every negative is satisfactory in gradation (contrast range). There may be many reasons for this: either the exposure was too long or too short, the developer too warm or too cold, the development too long or too short, or the subject contrast was abnormally high and the photographer failed to take corrective measures. Luckily, such faults can usually be corrected in the print by selecting a paper of appropriate gradation in accordance with the following table:

Character of the negative	Extremely contrasty	Contrasty	Normal	Soft	Extremely contrastless
Recommended paper gradation	Extra soft (No. 1)	Soft (No. 2)	Normal (Nos. 2, 3)	Hard (No. 4)	Extra hard (Nos. 5, 6)

In analyzing a negative to determine the most suitable paper gradation, do not confuse gradation and density. One has nothing to do with the other. A very *thin* negative can be very *contrasty* (as a result of underexposure and overdevelopment), or extremely *lacking in contrast* (overexposed and underdeveloped). And a very *dense* negative that appears almost uniformly black can be very *contrasty* (if considerably overdeveloped) or extremely *lacking in contrast* (if considerably overexposed). When in doubt, make a test print on paper of normal gradation. If the print is too contrasty, make the final print on softer paper. If it lacks sufficient contrast, choose a paper of harder gradation.

> The second prerequisite for successful printing and enlarging is
> the selection of a paper with a gradation appropriate to the
> contrast range of the negative.

Focusing

An unsharp negative will, of course, not yield a sharp print, but unsharp prints from perfectly sharp negatives are common. The best way to get sharp prints is to use a focusing magnifier and focus on the negative grain (disregarding fine

subject detail). This is easy if the negative is held flat between glass in the nega-tive carrier of the enlarger. But if a glassless negative carrier is used, heat from the enlarger lamp may cause the negative to warp and buckle out of the plane of focus between the time of focusing and exposing, with the result that the "sharply focused" negative yields an out-of-focus print. To avoid this, give the negative half a minute or so to warm up before you focus, and if you make several prints from the same negative, check the focus before you make each print.

> The third prerequisite for successful enlarging
> is correct focusing.

The exposure

The operation most likely to cause trouble in making prints is the exposure. Unlike most films, which have a relatively wide exposure latitude, i.e., can stand a good deal of overexposure and even some underexposure and still produce usable nega-tives, sensitized paper must be accurately exposed to yield good prints. A negative is an intermediary step in picture-making, and mistakes in the negative can largely be corrected in making the print. But a print is the final step, and mistakes made in printing cannot be corrected; a new print must be made.

Contact print exposure determination. Duration of exposure depends on: in-tensity of the light source, distance between the light and the paper, sensitivity of the printing paper, density of the negative. The first three factors can be standard-ized by using the same type of paper with the same light at the same distance. The only variable then is the density of the negative. If the negative is small, make a few test exposures until you get the right one. Use a 60-watt bulb at a distance of 20 inches from the printing frame and expose a sheet of, for example, Kodak Azo or Velox Paper for twenty seconds. If the negative is large, to save paper use a strip about 1 inch wide the length of the negative for the test exposure. De-velop the strip for the time recommended by the paper manufacturer, fix, and examine it by white light. If the image is too dark, exposure was too long; if it is too light, exposure was too short.

Enlargement exposure determination. In principle, exposure is determined by the same factors that apply in contact printing. In practice, however, two addi-tional variables must be considered: the degree of magnification of the projected image and the diaphragm stop of the enlarger lens. The higher the magnification and the more the lens is stopped down, the longer the exposure time required. If

the negative has average density, the lens should normally be stopped down to around f/8 or f/11 to produce exposure times of ten to twenty seconds—long enough to be timed precisely and to allow time for "dodging," yet short enough to prevent the negative from overheating and buckling. p. 215

The simplest way to determine the exposure time for an enlargement is to make a test strip as follows: cut a sheet of paper of appropriate gradation in strips about 1½ inches wide. Place a strip on the easel. Cover four-fifths of it with a piece of cardboard, and expose the exposed part for thirty-two seconds. Uncover one-fifth more, and expose for sixteen seconds. Repeat this operation, exposing the remaining three-fifths of the strip for eight, four, and four seconds, respectively. Thus, the five sections of the strip receive exposures of sixty-four, thirty-two, sixteen, eight, and four seconds, respectively. Develop the strip for the time recommended by the paper manufacturer, fix, and examine it by white light. Decide which exposure is correct and use it as the basis for making the final print. Of course, the best exposure may be between two steps. If so, that time should be used in exposing the final print. After exposing a few prints successfully, a beginner will quickly get enough experience to judge the density of most negatives correctly.

The crucial test for the correctness of exposure is the reaction of the sensitized paper in the developer. The print must appear satisfactory at the end of the development time recommended by the paper manufacturer. If, beyond this time, the print is too light—if highlights are chalky and shadows are grayish instead of black—the exposure was too short. Conversely, if the image appears within a few seconds after immersion and rapidly turns too dark, exposure was too long. In both instances the print is worthless. In the first instance longer development would produce over-all grayishness from fog and yellow stain from oxydizing developer. In the second instance if the paper were prematurely taken from the developer, the result would be a brownish print with mottled and streaky tones.

> The fourth prerequisite for successful printing and enlarging is correct exposure of the paper.

The development

Exposure of the sensitized paper produces a latent image which must be developed like the latent image in a negative, except that a paper developer must be used. Best results are usually achieved with one of the developers recommended by the paper manufacturer.

The temperature of the developer. This factor influences not only the duration of development but also the tone of the print. When paper developers are relatively cold they act sluggishly and produce prints that appear underexposed, with chalky highlights and grayish shadows. When developers are too warm, prints appear brownish in tone like a print that is overexposed.

> The fifth prerequisite for successful printing and enlarging is a developer temperature between 68 and 75 degrees F.

The time of development. To reach their full inherent richness of tone, prints must be fully developed within a certain time, usually from one to two minutes. Prints that appear fully developed before this time, and those that have not yet acquired their full strength within this time, are incorrectly exposed and will appear so. The only way to regulate the developing time is to adjust the time of exposure accordingly.

> The sixth prerequisite for successful printing and enlarging is maintenance of a developing time of one to two minutes.

Practical print processing

Developing. Do not touch the emulsion side of the paper with your hands. Slide the paper edgewise into the developer, emulsion-side up. Be sure to immerse the paper smoothly without interruption to prevent streaks. Agitate continuously. If the developer tray is small, agitate by gently rocking it alternately from side to side and from front to back. If the tray is large, use tongs to agitate the print, moving it around in the developer. Do not dip your hands into the developer, because it may become contaminated by the residue of another solution, be spoiled in a very short time, and make brown and yellow spots or streaks in the print. Always use different print tongs for the developer and the fixer. Stop bath and fixing solutions spoil developers—be careful to keep developing tongs from becoming contaminated with them.

Stop bath. When the print is fully developed, transfer it to the stop bath for five to ten seconds. Use the developer tongs, but be sure that they do not touch the stop bath solution. Let the print slide edgewise into the stop bath, then dunk it with the fixer tongs. Agitate continuously. The stop bath not only stops development almost instantly, but also prevents the print from staining in the fixing bath. Staining occurs frequently when prints are transferred directly from the developer to the fixer and when they are not sufficiently agitated in the fixing bath.

Fixing. Remove the print from the stop bath to the fixing bath, using the fixer tongs. Agitate thoroughly for about ten seconds. Fixing takes from five to ten minutes (depending on the freshness of the hypo), during which time the accumulating prints must be separated and agitated occasionally. Prolonged immersion in the fixer causes the image to bleach and may also cause the phenomenon known as "water soak," a condition which shows as a mottle on the back of the print which in time may turn into a yellow stain. For greatest print permanency, use the two-bath fixing method described before; leave prints from three to five minutes in p. 200 each bath. After a print has been in the fixer for about one minute, it is safe to inspect it in white light.

Hypo neutralizing. Although not absolutely necessary, this step is recommended for greatest print permanency. Take the print from the fixer, rinse it briefly, and transfer it to the hypo-neutralizing bath. Treat single-weight prints for a minimum of two and double-weight prints for a minimum of three minutes, agitating continuously. Prints that have been thus treated require only half an hour's washing.

Washing. Adequate washing is vitally important to print permanency because residual chemicals left in the emulsion and entrapped in paper fibers will, with time, cause stains and fading of the image. This is most likely to happen if prints have been treated in strong stop baths, in exhausted fixing baths, or if they have been left overly long in the stop bath or the fixing solution. Wash double-weight prints for a minimum of one hour (if treated with a hypo neutralizer, wash half an hour) under running water 70 to 75 degrees F. in a deep tray equipped with a tray-syphon. Do not overload the tray or the prints will stick together and they will not be properly washed. From time to time move the prints around by hand, transfer prints from the bottom of the stack to the top, and see to it that each print gets a proper wash. If running water is not available, soak the prints in a large, deep tray for five minutes, then change the water; repeat this process twelve times. Agitate and separate the prints during washing.

Drying. To remove excess water, place the print on a clean, smooth, inclined surface (in the processing sink lean a sheet of plate glass against a wall or use the bottom of a large tray turned upside-down and set up at an angle). Let the print drain, then swab it off with a viscose sponge or roll it with a squeegee before you place it on an electric dryer or in a photo blotter roll. To ferrotype glossy prints, use a soft cloth to clean the ferrotype plate under a stream of water, roll the print onto the ferrotype plate with a squeegee. Let the print dry thoroughly, either at room temperature or in an electric dryer. Do not remove prints from

ferrotype plates prematurely or the emulsion will crack. Prints that are perfectly dry strip off easily. Lift one corner and draw the print diagonally off the plate. If sticking occurs, the plate was not clean. Yellow stains are a sign of insufficient agitation during fixing, exhaustion of the fixing bath, or insufficient washing. Matte spots in the glossy finish are caused by air trapped between the ferrotype plate and the paper. They can be avoided as follows: transfer the print dripping wet to the ferrotype plate; stand the print on its short edge, let it down gradually in such a way that the water running down from the print forms a cushion between print and plate, driving all air ahead of it and preventing the formation of bubbles. Then roll the print down with a squeegee.

Finishing. The effect of a print depends to a surprising degree on the way in which it is presented. If it is perfectly flat or faultlessly mounted, evenly trimmed, clean, and free from dust specks and spots, the observer is much more likely to overlook or excuse minor faults of composition, definition, or contrast. However, if a photograph is good in other respects but is poorly dried, bumpy and curling, spotty from dust specks on the negative, sloppily trimmed, with corners that are worn from careless handling, its faults would probably obscure all its good features.

Flattening. Papers that have a tendency to curl can be flattened by treating them in a commercial flattener solution or by dampening the back with a moist cloth or sponge and placing them overnight between blotters under a weight.

Trimming. To get a perfectly straight, clean edge, use a cutting board (paper trimmer) or place the print on a sheet of plate glass and trim it with a single-edge safety razor blade and a steel straight-edge. The glass, of course, dulls the blade within a relatively short time, but no other support produces an equally crisp cut. If the blade gets dull, keep it sharp by breaking off worn corners. If a narrow white edge is left around the print, be sure it is even. I prefer to trim off the white edge because I feel that it makes the near-white tones of a photograph appear grayish by comparison. On the other hand, a white edge protects prints that must be handled frequently. If the white edge gets ragged, trim off a bit, and the photograph will look new.

Spotting. To spot a print, first remove dark spots with a knife—an etching knife or a safety razor blade which can be kept sharp by breaking off worn corners. Work very lightly. Carefully shave off the emulsion layer by layer until the spot blends with the surrounding tone. Be careful not to dig through to the paper base —a common mistake of the beginner. Practice on inferior prints before you start on a good one. If you have overdone the shaving and the spot is too light, darken

it with a no. 4 pencil or watercolor when you retouch the light spots on the print.

Light spots must be darkened with a hard pencil, watercolor, or dye. For glossy prints, special retouching colors are available at photo-stores. Apply a shade of watercolor somewhat lighter than the area surrounding the spot because as the watercolor dries, it darkens. Mix the proper shade from black and white and apply it with the tip of a fine watercolor brush. Use the color as dry as possible and apply it in very thin layers, gradually blending the spot with the surrounding area. If necessary, apply a slightly darker coat of paint after the first has dried, or use a no. 4 pencil. If a spot appears too dark after drying, shave it off before you apply a lighter tone to avoid raising a spot of paint on the print.

Mounting. Prints can be mounted on exhibition boards (standard size is 16 x 20 inches) in several different ways. However, the "professional" and permanent way to mount a print is with dry-mounting tissue that has a chemically inert resin base which is not affected by humidity and water and does not warp the print or mount. The mounting process is simple. It is best done with a dry-mounting press, but it can also be done with an ordinary flatiron; instructions accompany the tissue. Rubber wax-base mounting tissues are subject to early decomposition of the organic rubber component. Rubber cement is temptingly easy to use but in time will discolor and stain the print. Water-soluble pastes and glues distort the paper and cause the print and mount to buckle—only a professional bookbinder or paperhanger can do a competent job with glue.

Creative enlarging

Important as a good, i.e., technically perfect, negative is for the production of a good photograph, it is only an intermediary step in the making of the print. A good photo-technician can use the same negative to make many enlargements, each so different that the uninitiated would never believe they were made from the same negative. Instructions have already been given for the customary processing of prints. The following are offered to the reader whose interest goes beyond technical perfection.

Cropping. Instead of enlarging an entire negative, a section can be enlarged. To select an area for enlarging, study your contact prints and decide which parts of the picture are important. Use two L-shaped pieces of cardboard to mask off the margins of each contact print, gradually decreasing the size and changing the proportions of the area within the L-masks until you find the most effective section of the photograph. Mark it with a grease-pencil (such marks can easily be

removed with a cloth dampened in cleaning fluid). Eliminate unsharp foreground, untidy background, wires cutting across the sky, and other superfluous subject matter and marginal detail until the subject proper appears in its most concentrated form. Then enlarge it to the most effective size.

Masking. When a section of a negative is to be enlarged, the rest must be masked with black paper. Otherwise, stray light passing through the marginal parts of the negative would fog the sensitized paper, highlights would appear grayish instead of white, and the contrast range of the print would be lower than expected. Neglect of this precaution is a common cause of the grayish appearance of many enlargements made by amateurs.

p. 54 **Proportions.** The size and proportions of a photograph should be determined by the nature of the subject rather than the proportions of the negative or the paper. Although the standard proportions of the most common sizes of printing paper are four-to-five, many subjects appear more effective if presented in more horizontally elongated or vertically narrow shapes, or as squares. If enlarging paper is cut down to such sizes, the part removed makes excellent test strips for determining the correct exposure of prints.

Perspective control. "Converging verticals" in negatives of architectural subjects can be restored to parallelity during enlarging: adjust the paper in such a way that the side of the projected image toward which the verticals converge is farther from the lens than the opposite side of the image. This is done by tilting the paper easel until the verticals appear parallel. Such a tilted image is sharp only within a very narrow zone. If the degree of tilt is very slight, the entire image can be brought into focus by stopping down the lens. Otherwise, over-all sharpness must be restored either by slightly tilting the negative in the opposite direction from which the paper is tilted (for this purpose, some enlargers have a tilting negative carrier; if yours is not, support the negative carrier in a tilted position by blocking up one of its sides as best you can), or by *slightly* tilting the lens in the same direction the paper is tilted (for this purpose, some enlargers are equipped with a tilting-lens stage). The principle according to which such tilts must be adjusted demands that imaginary lines drawn through the planes of the negative, the lens (diaphragm), and the sensitized paper, if sufficiently extended, would meet in a common point. If this condition is fulfilled, the entire print will be sharp without the need for stopping down the lens beyond normal. If the tilt of the easel is considerable, to produce an evenly exposed print, additional exposure must be given to that part of the image that is farthest from the lens.

214

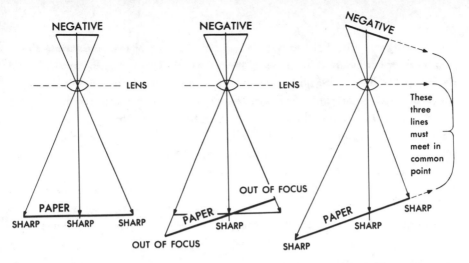

Over-all contrast control. Generally, the best results are achieved if paper exposure is timed so that the print is fully developed in not less than one and not more than two minutes. However, the exposure latitude of photographic papers varies, and some papers allow more leeway in this respect than others. As a result, it is sometimes possible to influence the contrast of a print by appropriate manipulation of the times of exposure and development: prolonging the exposure and shortening the time of development decreases contrast; conversely, shortening the exposure and prolonging the time of development increases contrast. Since different papers react differently, the permissible latitude of such deviations from the normal times must be determined by test.

Local contrast control. A common fault of many negatives is that they are both too contrasty (hard) and too contrastless (soft). For example, in a portrait taken in bright sunlight, if shadow fill-in illumination is not used, contrast between the sunlit and the shaded parts of the face is very high; at the same time, contrast *within* the shadows, and contrast *within* the sunlit areas, is very low. If such a negative were printed on paper of soft gradation, contrast between light and shadow would be reduced to a pleasing level; but *within* the shaded and sunlit areas, contrast would be much too low and the effect would be one of flatness. The simplest way to make a satisfactory print from such a negative is to use relatively contrasty paper to produce sufficient contrast within the areas of highlights and shadows and reduce over-all contrast through "dodging."

Dodging involves giving the dense parts of a negative more exposure than the thin parts. This is done by techniques known as "burning in" and "holding back." Dense areas of the negative that normally would be too light in the print can be

215

darkened by "burning in." This is done by cutting a hole of the appropriate shape in a piece of cardboard through which the light is allowed to fall for an additional period on the area to be darkened, while the rest of the picture is shielded from overexposure by the cardboard. Conversely, thin negative areas that normally would appear too dark in the print can be kept lighter by "holding back." This is done by using a "dodger," a small circular piece of cardboard attached to a wire handle, to shade the thin area from the enlarger light while the rest of the picture is exposed. In both cases, to avoid unsightly "haloes" surrounding the treated areas, the dodging device must be kept in constant motion to blend the tone of the treated and untreated areas of the picture. Experienced printers use mostly their hands for burning in and holding back, forming the appropriate shapes with their fingers.

Local darkening of the print. Despite care, it sometimes happens that toward the end of development an area of a print appears too light. If the print is small, it is usually simpler to make a new print than to try to improve it. But if it is a large print, and particularly if it was difficult to make because it required extensive dodging, there are two means by which it may be improved:

Hold the print, emulsion-side down, under the hot water faucet. Let the hot water run only over the area that is too light. Move the print back and forth slightly while it is under the stream of hot water to avoid streaks and to blend the tone of the treated and the untreated areas. Then put the print back into the developer for additional development. If necessary, repeat this once or twice.

Or darken areas that are too light by swabbing them with concentrated developer solution. For this purpose keep a small jar of developer-concentrate. Apply it to the print with a tuft of absorbent cotton. If the area to be treated is very small (for example, a small face in a crowd), apply the concentrated developer with a Q-tip. Extreme care must be taken to avoid streaks and spots caused by developer drops, runs, and inappropriate application which fails to blend the treated area with surrounding areas. To avoid runs and streaking, place the print in horizontal position on the back of a processing tray set in the sink, touch the developer-dampened cotton to the area to be treated for a while, then put the print back into the developer tray for additional development. Since these techniques require a considerable degree of skill to produce satisfactory results, a photographer should practice with test prints before he works on an important print.

Local lightening of prints. Areas of a print that appear somewhat too dark after development can be made lighter by treating them with a potassium ferri-

cyanide solution (Farmer's reducer). This solution is highly poisonous, does not keep, and must be freshly prepared before use: shake a teaspoon of the red crystals into a small tray half-filled with water and dissolve them completely. The strength of the solution is not too critical, but if it is too concentrated it works so fast that it cannot be controlled and it may also stain the print. A properly prepared solution of potassium ferricyanide is yellow; if it is orange or red, it is too strong and must be diluted with water; if it turns green, it is exhausted. Prints to be treated must be *completely* fixed; if not, they will stain. Take the print from the fixer and apply the reducing solution with a cotton swab to the area that is to be lightened (for very small areas, use a Q-tip). This must be done quickly, and immediately thereafter the print must be immersed in the fixing bath and agitated vigorously to prevent staining (fixer neutralizes the reducer). Areas that demand considerable lightening should be reduced in stages. Once overdone, the print is spoiled. Furthermore, great care is needed to prevent streaks and spots which result if the reducer runs across, or falls in drops on, print areas that should not be reduced. Correct use of ferricyanide requires a high degree of skill and a great deal of experience. But since it offers the only means for achieving certain effects, it seems to me important that a photographer who does his own printing train himself in its use by practicing on test prints made especially for this purpose.

Test strip data. When making tests for exposure determination and dodging, experienced photographers often pencil the exposure times on the back of the paper before developing the strip. If this is not done, the exposure times may be forgotten and the whole procedure may need to be repeated.

Check for pure white. The best way to determine whether highlights and white in a print are truly white or slightly gray is to curl back a corner of the sensitized paper while it is in the developer and hold it against the image. Since the back of the paper is pure white (unless, of course, a tinted paper is used), even the slightest degree of grayishness in a seemingly white highlight can be detected. Otherwise, even surprisingly dark shades of gray can seem white under the safelight if not subjected to such comparison.

Check on darkness. Prints always appear lighter in the fixer or water than when they are dry. If a wet print appears just right under the safelight, one can almost be sure that it will be too dark after it has dried. Allow for this change by developing prints slightly lighter than you wish them to be when dry.

Hand protection. During long darkroom sessions, it is unavoidable that the hands come into repeated contact with processing solutions. Since some people

are allergic to certain chemicals used in photography (Metol poisoning is not uncommon), to avoid the danger of skin irritations and rashes, some darkroom workers use thin rubber gloves. I prefer using Kerodex protective hand cream which, if applied according to instructions, offers complete protection against skin irritation and chapping.

COLOR PROCESSING

In black-and-white photography if a photographer processes his films and prints, he can, through using appropriate deviations from standard procedure in negative development and different controls during enlarging, influence the appearance of his prints to an almost unbelievable degree. In color photography, however, matters are somewhat different. If a reversal-type color film is used, this kind of influence is limited and best results are usually achieved by strictly following standard procedures. If a negative-type color film is used, the possible control over the color print is, of course, as far-reaching as it is in black-and-white photography. However, such control is not easy to achieve because the techniques involved are critical and a very high degree of skill is necessary to take full advantage of the potentials.

In view of these facts I feel that too few readers will be interested in color film development and printing to justify giving detailed instructions. Furthermore, specific technical information of this kind is soon obsolete because new processes are developed. Therefore, in the following, I give only outlines of the developing and printing processes for color films to show those readers who are interested in these techniques what is involved. Should they decide to do their own color work, they will find all the necessary information in the authoritative and always up-to-date instructions that accompany the respective color processing kits.

Negative-color film development

The entire process, which takes about an hour, involves ten steps. The first three take place in total darkness (but not necessarily in a photographic darkroom) while the remaining steps can be performed in ordinary light. Two things are critical: the temperature of the developer, which must be accurate to within plus or minus one-half degree F., and the agitation. In both respects the film manufacturer's instructions must be strictly followed. For the processing of Kodacolor and Ektacolor films (Process C-22), these are the necessary steps: (1) developing, (2) immersion in a stop bath, (3) immersion in a hardening bath—after the prescribed time in the hardener, the room light can be turned on and processing continued

by white light—(4) washing under running water, (5) bleaching, (6) washing under running water, (7) fixing, (8) washing under running water, (9) brief immersion in a wetting-agent solution, (10) drying.

Reversal-color film development

The entire process, which takes less than an hour, involves thirteen steps. Of these, the first five take place in total darkness (but not necessarily in a photographic darkroom). The remaining steps can be performed by ordinary (white) light. Two things are critical: the temperature of the prehardener must be accurate within plus or minus one-half, and that of the first developer within one-quarter, degree F., and agitating must be done exactly as prescribed by the film manufacturer.

For the processing of Kodak Ektachrome films (Process E-4), these are the necessary steps: (1) in total darkness, place film in prehardener, (2) place film in neutralizing bath, (3) place film in first developer, (4) place film in first stop bath, (5) wash film in running water. Turn on room lights—no reversal exposure using light is necessary as reversal is accomplished chemically in the color developer. (6) place film in color developer, (7) place film in second stop bath, (8) wash film in running water, (9) bleach film, (10) place film in fixing bath, (11) wash film in running water, (12) place film in stabilizing solution, (13) dry film in clean air at a temperature not exceeding 110° F.

The principles of color-negative printing

The main difference between black-and-white and color printing is that in color printing the enlarger light must be color-balanced in accordance with the character of the color negative and the desired over-all color of the print. This is done with special color filters which come in two types: Kodak CP (acetate Color-Printing) filters for use in enlargers which accommodate filters between the lamp and the negative (this is the best filter location; filters so placed cannot interfere with the sharpness of the print); and Kodak CC (gelatin Color-Compensating) filters for use between the enlarger lens and the sensitized paper. Minimum requirements: a red, a magenta, and a yellow set of filters, each set having four filters in different densities if acetate, and six filters in different densities if gelatin. In addition, no matter what type and number of filters are used, the enlarger must be equipped with a constantly used ultraviolet-absorbing filter (Kodak Wratten Filter No. 2B or Color Printing Filter CP2B) and a heat-absorbing glass (Pittsburgh No. 2043).

p. 137

p. 141

The most important step in color printing is finding the correct *basic filter pack,* i.e., that combination of filters which, used with a "normal" color negative, will produce a print of satisfactory color balance. Unfortunately, the combination of color filters will vary with the voltage applied to the enlarger lamp, the color of the enlarger's condenser and heat-absorbing glass, the specific color paper emulsion (which usually varies from batch to batch) and, of course, what the photographer prefers. Consequently, it is not possible to predict in advance which combination of color filters will give the best results, and the only way to establish the basic filter pack is by trial and error.

Photographers who work with Kodak negative color films (Kodacolor or Ektacolor) should begin by making an exposure determination test using a basic filter pack consisting of a 2B and a 50R filter and the combination of diaphragm aperture and image magnification with which the final color print will be made. The test
p. 209 paper should be exposed in strips as described before. Develop and dry the strip. In bright white light (but *not* in fluorescent illumination), examine the print for *exposure* and *color balance*. If the darkest section of the strip is still too light, the longest exposure was still too short and a new test with longer exposures must be made. If the lightest section of the strip is still too dark, the shortest exposure was still too long and a new test with shorter exposures must be made. If one of the strips contains the correct exposure, judge its color; if you like it, you are all set to make the final color print.

However, it is much more likely that your first test will be unsatisfactory and its overall color not correct. If this is the case, determine the exact shade of the excess color. This is most easily done by analyzing the neutral shades, particularly pastel shades, skin tones, and gray and white. If they are too red, too yellow, too blue, etc., *add a filter in the same color as the color cast of your test print to your basic filter pack* and make a second test. The density of this additional filter depends on the degree of the color cast: if the cast is very mild, use your palest filter (CC05); if the cast is moderate, use a moderately dense filter (CC10, CC20); if the cast is very pronounced, use a still denser filter (CC40, CC50). And if the color cast seems to be a combination of two colors, for example, red and yellow, add one red and one yellow filter to your basic filter pack.

But what should one do if the print happens to turn out with, for example, a blue-green (cyan) color cast? Then, instead of *adding* a cyan filter in the proper density (which, of course, would correct the color cast), it is more practical (because it requires the use of a smaller number of filters) *to take away excess red filtration*

(which achieves the same result because red is the complementary color of cyan as will be explained shortly) and, instead of the originally used 50R filter, use a weaker red filter, perhaps 30R, 20R, 10R, 05R or, if this not sufficient, omit the red filter altogether.

As this example shows, the overall color cast of a color print can be corrected in two different ways: either, by *adding a filter in the same color as the color cast* or by *taking away a filter in the complementary color*. In practice such corrections p. 135 can usually be accomplished by combining color filters in different ways, and *the best way is always that which requires the smallest number of filters*. To be p. 138 able to select the best possible filter combination, a photographer must know the following:

With a prism, white (colorless) light, as anyone knows, can be separated into its color components and a spectrum produced. Now, this process can be reversed by *adding* beams of light in different colors to produce other colors and ultimately white. If we select the right colors, we can produce white light by mixing only *three colors: red, green, and blue*. Because these three colors added together make white light, they are called the "additive primary colors." To visualize this imagine that there are three projectors set side by side in a darkened room. Each has in front of its lens a filter in one of the three additive primary colors so that there are three beams of differently colored light—red, green, and blue—projected onto a white screen so that they partly overlap, making a color pattern like that in the following sketch:

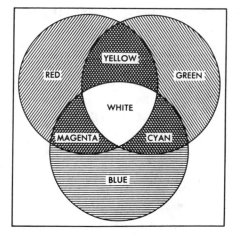

Where red and green overlap, yellow is formed. Where green and blue overlap, cyan is formed. Where blue and red overlap, magenta is formed. And in the center, where red, green, and blue overlap—where the three additive primary colors are added up—white is formed. The three newly created colors—yellow, cyan, magenta —which were produced by overlapping pairs of additive primaries, are called the "subtractive primary colors." Each represents white light from which one of the additive primary colors has been *subtracted*. In other words, if combined with the appropriate additive primary colors, each of these subtractive primaries will produce white light. Consequently, since they *complement* the additive primary colors, they are the *complementary colors* of the additive primaries. The relationship of these six colors can be expressed thus:

p. 135

Additive primary colors		Subtractive primary colors
RED	is complementary to	CYAN
GREEN	is complementary to	MAGENTA
BLUE	is complementary to	YELLOW
RED	is equivalent to	YELLOW + MAGENTA
GREEN	is equivalent to	CYAN + YELLOW
BLUE	is equivalent to	MAGENTA + CYAN

Now it should be clear why any desired color correction can be made with filters in only three different colors: red, magenta, and yellow. For example, if the over-all tone of the test print is too blue, you can remove the excess blue either by *adding blue* to your basic filter pack (which means increasing the number of filters which, as we have seen, is always disadvantageous); or you can get the same effect by *subtracting yellow,* since blue and yellow are complementary colors. Now, if you started your test series with a 50R filter as recommended, you can NOT, of course, take away a yellow filter because there is no yellow filter in your filter pack. However, in effect, a 50R filter is the equivalent of a 50Y (yellow) and a 50M (magenta) filter. Hence, if you substitute these two filters for your 50R filter, you would get the same basic effect. But *now* you have a yellow filter in your basic filter pack, and if you chose instead to combine a 30Y (instead of a 50Y) + a 50M filter, you would in effect have subtracted yellow in the amount of a 20Y filter. The following table, which shows the interrelationship between color cast and color correction filters, should make it easy to select the appropriate correction filters:

222

If your test print contains too much	Either subtract filters in these colors	Or add filters in these colors
RED	cyan	red (or yellow + magenta)
GREEN	magenta	green (or cyan + yellow)
BLUE	yellow	blue (or magenta + cyan)
YELLOW	magenta + cyan (or blue)	yellow
CYAN	yellow + magenta (or red)	cyan
MAGENTA	cyan + yellow (or green)	magenta

Changes in the basic filter pack, of course, influence the exposure which must be corrected accordingly. The new exposure can be determined either by making a new test strip with the changed filter pack or by using the Kodak Color-Printing Computer. It is included in the Kodak Color Dataguide which costs $4.95 and is, in my opinion, indispensable to any photographer who wishes to develop and print his own Kodak color films. This guide should be supplemented by the Kodak data book *Printing Color Negatives,* which costs only $1.

Once the principle of corrective color filtration is understood, the mechanics are simple and can be summed up as follows:

To eliminate a color cast (excess color) from your basic filter pack, subtract a filter in the complementary color. This method usually gives the best results because it normally involves the smallest number of filters. Alternatively, you can add a filter in the same color to your basic filter pack.

To give the print a special over-all color shade (for example, yellow, to make it "warmer," or blue to "cool it off"), subtract a filter in the same color from your basic filter pack. Alternatively, you can add a filter in the complementary color to your basic filter pack.

The greater the amount of color you wish to remove or add the greater the density (and the higher the number) of your CP or CC filter. If a filter with the highest number is not dense enough to produce the desired effect, two or more filters of the same color can be combined. For example, a combination of a CC40R and a CC50R filter is equivalent to a CC90R filter (which is not available in the form of a single filter).

The color relationship between Kodak color correction filters is such that the *additive* filters red, green, and blue each contain approximately the same amount of the same dye as the two corresponding *subtractive* filters yellow + magenta, cyan + yellow, and magenta + cyan. For example, a 10R (red) filter produces

the same effect as a 10Y (yellow) + a 10M (magenta) filter, and a filter pack consisting of a 10R + 20Y + 10M filter is equivalent to one consisting of a 30Y + 20M filter (because 10R is equivalent to 10Y + 10M). Accordingly, a specific color can usually be produced by different combinations of filters, and the best combination

p. 138

is always that which requires the smallest number of filters and which also has the least density and requires the shortest exposure.

Color print development

The entire process takes only seven minutes if the Kodak Rapid Color Processor Model 11 is used. Otherwise, it takes slightly more than half an hour and involves ten steps. Of these, the first three take place in a dark room by safelight illumination (for Kodak Ektacolor Professional Paper, use the dark amber Wratten Series 10 Filter and a 7½-watt bulb at a distance of 4 feet from the paper for not longer than four minutes). The remaining operations can be performed in ordinary (white) light. Two things are critical: the temperature of the developer must be accurate within plus or minus one-half degree and agitating must be done exactly as specified by Kodak. For processing Ektacolor Paper (Process P-122), these are the necessary steps: (1) developing, (2) immersion in a stop bath, (3) immersion in the first hardening-fixing bath—after the prescribed time in the bath, the room light can be turned on and processing continued by white light— (4) washing under running water, (5) bleaching, (6) washing under running water, (7) immersion in the formalin fixing bath, (8) washing under running water, (9) immersion in a buffer bath, (10) drying.

PRACTICAL PHOTO-CHEMISTRY

Any photographer who intends to do darkroom work must know how to store and handle chemicals and prepare solutions. If wrongly stored, some chemicals spoil in a short time; if wrongly handled, poisonous chemicals are dangerous; if wrongly prepared, processing solutions may spoil even before they are used. The following pages contain information that will prevent this.

The equipment for mixing formulas

It is simple and not expensive. Savings made through the self-mixing of formulas

p. 185

should soon amortize the initial cost. In addition to the darkroom equipment previously listed, you need:

A laboratory balance that must be accurate to within 0.1 gram, complete with a set of weights from 1 to 100 grams.

A set of spoons for taking chemicals out of their containers; stainless steel or glass are the best. Wooden spoons are unsuitable because they are difficult to clean.

Stainless steel vessels, in different sizes up to one gallon, for dissolving and mixing chemicals.

A number of mason jars, or wide-necked bottles with plastic screw tops, in different sizes, for storing dry chemicals. Some chemicals are sensitive to light and must be stored either in brown bottles or jars or in a dark place.

Additional quart and gallon bottles of brown Polyethylene or brown glass, for storing stock solutions.

How to buy chemicals

The cost of most chemicals constitutes only a fraction of the expense involved in making a photograph and is completely out of proportion to their importance with regard to the successful outcome of a picture. Chemicals that are not pure enough can unbalance a developer or a correction bath so completely that negatives are spoiled beyond repair. Consequently, only chemicals of guaranteed purity, uniformity, and freshness should be used, though actually they are somewhat more expensive than unguaranteed store brands, and they should be bought only through reputable photo-supply houses or drugstores. Manufacturers with enviable reputations for producing chemicals of highest quality are, among others, the Eastman Kodak Company and the Mallinckrodt Chemical Works.

The degree of purity of chemicals is customarily indicated by the following symbols:

TECHNICAL—of comparatively low grade, generally not suitable for photographic work.

PURIFIED—of medium quality, suitable only for stop and fixing baths.

U.S.P.—of high quality, meeting the requirements of the United States Pharmacopoeia; satisfactory for photographic work.

A.R.—"Analytical Reagent," of highest purity, intended mainly for analytical purposes, unnecessarily expensive and pure for most types of photographic work.

How to store chemicals

The majority of chemicals used in photographic work are sensitive to either moisture, air, light, heat, or cold. Exposed to these influences, in time they deteriorate and become useless. The best way to store chemicals is in glass containers, the

225

worst in paper bags. Cardboard containers are unsuitable because they attract and retain moisture. Mason jars stored in a dark place are excellent for all dry chemicals. Brown Polyethylene or glass bottles with rubber stoppers are best for solutions. Glass stoppers have an annoying tendency to get stuck. To loosen, with one or two matches heat the neck of the bottle slightly from all sides, then gently tap the sides of the neck with a piece of wood and twist the stopper counter-clockwise. When replacing the stopper, do not forget to give it a light coat of Vaseline to prevent further trouble.

Chemicals should be stored in a dry, dark, cool (but not cold) place. To avoid mistakes, attach permanent labels to all bottles and jars. Poisonous chemicals must be clearly marked "poison." Do not leave chemicals unnecessarily exposed to air from which many substances attract moisture.

All developers are highly sensitive to oxygen which they absorb from the air. For this reason completely fill bottles with stock solution to keep out air. If a bottle is not completely filled, fill the empty space by dropping small glass marbles or pellets into the solution until capacity is reached. Large amounts of developer stock solution should be kept in a number of smaller bottles rather than in a single large one. Whenever a solution is used, therefore, only one bottle containing a small amount of liquid (which probably will be used within a short time) has to be opened and exposed to air, and the bulk of the stock remains undisturbed.

Fumes are given off by ammonia water and ammonium sulfide, for which reason they must be stored separately from all other chemicals and from films and sensitized paper.

Sensitive to moisture to an exceptionally high degree are the following chemicals which must be stored in a perfectly dry, moisture-proof place: amidol, ammonium persulfate, caustic soda, pyrocatechin, glycin, hydroquinone, metol, potassium carbonate, pyrogallol.

Sensitive to light to an exceptionally high degree are the following chemicals which, despite use of brown bottles, must be stored in darkness: ferric oxalate, gold chloride, potassium ferricyanide, potassium iodine, potassium permanganate, silver nitrate.

Unusually sensitive to heat are the following chemicals which must be dissolved only in cold water and added only to other cold solutions: acetic acid, ferric oxalate, potassium metabisulfite, sodium bisulfate.

Poisonous are the following chemicals which must never be touched or be per-

mitted to come in contact with the skin: caustic soda (developer alkali), potassium bichromate (intensifying agent), sulfuric acid (cleanser for developer trays, gives off poisonous fumes extremely dangerous for the lungs), uranium nitrate (intensifying agent), potassium ferricyanide (reducing agent), pyrogallol (developing agent).

How to mix solutions

Prepared developers, fixers, etc., are always accompanied by printed instructions which must be followed implicitly, otherwise failure may result. When compounding your own solutions, observe the following rules:

Only containers of glass or stainless steel are suitable for dissolving and mixing chemicals. Hard rubber absorbs certain chemicals and leads to contamination of subsequently prepared solutions. Enameled containers chip and rust and sometimes give off alkali (disastrous to fine-grain developers). Glazed stoneware sometimes has flaws through which chemicals can penetrate and subsequently contaminate other solutions.

When compounding a printed formula, always dissolve its components in the order in which they are listed.

Never add a new chemical to a solution before the previous component has been completely dissolved.

When weighing chemicals, do not pour them directly onto the pan of the balance. Instead, place a piece of paper on each of the pans (to preserve equilibrium), then pour the chemicals onto the paper to avoid contamination with other chemicals. However, the same piece of paper may be used for weighing all the components that go into one formula.

Minute quantities of chemicals must be measured particularly accurately. When measuring liquids, hold the glass graduate so that the surface of the liquid is level with your eye, then take the reading at the bottom of the curve formed by surface tension at the top of the liquid. When taking a thermometer reading, keep your eye level with the top of the column of mercury, otherwise your reading may be off as much as 2 degrees because of the refraction effect of the cylindrical magnifier built into the thermometer rod.

Dry chemicals must always be poured into the water. If you pour the water on desiccated chemicals, they cake into a stony mass and take a very long time to dissolve. This is particularly true of prepared acid-fixing salts.

To speed up dissolution, stir vigorously while slowly pouring the chemical into the water or solution. However, be careful not to whip air into the solution when preparing a developer, for the oxygen contained in the air may prematurely corrode the solution (visible sign: brownish discoloration).

Label and date every bottle of stock solution immediately after preparation. It later enables you to estimate its freshness. If you intend to reuse a developer, mark on the bottle the number of films developed in it to keep track of the degree of exhaustion. This is important for determination of necessary increases in subsequent developing times.

Filter developers before use by pouring them through a funnel loosely stoppered with a wad of absorbent cotton, to eliminate sludge and particles of gelatin and dirt which otherwise may settle on the developing films and cause spots. Before filtering, however, be sure that the developer is warmed to the correct working temperature. The solubility of most chemicals decreases with decreasing temperatures, and consequently, if solutions have been stored at relatively low temperatures, some of their components may crystallize and precipitate to the bottom of the bottle. If such a solution is filtered at a temperature lower than 68 degrees F., some of its most important components may be inadvertently filtered out and the solution will then be useless.

When preparing or using a fixing bath, do not spill hypo crystals or solution. Hypo is "poison" to developers. Spilled fixing solution dries, and the fine powder subsequently contaminates the entire darkroom, leaving spots wherever it settles on film and sensitized paper.

The water for solutions

Developer stock solutions are sometimes (but normally do not have to be) prepared with boiled water. Boiling eliminates most of the free air contained in water, the oxygen content of which otherwise would prematurely oxidize the developing agent. Furthermore, boiling precipitates most of the suspended impurities and eliminates a large percentage of the calcium and magnesium salts.

Fine-grain developers are sometimes (but normally do not have to be) prepared with distilled water which in addition can be boiled. Distilled water is chemically free from impurities but still contains some free air which would be eliminated by boiling.

Stop baths and fixers can be prepared with any water that is pure enough for drinking purposes.

228

Intensifiers are extremely sensitive to chemical impurities and should be prepared only with distilled water.

Reducers can normally be prepared with ordinary tap water.

The temperature of solutions

The rate of chemical reaction increases with increase in temperature. As a result, all chemicals dissolve more readily, and in greater amounts, in warm than in cold water. However, some chemicals are so sensitive to heat that even moderate temperatures change their chemical properties to such a degree that they become useless for photographic purposes. Such chemicals, of course, must be stored, dissolved, and used at correspondingly low temperatures. p. 226

Most developers can be prepared with water as hot as 125 degrees F., but not hotter. Before use, of course, such a solution must cool down to the normal temperature of 68 degrees F. (exception: solutions for use in color processes are 80 and 85 degrees F.; in the Kodak Rapid Color Processor standard temperature is 100 degrees F.).

Hypo crystals can be dissolved in water as hot as it comes out of the hot faucet. When hypo crystals are poured into water of 140 degrees F., the temperature of the solution is almost instantaneously lowered to around 50 degrees F. Before use, of course, the temperature of such a bath must be raised to 68 degrees F. or frilling or reticulation (wrinkling of the emulsion of negatives) may result.

The acid-hardener component of an acid-fixing bath is moderately sensitive to heat and decomposes at temperatures above 125 degrees F. It should always be dissolved separately from the hypo in water not hotter than 100 degrees F. and mixed with the hypo only when both solutions are at the normal temperature of 68 degrees F.

The concentration of solutions

The strength of a solution can be indicated in two different ways: in terms of *percentage solution,* used mostly in reference to solids dissolved in a liquid, and in *parts,* used mostly when referring to a mixture of a solution and water.

A percentage solution is prepared by dissolving the specified quantity (in grams) of a chemical in a small amount of water, then adding sufficient water to make 100 cc. of solution. For example, to make a 5-percent solution, dissolve 5 grams of the chemical in a graduate containing a small amount of water, then fill with water to the 100 cc. mark. The result will be 100 cc. of a 5-percent solution.

229

A parts solution is prepared by mixing one unit of a specified stock solution with a specified number of identical units of water. Such units can be of any weight from grams to tons, provided that all quantities are reckoned in the same units of weight or volume. For example, to make a developer from one part of stock solution and five parts of water, mix one unit of stock solution with five units of water—1 ounce of stock solution mixed with 5 ounces of water or 100 cc. of stock solution mixed with 500 cc. of water—the result will be identical as long as identical units of measurement are used for both stock solution and water. If both liquids and solids are given in "parts," of course, equivalent units of measurement must be used. Thus grams for solids go with cubic centimeters for liquids and ounces for solids go with fluid ounces for liquids.

To convert a "parts solution" into a "percentage solution" proceed as follows: The developer mentioned above consisted of one part stock solution and five parts of water, in all six equal parts. In order to convert this ratio into percentage, divide 100 by 6, the result of which is 16.7. In other words, a solution of 1:5 is equivalent to a 16.7 percent solution.

The criss-cross method offers the easiest way of figuring the dilution of a high-percentage stock solution into a low-percentage working solution; see the following diagram:

A C 99% stock solution 28 parts

X 28% working solution

B D 0% (water) 71 parts

Place the percentage strength of the stock solution at A. Place the percentage strength of the solution you dilute with at B (in the case of water, of course, this is 0 percent). Place the desired percentage strength at X. Subtract X from A and write the result at D. Also subtract B from X and write the result at C. Finally, take C parts of A and mix them with D parts of B, and you will get a solution of X percent.

For example: to dilute a stock solution of 99 percent acetic acid to 28 percent acetic acid working solution, take 28 parts of the 99 percent stock solution and mix it with 71 parts of water (0 percent solution).

The Symbols of Photography

Perhaps the most serious obstacle to the making of good photographs is the popular but fallacious belief that photography is a naturalistic medium of rendition. For instance, in judging a color photograph, the most usual consideration is, "Are the colors true?" And if one feels that they may not be, one is likely to reject the photograph. Why? Because photography is supposed to be a "naturalistic" medium of rendition, and if a picture is thought not true to reality it cannot be "good." And yet it is a fact that the overwhelming majority of all photographs cannot rightly be called naturalistic for the following reasons:

1. Most photographic subjects have height, width, and depth, but a photograph has only height and width. The impression of depth in a photograph is an optical illusion.

2. Reality is colorful whereas a black-and-white photograph consists of shades of gray. Color is an important quality of most subjects. In a black-and-white photograph, red hair appears gray. Is this "naturalism"?

3. Reality has constant motion of people, automobiles, airplanes, animals, clouds etc., but all motion is "stopped" in a photograph.

A *naturalistic* rendition of a subject is a copy which in every important respect is a replica of the original, like, for example, the photograph of a printed page. Conversely, any rendition that deprives a subject of three important qualities— depth, color, and motion—obviously cannot be sensibly called "naturalistic."

Actually, the reason the discussion of whether photography is a naturalistic or a semi-abstract medium of rendition has interest is that many people, including photographers, picture editors, and art directors, consider "naturalism" a most desirable quality. Consequently, they are likely to reject photographs that include unusual effects because such pictures don't conform to their concept of what a photograph should be, even when such effects have been deliberately used by the photographer to make the subject more interesting or more significant. By this

231

limited appraisal they bar themselves and others from the heightened awareness and insight into phenomena, and from the enjoyment of graphically interesting effects which the camera can give.

As a matter of fact, if demand for "naturalness" were consistent, all wide-angle and telephotographs, all high-speed photographs as well as time exposures of subjects in motion, and all photographs that are completely sharp in depth would have to be rejected because they show things in a form in which the eye cannot see them in reality. And one would have to reject as "unnaturalistic" every black-and-white photograph because it lacks color, and every color photograph because it lacks real depth. This shows the absurdity of this concept.

The reader may wonder where the line should be drawn between "acceptable" and "objectionable" deviations from naturalism. Some people speak of what they call "straight" photography as opposed to "controlled" photography, advocating one, rejecting the other. But where does "straight" photography end and "control" begin? Doubtlessly, Mathew Brady's Civil War photographs and Atget's pictures of Paris are examples of "straight" photography. But what of Edward Weston's

p. 215

work which is dodged (i.e., controlled) during contact printing? And should a "straight" unfiltered photograph be considered more "naturalistic" than a "controlled" filtered shot, although in the first the sky may appear white and empty and in the latter show the clouds more or less as they appeared to the eye in reality? And should a speeding automobile be rendered sharp or blurred, appearing to stand still or in motion? And if such controls as dodging and filtering are considered permissible, why is the use of blur as an indicator of motion not? Or,

pp. 294-297, 316

for that matter, the use of spherical perspective to show a 180-degree view?

It seems to me that there can be only one conclusion: since photography is not a "naturalistic" medium of rendition, it is futile to insist on "naturalism" in one's pictures, because the best to be produced in this respect is a limited pseudo-realism rooted in academic standards which can lead only to standardized photographs. Instead of accepting such stifling restrictions, I think one should utilize to the fullest extent the fabulous potentialities of the photographic medium and use it to take us *beyond* the inherent limitations of our vision. I think of the camera as a means for exploring our world and extending our horizons, as an instrument that can be used to make life richer by disclosing many of its aspects which otherwise would remain unknown, as a powerful probing tool of research, and ultimately as a disseminator of knowledge and truth.

Unsharpness suggests mystery. This photograph by *Nina Leen* portrays two people in love. Deliberately unsharp rendition creates a mood which induces the observer to share their moment of bliss.

More on pp. 18 and 318

More on pp.
51 and
309–312

Photomacrograph. Head of a wood-boring beetle, magnified some 40 times linear. Here, I used its unlimited range of vision to turn the camera into an instrument of discovery. To explore new territories is one of the most rewarding aspects of photography.

Light and shadow. Breaking with tradition, *Richard Avedon* (Courtesy of *Harpers Bazaar*), boldly modeling with shadow and light, creates a portrait whose power of expression makes it unforgettable.

See pp. 263, 282

The radiance of direct light. "Burst of speed to catch a ride" is the title of this exciting photograph by *George Silk* which shows a surf boarder paddling frantically to get on a wave at the be-

ginning of his ride. By shooting smack into the sun, Silk, through star shapes, flares, and halation, photographically expresses the fierceness of radiant light and the glitter of flying foam and spray.

More on pp. 108, 264 and 328

More on pp.
11 and 260

Light as creator of form. To express a feeling of roundness and depth
and to do justice to this voluptuous statuette by Lachaise, I made
sure every important highlight appeared in a strategic place.

A detail can express the whole. To avoid the banality of an overall shot when summing up an automobile show, I made instead a close-up of the front of a Bentley, indicating the rest by blur.

More on page 62

Significant color. Left: removal of red-hot Pyroceram missile nose cones from an electric furnace. Right: cast-off skins of stoneflies and mayflies on horsetails. I made both pictures in color because

color was the most important property of these subjects. Although each is virtually a monochrome in a single color, without this color, in black and white, the rendition would have been meaningless.

More on pp. 36, 56–57 and 267

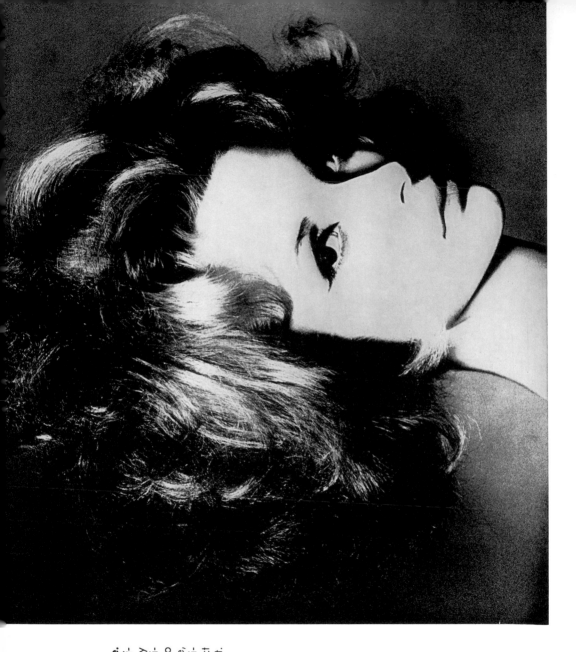

Pure black and white. Photographed by Richard Avedon (Courtesy Harpers Bazaar). By limiting his gray scale to pure black and white, Avedon achieved a highly sophisticated effect in this glamorous shot.

More on pp. 39, 46, 176 and 282

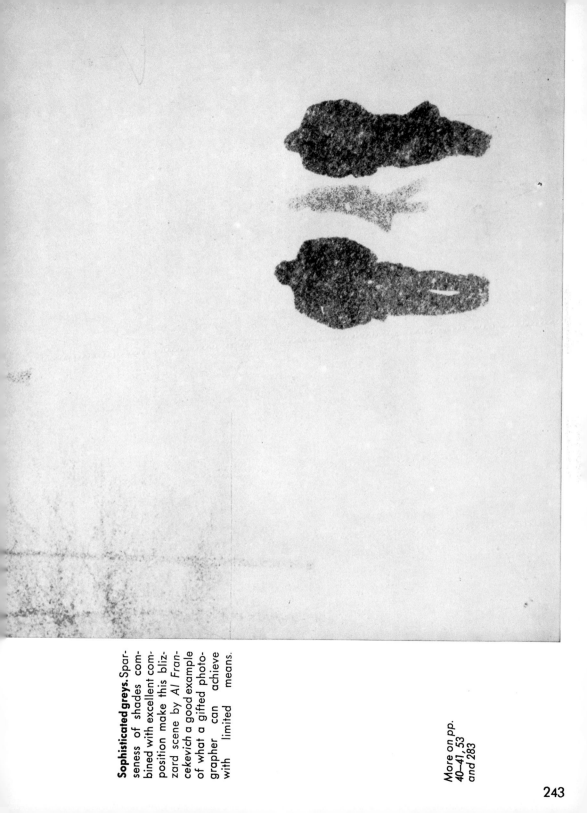

Sophisticated greys. Sparseness of shades combined with excellent composition make this blizzard scene by *Al Francekevich* a good example of what a gifted photographer can achieve with limited means.

More on pp. 40–41, 53 and 283

Muted desaturated color shades. The cemetery of Venice on the island
of San Michele, photographed by *Ernst Haas*. A veil of fog rolling in
from the lagoon imparts a quiet, solemn mood to the scene which it

would have lacked had it been photographed in sunshine. The impression of almost any subject can be strengthened, by showing it in an appropriate mood, or weakened, if the mood is unsuitable.

More on pp. 41 and 333

More on pp.
320–321

Reticulated bas-relief. The artificially created texture elimina-
tes detail, unifies the picture, and impersonalizes the model;
while bold bas-relief outlines accentuate important forms.

Solarization. Precisely etched lines and interpenetration of positive and negative tones give solarized photographs a highly abstract effect. I printed this picture from a solarized paper negative.

More on p. 320

247

More on pp.
271 and 336

Subject and background. The painter Willem de Kooning in front of one of his paintings, photographed by *Bert Stern*. By relating subject and background, Stern gave his picture added impact.

THE SYMBOLS OF PHOTOGRAPHY

One of the barriers to effective photographic rendition seems to be that many photographers are not aware of the fact that, in photography, reality can be expressed only through symbols: perspective symbolizes depth, gray shades symbolize color, blur symbolizes motion, halation symbolizes the radiance of brilliant light. These symbols are abstractions as are the sounds and letters used in speech and writing to symbolize specific concepts. As no one can be a good writer without mastery of symbols—the meaning and use of words—so no one can become a good photographer until he has learned how to use the symbols of his craft. We know, for example, if we think about it, that in a photograph of whirling dancers, motion is symbolized by blur and that our feeling of space and depth in looking at a picture is caused by the converging parallels and diminution which symbolize these. We are so used to graphic symbolism that we complete the suggested motion and feel the space and depth through memory and experience without noticing that we do this. If a photographer becomes aware of the presence of symbols, he will also see that symbols should be carefully selected, and that instead of being satisfied with the symbols that chance presents, he must deliberately choose those symbols that will help him to express what he wishes his pictures to say.

The primary symbols of photography are light, color, contrast, abstract black and white, perspective, sharpness, graininess, unsharpness, and blur. Through the skillful use of these symbols, a photographer can effectively translate reality into picture form.

The principles of such translation are not unlike those of translating from one language into another. Either the translator makes a literal translation which is usually inadequate and always clumsy, or he translates freely, trying to capture in his translation the meaning and feeling of the original.

Similarly, in photography, the literal approach to translating reality into picture form is likely to result in a stereotyped and often incomplete and even misleading rendition. On the other hand, if translated with feeling and imagination, even common subjects can be made to appear in a form that is stimulating and therefore effective. Two examples will illustrate this:

A photographer has to make a picture of a traffic jam. The obvious place from which to make such a shot would be as close as possible to the jam. To show the largest number of cars in his picture, the photographer uses a wide-angle lens. Unfortunately, this "obvious" approach renders closeby cars very big and cars

farther away very small, as a result of which a few nearby automobiles fill most of the picture space and the rendition fails to convey the feeling of a huge mass of cars. But if the photographer moved as far back as conditions would permit and from a second-story window took the picture with a telephoto lens, he would

pp. 58, 60

utilize the symbol *telephoto perspective*—the space-gathering effect—and thus show the cars tightly packed together and more or less identical in size, and express the *feeling* of a traffic jam that in the picture might give a sensation as powerful as that felt in the actual experience.

Another example: the fiery spectacle of tapping an open-hearth furnace in a steel mill must be photographed. To balance the glare of the molten steel and retain detail in the shadows, most photographers might decide that batteries of powerful fill-in lights should be used. Although this approach would produce photographs that are technically perfect in the academic sense, it would fail to convey the almost unbearable brilliance and heat of the scene. These can be conveyed only through lens flare and halation—the symbols of brilliant light.

The symbols in practice

The number of photographic symbols is *in effect* very large since each can be varied to a very high degree. For example, lightness and darkness express different kinds of mood, and by adjusting the exposure in printing, a photographer can make the overall tone of a picture lighter or darker as desired. Thus he has a choice of an infinite number of shades between light and dark, and through correct choice he can express many different moods.

Another example: perspective, in the form of convergence and diminution, symbolizes depth. The more abruptly actually parallel lines appear to converge and the greater the difference in apparent size between near and far objects, the more pronounced the illusion of depth in the picture. With lenses of different focal lengths and appropriate subject-to-camera distances, a photographer can produce any perspective, from wide-angle perspective with its abrupt transition from near to far, to telephoto perspective in which differences in apparent object size between near and far are very small. The same space or depth can thus be made to appear deep or shallow in a photograph. And through appropriate use of lenses of intermediary focal lengths and suitable subject-to-camera distances, any intermediary effect can, of course, be produced. Thus, a photographer who has a knowledge of symbols has complete control over the rendition of depth and space in his picture.

250

Not only can each photographic symbol be varied to a very high degree, but a number of them can also be used together. For example, the effect of either lightness or darkness can be combined with the effects of any kind of perspective, or with any kind of color translation into shades of gray, and these in turn can be combined with any kind of motion symbolization—and so forth. These photographic symbols, their implications, uses, and controls, are discussed in the following chapters.

LIGHT

Every art form has its specific medium. That of the photographer is light. Unfortunately, most photographers pay little attention to light beyond whether it is bright enough for sufficiently short exposures. They seem unaware that light has different properties and manifests itself in many different forms from which they can select light to create specific effects and that they can also control light for such purposes. Before a photographer can fully utilize the great inherent potentialities of light he must, of course, understand its different properties, functions, and controls.

The properties of light

Light has two principal properties which are of interest to photographers: brightness and color. Additional factors that influence the quality of illumination are the effective size of the light source—whether it is point-like or area-like—and whether the light is direct (emitted by an incandescent source), reflected, or filtered.

The brightness of light

Brightness is the measure of the intensity of light. It determines the exposure and influences the mood of a picture.

Bright light is harsh, crisp, sharply matter-of-fact. Dim light is vague, restful, mysterious. High-intensity illumination makes subjects appear not only lighter, but also more contrasty and their color more saturated than low-intensity illumination. Accordingly, through choice of the intensity of the light, a photographer can influence the appearance of his subject.

To properly utilize this control it is, of course, necessary that the characteristics of the illumination be transferred to the color transparency or print. Some photographers, feeling that in brilliant light the subject appears too harsh, artificially reduce its brilliance and contrast and destroy a characteristic of the illumination.

And if they feel that the low-intensity illumination of a subject is too dark and soft, they artificially increase lightness and contrast. In both instances, by changing the quality of the illumination, they change the impression created by the subject. Accordingly, if harshness and brilliance are characteristic qualities, the photograph should be made contrasty and bright, and if softness and dimness are typical, these qualities should be stressed by making the picture contrastless and dark.

On the other hand, if the brightness of the illumination should be changed, it can be changed in several ways. When artificial light is used, adjusting the distance between subject and light source is the simplest way. In this respect the inverse-square law applies: doubling the distance between subject and lamp reduces the effective illumination to one-fourth, and tripling the distance reduces the effective illumination to one-ninth the initial brightness. When flash is used as a fill-in light, a simple means for reducing its intensity and preventing overlighting of shadows is to drape a white handkerchief over the reflector; one layer reduces the brightness of the flash to approximately one-half, two layers to one-quarter, its original intensity.

p. 280

If the light is very bright and, for pictorial reasons, it is desirable to work with large diaphragm apertures, slow shutter speeds, and fast film, a neutral density filter can be used to prevent overexposure. On the other hand, if fully detailed negatives must be made in very dim light, the exposure can be prolonged accordingly. As a matter of fact, through the use of sufficiently long exposures, photographs with as much detail as pictures made in daylight can be made at night.

p. 144
p. 51

The color of light

This property of light, although of no interest to the photographer who works in black and white, is of vital importance to every color photographer because of its influence upon the color rendition of the transparency.

p. 120
p. 120
p. 138

I have previously mentioned that color film will produce pictures in "natural" colors only if the photograph is taken in the kind of light for which the color film is balanced. I also listed the three types of color film currently available, each of which is balanced for use with one particular kind of light. And finally, I said that if the color of the light in which the film is to be exposed differs from the standard for which the film is balanced, it can be made standard by the use of the appropriate light-balancing filter. Now, how does one know whether or not the light conforms to standard? And if the light does not, how does one know how much it differs?

To answer these questions, color photographers need a gauge by which to measure the color of the light. If they find in measuring the illumination that its color does not conform to the standard for which their color film is balanced, they can determine to what degree it does not conform and, by using the appropriate filter, they can in effect convert the light to standard. This measure for the color of the illumination is the color temperature of light.

The color temperature

If we place a piece of iron in a gas flame, it changes color as it heats up. It begins by turning a dull red. Then, as the temperature rises, it gradually changes to a brighter red, to orange, and finally, if the flame is hot enough, to yellow and then to white. Obviously, a direct relationship exists between the temperature of a radiating body and the color of the light it emits. This relationship is the basis of the concept of color temperature.

The Kelvin scale

The unit of color temperature measurements is the degree Kelvin, its scale is the Kelvin scale. The Kelvin scale measures temperatures in degrees Centigrade starting from absolute zero which corresponds to minus 273 degrees. Thus, for example, the reddish light emitted by a piece of iron heated to 1000 degrees C. has a color temperature of 1273K.

In this connection it is interesting to note that artists distinguish between "warm" (reddish) and "cold" (bluish) light. According to the laws of physics, however, the contrary is true: reddish light is produced by radiation at relatively low temperatures, whereas blue-white light is emitted only by the hottest stars. In terms of color temperature, reddish light rates around 1000K. while blue light (for example, the light of a clear blue northerly sky) rates as high as 27,000 on the Kelvin scale.

And this observation brings us up against one of the most important, and most consistently misunderstood, concepts in color photography: the color temperature of light that has been reflected, scattered, filtered, or otherwise altered in regard to its spectral energy distribution since emission from its radiant source.

True and false color temperatures

The concept of color temperature is based upon the observed uniformity in relationship between the temperature and the color of an incandescent body. For this reason alone, it should be obvious that *only incandescent light sources can have a color temperature* in the true meaning of the term. The so-called color tempera-

ture of, for example, a blue sky is *not* a true color temperature since the sky, obviously, is not radiating at a temperature of some 25,000 degrees C. above absolute zero.

However, the subject is even more complicated. The cause of this complication lies in the fact that *color temperature tells us only something about the color of light*, but nothing about its composition, i.e., its spectral energy distribution. Actually, light emitted by two different sources can be identical in regard to color temperature, but differ in regard to spectral composition. If such is the case, light emitted by both sources appears identical to the eye. But since color film is highly sensitive to differences in the spectral energy distribution of light, the effect of one light upon the color film will be different from the effect of the other.

For example, a color temperature meter reading of daylight and light emitted by a fluorescent lamp may indicate the same color temperature. In that case the color of the light emitted by both would appear identical to the eye. But since the spectral energy distribution of one is quite different from that of the other, the same colors photographed in daylight and in fluorescent light would appear very different in the two transparencies.

The spectral energy distribution of incandescent lamps conforms very closely to the spectral energy distribution of a true "black-body radiator," which is the standard of all color temperature measurements. If the color temperature of incandescent light does not conform to the color temperature of the light for which the color film is balanced, color temperature readings taken of such lights are accurate enough to provide data for the selection of suitable light-balancing filters. In other instances, however, color temperature readings may be misleading rather than helpful, unless they are evaluated in the light of previous experience based upon experiments and tests.

How to use a color temperature meter

Artificial light. It should be evident from the foregoing that true color temperature readings can be taken only of tungsten-type light sources in which an incandescent filament produces the illumination. To take such a reading, stand directly in front of the lamp and point the color temperature meter toward its center. Make sure that no colored objects are so close to the lamp that colored light can reflect upon the meter and falsify the reading.

Do not attempt to measure the color temperature of fluorescent lamps. Instead, use the filters which the film manufacturer suggests.

p. 148

254

Daylight

All color temperature readings, including readings taken directly of the sun, are at best approximations. If such readings have been verified by previous tests and, if necessary, are modified on the basis of such experience, they may provide valuable information upon which to base the selection of corrective filters. Otherwise, they are more likely to confuse the photographer and lead to results that, with respect to color rendition, are less satisfactory than unfiltered shots.

Frontlighted subjects in sunlight. Point the color temperature meter straight at the sun to take the reading.

Subjects in the shade. From the subject position, point the color temperature meter at the sky directly behind the camera, as if you were taking an incident-light reading. Be sure that no colored light reflected from the ground or from trees or buildings behind the camera can reach the meter and falsify the reading. If such danger exists, tilt the meter upward until only pure skylight can fall upon its cell.

Subjects under an overcast sky. Use the color temperature meter as described above under "subjects in the shade." However, no correction filter will ever give a color picture taken on an overcast day the effect of a photograph taken in the sun.

General principles. As far as illumination is concerned, it is the color of the light that illuminates that side of the subject which faces the camera which determines the color rendition of the subject. This illumination always comes from the direction of the camera. Except when measuring the color temperature of an incandescent lamp, it is in this direction that you must always point the cell of the color temperature meter.

For example, in a backlighted shot, as far as color rendition is concerned, the illumination does *not* come from the sun (which in such a case is *behind* the subject), but from that part of the sky which is behind the camera. If this part of the sky happens to be deep blue, the light that falls upon the subject will also be strongly blue, even though the color temperature of the light, *in general*, may match exactly the color balance of the film. In such an event, unless this strong bluish cast is specifically wanted to give the picture a special effect, the use of a corrective filter will improve the rendition of subject color.

Approximate color temperatures of light sources

The following table lists the average color temperature of a number of light sources which might be of interest to color photographers. Except in the case of incandescent lamps, indicated color temperatures are approximations.

Color temperatures of incandescent lamps

These color temperatures apply only if the lamps are operated at the voltage for which they are designed.

Light source	Degrees Kelvin	Decamired values
40-watt general purpose lamp	2750	36
60-watt general purpose lamp	2800	36
100-watt general purpose lamp	2850	35
500-watt projection lamp	3190	31
500-watt professional photo lamp	3200	31
250-watt photoflood lamp (amateur color)	3400	29
500-watt photoflood lamp (amateur color)	3400	29
all daylight photoflood lamps (blue glass)	4800-5400	21-19

Color temperatures of miscellaneous artificial light sources

candle flame	1500	66
standard candle	2000	50
clear flash lamps (press type)	3800	26
white flame carbon arc	5000	20
daylight flash lamps (blue lacquered)	6000-6300	17-15
speedlights	6200-7000	15-16

Color temperatures of different kinds of daylight

morning and afternoon sunlight	5000-5500	19
sunlight through thin over-all haze	5700-5900	18
noon sunlight, blue sky, white clouds	6000	17
sunlight plus light from clear blue sky	6000-6500	16
light from a totally overcast sky	6700-7000	15
light from a hazy or smoky sky	7500-8400	12
blue skylight only (subject in shade)	10,000-12,000	9
blue sky, thin white clouds	12,000-14,000	7
clear blue northerly skylight	15,000-27,000	4

The color of different kinds of light

Daylight. For the color photographer daylight is the most difficult and troublesome type of light because it frequently varies not only in brightness (which can easily be checked with an exposure meter), but also in color.

White daylight. For daylight-type color film, white light is a combination of direct sunlight and light reflected from a blue sky with a few white clouds. Such light has an equivalent color temperature of approximately 6000K. When this combination of sunlight and clouds exists, from approximately two hours after sunrise to two hours before sunset, the overall illumination is white as far as daylight color film is concerned. Under such conditions, color rendition in a correctly exposed and processed transparency appears natural, and corrective filters are not needed.

The only other type of daylight that approximates white as far as daylight color film is concerned is light from a uniform low-altitude haze dense enough to completely obscure the sun. However, since even slight changes in the nature of such an overcast can shift the color balance of the illumination toward blue, use of a filter such as the Kodak Skylight filter is often advisable.

Blue daylight. On a cloudless day, shadows are always blue (unless a strongly colored object adds its color to the shadow area, in which case the shadow color becomes an additive mixture of both colors) because they receive their illumination from the blue sky. This is easily seen by comparing the color of a shadow on a white surface with the color of the blue sky: hold a mirror against the shadow on the white surface and tilt it so that it reflects the sky; the two blues, the shadow and the sky, will match.

If subjects are photographed in open shade, i.e., if they are illuminated exclusively by the blue light of the sky, their color will naturally be distorted toward blue. If such a color cast is unacceptable, it can be corrected by using a reddish light-balancing filter in the appropriate density. p. 138

On cloudy days illumination tends to be bluish in character, particularly if the sun is hidden behind heavy clouds and large areas of the sky are clear or if the sky is entirely covered by a high, thin haze.

Red daylight. At sunrise and sunset the sun appears yellow or red. This is caused by light-scattering within the lower, heavily dust-laden layers of the atmosphere which only the red-producing wavelengths can penetrate, making such early morning and late afternoon light appear yellowish or reddish. The colors of subjects photographed in such light appear, of course, "warmer" than they would in white light. To avoid such color casts, manufacturers of color film recommend taking color photographs only from two hours after sunrise to two hours before sunset. Otherwise, the color cast can be corrected by using a blue light-balancing filter in the appropriate density. However, once a photographer learns to see p. 138

257

color in terms of photography, he will be aware of the inherent beauty of the different kinds of daylight and find that color pictures taken in the early morning and late afternoon hours have a mood and beauty of their own.

Artificial light

Perhaps the most valuable qualities of artificial light are stability and uniformity of brightness and color, provided, of course, that incandescent lamps are operated at the proper voltage and that this voltage is constant. As a result, correctly exposed color photographs taken in suitable artificial light usually have excellent color rendition. Since the different types of artificial light, their characteristics and color temperatures, have already been discussed, I refer the reader to the

pp. 146-153 respective chapters.

Point-like and area-like types of light sources

The smaller the effective size of a light source or the more parallel the beam of light it emits, the harsher the light and the more sharply defined the shadows it casts. Conversely, the larger the light source, the softer its light and the more diffused the shadows it casts. Examples of harsh light are sunlight and light from a spotlight; of soft light, light from an overcast sky and from fluorescent lamps. The harshest light is produced by a zirconium arc lamp which casts shadows as sharp as if cut with a razorblade, followed closely by the end-on ribbon filament lamps used in point-source enlargers and photo-engraving. The softest light is

p. 21 the shadowless illumination produced by a "light-tent." Between these extremes, there is light of intermediate qualities: outdoors, degrees of haze-diffused sun-

pp. 146, 148, 151 light; indoors, light from photoflood lamps, flashbulbs, and speedlights.

The quality of artificial light varies widely with the reflector and diffuser used. The same bulb can be made to produce a relatively harsh or a very soft illumination. To effectively diffuse a light source and make it cast softer shadows, its luminous area must be increased. A diffuser of the same size as the reflector placed tightly in front of a lamp does not increase its effective area or appreciably diffuses its light but only cuts down its brightness. To be effective, a diffuser must therefore be larger than the reflector, and it must be placed far enough in front of the reflector so that its entire area is fully illuminated. Kodapak sheeting is excellent. The following combinations of bulb, reflector, and diffuser would produce different illuminations beginning with relatively harsh light, going through increasingly softer light effects, and ending with a practically shadowless illumination: photoflood lamp used without a reflector; with a small, deep, narrow reflec-

258

tor; with a small, shallow reflector; with a medium-size reflector; with a large, shallow reflector; with a large, shallow reflector equipped with a larger spun-glass diffuser 5 inches or more in front of it; with a large, shallow reflector 2 feet behind a diffuser made of a sheet of translucent paper stapled to a 2 x 3-foot frame.

Reflected and filtered light

As far as the color photographer is concerned, an important difference between direct light, on one side, and reflected and filtered light, on the other, is that the color of direct light is always the same as that of its source, whereas the color of reflected or filtered light changes with the color of the reflector or filter. If a reflecting surface is, for example, blue, the light it reflects will also be blue, even if the light which illuminated the reflecting surface, as far as the color film is concerned, was white. A similar effect results, of course, when white light passes through a colored medium. For example, light in a forest or under a big tree is always more or less green from being reflected or filtered by green leaves. And light which has passed through a colored diffuser assumes the color of the diffuser. Such "accidentally" colored light is a frequent cause of unexpected color cast in a transparency.

Reflected light is commonly used both indoors and outdoors to lighten shadows which otherwise would be rendered too dark. The usual means for this are plywood panels covered with crinkled aluminum foil placed so that they reflect the principal source of illumination onto the shadow areas of the subject. Indoors, a very effective indirect illumination can be arranged with large frames covered with muslin or white paper, their angle and height precisely positioned in relation to the subject. Floodlamps or speedlight illumination is then directed toward and reflected from these surfaces which illuminate the subject with either softly diffused or shadowless light, depending upon whether this illumination is used alone or with direct front or side light.

A variant of this method—bounce-light—is used primarily for making candid indoor photographs: the reflector of the flashgun or speedlight is turned up and slightly forward so that the light strikes the ceiling, is reflected by it, and thus illuminates the subject with evenly diffused light. If bounce-light is used with reversal color film, the ceiling must, of course, be white, otherwise the transparencies will have a color cast in the ceiling color. If negative color film is used, such a color cast can be corrected through appropriate filtration during enlarging.

pp. 149-
150 Exposure is usually computed with guide numbers: use the focusing scale of the lens to establish the distance from the light source (flash at the camera) to the reflecting point on the ceiling and from there to the subject; divide the guide number by the sum of these two distances to find the basic f-stop number, and increase the exposure by opening the lens an additional two stops if the ceiling is white, three stops if the room has a colored ceiling, dark walls, or if it is unusually large.

THE FUNCTIONS OF LIGHT

Besides making the subject visible and thus photographable, light, as far as the photographer is concerned, has three important functions:

> Light symbolizes volume and depth.
> Light sets the mood of a picture.
> Light creates designs in black and white.

Light symbolizes volume and depth

To give a photograph a feeling of depth, a photographer must create an illusion of three-dimensionality. Light is perhaps the most important means for creating this illusion.

If a subject—a face—is illuminated from directly in front with "shadowless" light, it appears "flat." However, if the light is moved toward one side, it casts shadows on the face and thus creates the impression of roundness and depth. In a drawing, "shading" adds depth and gives the subject of the rendition a feeling of substance and solidity. Similarly, in a photograph, shadow suggests three-dimensionality and absence of shadows produces an impression of flatness. Photographed in a flood of shadowless light, the Venus de Milo would appear as flat as a paper-doll. On the other hand, properly lighted to create shadows, a shallow bas-relief can acquire depth. It is the counterplay of light and shadow that creates the illusion of three-dimensionality in a photograph.

Whether or not a photograph will have shadows, and where shadows will fall, depend upon the direction of the incident light in relation to the camera. Accordingly, by controlling the direction of the illumination or, if this is impossible, by controlling the position of the subject and camera in relation to the direction of the incident light, a photographer can control the rendition of the subject in regard to form, volume, and depth. In particular, he should know the following:

Front light. The light source is more or less behind the camera. This is the "flat-

260

test" type of illumination because shadows are partly or entirely hidden behind the subject and thus not visible to the lens. Contrast is always relatively low. This kind of light is most suitable for rendition of subject color that must appear "natural" in a color photograph, and in black-and-white photography it is most suitable for the rendition of subjects with strong inherent graphic qualities, since front light emphasizes lines and planes. Because it is the least "plastic" illumination and the one least suited to create illusions of depth, it should be used only by photographers who have considerable experience and a feeling for graphic design.

Sidelight. Illumination strikes the subject more or less from the side. This is the most commonly used illumination and the one most suitable for making photographs in which clarity of rendition and illusion of three-dimensionality are important. Sidelight consistently produces good results, but it rarely produces spectacular effects.

Top light. Illumination strikes the subject from above. Usually this is pictorially the least effective illumination. A beginner commonly makes the mistake of shooting outdoor pictures around noon when the sun is high because then the light is brightest. An experienced photographer knows that the best times for making pictures outdoors are the early morning and the late afternoon hours when the sun is low.

Light from below. Because it almost never occurs in nature, this illumination creates unnatural and theatrical effects (the effect of footlights). It is a difficult light to use because it is conducive to the creation of weird, unreal, and fantastic effects that easily appear forced—novelty for novelty's sake.

Backlight. The light source more or less faces the camera, illuminating the subject from the rear. This is the most contrasty illumination. It is not easy to use. Almost invariably, its use either leads to outstandingly beautiful and expressive pictures or to failure. It is the most dramatic light and excellent for expressing mood.

Lighting for texture rendition. Texture is surface structure—an aggregate of minute elevations and depressions. To show texture photographically the elevations must be illuminated and the depressions filled with shadow. Since the elevations—the grain of wood and stone, the mesh of a fabric, etc.—are usually very small, to be effective, the shadows they cast must be elongated by low-skimming light. Up to a point, the more the incidence of the light approaches parallelity

with the textured surface, the better the texture rendition will be. Directionally, three-quarter backlight is the most effective illumination. For best results, the light source should emit parallel or near-parallel light (the sun is the best source; spotlight illumination is better than the light of a photoflood lamp), otherwise contrast between the illuminated elevations and the shaded depressions may be too low. Since the units that make up texture are usually very small, texture, of course, can be rendered satisfactorily only if, in addition to having sufficient contrast, the photograph is also perfectly sharp.

Light sets the mood of a picture

It is often the mood or "atmosphere" of a subject rather than the subject itself which induces a photographer to photograph it, and had it appeared in a different mood, it might have held no interest for him. Mood and atmosphere are largely created by light.

For example, the mood of a church interior is created mainly by the character of the illumination. We feel a different mood in a whitewashed New England church with bright sunlight streaming through large clear-glass windows, than in a cathedral where light is dim and mysterious and filters through deeply colored stained glass.

The specific mood of such different interiors can be conveyed only if the quality of the illumination is preserved. Photographers who tamper with this light, who indiscriminately use auxiliary illumination to fill-in shadows and "balance" the light to record every detail that otherwise would have been lost in shadow, destroy the mood. I know that often use of fill-in light is unavoidable. But a sensitive and resourceful photographer should be able to use such auxiliary light in a way that does not change the mood of the subject.

Fortunately, an increasing number of photographers and picture editors realize the enormous influence that the illumination has on the feeling of a picture and as a result, available light is increasingly used. To me, a grainy and slightly fuzzy photograph taken under marginal conditions in available light, *that preserves the mood of the subject,* is far more interesting than the sharpest and most detailed picture in which the mood is falsified or destroyed by additional illumination. As a matter of fact, when light intensity is too low to make detailed photographs at shutter speeds sufficiently fast to prevent blur due to subject motion, the actual subject when seen creates the same slightly vague impression typical to a photograph of it taken "in available light."

In mood pictures light is used as a means for making emotional statements. In such pictures the subject proper is an intangible. The tangible subject of such a p. 18 photograph is merely used to convey the mood. Occasionally light itself is the subject proper, as in sunset shots. Abstract concepts such as mood cannot be photographed directly. They can only be suggested. A photographer must direct the observer's imagination through use of symbols that will lead him to complete the indicated mood. To suggest mood muted illumination is usually necessary, and large areas of the picture must be filled, *not* with detailed subject matter, but with light, or shadow, or shadow and light.

Light creates designs in black and white

Brightly illuminated subject areas appear white in a photograph, and areas in deep shade appear black. In between is a range of different shades of gray. These graphic effects produced by the illumination are as important to the im- p. 235 pression a picture creates as are the space and mood-suggesting qualities of light.

In analyzing the graphic and emotional effects of black and white, one finds that white is dominant and aggressive, black passive and receding. In a picture, since white (or light areas) attract attention first (exception: bold black silhouettes), they can be used to lead the eye of the observer to points of major interest. An effective way to draw attention to the subject proper is to deliberately keep it light and "frame" it with dark areas along the margins of the picture. White (or a predominantly light photograph) suggests lightness, gaiety, happiness, youth. Black (or a predominantly dark photograph) suggests strength, solidity, and power, but also seriousness, age, sorrow, and death. To make white appear as bright as possible it must be contrasted with black. Similarly, to make black appear as dark as possible, it must be contrasted with white.

To study the potentialities of light as a creator of graphic design, the following experiment is recommended: place a white plaster statue well in front of a white background. With a single photo lamp, illuminate and photograph the statue in three different ways: (1) Using front light, illuminate the statue and the background so that both appear as white. (2) Use a combination of front and overhead illumination to fully light the background; leave the statue outside the circle of illumination so that it will be rendered dark. (3) Again use a combination of overhead and front light; but this time, direct the cone of light so that it strikes the statue but not the background, to make the statue stand out white against dark. Now, from the first negative, on paper of *soft* gradation, make a series of three different prints: (1) Make a very light print, showing the statue white

263

against a white background. (2) Give the paper sufficient exposure to make the statue appear gray against a gray background. (3) Increase the paper exposure to produce a print in which a nearly black statue appears against a nearly black background. In this way, *merely by working with light,* you can show the same subject in five totally different forms: white against white; gray against gray; black against black; black against white; white against black. Truly an impressive demonstration of the graphic potential of light.

THE SYMBOLS OF RADIANT LIGHT

To the eye, there is a great difference in the quality of the light that is reflected from a white surface and the light that illuminates it. In looking at a white surface, we see the "color" white—soft, evenly diffused, *reflected* light. In looking at the light source itself, we see blindingly brilliant, direct, *radiant* light. And if we continue to look, we see stars, haloes, and other optical illusions which the radiance of the light produces upon the overstimulated retina of our eyes.

pp. 236-237 If we wish to convey this feeling of radiance, we must use symbols. The traditional symbols of radiant light are the halo and the star. Photographers wishing to symbolize the radiance of direct light in their pictures in a more expressive form than that of a blob of white have the choice of the following:

Haloes and halation. According to academic rules, it is wrong to take a photograph with the lens facing a strong source of light because it may cause halation in the film. Although halation is not present in reality, it closely corresponds to the sensation we experience when we look at a bright source of light, and if halation is well used, it is not a fault, but a valid and expressive symbolization of the radiance of direct light.

Since the effects of halation are not predictable, photographers who wish to have somewhat more control over the appearance of the haloes which surround the lights should investigate the following techniques:

Diffusion screens. Placed in front of a lens, a diffusion screen affects bright areas of the image more than it affects dark areas. For example, in a photograph of sun glitter on water, each tiny reflection of the sun would be surrounded by a halo, whereas the rest of the picture would be almost unaffected. Similarly, highlighted hair, sparkling jewelry, and the silhouettes of backlighted objects would appear edged by softly diffused light. Somewhat different diffusion effects are produced by the Rodenstock Imagon lenses which, with the aid of variable sieve-

like diaphragm stops, permit the photographer to adjust the degree of diffusion in accordance with the demands of the subject. These lenses, which are particularly suitable for taking romanticized portraits of women, are available in focal lengths suitable for use with 2¼ x 2¼-inch SLR and larger cameras.

Star patterns. Sharply pointed star shapes better suggest the harsh, aggressive brilliance of the electric light of night scenes in cities than the halation effects described above. Star patterns can be produced in two ways:

Small diaphragm apertures. In photographs taken with very small (f/16 or smaller) diaphragm apertures, the images of bright, point-like light sources are rendered as many-pointed stars, their size increasing with increases in exposure. In night photographs which include street lights, in photographs of sun-glittering water, or in photographs in which the sun itself appears, star shapes effectively symbolize the radiance of direct light. This method of light symbolization has an advantage in that it affects *only* the brightest lights within the picture, the rest of the image is rendered crisp and sharp.

Wire screens. When very small diaphragm apertures cannot be used, or when diaphragm-produced stars would be too small, screens made of the kind of wire cloth used for porch screens, placed in front of the lens, can be used to produce star shapes. Such stars always have four points. If eight-pointed stars are desired, two such screens, one rotated against the other by 45 degrees, must be used. The size of such stars increases with exposure. Since the wire screen acts as a diffuser, the image is never really sharp. However, the slight degree of unsharpness which results is usually inconsequential in the kind of picture for which this device is best suited: night photographs of city scenes in which documentation is subordinate to mood.

THE FUNCTIONS OF SHADOW

From the graphic point of view, shadow is perhaps even more important to the picture design than light because darkness carries more "weight." Photographically, shadow manifests itself in three different ways and it has the following functions within the design of the picture:

Shadow as darkness. In this respect the value of the shadow is in its depth of tone, its form usually being of subordinate interest. Darkness, in conjunction with light areas, creates graphic contrast. It provides forceful accents upon which sometimes the entire composition of a picture can be based. It symbolizes certain

intangible concepts such as strength, power, drama, poverty, suffering, death. And it is a means for creating a serious, somber, or mysterious mood.

Shadow as creator of volume, depth, and space. The importance of shadow to the symbolization of three-dimensionality can be appreciated by making the following experiment: take two photographs of a bas-relief (perhaps a medal), using low-skimming light to bring out the design. Illuminate the subject of the first photograph so that the light comes from the upper left-hand corner. Without changing anything else, take the second picture with the light coming from the lower right. Compare the two renditions. You will find that the first appears natural whereas the second appears reversed: forms that in the original were elevations will appear as depressions, and depressions in the original will appear to stand out in high relief. A similar effect can be seen in aerial photographs of mountainous landscapes taken from directly above. Such photographs have, of course, neither "top" nor "bottom." If such pictures are held vertically, with the shadows pointing more or less downward and toward the lower right, the scene will appear true to reality. However, if the picture is held so that the shadows point toward the upper left, the landscape will appear turned inside-out—a mountain will appear as a crater and a mountain range as a valley.

In a landscape photograph that includes mountains, the shadows of passing clouds can be used to make the scene stand out in bold relief. By waiting until the position of the cloud shadow is right—one range in shadow and the other in light—a photographer can indicate the space between neighboring ridges and thus create an effect of greater depth in his picture.

Shadow as independent form. Grotesque shadows that repeat in distorted form the shape of the subject by which they are cast, can be used to create strong interpretative pictures and, through exaggeration, emphasize a subject's qualities in a highly expressive form.

Although shadows with forms strong enough to be the principal subject of a photograph are rare, the main shadows within the field of view of the lens should be observed and analyzed since imaginative use of shadows can sometimes give a photograph a feeling of greater power and distinction. In the early morning and late afternoon, long slanting shadows can assume a strange life of their own. There are bird's-eye views of people hurrying along the street which show weirdly distorted shadows, fantastically stretched by a low-riding sun, which express in almost surrealistic intensity the hectic way of life in a big city. And I'll always

remember an aerial photograph of a bombed city made by Margaret Bourke-White. It was taken straight down from a low altitude in late afternoon, and the shadows cast by the roofless empty-windowed houses formed a macabre black-and-white pattern of hollow squares that reflected in the form of a "city of shadows" a mood of horror and senseless destruction impossible to forget.

COLOR

In a color photograph, "false" color will often be accepted as "true" whereas the same subject shown in color that actually is true to reality will be rejected as "unnatural." To understand this apparent paradox—and without understanding it no one can make good color photographs—it is necessary to have a basic understanding of the nature of color and color perception.

The nature of color

Color is a psycho-physical phenomenon induced by light. Its effect in terms of color sensation depends upon the spectral composition of the incident light, the molecular structure of the light-reflecting or transmitting substance, and our color receptors, eye and brain. Accordingly, we must distinguish between two things: the psychological sensation of color as we perceive it and the colored substances which cause this sensation. To avoid confusion, in the following I'll refer to the first as "color" and to the second as "colorants."

A good way to study the interaction between light and a colorant is to look at colored objects through different color filters. For example, if one looks at a blue object through a red filter, the object will appear black. This is so because the red dye of the filter absorbs the blue component of light—blue light is not transmitted. This, of course, explains why in black-and-white photography a red filter darkens a blue sky and thus brings out white clouds: by selectively absorbing the blue component of the sky light, this filter reduces the exposure of the blue sky proportionally more than it reduces the exposure of the white clouds, the light of which also contains red and yellow which are transmitted by a red filter. Therefore, it increases the contrast between the clouds and the sky.

The effect of a colorant is to *remove its complementary color* from the incident p. 135 light, *not* to add its own color to it. In other words, what we perceive as color is what remains of the incident light after it has been modified by the colorant. For example, in the amber illumination of the darkroom safelight, a sheet of

photographic paper looks amber, *not* because the amber light adds its own color to the white of the paper, but because the amber dye in the safelight filter *removes* by absorption all the components of the white light emitted by the incandescent bulb *except* those which produce the sensation "amber." These alone are transmitted by the filter, fall upon the paper, and are reflected by it into our eyes. Similarly, in daylight, green leaves appear green because chlorophyll strongly absorbs the blue and red components of white light but rejects green which is reflected. And a red automobile appears red because its colorant absorbs the blue and green components of white light but rejects red which is reflected.

The light-modifying effect of a colorant is, of course, the same whether the colorant reflects the light (as a surface does) or transmits it (as a filter does): if we look at the sun *through* a green leaf we see the same green as that which we see if we look *at* the leaf in sunlight. And if we were to paint a thin coat of red on a sheet of glass, we would see the same color if we look at it or through it. This is so because color is produced by the interaction between light and the molecules of the colorant, the atoms of which either absorb, or do not absorb, specific wavelengths (colors) of the incident light. And it is those wavelengths that are *not* absorbed that we see as color.

Color is a product of light. In the absence of light—in darkness—even the most colorful objects appear black. They lose their color. This is literally true. It does NOT mean that color still exists but cannot be seen because of lack of light. It simply means that in darkness color ceases to exist.

But what of pigments, paints, and dyes—the stuff that gives objects their colors —are they not absolute, existing as colors in their own right?

No—the colors of such substances are also produced by light. Conclusive proof can easily be obtained by anyone who examines an array of pigments or paints in differently colored lights (cover a lamp with sheets of cellophane in different colors). The paints will change color each time the color of the light is changed. Why? Because color is light.

This explains why an object can have only those colors which are present in the spectrum of the illuminating light. Therefore, an object that appears red in daylight (which is rich in red-producing wavelengths) appears black when illuminated by green light (which does not contain light of red-producing wavelengths) or when seen through a green filter (which absorbs red). Fluorescent light is so un-

flattering because it is deficient in red-producing wavelengths: things illuminated by it often look "unnatural" in comparison to their familiar appearance in daylight which is richer in red (in fluorescent light, a rare roast looks positively putrid, and a pink complexion assumes a corpse-like hue). Even more "unnatural" are the effects of sodium and mercury vapor illumination which, being monochromatically amber and blue-green, make everything appear either amber or blue-green, and no filtration can change this appreciably. Renditions of this kind appear, of course, totally "unnatural" in color photographs.

Although a color photograph taken in fluorescent illumination or in the light of a sodium or mercury vapor lamp would render the subject virtually the same color as that seen by the eye, most people would reject such a rendition as "unnatural" despite the fact that its colors are "true." In other words, under certain conditions a "true" rendition of color appears "false." That it is equally possible that a false color rendition can appear true will be shown presently.

The nature of color perception

The psychological effect of color is a personal and subjective experience. As a result, we constantly see color not as it actually is (and as it is rendered by the color film), but as we think it ought to be. For example:

In a portrait taken of a person sitting in the shade of a tree, because the illuminating light consists partly of light reflected from a deep-blue sky and partly of sunlight modified by green leaves, the rendition will have a blue-green overall color cast: the skin will look bluish, the lips purple, and shadows around the eyes and beneath the chin will be green. This objective recording of color would, of course, be rejected by most people.

Most people do not *consciously* notice minor deviations in color from the memorized ("normal") colors of things as they appear in white daylight. If actual color differs from the norm—which automatically happens when the illumination is not white—they often fail to notice the resulting color changes. Color film, however, is extraordinarily sensitive to any deviation from the standard light for which the film is balanced. When a correctly exposed and processed color transparency strikes us as unnatural because its colors appear distorted, it usually is *not* the fault of the color film but our own persistent color memory which prevents us from recognizing the truthfulness of such color.

To return to the example given, if the blue-green light were "corrected", i.e., falsi-

fied, by the appropriate color correction filter to make it conform to white daylight—the standard for our color memory as well as for daylight color film—the rendition would be accepted as "true," although actually it would be false. It is quite common in color photography that a color rendition that is true appears false and that color must be deliberately falsified to appear true.

p. 141 To understand how quickly the eye adapts to colored illumination and sees it as white, take a few color-compensating filters in pale shades and, for half a minute at a time, look through them at the view beyond the window. At first glance, a pale blue filter makes everything appear distinctly blue; but within a very short time the eye sees colors as if the light were white. Then put the filter down and everything will look pink—the complementary color to pale blue—but in a short time the eye will adapt again and see color as it originally was.

Conversely, observed through a pink filter, everything looks rose-colored. But since the eye quickly adapts, the colors of view and sky soon appear normal. When you put the filter down, everything looks blue; but in a few moments, colors will be seen once more as they appear in white light.

While the untrained eye consistently fails to notice the small changes of color that constantly occur around us, painters have long been aware of this fact. In 1886, the French novelist Émile Zola, in his book L'Oeuvre (the Masterpiece), wrote about this conflict between actuality and appearance in a scene in which he describes the reaction of a young wife to the "impressionistic" paintings of her husband:

> And she would have been entirely won over by his largesse of color, if he had been willing to finish his work more, or if she had not been caught up short from time to time by a lilac-toned stretch of soil or a blue tree. One day when she dared to permit herself a word of criticism, on the subject of a poplar tree washed in azure, he took the trouble of making her verify this bluish tone in nature itself; yes, sure enough, the tree was blue! But in her heart she did not accept this; she condemned reality; it was not possible that nature should make trees blue. . . .*

In a similar way color photography can open our eyes to the true nature of color. Often in looking at a transparency we are dismayed and think that a certain color could not possibly be true. But if we take the trouble to check the subject

* Copyright 1946 by Howell, Soskin, Publishers, Inc. Used by permission.

under conditions which are similar to those that prevailed at the moment of exposure, we will find that only too often it is we who are mistaken. And learning from this we will become more observant and more fully aware of the changing aspects of our ever-changing world.

The psychological effects of color

Color is the most powerful symbol of expression a photographer has. It is stronger than line, form, contrast, or design.

Through choosing colors whenever possible for their associative value, a color photographer can give his picture a specific meaning or mood. This can be done in several ways (and each combined with one another): the photographer can choose his subject for its color (a *blond* girl, a *red* automobile); he can choose certain colors as auxiliary picture elements (a background in a specific color, a blue-green scarf); and he can overlay his entire picture with a specific, paler or stronger color shade by placing colored gelatins in front of his lamps or shooting through the appropriate filter.

Highly saturated colors create vigorous, virile, or aggressive impressions, emphasizing the power of powerful subjects. Pale pastel shades should be used for sophisticated, pensive, or delicate subjects and to suggest more languid moods. Light colors are joyous and gay, dark colors moody and somber. Combinations of related colors (for example, red, orange, yellow, brown) generally produce p. 95 more pleasing effects than mixtures of unrelated colors. Combinations of comple- p. 135 mentary colors produce the graphically most powerful effects. Clashing colors symbolize conflict and violence. Some colors—red, orange, yellow, yellow-green —are "warm"; others—blue, blue-green, purple-blue—are "cold." Friendliness, compassion, and love might be symbolized by warm colors; haughtiness, hostility, and hate are more effectively symbolized by cold colors. Accordingly, through choice and intensity of color, a photographer can strengthen (or neutralize!) his picture's impact and mood.

As far as specific colors are concerned, the following might be of interest. Red is the most aggressive and advancing color of the spectrum, active, exciting, and p. 277 therefore widely used for advertisements, book jackets, and posters. Red suggests blood and flames and is associated with danger (warning signals are usually red); it is also the symbol of revolution, violence, and virility (we speak of a "red-hot temper" and "red-blooded Americans"). Blue, at the opposite end of the spectrum from red, is the most passive and receding of all colors, restful, remote, p. 277

and "cool" (perhaps because it makes us think of the coolness of water and the cold of ice). We speak of a "blue" mood, and the French have their *l'heure bleue*, the blue hour of dusk, a time of calm and relaxation. One has "the blues"—one feels low, the opposite of excited as in, "He saw red." Yellow has two connotations: it is associated with pleasant feelings—the sun, warmth, cheerfulness, and spring (yellow baby chicks and daffodils)—but it also suggests cowardice and disease (someone is said to have "a yellow streak," he is called "yellow-bellied," the yellow flag of quarantine, the yellow color of a sick face). Orange, the color between yellow and red, is "hot," somewhat less hot in feeling than red but hotter than yellow, which is only a "warm" color; orange brings to mind fall foliage, pumpkins, our celebrations of Thanksgiving and Halloween. Brown suggests earthiness and the soil, autumn and falling leaves, tranquility, serenity, and middle age; someone is "in a brown study." Green, the dominant color of nature, is the least "artificial" of all the colors. It is neither aggressive nor passive, neither hot nor cold, neither advancing nor receding; it is neutral without being dull. Violet is either mildly active or passive depending on its red or blue content: as purple (high red content) it is often associated with the Roman Catholic Church and royal robes; as lavender (high blue content) it makes us think of old ladies. White is the color of innocence, and black is the color of death.

Three ways to good color rendition

Experienced photographers know that true color is not necessarily good color, that good color is not necessarily true color, and that distorted color is not always bad color, because color rendition can be good in three different ways:

1. Color rendition can be good because *it appears natural,* i.e., because it corresponds to the color of the subject as it appears in white daylight ("color as remembered"), whether the color in the rendition corresponds to the actual color of the subject at the time the picture was made or not.

pp. 269-270

2. Color rendition can be good because *it is accurate,* i.e., because the color matches the color of the subject at the moment the picture was made, even though the color may differ from the color of the subject as it would have appeared in white daylight.

3. Color rendition can be good because *it is effective* even though subject color is obviously distorted.

Natural-appearing color rendition. Subject color appears natural if it matches the color of the subject seen in white light ("color as remembered"). Such rendi-

tion is particularly desirable in reproductive-utilitarian photography. For such color rendition the subject must be illuminated by the light for which the color film used is balanced. If the color of the light differs, the appropriate color correction filter must be used. If the light is wrong and a correction filter is not used, it is impossible to make a natural-appearing color rendition as defined above with reversal-type color film. If negative color film is used, however, fairly large deviations from the recommended illumination can be successfully corrected in printing. But it is never possible to make a natural-appearing color rendition with mercury vapor illumination, daylight after sunset, under water without auxiliary illumination, or with any other light that is strongly deficient in any part of the spectrum.

p. 7

To *appear* natural, color must often be distorted and falsified in the rendering. Photographed in reddish sunset light, a face, for example, would appear exaggeratedly red. Although this color would actually be true to reality because it would match the actual color of the face at the moment of exposure, it must be corrected by a blue light-balancing filter, i.e., falsified, to make the face appear as It would in white light—as we remember it.

p. 138

Whereas the *accuracy* of color rendition can be checked and measured with instruments, the degree to which color rendition *appears natural* is subject to the judgment of the observer. To the untrained eye, a shadow that is even slightly blue appears unnatural. Color renditions that experienced photographers and persons with artistic training accept as natural will appear exaggerated and false to others.

Accurate color rendition. Subject color appears in the transparency as it appeared at the time of the exposure. Accurate color rendition preserves the identity of the subject and reflects the conditions that existed when the picture was made. Such color rendition is usually desirable in documentary-illustrative photography and is a welcome relief from the bore of "natural-appearing" color.

p. 8

Actual color rendition usually (though not always) results if photographs in daylight (no matter what kind) are made on daylight color film, and photographs in artificial light (no matter what kind) on Type A or B color film. No filter should be used even when the illumination does not correspond to the light for which the color film is balanced. Occasionally, if a photographer wishes to make a somewhat more natural-appearing color rendition, he can use a light-balancing filter which *partially* corrects the light and makes the subject appear *somewhat* less unusual yet preserves the typical character of the illumination.

273

Effective color rendition. Subject color appears interesting and stimulating rather than natural or accurate. Such color rendition is particularly appropriate in creative-interpretative photography. For example, as color consultant to the producer of the motion picture "Moulin Rouge," Eliot Elisofon deliberately colored the illumination to emphasize the mood of scenes. To symbolize gaiety and joy, he used pink; for excitement, red; for sorrow and despair, blues and greens. Some of the most exciting fashion photographs are made with colored lights that create different moods and unusual and beautiful effects. Such going against the academic rules of color photography produces color photographs that are far more stimulating than those that are conventional, but the demand for them is, of course, rare in comparison to the demand for ordinary photographs.

Whereas it is easy to give rules for natural-appearing color rendition, it is impossible to give rules for creating unusual effects. In this, a photographer is on his own. However, the following suggestions might get him started:

Use unbalanced illumination. Through tests, find out how color film reacts when used with light for which it is *not* balanced. For example, use daylight film with incandescent light, tungsten-type film with daylight, and either type of film with different kinds of fluorescent light. File the results of such tests and all pertinent data for future use.

Use different types of illumination in the same picture. For example, use daylight (or blue flash or blue floodlamp illumination) and incandescent light together, but do NOT mix these different types of light. Instead, use each to illuminate a separate section of the picture, experimenting with both daylight and tungstenlight color films. Notice that one type of light appears blue and cold, the other yellow and warm. Use the contrast of warm and cold light to accentuate different picture areas. For example, in interior shots emphasize the difference between outdoors and indoors by rendering the light falling through the window cold and the interior room illumination warm. Such differences in illumination can produce a more stimulating and effectful rendition than one type of light used throughout the photograph.

Use color filters in front of the lens to change the quality of the illumination in accordance with the spirit and mood of the subject or occasion. The paler shades of CC filters are most suitable for this purpose. Usually, such overall color is most effective if it is subtle; it should be sensed rather than seen.

Use colored acetate filters in front of lamps. Whereas a filter in front of the

p. 9

p. 141

274

lens uniformly tints the entire photograph, filters in front of individual lamps (Roscoe Theatrical gels) permit a photographer to control the illumination of separate areas. Elisofon used this technique in "Moulin Rouge." Its advantage is that by limiting the effect of colored light to certain sections of the picture, natural-appearing and creatively controlled color can be used in the same photograph. For example, the foreground of a scene can be rendered moody and blue, the middle distance neutral, and the background rosy and gay. Or colored illumination can be used to emphasize one area of the picture.

The more white a subject contains, the greater the potential of colored light. Whole pictures can be painted with it. The most delicate transitions from one color to another or from warm color to cold can be produced and new effects can be achieved. This field of creative photography is unlimited and offers rewarding opportunities to those photographers who dare to "break the rules."

Color rendition in terms of black and white

Although black-and-white films automatically translate color into shades of gray, the form which this translation takes is not unalterable; it can be controlled by the photographer. Such control may be desirable for one of the following reasons:

To increase the accuracy of color translation. As mentioned before, all black-and-white films are overly sensitive to blue and all orthochromatic films are insensitive to red. All panchromatic films are somewhat less sensitive to green than to other colors, and some are overly sensitive to red. As a result, there is as yet no black-and-white film that automatically translates all colors into shades of gray that match in brightness the brightness of the colors they represent. Consequently, if color has to be translated into gray shades of precisely corresponding brightness, the photographer must control the translation by using panchromatic film in conjunction with the right correction filter.

p. 118

p. 141

To utilize particular characteristics of certain types of film. The fact that orthochromatic films are insensitive to red does not mean that every red will be rendered as black in pictures made on orthochromatic film. Most reds contain some yellow or blue. As a result, they are not rendered as black but merely darker than they appeared to the eye. In making portraits of men, for example, orthochromatic films, because of their insensitivity to red, usually produce better skin tone rendition than panchromatic films which, because of their high red-sensitivity, tend to render reddish tones too light, producing a washed-out effect.

Predominantly green subjects such as landscapes and trees have better differen-

275

tiation if photographed on orthochromatic rather than on panchromatic film because panchromatic films render green unproportionally dark unless the right correction filter is used.

To improve tonal separation. Colors different in hue (for example, red and green) but similar or equal in brightness (light red and light green), which appear well differentiated to the eye, may be rendered as similar or equal shades of gray in an uncontrolled black-and-white photograph. As a result, objects of different colors that appeared well differentiated in reality might merge and their outlines be lost. To prevent this, color translation must be controlled with contrast filters.

pp. 141-142

p. 118 The following chart, which applies only to *panchromatic films,* lists the more important filters used in black-and-white photography together with their uses and factors which, however, are only approximate inasmuch as they have to be modified in accordance with the filter manufacturer's instructions.

Filter	Principal purpose	Factor
Light yellow	The effect of this filter is so slight that I consider it useless for all normal purposes.	1½ × (open up ⅔ stop)
Medium yellow	A good all-round filter which slightly darkens a blue sky, slightly lightens green foliage, and slightly reduces the veiling effect of haze.	2 × (open up 1 stop)
Dark yellow	The effect is similar to that of a medium yellow filter but more pronounced. This filter makes skin tones appear somewhat too light.	3 × (open up 1⅓ stop)
Light green	Slightly lightens green foliage, slightly darkens blue sky. If filtration is required, this is the best filter for close-ups of people because it does not make skin tones appear too light.	4 × (open up 2 stops)
Red	Strongly darkens blue sky and reduces veiling effect of blue haze. Excellent for long-distance views and aerial photographs. Unsuitable for close-ups of people because it renders skin tones much too light, producing a chalky appearance.	8 × (open up 3 stops)

The working rules for the use of these filters have already been given. This information, however, is useless unless one has a feeling for color and color effects —when to make a certain color lighter and when to translate it into a darker shade of gray. If two colors are different in hue but equal (or very similar) in brightness, the best effects are usually achieved if the more active, aggressive,

and warmer color is rendered as a lighter shade of gray and the more passive, receding, and cooler color is rendered as a darker shade of gray.

Active, aggressive, and warm colors	Neutral colors	Passive, receding, and cool colors
red	green-yellow	blue-green
orange	green	blue
yellow	magenta	violet

CONTRAST

In reality, visual differentiation between objects is based upon differences in object coloration and parallax—the stereo-effect caused by the fact that each of our eyes sees the same object from a slightly different angle. In black-and-white photography differentiation is based primarily upon contrast of light and dark, and control of contrast is desirable for two reasons:

To produce prints of normal contrast range. If subject contrast is too high or too low, contrast must be controlled. Contrast is most often too high in subjects photographed in bright sunlight at distances of less than 15 feet, too low in most long-distance telephotographs, aerials, and pictures made in very dim light.

To increase graphic impact by rendering the subject either more or less contrasty than it would normally have been rendered.

In color photography the main reason for contrast control is that if subject contrast is too high, simultaneous satisfactory rendition of the lightest and darkest colors is impossible.

Contrast control can be exercised at three levels:

1. By influencing the contrast of the subject
2. By influencing the contrast of the negative
3. By influencing the contrast of the print

Contrast control at the subject level

Usually, the only practical way to control the contrast range of the subject is with light. In daylight one can either wait until the illumination is suitable or, if the subject is relatively close and not too large, reduce its contrast with auxiliary fill-in illumination. Indoors, subject contrast can easily be controlled by controlling the brightness, distribution, and light-to-subject distance of the lights.

Subject contrast is the product of lighting ratio and reflectance ratio. A practical example will best explain what this means. A portrait has to be made. Illumina-

p. 176

tion (not counting background and accent lights which do not affect the exposure meter reading of the face) should consist of two lamps of equal wattage placed at equal distances from the subject: the main light placed at an angle of approximately 45 degrees to the subject-camera axis, and the fill-in light placed next to the camera.

Lighting ratio. Under these conditions, subject areas illuminated by *both* lamps receive *twice* the light that the areas in the shadows cast by the main light receive which are illuminated by only *one* lamp, the fill-in light. In such a case, the lighting ratio would be 2:1. In relation to the fill-in light, if the main light were placed at half the distance from the subject, it would throw four times more light on the subject than the fill-in light does, since the intensity of illumination is inversely proportional to the square of the distance between subject and light source. In such a case, the subject areas illuminated by *both* lamps would receive five units of illumination and the shadows still receive only one; consequently, in that case, the lighting ratio would be 5:1.

Reflectance ratio. To establish the reflectance ratio, *uniformly* illuminate the subject with shadowless front light. Check evenness of illumination by taking meter readings off a Kodak Neutral Test Card held at different locations within the picture area and be sure that all the readings indicate the same value; if not, arrange the illumination accordingly. Then, *disregarding black and white, measure the reflectance of the lightest and darkest subject color* with an exposure meter. Let us assume that you find a ratio of 6:1, i.e., that the lightest color reflects six times as much light as the darkest. This ratio of 6:1 would represent the reflectance ratio of the subject.

Subject contrast is the product of lighting ratio and reflectance ratio. In our example in which the lighting ratio was 2:1 and the reflectance ratio 6:1, the lightest colors of the subject which are illuminated by both lamps were 6 times as bright as the correspondingly illuminated darkest colors, and 2 x 6, or twelve times as bright as the darkest colored areas of the subject which received their illumination only from the fill-in light. Therefore, the subject contrast ratio would be 12:1.

In color photography, for natural-appearing color rendition, the lighting ratio of subjects with average reflectance ratios should normally not exceed 3:1. However, if the subject reflectance ratio is lower than average, i.e., if all the subject colors are either light, or medium, or dark, and therefore light and dark colors

278

do not occur together, *the lighting ratio can be increased to 6:1* without subject contrast exceeding the contrast range of the color film. Transparencies made for viewing and projection can stand a somewhat higher contrast ratio than transparencies from which prints or four-color engravings are to be made.

Lighting contrast ratios for portraits and other types of studio work can easily be calculated by substituting f-stop numbers for lamp-to-subject distances in feet. This method is based upon the fact that the inverse-square law applies to both lamp distances and f-stop numbers. For example, if the f-stop number is doubled, say, from f/8 to f/16, the exposure must be four times as long at f/16 to produce a negative of the same density as one made at f/8. Similarly, if the subject-to-lamp distance is doubled from 8 feet to 16 feet, exposure must be four times as long at 16 feet as at 8 feet to produce the same density in both negatives. Accordingly, it is possible to establish lighting contrast ratios by converting the lamp-to-subject distances of the main light and the fill-in light to f-stop numbers and comparing the differences. In this respect, the following ratios apply:

> Equality of f-stop number is equal to a 2:1 lighting contrast ratio
> a one-stop difference is equivalent to a 3:1 lighting contrast ratio
> a 1½ stop difference is equivalent to a 4:1 lighting contrast ratio
> a 2 stop difference is equivalent to a 5:1 lighting contrast ratio
> a 2½ stop difference is equivalent to a 7:1 lighting contrast ratio
> a 3 stop difference is equivalent to a 10:1 lighting contrast ratio

For example, let's assume the main light is placed at a distance of 5½ feet from the subject and the fill-in light at 11 feet. Converted to the nearest f-stop numbers, this would be equivalent to f/5.6 and f/11, a difference of two stops. According to the above table, a two-stop difference corresponds to a lighting contrast ratio of 4:1.

Conversely, of course, any desired lighting contrast ratio can easily be established on the basis of the following table:

Desired lighting contrast ratio:	2:1	3:1	4:1	5:1	6:1
Fill-in light distance factor	1	1.4	1.7	2	2.2

To establish the desired lighting contrast ratio, place the main light at the most suitable distance from the subject. Multiply this distance in feet by the fill-in light factor which, according to the above table, applies, and place the fill-in light at this distance from the subject.

(NOTE: These two methods of figuring lighting contrast ratios can, of course, be used *only if identical lamps are used* for the main light and the fill-in light, whether they are photoflood lamps, flashbulbs, or speedlights.)

Outdoor flash fill-in exposure determination

Outdoors, if subject-to-camera distance is not too great, the best way to control subject contrast is with synchronized daylight flash (for color film, a blue flashbulb must be used) or speedlight. Exposure must be calculated on the basis of the following considerations:

Fill-in illumination is supplementary illumination. Its purpose is to reduce subject contrast to the contrast range of the film. Consequently, flash intensity must be related to the main light, in this case, the sun. The problem is to lighten shadows sufficiently to bring out detail and, if color film is used, color, without destroying the effect of the sunlight through overlighting. Fill-in illumination that is too strong obliterates all shadows and causes pictures to appear as flat as if only front light were used; conversely, underlighting leaves subject contrast too high and shadows too dark.

pp. 175-176

p. 169
p. 149
To find the correct exposure, take an overall meter reading of the subject and set the diaphragm aperture and shutter speed accordingly. To find the correct distance between the subject and the fill-in flash, use the guide number for the particular combination of flashbulb (or speedlight unit), film type, and shutter speed, and divide it by the f-stop number to be used. For example, the exposure meter reading chosen is 1/100 sec. at f/16. The corresponding guide number is, say, 160. To find the flash-to-subject distance, divide 160 by 16 (the f-stop number) and get 10 as the result. Placed at this distance from the subject, the flash would, however, *produce a fully exposed* negative or color transparency devoid of shadows. This, of course, is not what is wanted, and to retain part of the shadow effect of the sunlight, flash intensity must be reduced accordingly. This can be done either by increasing the distance between flashbulb and subject by

p. 252
50 to 100 percent, or by draping one or two thicknesses of a white handkerchief over the reflector. Some photographers prefer to fill in shadows to a higher degree than others, and each must establish his own formula by test.

280

Contrast control at the negative level

In black-and-white photography the contrast range of the negative can be controlled with the following means and techniques which have previously been discussed in detail. The greatest changes in contrast are, of course, achieved by combining several of these methods.

Choice of film. To decrease subject contrast use a film with soft gradation. To p. 127 increase contrast use a film with hard gradation. An almost pure black and pure white rendition can be made by photographing the subject on high-contrast film such as Kodalith.

Choice of developer. Rapid and high-contrast developers produce negatives p. 187 of harder gradation, and fine-grain developers produce negatives of softer gradation than standard developers.

Exposure in conjunction with development. Increasing the exposure beyond the meter-indicated value and developing the film for a shorter than normal time leads to negatives of softer than normal gradation. Conversely, the contrast of the negative can be increased by shortening the exposure and prolonging the time of development. Exposure increases of 500 percent and decreases of 50 percent from standard, and development increases of 100 percent and decreases of 30 percent from standard, are normally the boundaries within which extreme though still satisfactory results can be expected.

Choice of filter. Contrast in the black-and-white negative can usually be increased through use of the appropriate contrast filter. Only occasionally will it pp. 141-142 be desirable to decrease contrast. For example, in copying a document or photograph stained by yellow or reddish-brown spots, if a red filter and panchromatic film are used, such stains will not appear in the print unless they are unusually dark.

Copying. Maximum contrast increases can be achieved by producing a diapositive by contact-printing or enlarging the negative on high-contrast film such as Kodalith and contact-printing the diapositive on Kodalith film to produce a second negative. This negative will be so contrasty that prints made from it will consist entirely of black and white and resemble woodcuts.

Masking. Maximum reduction of contrast is achieved by masking. To make the mask—a low-contrast diapositive—contact print the negative on film of soft grada- p. 127 tion. To facilitate registration of negative and diapositive in making the final print, diffuse the diapositive image slightly by inserting a Kodapak Diffusion Sheet

between the negative and the film before contact-printing. By appropriate adjustment of exposure and development, a diapositive of any desired contrast gradient can be produced. The more the contrast of the original negative must be reduced, the more contrasty the diapositive mask must be. After the diapositive is dry, to further increase diffusion, *tape it in register to the base side of the negative* and enlarge the "sandwich" as you would enlarge an ordinary negative. This method of contrast reduction can be used with both black-and-white and color negatives.

Contrast control at the print level

The contrast range of a print can be changed with the following means and techniques which have previously been discussed in detail:

Paper gradation selection. To increase contrast, print the negative on paper of hard gradation. To preserve the contrast of the negative, use a paper of normal gradation. To decrease contrast, print the negative on paper of soft gradation. For photographers who use negative color film, Agfa offers Agfacolor paper in two different gradations.

p. 193

Dodging. Contrast can be controlled on a local scale during enlarging by "burning in" and "holding back" negative areas that are respectively too dense or too thin. This method is normally used to reduce contrast but it can, of course, also be used to increase contrast in the print. It is applicable to both black-and-white and color photography.

pp. 215-216

Deviations from normal procedure in exposing and developing the print previously described can be used to change overall contrast as well as contrast on a local scale.

pp. 215-217

GRAPHIC BLACK AND WHITE

If we disregard its subject matter and meaning, a black-and-white photograph can be seen as a design in black, gray, and white. This design can be evaluated esthetically in terms of balance and composition, and if the design is good, a picture can be successful and satisfying purely as an abstract arrangement in black and white.

pp. 92-93, 235, 242

Examples of pictures whose *only* function is to satisfy esthetic demands are abstract photographs and photograms whose effect is solely dependent upon their graphic design. But in all photography one finds that, regardless of other values, a photograph appears more striking if it is also satisfactory in design.

Black, shades of gray, and white are symbols which stand for something else, usually color. But much more is involved than that. These abstract graphic shades have specific psychological effects which can be used to give impact to a picture. White, for example, is felt as aggressive and "advancing," black as passive and receding. A parallel with color can be drawn: red is aggressive and advancing, blue passive and receding. Therefore, to adequately translate these color characteristics into black and white, red must be symbolized by a light shade of gray or by white, and blue by a dark shade of gray or by black. This, of course, is easily done by using panchromatic film and a yellow or red filter. If an orthochromatic film were used or panchromatic film with a blue filter, red would be rendered as black and blue as white; such a translation of color would not give an effect related to red and blue and the impression created would be misleading.

A photographer can control and vary the mood and character of his picture by using black, gray shades, and white in different proportions. The larger the number of different shades of gray, the more naturalistic the photograph, and the fewer, the more abstract the impression which it creates.

Graphically, black carries more weight than white. Thus, a small black area balances a larger white area. If these proportions are reversed, the design of the composition may still balance but the effect will be similar to that of a negative or a picture taken at night.

Pure black and white can be used to strengthen the effect of a subject through simplification: undesirable detail can be eliminated by submerging it in solid black or white. This is one of the reasons why, imaginatively treated, a silhouette can p. 97 express the essence of a subject.

Compared to black and white, gray shades may seem dull and monotonous. However, used well, gray shades can strengthen the impact of a picture. If monotony is typical of a subject like, for instance, the mood of a rainy day, a graphically monotonous treatment will best characterize it. p. 243

DEPTH AND SPACE

Although one dimension—depth—is lost in transition from reality to picture form, a photographer can create an illusion of depth in his photographs. To do this he uses symbols, whether he is aware of it or not.

Every photograph that shows a subject as three-dimensional contains such sym-

bols; for example, the apparent converging of actually parallel lines as they recede from the observer. The form which these symbols take need not be accepted as chance presents them. They can be controlled, the photographer can deliberately choose those depth-symbols that will best express a particular concept and produce the strongest effect.

"Depth" can be defined as "contrast between near and far." In terms of photography, this contrast can be expressed in four ways:

Contrast between light and shadow. Light accentuating elevations symbolizes the advancing forms of the subject, and shadow filling its depressions symbolizes its receding forms. From distribution of light and dark an illusion of depth results. The means and techniques used for such depth-symbolization have pp. 260-264 already been discussed.

Contrast between large and small (perspective). This form of depth-symbolization is based upon the relationship between the apparent size of an object and its distance from the observer—the farther away it is, the smaller it appears.

p. 297 **Contrast between sharp and unsharp** (selective focus). This form of depth-symbolization is based upon the eye's inability to simultaneously see objects at different distances sharply.

p. 298 **Contrast between light and dark** (aerial perspective). This form of depth-symbolization is based upon the effect of atmospheric haze which makes objects appear increasingly lighter with distance.

Contrast between large and small

The most widely used of all space symbols are variations of perspective—the optical illusion which makes things appear increasingly smaller the farther away they are. The best known manifestation of perspective is, of course, the apparent converging of actually parallel lines as they recede from the observer. Other manifestations are diminution, overlapping, and foreshortening. The essence of all these phenomena is distortion. The degree of distortion is subject to the photographer's control.

I do not wish to limit distortion to what is popularly called "wide-angle distortion" or the apparent "compression" of space in telephotographs. I literally mean that every photograph of a three-dimensional subject is a distortion of reality. This is easily seen if one looks at a photograph of a street. Buildings, people, and automobiles close to the camera appear much larger than those

284

farther away. This is distortion, because their actual size is the same whether they are close by or far away. Horizontal lines of buildings appear to converge as they recede—in reality they are parallel. Rectangular windows are rendered as trapezoids, automobile wheels elliptical, and so on.

The reason photographs taken with lenses of standard focal lengths don't appear pp. 82, 110 distorted is that the degree of their distortion corresponds to the images produced by our eyes—perspective appears "natural" although reality is shown in distorted form. A distortion-free rendition is possible only if a flat subject is photographed with its surface parallel to the film. For example, photographed head-on, the façade of a building or the reproduction of a painting will appear distortion-free: right angles will be rendered as right angles and parallel lines will be rendered parallel. But if the parallelity between subject and film is upset, i.e., if a photographer tilts or turns his camera, depth is involved and will become apparent in the picture in the form of distortion: parallel lines will converge, even if only slightly, and right angles will no longer measure 90 degrees.

Obviously, then, if a subject is three-dimensional, *only one of its sides can be rendered distortion-free.* The other sides, "seen in perspective," i.e., in terms of receding lines and planes, always appear "distorted" The degree of distortion—the degree of diminution and the form foreshortening takes—is subject to the photographer's control.

Perspective controls

When we speak of "perspective," we usually mean rectilinear perspective (not cylindrical perspective or spherical perspective which I'll discuss later). There are pp. 294-297 two kinds of rectilinear perspective: academic and true. The specifications of academic rectilinear perspective are:

1. Straight lines are rendered straight.

2. All two-dimensional forms parallel to the plane of the film are rendered distortion-free: parallels are rendered parallel, circles are rendered round, angles are rendered in their true shapes.

3. Receding horizontal lines converge toward vanishing points. All such vanishing points are located on the true horizon, whether the horizon is visible in the picture or not.

4. Vertical lines must appear parallel and vertical.

True rectilinear perspective is identical to academic rectilinear perspective in

regard to points one, two, and three; it differs in regard to point four: verticals are rendered parallel *only* if they fall under point two. If the film is *not* parallel to the verticals, i.e., if the camera is tilted either upward or downward, verticals will converge in the picture. Although this convergence may seem "unnatural" and be objectionable in a photograph, it is, of course, nothing but the perfectly natural manifestation of perspective in the vertical plane. This phenomenon, if unwanted, can be avoided by one of the following controls:

Control of vertical lines in the negative. The film must be parallel to the vertical lines of the subject. This condition is fulfilled if the camera is in level position. However, if the subject is a tall building and the picture is made with the camera in level position, the top of the building will be cut off in the photograph and the foreground would appear unproportionally prominent. On the other hand, if the camera is tilted to include the top of the building and reduce the amount of foreground shown, vertical lines would converge. In such a case the only way to make a satisfactory negative is to use a camera equipped with a rising front (or the Nikkor P.C. lens) as follows:

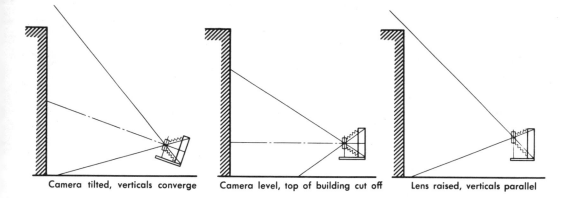

Camera tilted, verticals converge Camera level, top of building cut off Lens raised, verticals parallel

Place the camera on a tripod. Aim and focus as usual observing the image on the groundglass: the verticals will converge. Tilt the camera forward until it is level. Now, the vertical lines will appear parallel, but the top of the building will be cut off. Without altering the camera position, elevate the lens by raising the front until the entire building appears on the groundglass. Stop down as usual and make the picture.

Control of vertical lines in the print. Any negative in which verticals converge can be enlarged to restore verticals to parallelity in the print. How this is done was described before. p. 214

The foregoing explained how perspective can be controlled in one dimension—height. If perspective must be controlled in two dimensions—height and width—the photographer needs a view-type camera equipped with a lens of adequate, p. 78 i.e., more than normal, covering power and a complete set of "swings." These p. 88 are individual camera adjustments that make it possible to independently adjust the positions of lens and film. The principal functions of the different swings are as follows:

The back tilts and swings control the perspective of the rendition.

The front tilts and swings control the overall sharpness of the image.

The vertical and lateral front and back adjustments (slides and rises) control the position of the image on the film.

How to use the swings of a view camera

Before a photographer can successfully control the perspective of his picture he must realize two things:

1. Only those planes, forms, and angles of the subject that are parallel to the plane of the film can be rendered distortion-free. All forms and angles not parallel to the plane of the film will be rendered distorted. Therefore, those parts of the subject that must be rendered distortion-free must be parallel to the film. This can be accomplished either by placing the camera accordingly in relation to the subject, by placing the subject accordingly in relation to the camera, or, if neither is possible, by using the camera back adjustments to adjust the film parallel to the part of the subject that must be rendered distortion-free regardless of the direction in which the lens is pointed. If none of these conditions can be fulfilled, distortion-free rendition in the negative is impossible.

2. The lens, because it may be necessary to adjust it in such a way that its axis no longer points at the center of the film, must have more than average covering p. 88 power. Otherwise, use of the front swings may cause part of the film to be outside the sharply covered area, and that part will be rendered either unsharp or, in more extreme cases, blank. To avoid this, either a lens with extra covering power must be used, such as, for example, the Schneider Symmar or the Goerz Dagor, or instead of a standard lens designed to merely cover the respective

p. 105 negative size, a wide-angle lens of equal focal length designed to cover the next larger film size must be used as explained before.

The best way for a photographer to understand the principles of perspective control is to make the following experiment. Photograph a large box so that three of its sides are visible in the picture, one of which—the front—must be rendered distortion-free, i.e., its vertical lines parallel, its horizontal lines parallel, and its angles 90 degrees. Proceed as follows:

p. 78 1. Mount a swing-equipped view camera on a tripod. Place it to show two sides of the subject and high enough to provide an oblique view of its top. With the diaphragm wide-open and all the swings in neutral position, center the image of the box on the groundglass.

2. Adjust the back of the camera so that the film is parallel with the vertical lines of the box. In this position the vertical lines of any subject will be rendered parallel instead of converging. The image will, of course, be partly out of focus; disregard this unsharpness temporarily.

3. If adjusting the back (or making any of the following adjustments) results in an objectionable displacement of the image of the subject on the groundglass, *do not change the camera position*. Instead, center the image by using the vertical (rising) and lateral (sliding) adjustments of either the lens or the camera back.

4. Swing the back of the camera laterally until it is parallel to the front of the box. In this position, the horizontal lines of the front of any subject will be rendered parallel instead of converging. In making this adjustment be careful not to upset the parallelity between the camera back and the vertical lines of the subject. The image will now appear very unsharp.

5. Refocus the lens for the best possible focus; large parts of the image will still remain out of focus.

6. Tilt and swing the lens until the plane of sharpest focus coincides with the principal plane of the subject, i.e., until you get the best possible overall sharpness. This is a delicate adjustment because only small changes from the neutral position of the lens are required. Refocus the lens while making the front adjustment, checking the sharpness of the image on the groundglass. Although this adjustment will not bring the entire depth of the subject into sharp focus, it will improve overall sharpness to a point where stopping down the diaphragm will be sufficient to provide a critically sharp picture of the entire box.

288

How to extend sharpness in depth

The second purpose of camera swings is to extend the sharply covered zone in depth *in oblique angle shots of relatively flat subjects* (and only these), for example, a floor (perhaps to show a rug) or the façade of a building. Any part of the subject that projects beyond this inclined plane (inclined in regard to the film plane) must, of course, be brought into sharp focus by stopping down the lens accordingly. However, even if stopping-down is necessary, the overall gain in sharpness achieved by using "swings" is so great that the entire depth of the subject can be rendered sharp with considerably less stopping-down than would otherwise be required.

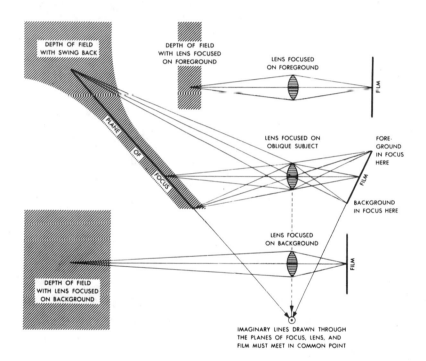

To achieve this desirable degree of overall sharpness, the position of the film in relation to the lens and the subject must be adjusted in such a way that closeby areas of the subject are sharply focused at the top part (or one side) of the groundglass (relatively great groundglass-to-lens distance) and distant areas of the subject are sharply focused at the bottom part (or the other side) of the

groundglass (relatively short groundglass-to-lens distance). This is most easily done by tilting (or laterally swinging) the back of the camera accordingly. The entire depth of the subject will appear sharp without the need for stopping down the lens if the camera back is tilted (or turned) in such a way that imagined lines drawn through the principal plane of the subject, the plane of the diaphragm, and the plane of the film (groundglass), meet in a common point.

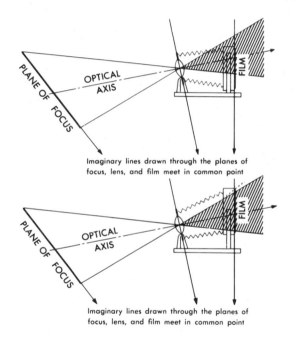

Imaginary lines drawn through the planes of
focus, lens, and film meet in common point

Imaginary lines drawn through the planes of
focus, lens, and film meet in common point

The same gain in sharpness in depth can also be achieved by tilting the lens forward instead of tilting the back of the camera backward. This method must be used when the camera back must be kept vertical to render vertical lines of the subject parallel (for example, furniture standing on a rug). However, tilting the lens throws its axis off the center of the groundglass and, if its covering power is insufficient, vignetting will result. (Vignetting manifests itself in images in which corners are cut off or, in more severe cases, in negatives that are partly blank.) Vignetting can usually be avoided by using the respective vertical sliding adjustment to lower the lens or raise the camera back until the lens axis is centered once more on the groundglass.

Foreshortening, diminution, convergence

The perspective of any photograph is determined by a combination of three factors: *The angle at which the subject is seen* determines the degree of foreshortening; *the focal length of the lens* and the *distance between subject and camera* determine the scale of rendition and the degree of diminution and convergence.

The angle at which the subject is seen. Photographed at an angle of 90 degrees to its principal plane, any subject will appear free from perspective distortion (for example, a circle will appear round). But the more acute the angle, the greater the degree of perspective distortion (a circle appears increasingly elliptical instead of round). The illusion of depth in a photograph is inseparable from distortion: the more nearly distortion-free a subject is rendered, the "flatter" it appears, the more it seems to lack "depth." For example, photographed head-on, a cube, undistorted, appears indistinguishable from a square—a two-dimensional subject—because only one of its sides is visible. Photographed at an angle, it acquires "depth" because two or three of its sides are simultaneously visible—its three-dimensionality becomes apparent. Its parallel edges would, of course, converge in the picture and be rendered "distorted." However, it is precisely this "distortion" that creates the illusion of three-dimensionality; distortion becomes a symbol of "depth." Accordingly, photographed in an oblique view and thus rendered distorted in elliptic form, even a two-dimensional subject such as a paper disk can appear three-dimensional: depth is implied by its oblique position, obliqueness distorts the circle into an ellipse, and distortion is proof of depth.

Focal length and subject distance. It is popularly thought that wide-angle and telephoto lenses produce "unnatural" perspectives because wide-angle lenses seem to distort the subject and exaggerate depth in the picture while telephoto lenses seem to compress space. However, these effects are not "faults" inherent in the respective lens designs but are caused by the way in which these lenses are used. All lenses—standard, wide-angle, and telephoto—*produce identical perspectives if they are used at the same working distance from the subject* as a simple experiment will prove:

From the same camera position, take three photographs of, for example, a monument against a background of buildings. Make one with a lens of standard focal length, one with a wide-angle lens, and one with a telephoto lens. Enlarge these negatives to the same size and compare the prints. The effect will, of course, be different in each of these photographs. In the wide-angle shot the monument will appear rather small and the foreground very prominent. In the telephoto

shot the monument will be rendered quite large and space appear "compressed." To prove that this is only an optical illusion, make two additional enlargements. Start by projecting the negative made with the telephoto lens onto the enlarger easel and, with a pencil, trace its principal outlines on a sheet of paper the size of the first prints. Replace the telephoto negative with the negative made with the standard lens and, using the tracing made from the telephoto negative as a guide, enlarge the corresponding section of the negative made with the standard lens to the exact scale of the print made from the telephoto negative. Finally, repeat this performance with the negative made with the wide-angle lens and enlarge its corresponding section to the exact scale of the print made from the telephoto negative.

Compare these two new prints with the print made previously of the telephoto negative: apart from slight differences in sharpness and grain due to differences in image magnification, the three will be identical in perspective, and if superimposed, they would register perfectly. The apparent differences among the first prints were not differences in perspective, but in angle of view and scale: the wide-angle shot encompassed a larger angle of view and showed the subject in a correspondingly smaller scale than the shot made with the standard lens, which in turn encompassed a larger angle of view rendered in smaller scale than the shot made with the telephoto lens. But in regard to perspective, the three were identical.

And now we come to the second and conclusive part of this experiment: take three additional photographs of the same monument with a standard, a wide-angle, and a telephoto lens, respectively. Begin with the telephoto shot because it determines the scale of the other pictures. Try to make the shot from a distance at which the monument will exactly fill the height of the negative. If this is impossible, make a mental note of the height of the monument in the viewfinder. The other two shots must be made from distances at which the height of the monument in the viewfinder is *the same as it was in the telephoto shot.* This, of course, means that the shot taken with the standard lens must be made from a shorter distance than the telephoto shot, and the wide-angle shot from a still shorter distance. Enlarge the three negatives to the same size and compare the prints. Although the size of the monument will be the same in each, their space-effects will be totally different. In the telephoto shot the distance between the monument and the background will appear very small; in the shot made with the standard lens, it will appear somewhat greater; and it will appear far greater

in the wide-angle shot. And this time this difference in perspective is real. It is not a matter of differences in scale which can be equalized through appropriate enlarging. It is a difference in the relative proportions of the various picture elements which enlarging cannot change.

This experiment shows that it is *not* the focal length of the lens, but *the distance between subject and camera* that determines the perspective of a picture, i.e., its space and depth effect, which in turn is determined by the relation of the picture components to one another in regard to diminution and scale. Accordingly, for example, the distortion in a portrait taken with a wide-angle lens is not the fault of the lens, but the photographer's wrong use of it: a subject-to-camera distance that was too short. Lenses of relatively *long* focal lengths are recommended for portraits, *not* because they produce less distortion than lenses of shorter focal lengths, but because they produce larger images and, consequently, they require a greater subject-to-camera distance, which in turn produces a better perspective. If a photographer made two portraits *from the same subject distance,* one with a wide-angle and one with a telephoto lens, *both would have exactly the same perspective.* The only difference between the two would be their image size. And if he would enlarge the wide-angle image to equal the scale of the picture made with the telephoto lens, the two portraits would, as far as perspective is concerned, be identical.

By selecting lenses of suitable focal lengths and appropriate subject-to-camera distances, a photographer can create whatever kind of perspective he desires. He can render space deep or shallow. He can preserve the natural proportions of his picture components or create emphasis through exaggeration. He can completely control the space effect of his picture.

How to give a picture scale

Although creating a feeling of depth and space in a photograph is usually not difficult, scale is often a problem. Beautiful views become uninteresting pictures. Subjects that were awe-inspiring—magnificent western landscapes, giant redwood trees—lose that quality in photographs because scale is missing.

Scale is comparison. By comparing a thing of unknown dimensions with one of known dimensions, we give the unknown thing scale and show how big or small it really is. If a treeless western landscape contains no indicator of scale, its size cannot be shown in a photograph. And without an indicator of scale, a redwood looks like many other trees of lesser size. Something of known dimen-

sions must be included in a photograph to indicate the actual size of unfamiliar subjects.

Many things of known dimensions can be used to give photographs scale. Heading the list is, of course, the human figure. For close-ups, a hand, and for extreme close-ups, fingertips, make excellent indicators of scale. In outdoor photographs people, automobiles, buildings and windows, telephone poles, cows and horses, boats and ships are good indicators of scale. For example, the small silhouette of a great liner seen against the horizon, will in contrast to its smallness make the sea appear immense. And seen from afar, the high buildings of a big city appear small in grayish haze that obscures their windows but they acquire scale and seem huge when their many windows are visible.

By controlling the apparent or actual size of his scale indicators, a photographer can control the scale of his pictures. If he wants something to look big, he must make his scale indicator appear small, and vice versa. For example, to make a landscape look big, the human figures chosen to give it scale must be rendered small by placing them far from the camera. And in an industrial photograph if a piece of machinery should look particularly large and impressive, to give his picture scale the photographer must select a *small* worker and place him at the far side of the machine to further decrease his apparent size through diminution.

Conversely, to make something appear small, the scale indicator must be large. For example, to emphasize the smallness of a new electronic device, the hand in which it is held must be the large hand of a big man instead of the small, delicate one of a girl.

Nonrectilinear perspective

Human vision is rectilinear and limited to a rather narrow angle of view, whereas certain birds and fishes have eyes that encompass a view of 300 degrees and more and the eyes of insects are so constructed that they produce images that must be totally different from anything we see.

Photographers also can create views very different in perspective from our own vision. The necessity for creating these arises when abnormally large angles of view must be included in a single picture. Cameras which are equipped with lenses that swing in a short arc and scan the scene during the exposure are used for this purpose (Panon, Widelux, etc.). They produce pictures that have cylindrical perspective, i.e., straight lines parallel to the sweep of the lens are rendered curved. And cameras equipped with so-called fisheye lenses that cover

p. 80
p. 316
p. 79

p. 316

an angle of view of 180 degrees produce pictures that have spherical perspective, i.e., all straight lines except those that are parallel to the optical axis are rendered curved. At first, such curving of actually straight lines appears totally unnatural, and it is difficult to "read" such renditions correctly. Actually, however, this curving is not only perfectly natural, but even inevitable when extremely large angles of view must be rendered in a single picture. To understand this, let's consider the following hypothetical problem:

Imagine that you have to take a head-on view of an enormously long, low building that stretches from horizon to horizon, encompassing an angle of view of some 180 degrees. Since you have no fisheye lens which covers 180 degrees, you decide to do the next best thing and make a composite picture of two separate views, each including an angle of 90 degrees. For the first picture you turn 45 degrees to the left and make a shot. Since now the subject is no longer parallel to the film, it will be rendered "in perspective," i.e., "distorted" insofar as the roof and base lines of the building will converge and eventually meet in a vanishing point on the left horizon. In the second picture which you shoot turned 45 degrees toward the right, the roof and base lines of the building will, of course, meet at the right. This convergence of actually parallel lines will seem normal until you join the two pictures together. Then you will find that the roof and base lines of the building, which were actually straight, form an obtuse angle in the center of the composite picture which did not exist in reality.

To avoid this angle, you might decide to make another composite picture of the building from *three* separate views. Make the central shot head-on: since then the building is parallel to the film, this section will be rendered undistorted, i.e., the roof and base lines will be rendered parallel. But the two other shots of the building, the one you take toward the left and the one you take toward the right, will, of course, be rendered "in perspective," roof and base lines converging. In the composite view you will now find instead of one, there are two breaks in the lines of base and roof.

There is, of course, a way of avoiding such breaks: you could take a very large number of pictures, each at a slightly different angle. Thus, by subdividing the view into a sufficiently large number of pictures, each break in the line of roof and base would be so small in the composite view that it would be unnoticeable, and the actually straight roof and base lines of the building would now appear in the form of two curves.

That these curves are "real," although the lines they represent are straight, be-

comes obvious when one reasons in this way: looking at the building head-on, it has a certain height. Looking toward the left, it seems to get lower and lower until finally the roof and base lines merge in a point on the horizon. The same happens in looking toward the right. Now, the only possible lines that can extend without a break from one point on the horizon to the top and base of the building in the center of the view, respectively, and from there to meet in a point on the other horizon, are curves. In other words, in views that encompass very large angles, straight lines must of necessity appear as curves. This is

p. 80 exactly what happens when one takes a photograph with a swing-lens-equipped camera which produces panoramic views that encompass an angle of view of 140 degrees.

Further consideration of this phenomenon leads to additional surprising conclusions:

To conform exactly to reality, the lines of the roof and the base of the building should have been rendered curved instead of straight even in the head-on view of our second experiment because they are sections of two great sweeping arcs that extend from horizon to horizon. Actually, this is the form in which such lines would have been rendered if the picture had been made with a simple uncorrected meniscus lens. The reason that ordinary photographic lenses render straight lines straight is that this is the way we see such lines, and such lenses are computed to duplicate this view. But strictly speaking, this form of rendition is not true.

And since the laws of perspective are not restricted to the rendition of horizontal lines but apply to *all* lines, vertical and oblique lines should also be rendered curved instead of straight. This is precisely the kind of rendition we get

pp. 79, with a fisheye lens which produces photographs in which perspective is spherical
316 and straight lines are rendered curved.

Normally, the eye is not aware of this curving of actually straight lines because within the narrow angle of our vision it is too small to be detected. But there is a way of seeing this curving in actuality: stand across from a narrow alley, hold a pencil horizontally at arm's length and measure the apparent distance between the alley walls at street level, then at roof level. The distance will be somewhat shorter at roof level—increasingly so the higher the buildings that make up the walls of the alley. Since the apparent distance between the building walls is narrower at the top than at the bottom, the verticals cannot be

296

parallel but must converge. However, if they were to converge in straight lines, the angles they form with the street would, of course, have to be smaller than 90 degrees. This is obviously not the case—each angle is 90 degrees. Hence, the only explanation is that the verticals rise from the street at an angle of 90 degrees and gradually curve inward. This is precisely how they would be rendered in a photograph made with a swing-lens camera with the lens scanning the subject vertically.

Cylindrical and spherical perspectives are new forms of rendition. Correctly used, they enable a photographer to show relationships between a subject and its surrounding space with greater clarity than was previously possible, and thus enable him to better depict certain aspects of our world.

Contrast between sharp and unsharp

The human eye can sharply perceive only those things located within the specific plane in depth upon which it is focused. Objects behind or in front of this plane of focus appear more or less indistinct. Look out the window: the view appears sharp. Then hold up your hand and look at it: you can see either your hand or the view sharply. In contrast to the one that appears sharp, the other appears indistinct—you can still see it, but not in detail. However, as the result of this juxtaposition of sharpness and blur, you experience a strong sensation of depth.

In a photograph this same sensation of depth can be evoked through juxtaposition of sharpness and unsharpness: by selectively focusing on a specific plane in depth and making the picture with a relatively large diaphragm aperture, a photographer can render this plane sharp and objects behind or in front of it unsharp—increasingly so the farther they are from the plane of focus. The sharply rendered zone will be the more limited in depth, the larger the diaphragm aperture, the longer the focal length of the lens, and the shorter the distance between subject and camera.

This technique of *selective focus* can be advantageously used for three specific purposes:

To draw attention to one specific part of the picture by rendering it sharp and the rest unsharp.

To symbolize depth. In a photograph juxtaposition of sharp and unsharp is proof of depth—a two-dimensional subject cannot simultaneously be rendered

sharp and unsharp unless, of course, it is photographed obliquely; but then it has acquired "depth."

To graphically separate subjects located at different distances from the camera. This is particularly desirable both in black-and-white photography when subject coloration, translated into shades of gray, would otherwise cause subject and background to merge and in color photography when subject and background colors are so similar that visual separation would be unsatisfactory without contrast between sharp and unsharp. By using selective focus a photographer can mute a background that is too prominent in detail or design. Rendered in unsharp form, the aggressiveness of such undesirable features is diffused into unaggressive blur.

p. 19

p. 297

Contrast between light and dark

Air is not a completely transparent medium. It contains varying amounts of impurities and droplets of water which form haze and impede the passage of light. The effect of haze is cumulative: the thicker the air mass which light must penetrate, the more it is scattered with the result that objects seen through large masses of air appear different than when seen close up. This phenomenon is called "aerial perspective." Since it is directly connected with distance, rendered in photographic form it is a symbol for depth.

Aerial perspective manifests itself in three ways: as distance from the observer increases,

> objects appear increasingly lighter,
> contrast decreases, and
> color appears increasingly distorted toward blue.

In black-and-white photography the effect of aerial perspective can be controlled either *through emphasis* to increase the feeling of depth in a picture or *through reduction* to render distant subjects more clearly than they appeared to the eye. The first approach is primarily used to strengthen a mood in a landscape photograph, the second to improve the clarity of rendition in long-distance and aerial photographs. The following controls are available:

Choice of color filter. Outdoors, as distance increases, color appears increasingly distorted toward blue. This bluish tone makes it possible to control the effect of aerial perspective with color filters. A blue filter intensifies, and yellow, orange, and red filters increasingly reduce, the haze effect of aerial perspec-

pp. 141-142

tive. Accordingly, in a comparison series shot through different color filters, the photograph made with the blue filter would produce the strongest, and the one made with the red filter, the weakest, impression of depth. In the blue-filtered shot the distant parts of the landscape would be lost in haze whereas in the red-filtered shot, unless the haze was exceptionally dense, they would be clearly visible.

Choice of film. When maximum haze penetration is desirable, a photographer should use infrared-sensitized film and the appropriate filter. In this way he pp. 119, 142 can produce pictures with good contrast and detail even of views that are more or less invisible to the eye. However, two things must be kept in mind: only haze (which is bluish) can be penetrated by infrared radiation; fog (which is whitish) cannot. And photographs taken on infrared film through a filter which absorbs all visible light render green foliage as white and water as black—an "unnatural" effect that may not always be acceptable.

In color photography, control of aerial perspective is limited to controlling the degree of bluishness of the distance, but contrast cannot be changed. In mild cases, particularly when photographing in high mountains and from the air, an ultraviolet-absorbing filter is often sufficient to reduce blue to an acceptable p. 142 level. Reddish or yellowish color compensating filters will partially or completely p. 141 eliminate the bluish tone of haze, but no amount of filtering can restore the actual colors of the subject. Under certain conditions, a polarizer can be used p. 143 to somewhat darken a pale blue sky near the horizon. Its effect can be checked visually.

MOTION

An important characteristic of many subjects is motion. To express motion in a photograph it must be rendered in symbolic form. pp. 98-101

The concept of motion is inseparable from space and time: motion is change in space, and a change takes time. If motion is very fast, the change takes place at a speed the eye cannot follow and the moving subject appears as a blur. And since blur can be rendered in a photograph, it is a symbol for motion.

A subject in motion can be photographed either sharp or blurred. Which rendition should be chosen depends upon the intentions of the photographer and the purpose of the picture. For example, two photographers take pictures of a boxing match. The first works with synchronized electronic flash, the second

299

takes candid shots by available light. The pictures of the first photographer show in razor-sharp detail things too fast to be clearly seen by the eye—the face distorted under the impact of the blow, the spray of sweat caused by the shock. The pictures of the second photographer are partly blurred because the light was too dim for shutter speeds high enough to stop fast motion. Which pictures are better?

Although the sharp photographs are "unnatural" in that they show things the eye could not actually see, they show what happened, and they unmistakably express motion.

The blurred pictures, precisely because they lack detail, graphically symbolize the drama of the fight as we would actually see it—the bobbing and weaving, the rapid shifts from advance to retreat, the flurries of feints and jabs—capturing the essence of motion through blur.

Neither set of pictures is better than the other, they are merely different. Which kind is preferable depends upon their purpose: whether they were taken to precisely show the style of the fighters or to capture the feeling of the fight. What is important is that, to graphically express motion, a photographer has a choice of different techniques to produce different results. To make the right choice he must consider the purpose of his picture which may be any one of the following:

The moving subject must be shown as clearly as possible. Motion must then be "arrested" in the picture, the subject "frozen" on the film in sharp rendition.

The fact that the subject is in motion must be expressed in the photograph. Motion must then be indicated in symbolic form.

Motion itself is the subject of the picture. Whether the tangible subject remains recognizable is unimportant, and movement can be symbolized with any means that will evoke the feeling of motion.

Degrees of motion

In regard to photographic rendition there are three degrees of motion:

Low speed. Motion is so slow that the moving subject can be seen as clearly as if it were at rest. In photographing such subjects, motion does not have to be indicated because it is not an important characteristic of such subjects.

300

Medium speed. Motion is so fast that the subject, although still clearly recognizable, appears at least partly blurred. In photographs of such subjects motion must usually be expressed in symbolic form because it is an important feature. Exception: photographs made for motion analysis which must, of course, be sharp.

High speed. Motion is so fast that the subject appears totally blurred and even becomes invisible. Since the majority of photographs dealing with this kind of motion are made for analytical purposes, sharpness of rendition is required. Besides, it is impossible to convey the feeling of ultra-fast motion with graphic means.

Proof of motion

Another consideration that influences the choice of "arresting" or symbolizing motion is whether or not proof of motion will be evident in a sharp rendition of the moving subject. Rendered in the form of a sharp image, an automobile traveling at high speed, for example, appears to be standing still. However, if a fast-moving automobile raises a big cloud of dust, even if the picture is completely sharp, motion is implied because the dust cloud is proof of motion. Similarly, the tack-sharp image of a horse above a hurdle implies motion. Still, although motion can be evident in a picture that is uniformly sharp, if the rendition were slightly blurred, "speed" would be emphasized and the blurred photograph would create a stronger impression of motion. This applies also to photographs of people. A sharp picture of a crowd at rush hour suggests motion through the positions of the swinging arms and legs. But if there were a slight degree of blur, the impression of motion would be intensified and instead of merely indicating movement the photograph would now suggest "rush."

Symbols of motion

Motion can be symbolized in a photograph in nine different ways:

"Freezing." The most significant moment of motion is selected and frozen on the film by one of two techniques:

High shutter speed. The picture is made with a shutter speed high enough to "stop" the subject's motion. If the light is too dim to allow for a sufficiently high shutter speed, flash can often be used. Determination of shutter speed is based upon three factors: the speed of the subject, its distance from the camera, and the direction of its motion in relation to the camera. The higher the subject's speed, the nearer it is, and the more nearly at right angle it moves relative to the optical

axis, the higher the shutter speed must be to produce a sharp picture of the moving subject. The following table indicates approximate shutter speeds for "stopping" different kinds of motion.

	Approximate distance between subject and camera	Motion is toward or away from camera	Motion is at 45-degree angle to optical axis	Motion is at 90-degree angle to optical axis
Slow moving subjects, people, slow traffic, animals, at 5-15 mph.	15 feet	1/200	1/300	1/400
	25 feet	1/100	1/200	1/300
	50 feet	1/50	1/100	1/200
Fast moving subjects, sports events, fast traffic, 15 mph. and up	25 feet	1/300	1/400	1/500
	50 feet	1/200	1/300	1/400
	100 feet	1/100	1/200	1/300

Note: The shutter speeds recommended above are approximations only. In practice, it makes very little difference whether the shutter is set at, for example, 1/50 or 1/60 sec., 1/100 or 1/125 sec., mainly because the actual shutter speeds rarely correspond exactly to the speeds engraved on the shutter speed dial.

p. 151 **Speedlight.** If the moving subject is photographed in speedlight illumination, it is the effective duration of the electronic flash that determines the exposure time (if a flashbulb is used, shutter speed determines the exposure time). The fact that most focal plane shutters can be synchronized for electronic flash only at rather slow speeds may create a problem—if the existing light is relatively bright and subject motion fast, the shutter speed may not be high enough to assure that the image created by the existing light will also be sharp. If it is not, a faint, blurred "ghost image" will be superimposed upon the sharp, speedlight-produced image of the subject. There is no way to avoid this.

pp. 98-99 **Panning.** This is another technique for rendering a subject in motion sharp. In principle it is like the technique of shooting a flying bird with a gun: the image of the moving subject is centered in the viewfinder, held stationary by following through with the camera, and the shutter released during the swing. As a result the image of the moving subject appears sharp and the background blurred. This technique is particularly effective if subject motion is uniform and more or less at a right angle to the optical axis. Shutter speeds of 1/5 to 1/25 sec. often produce the best results.

Blur. Effective motion symbolization through blur depends upon timing: the shutter speed must be slow enough to produce blur, yet not so slow that excessive blur makes the moving subject unrecognizable. Accordingly, shutter speeds must vary with the speed of the subject, its distance, and the direction of its motion in relation to the camera.

As well as providing proof of motion, blur also indicates a subject's speed: the more pronounced the blur, i.e., the relatively slower the shutter speed, the higher the *apparent* speed (regardless of the *actual* speed). The contrast between blur and sharpness will be most effective, if stationary subject matter is rendered perfectly sharp in the picture. Accordingly, if shutter speeds that are too slow to be safely hand-held must be used, to avoid blur caused by camera movement, the camera must be steadied by being pressed against a solid object or mounted on a tripod.

Motion graphs. This is a special technique of limited application for symbolizing motion through blur. Because it requires long exposures, the camera must be mounted on a tripod or otherwise firmly supported. The moving subject must be considerably lighter in tone or color than the background against which it is photographed because, if it were darker, the lighter background would "burn out" the image of the moving subject. The basis of this technique is a time exposure: the camera is set up and focused; the shutter is opened and remains open while the subject moves across the field of view of the lens, then it is closed. Well-known examples of photographs made by this technique are views of the night sky showing the tracks of the stars, pictures of lightning, and photographs of traffic at night in which headlights and tail lights of cars create a linear design: in this kind of rendition which fulfills its purpose through association, the moving subject itself is usually invisible and only its motion is shown in the form of a graph; but because we know that the graph was made by, for example, automobile lights, we sense the flow of traffic although no automobiles can be seen.

Combination time and flash exposure. With this technique a photographer p. 100 can superimpose a *sharp picture* of a moving subject on a *graph of its motion.* In very subdued light a motion graph of the moving subject is made against a very dark background. At a significant moment (perhaps at the peak of a leap or when the subject is within the central part of the picture), an electronic flash is fired at the subject and a sharp image is superimposed on the subject's track. The shutter, of course, remains open before, during, and after the flash, and it is not

303

closed until the subject is outside the field of view of the lens. The resulting picture is a graph of motion with the moving subject itself shown at one point in sharply rendered form. If circumstances and the nature of the subject permit, flashlight bulbs operated by small batteries can be attached to the subject (for example, the hands and feet of a dancer) to better trace its motion.

Picture sequence. The subject's motion is subdivided into a number of phases, each recorded in a separate photograph. This technique is particularly good for recording relatively *slow* motion or *gradual* changes such as the emergence of a piece of pottery from a lump of clay or the progress of a building under construction. But it is also suitable for rendering gestures and expressions of a speaker, children playing, or the changes in the appearance of a landscape with time of day or seasons. For sequence shots of rapid events, the use of a motorized camera is advisable and may even be necessary. Some 35-mm cameras can be equipped with spring-driven or battery-operated auxiliary motors which automatically advance the film and cock the shutter at a rate of up to five frames per second. For higher rates, special cameras are available. For best results, the camera position must be the same for all pictures of the sequence, so that the subject's changes can be evaluated in reference to the unchanging background.

Multiple exposure. Instead of recording selected phases of a motion in separate pp. 102-103 photographs, they can be recorded in a single negative by multiple exposure. This technique can be used successfully only if the subject in motion is light in tone or color and the background against which it is shown is dark. If subject motion is relatively slow, exposures can be timed manually with the shutter. If motion is p. 89 fast, repetitive (stroboscopic) electronic flash equipment must be used. In either case the camera must be firmly supported and its position must remain the same for all exposures. Care must be taken that the light used to illuminate the subject does not strike the background, otherwise the image of the subject might be "burned out."

Multiple printing. Instead of recording different phases of a motion on the same piece of film, they can be photographed individually and the negatives subsequently combined during enlarging. This technique, which is suitable only if the number of motion phases which must be shown does not exceed four or five, has two advantages: if a phase of the motion is rendered unsatisfactorily, it does not necessarily spoil the entire sequence and if the sequence was shot against a neutral background, the phases of motion recorded in the individual negatives can be combined during enlarging to form the most effective pattern.

Multiple prints can be made in two different ways: the negatives can either be placed together and enlarged in the form of a "sandwich" or each one can be printed separately on the same sheet of paper, the space reserved for each image protected from inadvertent exposure by masking.

Composition. Unless motion is random and chaotic in character, as when cattle mill around in a pen, it has direction. By emphasizing the direction of motion through a dynamic arrangement of the picture components, a photographer can suggest motion by composition.

In contrast to a static composition which is characterized by a framework of horizontal and vertical picture elements within which the subject is more or less centered, a dynamic composition is created by tilting lines and eccentric arrangements. Often merely by rendering the moving subject in slightly tilted form a feeling of motion is suggested, whereas the same subject, untilted, would appear at rest. Also if the subject proper is crowded into a corner of the picture, a feeling of motion results, whereas the same subject, centrally positioned, would appear motionless. If the image of a runner is placed in the middle of a photograph, it doesn't suggest as strong a feeling of motion as it does if it is placed near the edge of the picture. If it is placed near the edge from which the motion started, the runner seems to have a long way to go; if it is placed near the edge toward which he runs, he seems to be at the finish line. Through such placement of the pp. 92-93 subject the feeling of motion is intensified.

FILM GRAIN

Like unsharpness and halation, graininess is normally and rightly considered a fault in a photograph. However, coarse grain can sometimes be the most effective means for symbolizing certain intangible subject qualities. p. 18

When coarseness is a typical subject quality, a grainy rendition is highly effective. pp. 104, 126 This is illustrated by innumerable war photographs and other pictures of violence in which coarse film grain emphasizes the coarseness of the event and gives a photograph the stamp of harsh reality. If such pictures had been smooth and grainless they might have appeared staged rather than real.

Another useful quality of film grain is its diffusive effect—a grainy picture shows less detail than one that is grainless. When mood is important, a grainy photo- p. 40 graph will more likely express it than a grainless picture. Film grain suggests at-

mosphere and haze, dust, dirt, and smoke. In pictures of smoke-filled interiors —convention and hiring halls, cafes, bars, arenas—and in backlighted shots with shafts of light slanting through misty air, film grain can create such effects and express the mood of such subjects.

In color photography a grainy picture can sometimes have somewhat the effect of an impressionist painting—reality is reduced to its essentials in terms of color, space, and light. Admitted, this is difficult to achieve because control is limited, and as a result, much of what is attempted will end in failure. Nevertheless, I have occasionally seen color photographs of exceptional beauty whose particular effectiveness was dependent upon grain.

pp. 126, 129 To deliberately increase the size of the film grain, a photographer must begin by using a grainy film. In the print grain will appear increasingly prominent, the smaller the negative or the section of the negative used, the higher the degree of enlargement, and the more contrasty the paper. In black-and-white photography p. 187 graininess can be further increased by developing the film in a high-contrast developer.

TIMING

Timing is one of the most important photographic controls. Its purpose is to capture what Cartier-Bresson calls "the decisive moment"—the peak of an event, the most significant expression or gesture, the moment when all the picture components form a perfect composition.

Correct timing demands the ability to concentrate on an event so that the significant moment will be captured. Anticipation of such moments and preparation for them is necessary. In sports photography, for example, action is often so fast that by the time a photographer sees a good picture it is too late to shoot it. To capture such events he must release the shutter a fraction of a second *before* the climax is reached to allow for the unavoidable time-lag between the action and the exposure caused by his own reaction time and the mechanical inertia inherent in his equipment.

An effective way to be sure to capture the significant moment of an event is to take a large number of pictures. Amateurs often misunderstand this, complaining that if they took as many pictures as most professionals they would also have occasional "hits." This is not the point. Such shooting is not done indiscriminately. Each of these shots is carefully timed and taken as possibly the final climactic

picture. But then another more significant moment occurs, invalidating the previous photograph, and then another, and another. A professional photographer cannot afford to miss a good shot, and most successful photo-journalists take many pictures for this reason.

Timing is necessary in regard to three main aspects that affect a photograph's impression:

The psychological moment—the moment of greatest significance—must be captured. This is usually not difficult if the moment is spectacular—Khrushchev pounding the desk with his shoe, Oswald killed by Ruby. But then, many poignant moments are *not* spectacular—the abandoned Chinese baby sitting forlorn at the railroad station, the Frenchman crying at the defeat of France. To capture moments like these requires timing and a special kind of attention.

The moment of the most effective composition must be captured. We live in a world of motion. Not only do our subjects move, but in photographing them we move in relation to them, observing them in constantly changing views: with every move of theirs, every step of ours, the physical aspects of our picture change, apparent subject size increases or diminishes, foreshortening varies, the relationship of all the picture components, overlappings, and juxtapositions, constantly change. To recognize the moment when all the picture components fall into place to form a striking graphic design and to capture this moment is timing.

The moment when atmospheric conditions are just right must be captured. To appear effective or convey a particular mood in a picture, many subjects need to be photographed in a particular kind of light or weather. For outdoor portraits, for example, light from a hazy or overcast sky gives better results than direct sunlight. A moody subject should be photographed in a moody light. The feeling a slum creates is destroyed if it is photographed in sunshine. A shadow may fall in the wrong direction in the morning but in the right direction in the afternoon. The textured wall of a building may look dull all day except for fifteen minutes when sunlight strikes it at just the right angle. With frost in the air, the geysers in Yellowstone National Park appear fabulous with their enormous shrouds of steam whereas on hot days they do not because it is too warm for large amounts of steam to condense. Hundreds of examples could be cited to prove the importance that timing in relation to light and weather has upon the effectiveness of a photograph. To realize this importance, to have the patience to wait for better conditions, to reject the unsuitable moment rather than make a second-rate picture—that, too, is timing.

PART 8

Scope and Limitations

The scope of modern photography is so vast that an entire library would be needed to explore it thoroughly. Although it is true that many fields are of interest only to specialists who have access to specialized equipment, it is equally true that with very little additional expenditure in time, energy, and equipment any photographer can greatly broaden the scope of his own work. The one indispensable requirement is interest—the wish to leave the beaten track and start out on his own, to see his camera as an instrument for exploration, and through its imaginative use to create pictures from his own way of seeing and reacting to things.

However, the fact that photography can do so many things contains the danger of misuse. Tempted by the ease with which the camera will produce unusual forms of rendition, photographers frequently use a new form for its novelty rather than as a true means of expression. In my opinion the curse of present-day photography is the "gimmick." Photo-magazines in particular have been guilty of promoting the gimmick by indiscriminately printing any picture that is novel, whether its novelty is justified by an aesthetic, intellectual, or emotional gain. Specifically, the kind of photographs I consider not only valueless, but actually harmful to the development of photography are all forms of crude and vulgar distortions, shots made through different kinds of transparent material merely to produce novel images, multiple images, usually made by prisms or diffraction gratings placed in front of the lens, that uninterestingly repeat the same image a number of times, and the meaningless combinations of strong color produced by gelatins in front of photo-lamps. Less vulgar, though equally meaningless, are the turning of blue skies into black skies by using a red filter when none is called for and the use of extreme wide-angle lenses merely to produce "interesting distortions."

Needless to say, when in the following I give suggestions to the reader for expanding the scope of his work, I have none of these things in mind.

308

CLOSE-UP AND PHOTOMACROGRAPHY

The requirements for successful close-up and photomacrography * differ from those of ordinary photography in the following respects:

The camera. It should provide for parallax-free through-the-lens focusing. Rangefinder 35-mm cameras which permit interchangeability of lenses can be used for close-up and photomacrography by equipping them with a reflex housing. All twin-lens reflex cameras except the Mamiyaflex are unsuitable for extreme close-up photography. Although the Mamiyaflex provides sufficient bellows extension for close-ups of *static* subjects, it must be used on a tripod with an auxiliary parallax compensator—the Paramender—which, after the camera has been focused through the finder lens, permits raising the taking lens to the exact position previously occupied by the finder lens.

If photographs in near-natural, natural, or more than natural size are planned, the camera should provide for back-focusing. Front-focusing—moving the lens back and forth while the camera back remains stationary—also changes the distance between the subject and the lens. Front-focusing can be used if the lens-to-subject distance is more than approximately five times the focal length of the lens. However, if the lens-to-subject distance is shorter, changing *both* the lens-to-subject distance and the lens-to-film distance *simultaneously* makes it impossible to achieve sharp focus. But if back-focusing is used, the distance between the subject and the lens remains the same: only *one* distance is then changed, and sharp focus can be achieved. Thirty-five-mm and 120-size cameras which have no back-focusing should be used with auxiliary bellows which provide back-focusing. If back-focusing is impossible the only way to achieve sharp focus when lens-to-subject distance is less than approximately five times the focal length of the lens is to first achieve "coarse focus" by focusing the lens as well as possible, then leaving the lens in this position while achieving "fine focus" by moving the entire

* A photograph made at close subject distance (image to subject size ratio 1:20 to 1:1) is called a "close-up." A photograph in which the subject is rendered in natural or larger than natural size on the film (image to subject size ratio 1:1 to 20:1) is called a "photomacrograph." If a picture is taken through a microscope (image to subject size ratio approximately 20:1 to 1,000:1), it is called a "photomicrograph." And a microphotograph is a rendition in greatly *reduced* scale, usually of a document, a printed page, or a technical drawing, commonly made on small-size film.

camera forward or back accordingly. An alternative method is to leave the camera stationary and move the subject back and forth until the image appears sharp.

Extension between lens and film must be sufficient to produce the desired image size. Large cameras should have double or triple bellows extension. Small cameras which permit interchangeability of lenses can be equipped with auxiliary bellows or extension tubes.

The required extension between lens and film depends upon the focal length of the lens and the desired image magnification. A lens of short focal length requires correspondingly less bellows extension to produce a given image magnification than a lens of longer focal length. For example, to render a subject in natural size on the film, an 80-mm lens requires a distance of approximately 160 mm from lens to film whereas a 50-mm lens requires only approximately 100 mm. The greater the image magnification in the negative, the longer the extension and

pp. 87-88

the higher the exposure factor by which the exposure as indicated by an exposure meter must be multiplied if underexposure is to be avoided; see the following table.

Image magnification in the negative	½×	Nat'l. size	1½×	2×	3×	4×	5×	6×	7×	10×
Distance between lens and film in multiples of focal length of the lens	1½	2	2½	3	4	5	6	7	8	11
Multiply the exposure by the following factor	2¼	4	6¼	9	16	25	36	49	64	120

The lens. Unless demands in regard to technical quality are unusually high, any lens satisfactory for ordinary photography will also be satisfactory for making close-up and photomacrographs. However, for best results, lenses of *asymmetrical* construction (and this includes almost all *modern* lenses) *must be reversed in their mounts* when used to make photographs in more than natural size. The reason for this is that ordinary lenses are computed to give best definition when the front of the lens faces whichever is *larger,* the subject or its image on the film. In photomacrography the image on the film is larger than the subject, and consequently, for sharpest rendition, the lens must be reversed so that its front faces the film. For this purpose special reverse adapters are available for 35-mm cameras. If lenses of symmetrical construction or specially computed close-up (true micro or macro) lenses are used, reversal is, of course, not necessary. Such lenses are par-

310

ticularly recommended for larger cameras where lens-reversal poses severe mechanical problems.

The difference between true and pseudo-micro or macro lenses is that the true ones (Luminar, Micro Nikkor, Micro Tessar) are especially computed for sharpest rendition at near distances and in more than natural size, whereas the pseudo-micro and macro lenses (Macro-Kilar etc.) are ordinary lenses mounted in special close-up mounts that permit the photographer to work at subject distances of 2 to 4 inches without the need for auxiliary bellows or extension tubes.

The focal length of the lens. Although lenses of shorter focal lengths produce images in larger scale (higher magnification) at a given extension than lenses of longer focal lengths, they have the disadvantage that the distance between lens and subject becomes impractically short when rendition approaches natural size on the film. If this is the case, perspective will appear exaggerated, illuminating the subject satisfactorily will become increasingly difficult if not impossible, and if live subjects such as insects have to be photographed, the closeness of the lens will drive the subject away. Accordingly, in close-up and photomacrography, contrary to popular belief, the best lens is the lens with the longest focal length that can be used. p. 82

Many high-speed lenses are subject to focus-shift: if the image appears sharp when the diaphragm is wide-open, stopping-down will throw the image out of focus, if only slightly. Accordingly, such lenses should always be focused partly stopped down; for example, an f/2.8 lens should be focused at f/8. p. 162

Exposing. As previously explained, the effective f-stop value decreases with increases in the distance between lens and film, making it necessary to increase the exposure in close-up and photomacrography. How the necessary increases can be computed was also explained before. There are a number of devices that simplify this operation. Some auxiliary bellows have exposure factors engraved on their tracks. The Ansco Exposure Calculator and Proportion Guide, and the Kodak Effective Aperture Computer, are handy, inexpensive dial calculators. The Sinar Six exposure meter enables large-camera photographers to take accurate close-up readings directly at the groundglass plane, and many 35 mm single-lens reflex cameras have built-in exposure meters which, because they measure through the lens, give readings which already make allowance for the close-up factor. pp. 87-88

Another way to provide a basis for a close-up exposure is to establish the *effective* value of the diaphragm stop to be used. This can be done by using the following formula:

311

$$\text{effective f-stop value equals} \quad \frac{\text{indicated f-value} \times \text{diaphragm-to-film distance}}{\text{focal length of the lens}}$$

For example: if the indicated f-value is 8, the diaphragm-to-film distance is 4 inches, and the focal length of the lens is 2 inches, the corresponding equation would be

$$\frac{8 \times 4}{2} \text{ equals } \frac{32}{2} \text{ equals } 16$$

i.e., the *effective* f-stop value would be 16 instead of 8, which is equivalent to an exposure factor of 4. Accordingly, a photographer can either use the meter reading that applies to an f-stop value of 16 or he can arrive at the correct exposure by multiplying the meter reading which applies to f/8 by a factor of 4.

Reciprocity failure. In making photomacrographs that involve considerable degrees of image magnification, the necessary exposure increases may prolong the exposure to a point where reciprocity failure becomes a problem. The possible pp. 173-174 consequences and remedies have already been discussed.

Illumination. When distance between subject and lens is very short, effective lighting becomes difficult if not impossible. The problem is how to prevent the lens or the front of the extension bellows from casting a shadow on the subject. There are two ways:

1. The subject is illuminated with a ring light. This is a doughnut-shaped electronic flash tube that attaches to the front of the lens; the picture is taken through the central aperture of the ring light. Illumination is, of course, completely shadowless and thus more suitable to color than to black-and-white photography. If the light is too powerful, its effective intensity can be reduced by placing a neutral density filter in front of the lens.

2. The picture is made with a lens of relatively long focal length. Sufficient extension is provided by combining bellows and extension tubes. In this way the distance between subject and lens is increased while the desired degree of magnification is maintained. The subject can now be illuminated without the lens or the front of the extension bellows casting a shadow on it or otherwise interfering with the placement of the lights.

312

TELEPHOTOGRAPHY

Telephotography is close-up photography at a distance. The problems differ from those of ordinary photography in the following respects:

Camera movement. The magnifying power of a telephoto lens magnifies not only the image, but also the effects of undesirable factors such as filter inadequacies, air turbulence, and camera movement. Therefore, the longer the focal length of the lens, the more important it is to steady the camera to avoid unsharpness caused by accidental movement. There are several ways to do this:

1. When shooting hand-held telephotographs, use the fastest possible shutter speed (1/100 sec. being the slowest) even if this means limiting the depth of field.

2. Improvise additional support for the lens during the exposure. This can be done by resting its barrel on a wall, a window sill, the hood of an automobile, etc., or by pressing it tightly against a rigid object such as the side of a building, a tree, a lamp post, and so forth. If in addition the photographer braces himself by standing with feet apart and elbows tightly drawn against his ribs, and presses the back of the camera firmly against his forehead and cheek, exposures down to 1/10 sec. can often be hand-held without accidentally moving the camera. If additional support is not available, using the camera mounted on a chestpod or a gunstock is preferable to holding it in the ordinary way, especially if the photographer can also press his shoulder or back against a rigid object.

3. Use a tripod, but use it correctly. Most photographers believe that a heavy, rigid tripod is a guarantee against camera movement. This is not true. Regardless p. 145 of the rigidity of the tripod, any camera equipped with a long and heavy telephoto lens is subject to vibration, whether it is supported at its center of gravity or not. This can easily be checked by mounting the telephoto rig on a sturdy tripod and watching the groundglass image while gently tapping the front end of the lens: no matter how heavy the tripod and how light the tap, the image will tremble. A good way to avoid such vibration is to mount the camera itself on a rigid tripod and give additional support to the front end of the telephoto lens. I have found an ordinary collapsible light-stand excellent for this purpose. The best way of preventing accidental camera or lens movement is, of course, to mount the telephoto outfit on a *Pentapod,* the five-legged "tripod" which I described in my book *Total Picture Control.*

Low subject contrast. In photographs taken at great subject-to-camera distances, contrast is often undesirably low because of haze (aerial perspective). How p. 298

pp. 281-282 such undesirably low contrast can be increased has been discussed before.

Blue overall color cast. The blue overall tone seen in so many color tele-photographs is produced by atmospheric haze. Although it can be eliminated by p. 138 the right light-balancing filter, the actual colors of the distant subject cannot be restored in the color photograph. Accordingly, telephotography in color is often a disappointing experience because the result is likely to be a monochrome.

Turbulent air. The bane of the telephotographer, whether he works in black and white or color, is air turbulence caused by heat. This phenomenon can easily be seen by looking across the steel top of an automobile standing in the sun: the heat rising from the hot metal in waves causes the background to wobble and appear now sharp, now blurred. In ordinary photographs the effect of air tur-bulence is usually too small to be noticeable. But the magnifying power of the long-focus lens also magnifies the effects of air turbulence which makes it impos-sible under certain conditions to get sharp telephotographs. Air turbulence strong enough to cause blur is visible on the groundglass: parts of the image wobble, or the image appears partly or uniformly unsharp only to suddenly snap into sharp focus for a moment. This is the moment to quickly release the shutter.

WIDE-ANGLE PHOTOGRAPHY

No lens is as difficult to use successfully as a wide-angle lens, and disappointment can only be avoided if a photographer is familiar with its characteristics; in par-ticular, he must know the following.

Reduced image size is the price that must be paid for increased angle of view. Obviously, the only way to render a larger subject area in a negative without increasing the distance between subject and camera is to show everything in smaller scale. If this scale is too small, the photographer can either enlarge the picture so that detail will appear sufficiently large in the print; or, if a narrower angle of view is acceptable, he can make the shot with a lens of longer focal length. *But the one thing he must not do in an effort to increase his subject's scale in the negative is to go closer.* Because, although the subject would be rendered in larger size, not only would the subject area shown be reduced again, but per-spective would also appear "exaggerated" as a result of the shorter distance between subject and lens. In other words, the photographer gains nothing by going closer: less of the subject is included, and what is, appears in "distorted" form. This should be kept in mind by those photographers who use a moderate wide-angle lens for work normally done with a lens of standard focal length.

Extended sharpness in depth. As mentioned before, the shorter the focal p. 164 length of a lens, the greater the extent of the sharply covered zone in depth at a given diaphragm stop, provided that the subject-to-camera distance is the same. This fact gives wide-angle lenses an advantage over standard and long-focus lenses if overall sharpness is desirable. But extended sharpness in depth is not desirable when sharply rendered background matter interferes with the subject. This is particularly often true of "grab-shots"—candid pictures of people in the street—for which moderate wide-angle lenses nowadays are so often used. When the people and the background appear equally sharp, confusion results from the pp. 19-20 merger of important and unimportant picture elements and the feeling of depth is lost.

Wide-angle perspective. This phenomenon is characterized by an apparent exaggeration in size between near and far subject matter. Well-known examples of this are hands and feet extended toward the camera which are rendered unproportionally large while the head and body appear unproportionally small. This effect becomes increasingly pronounced, the wider the angle of view of the lens, the shorter the distance between the subject and the camera, and the greater the subject's depth. Accordingly, a photographer can reduce the effect of "wide-angle perspective" by reducing his subject's depth (for example, pose a person so that hands and feet are at the same distance from the camera as the face). Conversely, he can use this effect creatively to express extreme proximity.

That this phenomenon "wide-angle perspective" is the result of the way in which a wide-angle lens is used and not a "fault" of this kind of lens is shown by the fact that when the subject's depth is negligible, distortion does not occur. For example, if a shot of a test chart (which has no depth) is made with a wide-angle lens, it will show no distortion whatever and will be identical to a shot made with a standard lens.

Another often disturbing manifestation of wide-angle perspective is the "exaggerated" angle at which verticals appear to converge in shots made with the camera tilted. This is caused by the wider than normal angle of view encompassed by wide-angle lenses. This can easily be seen if one looks only at the central portion of such a wide-angle shot, that portion which corresponds to the angle of view encompassed by a standard lens used from the same camera position; within this part of the picture convergence is moderate. It is only toward the edges of the picture that the angle of convergence becomes "exaggerated." If such convergence is to be avoided, the camera must be held level. Since this operation

315

becomes increasingly critical the wider the angle of view encompassed by the lens, special wide-angle cameras are equipped with a built-in level. If holding the camera level would cause the top of a tall building to be cut off in the picture (and a swing-equipped camera is not available), the shot can sometimes be made with the camera held level *if a lens with a still wider angle of view is used*. In such a photograph the building will, of course, appear near the upper edge of the picture while the rest is filled with foreground. But at least the verticals will be rendered parallel, and enlarging the upper section of the negative will produce a satisfactory print.

True wide-angle distortion can be seen in group pictures of people made with an extreme wide-angle lens: the heads of the people close to the picture margins appear egg-shaped. This effect is the inevitable result of projecting a three-dimensional form upon a flat surface at an acute angle. If an extreme wide-angle lens must be used, the only way to avoid this phenomenon is to avoid placing subjects with distinctive shapes (and particularly people, faces, or heads) close to the edges of the picture.

RENDITIONS IN CYLINDRICAL AND SPHERICAL PERSPECTIVES

p. 294 These forms of perspective, which have been discussed before, appear strange only if the observer does not know how to "read" them correctly. To understand the cylindrical perspective of a photograph made with a swing-lens equipped p. 80 "panoramic" camera, the print should be held as close as possible while the observer scans the picture from left to right (as the lens scanned the film during the exposure), at the same time remembering *why* actually straight horizontal lines pp. 295-297 *must* curve in this kind of rendition (this was explained before). Thus, he will be able to "see himself into the picture," feel the unusual expanse recorded in such extreme wide-angle views, and realize the necessity for the "double perspective" —the converging of actually parallel lines toward *two* vanishing points, one at the left, one at the right.

p. 79 The spherical perspective of a photograph taken with a fisheye lens must also be intellectually understood before it can be emotionally accepted. For example, in photographs made with a fisheye lens pointing straight up, the horizon encircles the picture. In this kind of rendition which encompasses an angle of view of 180 degrees, the bottom part of the picture shows subject matter right-side up and the top part shows it upside down, while to the left and right, it appears to be lying on its side. There are two ways to "read" this form of perspective: the ob-

server can either hold the photograph horizontally above his head and look up at it, which would give him an impression essentially like that which he would get if he were taking in the actual scene while lying on his back. Or he can rotate the print slowly while looking at only its bottom sector, studying one part of the picture at a time. In doing either he must remember that the photograph shows an angle of view of 180 degrees—one-half of the visible world. And as he cannot take in an angle of 180 degrees at a single glance in actuality, so he must not expect to encompass it in a photograph at a single glance.

To get a preview of how a scene would appear if rendered in spherical perspective, a photographer can study its reflection in a mirrored sphere—a Christmas tree decoration or a garden ornament. The perspective he would see reflected in the sphere would be identical to that produced by a fisheye lens if the camera occupied the position of the sphere.

HIGH-SPEED PHOTOGRAPHY

The advent of the small, light, relatively inexpensive electronic flash unit has made p. 151 high-speed photography available to every photographer. However, only a few seem to realize that a speedlight is more than a glorified flash and that its potential use is far greater.

That high-speed photography need not involve expensive, complex auxiliary equipment has been proved by high-speed photographs of humming birds, dancers, falling drops, and pictures of shattering chinaware, etc., made by nonprofessional photographers using amateur equipment. Although interest in this kind of photography may be rare, those interested now have the means to investigate the phenomena of high-speed motion. If they can build simple timers that will automatically fire the flash at the appropriate moment, they can enormously broaden their field of activity. The principles according to which such timers work are either mechanical (for example, immediately before it hits the target, a bullet breaks a wire connection that sets off the flash), optical (the moving object interrupts a beam of light which triggers the flash through a photo-cell), or acoustical (a microphone activated by the crack made by a golf club hitting the ball effects the release). Information on how to build such timers can be found by consulting the pertinent literature.

UNSHARPNESS

To people with normal vision unsharpness is unfamiliar; they know what it is but

they do not experience it. Therefore, in photography, unsharpness provides a new form of seeing worth exploring. It suggests softness, femininity, and dreamlike qualities and moods.

p. 112
p. 303 That unsharpness is not necessarily a fault is borne out by the fact that photographers use soft-focus lenses and devices to deliberately reduce the sharpness of their pictures. Blur also is a form of unsharpness—directional unsharpness in which the direction of the blur shows the direction of the motion that caused it.

p. 233 A moderate degree of unsharpness softens the effect of a photograph and obliterates fine detail (this is desirable in a certain type of portrait). Unsharpness also lowers contrast and it can sometimes be used to unify a composition through uniform treatment of all the picture components. The more pronounced unsharpness is, the more it obscures the subject, and beyond a certain point it creates increasingly unrealistic and abstract effects. When the subject of a picture is less important than feeling and mood, unsharpness can be a valid means of expression. It is difficult to use successfully, and its possibilities have not yet been fully explored.

MULTIPLE IMAGES

p. 304 The creative potential of multiple images is virtually unlimited. Besides the use of multiple images to symbolize motion which has been discussed, different subjects can be combined in one picture to express a feeling or an idea. Often such combinations can create a more powerful effect than that created by the individual picture components seen separately. The master in this field of creative photography is H. Hajek-Halke whose book, *Experimentelle Fotografie* (Athenäum-Verlag, Bonn, Germany, 1955), is recommended to anyone interested in this kind of work.

Two or more normal negatives can be combined to make one print. This can be done either by using the negatives in the form of a "sandwich," or by enlarging each negative separately (perhaps to different degrees of magnification) on the same sheet of paper, or by printing a section of each negative while masking the space reserved for the others.

Normal photographs and photograms can be combined. For example, a piece of lace, a few feathers, some pressed flowers, etc., can be placed in direct contact with the sensitized paper before making the enlargement of the normal negative; such objects would appear in *white silhouette* superimposed upon the image of

the subject. If a *black silhouette* is wanted, the objects must be contact-printed or enlarged onto a sheet of film and the resulting negative must subsequently be printed or enlarged onto the print made from the normal negative. If instead of a pure white or black silhouette a more subtle effect is desired, the photogram can be solarized before it is superimposed upon the normal picture. It is also possible p. 320 to make a diapositive from a solarized photogram, to solarize the diapositive, and to superimpose it upon the normal picture to create a still more sophisticated effect. And if a diapositive were made from this double-solarization, a negative effect would be produced which would create yet another impression.

NEGATIVE PHOTOGRAPHS

Photography provides the only simple means for accurate reversion of tone values from positive into negative form. This applies not only to black and white but also to color, for colors can just as easily be changed into their complementary p. 135 counterparts—blue, for example, rendered as yellow, or red as cyan (blue-green).

A photographic negative is normally used only as an intermediary step in the making of a positive print. However, the possibility of making negative prints provides an aspect of photography that is well worth exploring to creative photographers in search of new forms of expression.

Negative prints have several unique properties. They are unusual and thus automatically attract the observer's attention. In negative prints shadow detail has a greater clarity than in positive prints, creating the effect of an illumination that appears to emanate from within the subject itself. And negative prints accentuate the structural aspects of a subject and stress its graphic-abstract qualities in the print. If a photographer uses negative prints with discrimination and understanding, he can create a type of imagery that blends fact and fantasy to produce pictures which show reality in a form that cannot otherwise be seen.

To make a negative print it is necessary to have a diapositive. To make a diapositive, contact-print or enlarge the negative on a sheet of slow orthochromatic film. A diapositive can also be made by placing the negative on a sheet of flash-opal glass, masking it carefully with a cut-out of black paper so that no extraneous light can strike the lens, and photographing it in transmitted light. Negative color prints can be made by enlarging positive color transparencies on Ektacolor paper. As a rule, the more abstract the subject, the more suitable it is for negative rendition. For example, a technical form is more suitable than a face, and bold simplicity is preferable to complex design.

THE GRAPHIC CONTROL PROCESSES

With these techniques a photographer can produce with typically photographic means effects resembling those of woodcuts, etchings, and other forms of expression found in the graphic arts. Because they change the familiar appearance of a subject to a very high degree, their uses are, of course, limited. They simplify the rendition of a subject by increasing contrast and suppressing detail, continuing the process of abstraction that begins with the translation of color into shades of black and white to a point at which the results in regard to boldness and power of expression rival the best examples of the graphic arts.

There are four different graphic control processes: bas-relief, solarization, reticulation, and photogram. Each can be used alone or in combination with one or more of the others. And since each can be used either in the positive or in the negative form, the creative potential of the graphic control processes is enormous.

Bas-relief

To be effective, this technique, which emphasizes lines and outlines, requires a sharp and contrasty negative. To make a bas-relief, contact-print the negative on film and make a diapositive. Place the negative and the diapositive together, emulsion facing emulsion, move them slightly out of register, tape them together, and enlarge the "sandwich" on paper of hard gradation.

p. 246

Lines of varying widths can be obtained by varying the degree of offset between the negative and the diapositive. As a rule, narrow lines look better than wide lines. White or black lines, respectively, can be produced by offsetting the negative and diapositive toward one side or the other. Prints with or without intermediate shades of gray can be obtained by varying the contrast grade of the paper. And if the "sandwich" is contact-printed on film, a bas-relief negative can be produced which, when enlarged, will yield a print in which tone values are reversed.

Solarization

To be effective, this technique requires a perfectly sharp and contrasty negative. Solarization is a rather unpredictable process that is difficult to control, and since it frequently ends in failure, a photographer should not risk solarizing a valuable negative but should work only with expendable duplicate negatives, diapositives, and prints.

p. 247

The simplest way to produce a solarization is to work with paper negatives: make

an 8 x 10-inch enlargement of a suitable negative on Kodak Fast Projection Paper Extra Thin (if unavailable, use ordinary single-weight paper of hard gradation). p. 194 The exposure must be correctly timed since over and under-exposure produce poor results. After the print has been in the developer for about one minute, turn the *white* light on and expose the paper for a few seconds while it is in the developer, then continue development by safelight illumination. The print will, of course, turn black, but not uniformly black. Beginning with areas that were white, blackness will quickly spread toward areas that were black before the second exposure. Interrupt development shortly before the print turns completely black by placing it in the short-stop bath; fix, wash, and dry. When you hold the print against the light, if the timing of the second exposure and the subsequent development were right, thin white seams will outline all areas of the picture that were originally dark in the print (this is the so-called Sabattier effect). If you contact-print this "paper negative," you will obtain a solarization which shows the subject delicately traced in black, with positive and negative characteristics intermingling.

Successful solarization depends largely upon standardization of technique. The wattage of the white-light bulb, its distance from the paper during the second exposure, the duration of this exposure, and the subsequent time of development must be recorded as a basis for future corrections in case of failure, or to permit repeating a successful test.

Reticulation

Since reticulation is unpredictable, to avoid spoiling a valuable original only p. 246 duplicate negatives or diapositives should be used (prints don't reticulate). The technique of reticulation makes use of the fact that excessive softening of the film emulsion produces wrinkling. Under controlled conditions, a uniform reticulation can be produced over the entire surface of the film which, in the print, produces a "pointillistic" effect of great expressive potential.

A sharp or unsharp negative may be used. Best results are obtained with fairly dense negatives of low to medium contrast that have not been hardened during fixation, or only moderately hardened, because a correctly hardened negative emulsion will reticulate incompletely or not at all. To reticulate a negative, soak it *in horizontal position* in a tray of warm water until reticulation appears satisfactory. Then *without tilting it,* carefully transfer it to a strong hardening solution (68 degrees F.) to harden the wrinkled emulsion and prevent it from melting and running off its base. Wash and dry as usual. The temperature of the water bath

and the time of the soaking required will vary with different films and the degree to which their emulsion was hardened and they must therefore be established by test. Up to a certain point the longer the soaking, the coarser the reticulation. Beyond this point the emulsion will begin to split and to frill along the edges, and further soaking will cause it to melt.

Photograms

Photograms are made without a camera. In its simplest form a photogram is a shadowgraph made in the darkroom by placing opaque objects on a sheet of sensitized paper, briefly exposing the paper to white light, and developing it. The result is a photographic "blueprint" in which areas covered by the objects placed on the paper appear as white silhouettes on a black background.

More sophisticated photograms can be made by suspending objects on a sheet of glass above the sensitized paper to obtain softened or blurred outlines, by combining this technique with the first technique to simultaneously produce sharp and blurred images, by modifying the exposing light through use of materials of different degrees of translucence, by reflecting the light onto the sensitized paper from differently curved polished surfaces, or refracting it with positive or negative meniscus lenses, prisms, or other light-modulating devices.

Still more intricate photograms can be made by using several light sources to produce cross-shadow effects, by moving the light source during the exposure, or by changing the angle of the exposing light from a perpendicular position to a more or less slanting position. Furthermore, multiple exposures can be made during which objects are added or removed to obtain overlapping silhouettes in different shades of gray. Through appropriate adjustment of the exposure the tone of the background can be made black or any shade of gray. To obtain a white background make a contact print of the photogram on paper of hard gradation. Impractically short exposure times can be avoided by using a lightbulb of very low wattage at the proper distance or by exposing the photogram with light from the enlarger, the lens appropriately stopped down.

A photogram can also be made by placing a flat object in the negative carrier of the enlarger and projecting it onto the sensitized paper. Suitable objects are feathers, leaves, transparent insect wings, fish scales, and other small objects of nature. Since a negative is not used, image degradation is held to a minimum and enlargements produced by this method have superb sharpness and faithfully reveal the most minute detail.

322

How to Make Good Photographs

The goal of every ambitious photographer is to make good photographs. But what qualities make a photograph good? And are there any standards to guide the beginner?

THE CHANGING STANDARDS

Like any other form of creative activity, photography has standards by which its works are judged. Such standards relate to the times. And as times change, attitudes change and so do the standards by which we judge photography. As Brodovitch once expressed it: what is good today may be a cliché tomorrow.

During the last fifty years the standards for judging photographs have changed drastically and often. At the beginning of the century when Steichen and Stieglitz began to use photography as a means of creative expression, the romantic landscape and city view and the idealized high-key or low-key portrait were in vogue. Photography was the rival of painting and a photograph had to be "soft" to qualify as "artistic" which then meant "good." Some twenty-five years later, beginning at the Bauhaus in Germany, a reaction against the romantic approach set in. A new standard—the New Realism (*Neue Sachlichkeit*)—was applied to photography. The world of the close-up and the beauty of technical forms was "discovered" and pictures had to be sharp to be accepted as "good." Albert Renger-Patzsch published his classic work *Die Welt ist schön*. The bird's eye and worm's eye views were the fashionable way of seeing things and "converging verticals" became respectable and were accepted as photographic symbols of height. Then the first practical high-speed camera—the Ermanox with its f/2 lens, associated forever with the name of Dr. Erich Salomon—made "candid photography" by "available light" possible and again standards changed; interest shifted from precisely seen objects and things to spontaneously seen "documentary" pictures of people.

Around that time the first Leica appeared, inaugurating the era of 35-mm photography. Its acclaimed exponent was Dr. Paul Wolff who opened new frontiers by

raising the technical standards of 35-mm photography to a level where miniature camera negatives were able to compete successfully with larger film sizes in many fields of photography, notably photo-journalism, in which Alfred Eisenstaedt did pioneer work first in Germany and later in the United States. However, this newly won freedom of photographic expression eventually led to sloppiness and mis-use and technical standards declined. But once more reaction set in and standards changed as photographers rediscovered the beauty and creative potential of precise rendition through the work of Edward Weston who used an 8 x 10-inch view camera. The "f64 school" came into existence and its followers raised photo-graphic standards to new heights until the inevitable happened: sharpness became the sole standard by which a photograph was judged—a picture's form became more important than its meaning.

The next change came with the depression. Under the pressure of harsh reality, Roy Stryker and his co-workers, photographing the American scene for the Farm Security Administration, set new standards through emphasis on documentation; once more the meaning of a photograph became more important than its form although technical quality remained very high. This lasted until true high-speed films freed photographers from dependence on auxiliary lights. Flashbulbs went out of fashion and pictures were considered "good" only if taken in "available light." The inevitable result was a lowering of technical standards—film grain and fuzziness were not only acceptable, but became a veritable badge of honor in the *avant-garde's* fight against the "slick" and "phony" type of "pictorial" photo-graph that still dominated academic salon photography. Soon the best photograph was the one taken under the most difficult light conditions, regardless of meaning, fuzziness, or grain. At the same time, photographers like Richard Avedon and Ernst Haas creatively explored blur as a symbol of motion while Gjon Mili per-fected techniques for stopping motion completely with speedlight. Color films were improved to the point where they could successfully compete with black and white and set new standards: first natural color was the goal, then creatively "expressive" color as exemplified later by the work of Art Kane and Gordon Parks.

Today different "schools" of photography vie with one another and the search for new forms of expression is being pressed more vigorously than ever. It may seem that there are no standards by which to judge a photograph and that the only criterion is whether a picture pleases the observer. But standards for judging photographs do exist. They are the same as those that exist elsewhere in art. They

evolve out of the nature of the photographic medium and out of the photographer's approach to it.

AN APPROACH TO PHOTOGRAPHY

Three conclusions can be drawn from this very much simplified outline of modern photography: what once was condemned as a "fault" (converging verticals, film grain, blur, etc.) eventually becomes a necessary part of technique; advances in photo-technology (high-speed lenses and films, electronic flash, etc.) lead to new forms of expression; and indiscriminate use of new forms of photographic expression eventually reduces them to clichés which, as reaction sets in, are replaced by new developments.

I believe that a photographer should use newly available means to create new forms of expression, even if this involves breaking established "rules" and risking the displeasure of the critics. I furthermore believe that if a change from traditional standards comes from a re-evaluation of these standards in the light of new experience, it is not mere rebellion but growth. Growth implies new ideas, improvement of old and development of new forms of expression, and planned violation of academic rules. If a photographer approaches photography in this manner, I feel he is on the road to making good photographs.

To avoid wasting his energy by going off in different directions simultaneously, a photographer must establish a purpose and a point of view. Unless the purpose of a photograph has been established, it cannot be judged intelligently because it is then impossible to know whether the purpose has been realized, or how well. It is this purpose which determines a photographer's approach to photography, and it is out of this approach that the standards will emerge by which his work will be judged.

As an example, I will use my own approach to photography, aware that the reader's may be different.

To me, photography is a mirror of life and any photograph worth looking at must be a reflection of life, of reality, of nature, of people, of the work of man, from art to war. I have no use for "arty" pictures nor for pictures that are stilted, posed, or faked. My approach is intellectual rather than emotional and I feel more closely related to the viewpoint of the scientist than to that of the artist. In consequence, I am more interested in facts than feelings, and clarity of rendition is important in my photographs. I have occasionally been criticized (unjustly, I feel) for being unemotional, cerebral, and cold.

Whatever my shortcomings, I have learned to accept them because I have found through experience that it is impossible to change basic traits. Instead, I try to make the best of what I am, to express myself through my pictures as precisely as possible, and to use my camera to give people new insight into some of the endlessly varying aspects of our world.

I see photography as a most important and beneficial discovery because it has made such a great contribution to our knowledge and experience. I believe every photographer is a potential contributor. The wish to contribute is one root of the creative drive to make something of worth, something by which we might be remembered and achieve a kind of immortality. The scale on which we work does not matter, nor does the field in which we make our contribution. Each gives what he can. Our civilization is built upon cumulative contributions. We learn from one another and from those who preceded us—the heritage they left, knowledge, art, teachings, philosophies. Without such contributions we would still be living in caves, making our own small discoveries, each starting anew. No aware person can fail to acknowledge the enormous debt he owes to those from whom he has learned. His only way to repay this debt is to preserve the continuity by adding his share.

I believe that the purpose of any photograph is communication, that communication presupposes meaning, and that the making of any meaningful photograph is a process that involves five consecutive stages:

1. Interest in the subject or event which suggests the idea or feeling which will underlie the picture. Without such interest in his subject a photographer cannot produce good photographs and the whole process of picture making becomes mechanical routine. Interest is the energizing factor that is vital for all creative work.

2. Knowledge and understanding of the subject shape the idea or feeling. Interest makes one wish to know more about a subject and to search for pertinent facts concerning it. For without knowledge of the subject which leads to an understanding of it, meaningful photographs cannot be made.

3. Evaluation of the subject. Knowledge and understanding provide a foundation for a personal response and point of view. When a valid personal opinion is combined with an individual way of seeing and creative ability, the result is bound to be a photograph which shows the subject in a form that provides insight and stimulation.

4. Seeing in terms of photography. The photographer's next problem is to find a way to translate intangibles—ideas, feelings, mood—into a photograph. This presupposes the ability to see reality in photographic terms. For as many a p. 47 photographer has found out to his dismay, the photograph of a beautiful girl is not necessarily a beautiful photograph. To make a photograph beautiful—and give it meaning—a photographer must be familiar with the use of photographic p. 249 symbols and know how to select those that will best express specific concepts.

5. Technical execution—the mechanics of making a photograph. Once a photographer has decided what he wants to say and how to say it, all that remains is to assemble the equipment required and use it according to the established prac- p. 68 tice of photographic technique. Exposing, developing, and printing can be re- pp. 167, 194, 203 duced to a science. In this age of fool-proof automated cameras, photoelectrically controlled exposures, and time-and-temperature controlled development, dial readings have largely replaced the need for laboriously acquiring the technical skill previously needed. Today anyone who can read, follow simple instructions, and use an exposure meter, a thermometer, and a timer, can also produce technically perfect negatives, color transparencies, and prints.

SUMMING UP AND CONCLUSIONS

Each of the five stages described above is equally important. Unfortunately, few photographers realize the importance of the first four, and many are not even aware of them. Seen superficially, creation of a photograph takes place at the moment of exposure, but the *real* process of creation takes place during the first four stages during which the photographer can plan and work out his picture. Only then can he control its final form by selecting the approach, tools, and techniques needed to translate his ideas or feelings into picture form. Once the exposure is made the main qualities of the picture are determined. What remains to be done can be done by any skillful apprentice.

Unfortunately, however, stage five—the technical execution of the picture—is that upon which the average photographer spends all his effort. This is, of course, why the majority of photographs are meaningless and dull. The photographer's attitude toward his medium, revealed in his approach to his subject, decides the success or failure of his work. For know-how is no use unless guided by "know-what."

THE IMPORTANCE OF BEING IMAGINATIVE

The unusual is always more sought after than the common and, accordingly, unusual photographs have a better chance of attracting attention than ordinary pictures. Unfortunately, the subjects of photographs are generally more or less the same: people, objects, landscapes, scenes from daily life. Hence, whatever unusual qualities a picture may have must be the result of an unusual quality existing in the photographer rather than the subject. This unusual and desirable quality is imagination.

It is his imaginative faculties which make a photographer capable of going beyond whatever he may have learned from others and creating in his own work something new. A new idea, a new approach, a new effect, a new point of view. An unimaginative person may read many books on photography, attend lecture after lecture, go to school—and still be unable to do more than copy what he has seen. Phototechnical knowledge and skill in its use can be acquired; the principles of composition can even be mastered in time; but no one can acquire imagination. One either does or does not possess this magic quality. However, many have latent imaginative qualities and such unrecognized talents can be brought out and developed.

pp. 102-103

A good way to train one's imaginative faculties is through mental exercises: try to imagine *different ways* of doing the same thing, different ways of seeing the same subject, different applications of photographic means and techniques. When confronted with a photographic problem, try to visualize how the subject would appear from a *different* point of view: from higher up, from lower down, from the side, from the rear. How would it appear if taken from farther away with a telephoto lens? Would the subsequent reduction of perspective distortion contribute to a better characterization of the subject? What would happen if a wide-angle lens were used? Would a certain amount of perspective distortion aid in rendering more clearly certain typical features of the subject—in the manner of a caricature which often is more characteristic of the subject it depicts than an objective rendition? What about a different kind of illumination? Backlight, for example, instead of the more ordinary sidelight? A silhouette instead of a detailed rendition? Stark graphic black and white?

p. 236-237

By investigating systematically every controllable factor which contributes to the appearance of a picture, by patiently searching for *other* ways than the obvious one for solving a specific problem, by critically analyzing the results of his in-

vestigations, and by making clever use of the possibilities which are inherent in his subject, the inventive photographer creates the kind of picture which makes less determined photographers jealously exclaim, "Why didn't I think of that! How could I overlook such possibilities!"

Another way to develop one's latent imaginative faculties is to study the work of imaginative photographers, similar to the student artist who learns from studying the work of the masters. I believe that there is no artist who, in one way or another, has not been influenced in his work by the thought and work of others. Such influences are necessary catalysts to the artistic growth and development of any creative personality. This must not be confused with imitation. Influence, in the best sense of the word, is synonymous with inspiration—provided, of course, that the influencing factors are evaluated and assimilated by one whose personality is strong enough to resist the temptation to imitate.

Inspiration derived from another's work can lead to the making of entirely original photographs—to pictures so different from those that inspired them that the connection is not apparent. A photographer may respond to the precision of Edward Weston's photographs and suddenly be struck with the importance that fine definition can have upon the effect of a picture; the sophisticated softness of unsharpness and blur used so successfully by Avedon and Milton Greene to symbolize mood may make him realize that intangibles can be conveyed by pictures; the bold composition in the photographs by Arnold Newman or Irving Penn may make him want to experiment with stark graphic black and white, such work waking his own creativity, bringing new impressions to things seen, forming an original concept or idea that, when given tangible form, is a creative work of his own.

When an imaginative photographer sees a subject to which he responds, images and associations form in his mind: the skyline of a great city seen from afar may seem the work of giants, the shapes like huge tombstones of a prehistoric race; a pianist may seem to become a part of his instrument; a woman's lovely face smiles out of darkness, with eyes closed floats toward the light, nearer and nearer until it fills the universe. All sorts of images from which he will choose will form round everything he sees.

An imaginative photographer retains his sense of wonder, imagination and curiosity existing side by side. Unlike the unimaginative photographer who becomes bored with his work, the imaginative mind constantly discovers new sources of stimulation. The imaginative photographer sees new and interesting pictures in

329

subjects others would bypass, discovering order and beauty in unexpected places. And it is he who, through his pictures, conveys to others the beauty and excitement of the world.

TO HAVE A STYLE OF ONE'S OWN

The artistic growth of any creative person follows a definite pattern which is based upon his character, temperament, interest, sensitivity, and taste. To find one's own pattern is the first step in becoming an original photographer.

Originality is the sum total of one's traits. These traits must be consciously recognized, accepted, and utilized to best advantage. They cannot be changed, although they can be suppressed. One must try to make the best of his abilities. This is *not* achieved by joining movements or subscribing to specific schools of thought. Photographers who identify themselves with a specific group consisting of people who agree with one another on most problems don't get the stimulating interchange which they need. For exchange of ideas and opinions with others is vital for one's intellectual and artistic growth. Anyone who has ever achieved anything of lasting value was an individualist—one who worked in his own way, unafraid to fight for his convictions. Photographers who are not willing to fight, if necessary, for their right to say in their pictures what they want to say in the way they want to say it, lose their freedom as artists. This fight is the silent fight of the mind against the corroding influence of public opinion (What will other photographers say? What will my editor think?); against one's own vanity (I wish I were like such and such a person!); one's own inertia (Why try so hard? No one will notice the difference.); the temptation to gain quick recognition by copying the successful work of others (After all, they all steal ideas from one another!). Only those who win this fight become personalities in their own right. And only through personal integrity can one ever arrive at a personal style of one's own.

A personal style distinguishes a photographer from the anonymous mass of photographers whose pictures look more or less alike. Quite a few photographers have gradually acquired such a personal style. Just as an art expert can recognize a painting by Picasso or a sculpture by Henry Moore without looking at the signature, so any experienced photo editor, without looking at the stamp on the back, can recognize a typical photograph by, for example, Weston, Avedon, Blumenfeld, Karsh, Mili, Newman, Siskind, or Penn, to name only a few that immediately come to mind. I say *typical* because only pictures which a photographer made in accordance with his own ideas can carry this seal of personality; those

made to order according to specifications set by clients or editors can, of course, not typify as clearly the style of their maker as those which originated entirely from himself.

To a certain extent, development of a personal style goes parallel with specialization. Each of the photographers mentioned above is a specialist in a more or less sharply defined field. Any creative mind is preoccupied with certain specific subjects. And any creative photographer will preponderantly photograph those subjects in which he is particularly interested. This, of course, leads to specialization. At the same time, however, precisely because he is imaginatively gifted, a creative photographer will gradually develop a style of his own. This style will evolve from the kind of work he mainly does. In this way specialization and the acquisition of a personal style evolve along parallel lines.

The first requirement for the development of a personal style is honesty. Knowledge of one's self and self-criticism are vitally important. A photographer in search of himself must ask: What do I think? What do I like? What do I want to do? Where do I want to go in my work? What do I want my pictures to accomplish? Which ideas and subjects move me? For a good photograph is far more than a pictorial record. It is a reflection of the attitudes and point of view of the one who made it. It is marked by his personal style.

To develop a personal style, a photographer must avoid being original for originality's sake. In our age of novelty for novelty's sake, a photographer can become known as "the man who makes those funny distortions," or "the man who lights a face or uses hands in a particular way." In my opinion, such things are trademarks rather than evidence of creativeness—the proof is their repeated application.

A personal style evolves from the photographer's personality. A man who is very orderly will express this orderliness in the form of precision in his pictures. If this is combined with a great interest in various aspects of nature, one sees why Edward Weston worked in the way he did. The man, his character, his interest, his way of seeing and expressing himself, the means he chooses are interconnected, each fused in the visible expression that is his personal style.

Look at the work of Harry Callahan and Aaron Siskind. Though related in their attitude toward the subject—each searches for the abstract in the real—and related in the way they photograph what they find—emphasizing design through use of graphic black and white—each has evolved a style unmistakably his own. In

Callahan's work the influence of Edward Weston—the precise way of seeing objects head-on in an almost geometrical way—is evident. But from a synthesis of different though related influences Callahan has created a personal way of seeing things. Aaron Siskind's work, more abstract than Callahan's, inevitably invites comparison with abstract expressionist painting—de Kooning, Pollock, Kline. But unlike a painter—and unlike Man Ray and Moholy-Nagy who created abstractions by manipulating sensitized paper, objects, and light in the darkroom— Siskind finds his abstractions in reality. He never rearranges what he photographs, but through sensitive selection and isolation he transforms nondescript subject matter—dilapidated fences and walls, peeling paint, scraps of paper, textures of wood and stone—into fascinating pictures that intrigue and delight the sophisticated observer by their power of graphic black and white, expressive form, and flawless design.

pp. 235, 242 Consider Richard Avedon, the modern romanticist, glamorizer of everything that is sophisticated, elegant, and feminine: his way of seeing things, his sense of motion, his use of blur and harshest contrast of black and white and subtle grays contribute to a style that, no matter how many different forms it may take, expresses his individuality unmistakably.

Eugene W. Smith's brooding character, his deep concern with human problems, and his utter sincerity which allows no compromise are evident in his dark, moving photographs. His is a style that evolved through suffering, insight, and burning idealism.

Every photographer will not, of course, develop as personal a style. Unless one has strong convictions, interests, and sensitivity as well as skill and drive, he will not be able to rise above mediocrity. And often one is held back by imitation. Instead of looking within themselves, many photographers look toward others. Admiring their accomplishments, they seek short-cuts, failing to give themselves a chance. And acclaimed photographers often fail to develop in their work through endlessly repeating the style that brought them fame. One thing is certain: a personal style cannot be forced. It must grow from within. It is the inevitable reflection of oneself.

GOOD, BAD, OR INDIFFERENT?

It is obvious that specific photographs have different meanings to different people. A particularly clear and informative radiograph of the head, for example, which

is of interest to the physician, may be uninteresting to a portrait photographer; and the picture that won the highest award at a pictorialists' convention would probably hold no interest for a documentary photographer.

Although no specific rules can be drawn for unequivocally classifying photographs as good, bad, or indifferent, it is possible to isolate and define certain basic qualities that are *always* found in good photographs and that are absent in bad ones. When a photograph is good, it has some or all of the following qualities:

> Stopping power
> Meaning
> Impact
> Graphic interest

Stopping power

To be appreciated a photograph must be studied. But unfortunately people are so exposed to photographs that a picture must be rather remarkable to receive attention. To command it a photograph must have stopping power. pp. 90-91

Stopping power is that quality which makes a photograph *visually* outstanding or unusual. Its essence is surprise or shock—anything unexpected, unusual, new, imaginative, or bold; anything that is intriguing; and, very likely, anything that makes another photographer exclaim, "Why didn't I think of that!"

This does not imply that a picture should be vulgar or loud. As a matter of fact, in our present society, subtlety, because it is rare, is often especially effective. The use of pastel shades in color photographs often commands greater attention than the use of many strong colors.

Some of the devices and techniques that, when properly used, provide a photograph with stopping power are: very much elongated print proportions, either horizontal or vertical; unusual and daring cropping; very large or very small picture size; very high or very low contrast; extreme simplicity or semi-abstract rendition; very light or very dark overall tone; color photographs that contain mostly white or black and very little color; very bold saturated color or very pp. 244-245 subtle pale color; deliberately distorted, "unnatural" yet meaningful color; use of a telephoto or wide-angle lens instead of a standard lens; cylindrical and spherical perspective; extreme close-ups and photomacrographic views; unusual light effects; unusual atmospheric conditions; glare, flare, and halation; creative use of p. 104 film grain.

333

In his search for stopping power if a photographer uses a particular effect for its own sake, although it may at first attract attention, it will very quickly cause the picture to be rejected as phony and thereby defeat its purpose. Meaningless distortions, overfiltered skies, indiscriminate use of colored light, shooting pictures through such trick-devices as diffraction gratings, prisms, or exposure meter grids, are examples of this.

Meaning

To make a photograph good, much more is needed than stopping power. Besides catching the observer's eye, a photograph must have something which will hold his attention. It must have meaning.

A good photograph must be informative, educational, entertaining, or inspiring. There is no limit to the variety of different meanings which can be embodied in photographs. The meaning may constitute an appeal to the heart (for example, a March of Dimes poster); it may be sex appeal; it may be an intent to deliberately shock one into an awareness of some condition by calling attention to it. Refusing to look at shocking pictures is like not daring to look at reality. Some things must be faced, whether one likes it or not. And a meaningful photograph is one of the most powerful instruments for arousing public reaction.

For example, through his photographs of sweatshops taken at the beginning of this century, Lewis W. Hine aroused public indignation and contributed much to the abolition of child labor practices. His awareness of the responsibility of the photographer comes out in his words, "There were two things I wanted to do. I wanted to show the things that had to be corrected. And I wanted to show the things that had to be appreciated."

And in its May 6, 1946, issue *Life* ran a story on the shocking conditions in an insane asylum which likewise aroused such a storm of protest that sweeping reformations were made. A sequel of this story published in the November 12, 1951, issue of *Life* showed how greatly these conditions had been improved.

I cite these two examples of responsible photo reporting because they illustrate something which seems important to me: the fact that a good photographer must report on *both* the bad and the good. Young photographers in particular, who are highly idealistic and impressionable, have a tendency to limit their reporting to the seamier aspects of our society and to neglect documenting the good. This seems wrong to me because, important as it is to point out the evils which exist, constant unrelieved preaching defeats its own purpose by ultimately making

334

people so used to such evils that they become impervious to them. On the other hand, an immense amount of good can be accomplished by stimulating example. Pictures which show the good things in life, the accomplishments great and small, the progress that is being made, provide encouragement and create constructive enthusiasm to contribute to the good.

Usually the meaning of photographs taken by professionals is clear: a picture is meant to tell a story as part of a documenting picture sequence, as a record of one kind or another, ranging from portraits to scientific photographs, or it is meant to advertise a product or a service.

Most amateur pictures fall under the heading of personal records and have no meaning beyond this. But another category of amateur pictures exists which, in my opinion, are completely meaningless. One really wonders what was in the photographer's mind when he took such pictures as: coils of rope lying on a pier, nudes contorted in an effort to conceal the face or parts of their anatomy, blue-eyed bums with beards (blue eyes photograph better than dark eyes . . .), old women clutching crucifixes in gnarled hands, spectacles resting on an open book (with a candle in the background), fake monks dressed in burlap, apple-eating freckled boys, and still lifes composed of spun-aluminum plates and vases—the needless photographic clichés, the pictures without meaning.

I have asked phootgraphers why they make such pictures. What they replied was in essence: Why not? Others take such pictures and do very well, get them hung in exhibitions and printed in magazines. Why shouldn't I?

This is a hopelessly futile approach to photography, the attitude representing on a smaller scale the lack of individual thinking which exists in our time. People get their opinions ready-made from newspaper columnists and radio commentators who edit and "digest" the news, slant it to fit particular interests, and serve it authoritatively to the reader or listener who, convinced of his own inferiority, does not dare to have an opinion of his own, accepts it as true, and repeats another's view until he believes it to be the result of his own thinking.

As long as a photograph has a meaning, it does not matter to what field or branch of knowledge, science, art, or entertainment this meaning applies. Not all subjects appeal to all people. Provided a photograph says something interesting and says it well, the photographer has not wasted his time. It is partly for this reason that, for example, *Life* is subdivided into different departments—news, science, art, fashion, religion, sports, and so on—to assure that everyone finds in it something

that is of interest to him. *Anything in which a photographer is genuinely interested is worth photographing* because if it is of interest to him, it stands to reason that it will also have meaning to some other people. No person is so unique that he cannot find others to share his interests.

It does not matter *what* you photograph, nor *how* you photograph it, as long as you don't surrender your inalienable right to express your personal opinion in picture form, as long as you know *why* you do it, and as long as your work is the outgrowth of conviction. If this comes out in your photographs, although people may still disagree with you, no one can question your integrity as a photographer and your pictures will have meaning.

Impact

Impact can be defined as emotional stopping power. It is an intangible difficult to define. Whereas a photograph that has visual stopping power will be noted by any observer, a picture that has emotional stopping power will command a deeper kind of attention, its meaning or feeling bypassed only by those almost devoid of sensitivity.

Before he can create photographs with impact, a photographer must himself feel the emotions which, via his picture, he wishes to impart to others. This is the main reason why I consider genuine interest in a subject one of the first conditions for the making of good photographs. If a photographer does not have a response to his subject, he obviously cannot produce work which contains any emotional quality and, just as obviously, an observer in seeing it must remain unmoved.

The emotional reaction of a photographer toward his subject may be compassion for children who have nowhere to play beyond the garbage-littered backlots of big cities, the awe-inspiring, almost mystical serenity felt in the redwood forests of California, or a sensitive appreciation of the exquisite structure of a seashell. The response may stem from admiration for the talents of an actress or her sex appeal, disgust with a demagogic politician, or hate of war. What matters, and what usually makes the difference between pictures with and without impact, is whether the photographer reacts emotionally to his subject or whether he is indifferent and simply shoots the picture as part of the job. In the first case he may succeed in transferring to his work something of what he felt in the presence of his subject. In the second he will merely produce a picture which, for all its worth, might just as well not have been made.

As it is impossible to establish rules for the creation of art, so it is impossible to

336

instruct photographers on how to produce photographs which have impact. However, although specific rules do not exist, it seems to me that from experience certain ideas evolve and from these certain suggestions may be made. How helpful such suggestions can be is, of course, questionable. Personally, I believe that the work of photographers like Eugene W. Smith, Leonard McCombe, or Ed van der Elsken is emotionally stirring, *not* because these photographers follow secret rules, *but* because they are sensitive artists who do not photograph subjects which leave them emotionally unaffected.

A photograph that has impact gives the observer some kind of an emotional shock. It may be slight, producing a mild response or calling forth comment in appreciation of the thing achieved. Or it may create a moving impression which turns the mind to deepening thought. Seeking the cause of such reactions, I analyzed a number of photographs which, as far as I am concerned, have impact. And I found that these photographs had one quality in common: they were genuine. By this I mean that there was about them nothing phony, nothing posed or faked. To me, then, genuineness is a prime requirement for the creation of impact.

Some of the most moving photographs I have seen were technically imperfect—grainy, unsharp, or blurred. But far from detracting, these imperfections actually heightened the impression of genuineness and realism in the picture and thus became, in fact, means of creative expression. They gave a visual sense of immediacy. They incorporated the rush and excitement of events or emphasized the difficult or dangerous situation. In a sense, these technically imperfect photographs reminded me of handmade objects which have interesting irregularities—which precisely because of their flaws are more appreciated and sought after than their technically perfect but impersonal counterparts. The fact that a (in the academic sense) technically imperfect photograph can have greater impact than a faultlessly finished picture proves that technical perfection alone is no criterion of the true value of a photograph.

Graphic interest

A photographer may be highly idealistic, compassionate, understanding of people, perceptive to his surroundings, and gifted with imagination. But unless he also knows how to present his feelings and ideas in a graphically effective form, these fine qualities will be wasted. A *good* photograph must not only say something worthwhile, it must also say it well.

As I see it, phototechnique can be divided into two parts: 1. The *basic* techniques of focusing, exposing, developing, and printing which are subject to specific rules. 2. The *selective* techniques which are based partly upon modifications of the basic techniques, and partly upon choice and use of different kinds of photo-equipment—different types of cameras, lenses, filters, films, etc. The basic techniques are comparatively rigid; the selective techniques are extremely flexible, offering the experienced photographer a wide choice of forms in which to render a specific subject. Making the right choice in this respect is the mark of a good photographer.

pp. 326-327

Because phototechnique is the only phase in the making of a photograph that can be taught, it is the subject of innumerable books and articles, most of which, unfortunately, do not point out that phototechnique is only *one* step in the process of making a *good* photograph. As a result, the value given to phototechnique has become so great that it completely overshadows the importance of the other steps. The consequence is that photographs are most often judged *not* as they should be, for their content and meaning, but for their technical excellence. And the saddest part of this is that this standard for technical excellence is usually the obsolete academic standard of the past.

Anyone who wishes to make good photographs must reject the academic standard. As paintings and sculpture that deviate from academic tradition are at first almost invariably rejected by the public and critics alike and, in time, works that once seemed strange become familiar, so, almost without exception, the work of experimental photographers is at first rejected. But eventually such means of expression are accepted and influence the work of other photographers throughout the world.

Realization of this should encourage a photographer to photograph exactly as he wishes. If the most modern forms of expression suit his purpose, he should use them. If these don't suffice, he should try to develop more expressive forms of his own.

Conclusion

Photography can be taught only in part—specifically, that part which deals with phototechnique. Everything else has to come from the photographer. All that a textbook can do is to guide a photographer by showing him what can be ac-

complished in photography when it is approached with intelligence and imagination.

The born photographer—the artist—makes his pictures intuitively, doing the right thing at the right time. Because the creative mind does not work by blueprint, this book is not intended for him. However, glancing through its pages may clarify conclusions he has reached intuitively and thus help him organize his work or provide some needed technical information.

The artistically less gifted photographer must substitute intelligence and energy for intuition. The greater his photographic knowledge, the better his chance for success.

From here on it is up to the reader, where he will go and how he will get there. No one cares what tools he uses. Few know the kind of person he is. But millions may participate in his work. This is the essential: if one's work is honest and sincere, if it has something to say, if it contributes in some respect to people's understanding of themselves, of others, of their surroundings and their world—what difference does it make whether such work is created with brush and paint on canvas, with chisel and mallet in stone, with words on paper—or produced with a camera?

Index

341

Questar, 113
rangefinder, 69, 161
reciprocity factor, 173
reciprocity failure, 174, 312
recycling times (speedlights), 152
reflectance ratio, 278
reflections, 60, 143
reflectors, 154
reflex cameras, 77
reflex system, 70
relative aperture, 83
resolving power (lenses), 107
reticulation, 198, 229, 321
retouching (prints), 212
rubber cement, 213
Sabattier effect, 321
safelight, 183, 184
scale, 58, 293
scrapbook, 33
scratches on film, 206
selective focus, 20, 297
shadow, 265
shadow fill-in, 65
shadows (negative), 195
shadowless light, 21, 177, 258
sharpness, 158
 definition of, 160
 in depth, 158, 163, 168, 289
 of films, 126
 of focus, 158
 of lenses, 106
 of motion, 158
shutter, 168
silhouette, 62
sky, 23
snapshot system, 165
snob appeal, 19
solarization, 320
solutions, 227
 concentration of, 229
 filtering of, 228
 measuring liquids, 227
 mixing of, 227
 parts solution, 230
 percentage solution, 229
 temperature of, 198, 229
spotting (prints), 212
standard illumination, 176
standard lens, 83, 110
static electricity, 132, 206

static marks, 132
stop bath, 187, 192, 198, 228
stopping power, 333, 336
subject 16
 dynamic, 17
 intangible, 18, 263
 secondary, 19
 static, 16
 tangible, 18
subject approach, 13
subject contrast, 278
subject motion, 168, 299
subtractive primary colors, 222
swings of view camera, 78, 287, 289
symbols in photography, 249
telephotography, 313
telephoto perspective, 60, 250
temperature of solutions, 198, 229
testing
 basic filter pack test, 220
 color film, how to test, 123
 darkroom (for light-tightness), 180
 enlarger hot-spot test, 190
 pure white in prints test, 217
 rangefinder synchronization test, 161
 shadow fill-in test, 280
 speedlight guide number test, 153
 test strips (enlargements), 209
texture, 62, 177, 261
time-and-temperature development, 195
timing, 306
trimming (prints), 212
tripods, 145
T-stops, 87
ultraviolet radiation, 142, 143
underdevelopment, 195
underexposure, 167
unphotogenic qualities, 63
unsharpness, 317
vanishing point, 285
viewfinder, 69
vignetting, 290
voltage control, 156
washing (films), 201; (prints), 211
watt-seconds, 151
wedging (focal-plane shutter), 71
wide-angle distortion, 284, 316
wide-angle photography, 314
yellow stain (prints), 212
zirconium arc lamp, 258